Critical Issues
in Public Art

Critical Issues in Public Art

Content, Context, and Controversy

EDITED BY
HARRIET F. SENIE AND
SALLY WEBSTER

ICONEDITIONS
An Imprint of HarperCollins*Publishers*

CRITICAL ISSUES IN PUBLIC ART: CONTENT, CONTEXT, AND CONTROVERSY. Copyright © 1992 by Harriet F. Senie and Sally Webster. All rights reserved. Printed in the United States of America. No part of this book may be used or reproduced in any manner whatsoever without written permission except in the case of brief quotations embodied in critical articles and reviews. For information address HarperCollins Publishers, Inc., 10 East 53rd Street, New York, NY 10022.

HarperCollins books may be purchased for educational, business, or sales promotional use. For information, please write: Special Markets Department, HarperCollins Publishers, Inc., 10 East 53rd Street, New York, NY 10022.

FIRST EDITION

Designed by Abigail Sturges

Library of Congress Cataloging-in-Publication Data

Critical issues in public art : content, context, and controversy /
 edited by Harriet F. Senie and Sally Webster. —1st ed.
 p. cm.
 Includes bibliographical references (p.) and index.
 ISBN 0-06-438518-3/ISBN 0-06-430220-2 (pbk.)
 1. Public art—United States. I. Senie, Harriet F. II. Webster,
 Sally.
N8835.C75 1992 92-52572
709'.73—dc20

92 93 94 95 96 CC/CW 10 9 8 7 6 5 4 3 2 1
92 93 94 95 96 CC/CW 10 9 8 7 6 5 4 3 2 1 (pbk.)

Contents

Acknowledgments

This anthology is an outgrowth of the work we did as coeditors of the Winter 1989 *Art Journal* issue devoted to public art and the panel "Content, Context, and Criteria in Public Art Since 1776," which we organized for the 1990 annual meeting of the College Art Association in New York. We want to thank Jane Edelson and Virginia Wageman at the CAA, and our contributors and panelists. Two articles from the *Art Journal* and one paper from the panel are included in this anthology.

We also appreciate the advice we received during this anthology's early stages from Arlene Raven and Brian Wallis. In addition, we thank Dr. Marlene Park for bringing to our attention the work of two of her students at the Graduate Center, City University of New York. It is important to note that only half of the articles included in this anthology have been published before. The serious study of public art is in its infancy, and it is our belief that the scholarship represented in this volume, with its variety of critical perspectives, begins to define a new field of inquiry. For their contributions to this endeavor, their participation and assistance, we thank all the authors. We are also grateful for the support and suggestions of our editor, Cass Canfield, Jr., of IconEditions, HarperCollins.

Introduction

Public art with its built-in social focus would seem to be an ideal genre for a democracy. Yet, since its inception, issues surrounding its appropriate form and placement, as well as its funding, have made public art an object of controversy more often than consensus or celebration. Originally viewed by many in the new nation as a luxury incompatible with republican values, public art (indeed, art in general) was (and continues to be) regarded with distrust. Thus, art, still largely viewed as elitist, is often discussed in terms of monetary worth or political usefulness rather than admired as an expression of culture or intellectual achievement. For any meaningful understanding of public art, it must be viewed in the complex matrix in which it is conceived, commissioned, built, and, finally, received. Much more is required than a formal analysis of the works, although the place of public art in the history of art as well as its value as art cannot be overlooked.

The articles in this anthology approach public art from a variety of critical perspectives. Part I, Defining National Values: American Monuments, Murals, and Memorials, addresses traditional categories of public art with a view toward understanding ways in which it conveys overt and covert national values. Part II, Politics, Patronage, and Public Art, discusses the motivation of patronage, itself an extension and expression of national and local politics, and its influence on the form and content of public art. Part III, Public Art and Public Response, addresses the critical issue of public art controversy by isolating some of the many factors that prompt it. Finally, Part IV, New Directions in Public Art, defines and interprets the evolution of public art during the last two decades.

Although this is not a history of public art in the United States, and the works of art discussed vary widely in form and content, it quickly

becomes evident that there has been a consistency in the concerns surrounding them. As early as 1781, the U.S. Congress voted to erect a "marble column adorned with emblems" to honor the conclusion of the War of Independence with the American victory over the British at Yorktown, Virginia. A year later, Congress resolved to honor the Definitive Treaty of Peace by commissioning a bronze equestrian statue of General Washington, dressed like a Roman complete with a laurel crown. Beverly Held has argued convincingly that the reason these monuments were never built was that members of Congress never intended that they should be.[1] Monuments were closely tied to the idea of luxury, anathema to Americans' Puritan roots. A clever political ploy thus allowed Congress to honor the proposed subjects without spending a penny. By the 1790s, when the decoration of public buildings in the nation's capital became a subject for debate, the issue of federal patronage could no longer be sidestepped.[2] When John Trumbull proposed a series of national history paintings for the Capitol Rotunda, President John Quincy Adams, never known as an art connoisseur, spoke firmly on the subject of government's sponsorship of art, viewing it as an index of our progress as a new country and a mark of our place in the history of civilized nations.

This influential support for public art did not, however, resolve a more immediate pragmatic problem. At this time, during the first half of the nineteenth century, there were few American artists who could either conceive or execute public art on a monumental scale. Indeed, it was the ultimate disappointment of the patrons and the critics with the various Capitol decorations—including Trumbull's paintings for the Rotunda and the Italian artist Constantino Brumidi's frescoes for the hallways and offices—that prompted leading critics, artists, and architects in the 1870s to look to European precedents for inspiration and guidance. It was evident to writers Henry Van Brunt and Montgomery Schuyler, architect H. H. Richardson, and painters John La Farge and William Morris Hunt that the issue facing this country vis-à-vis public art and architecture reflected the technical and conceptual inexperience of American artists and architects in this arena.

Travel and training in Europe and the publication of works by European authorities such as John Ruskin and Eugène Viollet-le-Duc strongly influenced the architects hired to design new American building projects, such as Trinity Church in Boston and the state capitol in Albany, New York, where color decoration and mural painting became important aspects of the interior design as well as carriers of religious and civic iconography.[3] In the 1880s a new wave of American painters, sculptors, and architects went

to Europe for training at the École des Beaux-Arts and returned home to help establish an American tradition of monumental painting and architecture based on Italian Renaissance precedent and French Beaux-Arts theory. The guiding principle was to unify the arts: architecture was to be enriched and complemented by the addition of painted and sculpted decoration. It was this concept, epitomized by the World's Columbian Exposition held in Chicago in 1893,[4] that was at the basis of the City Beautiful movement that spanned the last decade of the nineteenth century and lasted well into the early decades of the twentieth.

This era, known as the American Renaissance, ended with America's involvement in World War I, ushering in an era when old values and styles of art were increasingly questioned.[5] Debates over appropriate memorials to the Great War raised issues about attitudes to war itself as well as the form and function of the sculptures built to commemorate it. Should they be celebratory, emphasizing victory and triumph, or conciliatory, focusing on the human cost of war and future peaceful coexistence? Should they take the traditional form of art (usually a combination of architecture and sculpture) or should they be living, useful structures such as parks, playgrounds, or swimming pools?

These debates prefigured similar discussions concerning appropriate memorials for World War II. At that time architect Philip Johnson lamented that American monuments built over the last century were "very ugly" and urged a rethinking of the genre in contemporary terms. Prophetically, he observed, "The megalith and the mound are two traditional categories that since the days of Stonehenge and the mound builders have been relatively neglected, but which are admirably suited to the machine techniques of our day as well to the rigorous simplicity of our modern aesthetic."[6] Although traditional monuments and memorials continued to be built, these commissions went largely to artists who were tied to a conservative style with roots in another century.[7]

In the twentieth century, with the advent of modernism and International Style architecture and its disdain for traditional ornament, painting and sculpture were deprived of a significant role as an integral part of architecture, and therefore public art.[8] Although Bauhaus rhetoric called for the integration of the arts in theory,[9] in practice the very materials of the building and its functionalist rationale all but prohibited such inclusion. Where were sculpture and painting to go in a steel-framed glass edifice? To a great extent the emergence of large-scale sculpture in conjunction with modern architecture in the 1960s may be seen as an attempt at ornament after the fact.[10] What made this development even more problematic in

terms of public art was the abstract style practiced by the most important artists of the day, an artistic vocabulary difficult for many museum audiences, and completely foreign for large segments of the public who now had to contend with it in the spaces they used daily. In a museum it could be ignored; in a public space it clearly could not. (Whether this new style was misinterpreted or misunderstood more often than traditional sculpture with its allegorical figurations is a subject that still requires study.)

The development of public sculpture is closely linked to contemporary architecture, urban planning, and patronage. In the twentieth century the Great Depression with its attendant relief programs ushered in this country's first era of significant federal patronage of art.[11] The WPA/FAP (Works Progress [later Projects] Administration/Federal Art Project), partly influenced by the populist content of the Mexican mural movement, supported public art that related to local history and national ideals. With its emphasis on local artists and the decoration of public buildings, it served as a precursor for the later General Services Administration's Art in Architecture program and the National Endowment for the Arts' Art in Public Places programs.[12] Intermittently between 1963 and 1972 and steadily thereafter, the GSA has had a percent-for-art component in its building program. Similarly, the NEA began supporting public art directly in 1965, offering matching grants to civic and university communities for the commissioning of works for public sites. Both programs contributed significantly to the public art revival of the late 1960s.

This revival coincided with a period of widespread urban renewal. The Great Society task force was created in 1964, and a year later the Department of Housing and Urban Development was signed into being. In 1966 the Model Cities Act was passed,[13] and a variety of local zoning ordinances offered bonuses to builders for the inclusion of open space.[14] Public art became a part of urban renewal programs, as it had been in centuries past, functioning as an emblem of culture and a manifestation of economic wealth, a sign of the power of its patron. At first large-scale sculpture sponsored by the government or big business was commissioned on the basis of the fame of the artist. Surprisingly, even though the art and the artist had nothing to do with their respective sites, the Chicago Picasso and the Grand Rapids Calder eventually functioned effectively as civic sculpture.[15] Whether they were also good art was another matter. These abstract, independent object sculptures, placed in significant civic spaces, gave rise to a body of similar work that challenged expectations that public sculpture have some understandable meaning.

Maya Lin's *Vietnam Veterans Memorial* (1982) signaled both a revival

of interest in the genre of memorials and the importance of the individual in a democracy. By listing the victims of the war chronologically according to the date they were reported dead or missing, the memorial made them all equal. By providing a path to be walked, it offered visitors a rite of passage and the opportunity to grieve privately in a public place. Set into the ground and partially sheltered by it, the sculpture borrowed from the tradition of earthworks pioneered by Robert Smithson and others. In form it echoed the tradition of Minimal sculpture as practiced by Richard Serra. Indeed, the controversy surrounding Serra's *Tilted Arc*, contemporaneous with Lin's memorial, encapsulated the problems of monolithic abstract sculpture in the public domain. Issues regarding the selection process, as well as the nature of good public art, are still being debated today.

As contemporary public art evolved, the definition and role of the public in public art became increasingly important. The search for a meaningful definition of the public has been treated theoretically in recent critical literature and, in a more pragmatic way, in the burgeoning public art community.[16] The general public is now recognized as increasingly diverse and composed of special interest groups whose commitment to self-determination frequently overshadows their sense of participation in the broader fabric of society. How best to communicate and establish a dialogue with this complex public remains the single greatest challenge facing public art today.

Notes

1. These remarks were made by Beverly Held in a paper entitled "Money, Morality, and Monuments: The Debate Begins—American Public Sculpture in the 1780s," delivered at the annual meeting of the College Art Association in 1990.

2. For a history of early federal patronage, see Lillian B. Miller, *Patrons and Patriotism: The Encouragement of the Fine Arts in the United States, 1790–1860* (Chicago: University of Chicago Press, 1966).

3. For a complete discussion of these projects, see Helene Barbara Weinberg, "John La Farge and the Decoration of Trinity Church, Boston," *Journal of the Society of Architectural Historians*, 1974, pp. 323–53; and Sally Webster, *William Morris Hunt* (New York: Cambridge University Press, 1991).

4. The most recent publications on the World's Columbian Exposition are David F. Burg, *Chicago's White City of 1893* (Lexington, KY: University Press of Kentucky, 1976); Reid Badger, *The Great American Fair: The World's Columbian Exposition and American Culture* (Chicago: N. Hall, 1979); Jeanne Madeline Weimann, *The Fair Women* (Chicago: Academy Chicago, 1981); Stanley Applebaum, *The Chicago World's Fair: A Photographic Record* (New York: Dover, 1980); and

Daniel Burnham, *The Final Official Report of the Director of Works of the World's Columbian Exposition* (New York: Garland, 1988).

5. For an overview of the period, the World's Columbian Exposition, and the City Beautiful movement, see the exhibition catalog *The American Renaissance, 1876–1917* (New York: Brooklyn Museum, 1979). For an analysis of the transition from the American Renaissance to the modern era, see Michele H. Bogart, *Public Sculpture and the Civic Ideal in New York City, 1890–1930* (Chicago: University of Chicago Press, 1989). Also see: William H. Wilson, *The City Beautiful Movement* (Baltimore, MD: The Johns Hopkins University Press, 1989).

6. Philip C. Johnson, "War Memorials: What Aesthetic Price Glory?" *Art News*, September 1, 1945, pp. 8–10, 24–25.

7. For a discussion of these commissions in the context of the Fine Arts Commission, the Public Buildings Service, and the National Sculpture Society, see Charlotte Devree, "Is This Statuary Worth More Than a Million of Your Money?" *Art News*, April 1955, pp. 34–37, 67.

8. One of the most notorious expressions of antiornamentalism was Adolph Loos's polemical "Ornament and Crime," published in *Neue Freie Presse*, 1908. A recent response to Loos's and others' contempt for ornament and decoration is Valerie Jaudon and Joyce Kozloff, "Art Hysterical Notions of Progress and Culture," *Heresies*, Winter 1978, pp. 38–43.

9. The Bauhaus call for the integration of the arts is well known from Walter Gropius's proclamation of 1919 for the new school. Its origins in earlier theories are traced by Avram Kampf, "Some Aspects of the Relationship of Architecture, Painting, and Sculpture," M. Barasch, ed., *Studies in Art* (Jerusalem), 1972, pp. 183–212.

10. A close reading of architecture journals during the 1950s reveals the inclusion of art as a significant and pervasive theme. For a further discussion of this development, see Harriet F. Senie, *Contemporary Public Sculpture: Tradition, Transformation, and Controversy* (New York: Oxford University Press, 1992), ch. 2.

11. The bibliography on New Deal art is extensive and growing. Of special interest are Richard D. McKinzie, *The New Deal for Artists* (Princeton: Princeton University Press, 1973), which presents a carefully documented history and critical analysis of the program; Karal Ann Marling, *Wall-to-Wall America, a Cultural History of Post-Office Murals in the Great Depression* (Minneapolis, MN: University of Minnesota Press, 1982); Marlene Park and Gerald E. Markowitz, *Democratic Vistas: Post Offices and Public Art in the New Deal* (Philadelphia: Temple University Press, 1984); and Francis V. O'Connor, *Art for the Millions* (Boston: New York Graphic Society, 1973), which contains essays from the 1930s by artists and administrators of the WPA.

12. For art commissioned by the GSA, see Donald W. Thalacker, *The Place of Art in the World of Architecture* (New York: Chelsea House and R. R. Bowker, 1980). For a survey of NEA public funding, see John Beardsley, *Art in Public Places* (Washington, DC: Partners for Livable Places, 1981).

13. See Mark I. Gelfand, *A Nation of Cities: The Federal Government and Urban America, 1933–1965* (New York: Oxford University Press, 1975), pp. 348–87, for a discussion of federal legislature affecting cities.

14. For a discussion of relevant zoning developments, see Donald H. Elliott and Norman Marcus, "From Euclid to Ramapo: New Directions in Land Development Controls," *Hofstra Law Review,* Spring 1973, pp. 56–91.

15. These commissions are discussed in detail in Senie, *Contemporary Public Sculpture,* ch. 3.

16. A recent anthology of critical thinking on the topic is Hal Foster, ed., *Discussions in Contemporary Culture* (Seattle: Bay Press, 1987), with contributions by Thomas Crow, Martha Rosler, Craig Owens, Douglas Crimp, Barbara Kruger, and Krzysztof Wodiczko. See also Arlene Raven, ed., *Art in the Public Interest* (Ann Arbor: UMI Research Press, 1989).

Critical Issues
in Public Art

Defining National Values
American Monuments, Murals, and Memorials

Two seemingly unrelated events preoccupied the American press during the first half of 1991: the Gulf War and the political correctness of the academy. The first, an illusory war, united the country in an outpouring of patriotic fervor. The other, an appeal for diversity and multiculturalism, was mounted as a challenge to the hegemony of the traditional academic curriculum. For the "politically correct" crowd engaged in this struggle, American myths and legends became a code for capitalist oppression, covert (or overt) racism, and sexism. From the other end of the political spectrum, the country's heroic past was, for a moment, recaptured in a spurious war. These two desires, one, a need to define a new national identity based on multiculturalism, the other a wish to equate national unity with military supremacy—voices of the far left and far right—are, in reality, two sides of the same coin. They reflect a common ambition to define what it means to be American.

This search for a national identity has been ongoing since the birth of the republic, and the debates taking place today echo those of earlier centuries. As Kirk Savage observes in his article on the Washington Monument: "America was then—and to some extent remains—an intangible thing, an idea: a voluntary compact of individuals rather than a family, tribe, or race." It is within this context that he explains how the planning and design of a national monument to the first president mirrored the evolving political temperament of the new country. Debates ranged over most of the century about whether Washington should be memorialized as a modest citizen, a virtuous Cincinnatus, or canonized as a magnificent leader in the manner of Napoleon. The final compromise, completed in 1885, is, com-

pared with Sir George Gilbert Scott's elaborate and sumptuous Albert Memorial (1863–1872) in London's Hyde Park, a model of republican restraint.

In Savage's essay as in others, there remains a consistent factor in the pursuit of national definition: that there is, in fact, no consensus. One way we, as Americans, are different from, say, the French or the Japanese is that we are not tied by common ethnic bonds. Nor do we see ourselves as a nation of discrete tribes, as in Kenya, or of different religious sects, as in India. We do speak a common language and do share at least one common value—the primacy of individual liberty (although how this is defined varies, not unexpectedly, from individual to individual).[1] One of the extraordinary aspects of early U.S. history (as opposed to colonial history) is that the leaders of the new republic had to build a nation from scratch and had to select styles of architecture and symbols that would fairly communicate this new, unique enterprise in participatory government. The location of the capital city had to be decided, a capitol building constructed and decorated, monuments to its leaders authorized, murals narrating its history commissioned, and memorials to those who died in war erected. Where should the capital be located? In what architectural style should the capitol be built? What heroes immortalized? Which history remembered? Whose memory honored? The debates that surrounded all these decisions have begun to be documented, although it is surprising how little attention has been paid to these early public art issues—from the design of the Capitol to the creation of the Washington Mall.

In an anthology devoted to public art, several articles, particularly those dealing with the nineteenth century, of necessity highlight art in the nation's capital: Kirk Savage on the Washington Monument, Sally Webster on the paintings in the Capitol Rotunda, and Charles Griswold on Washington's *Vietnam Veterans Memorial.* (In the following part, Politics, Patronage, and Public Art, two more articles—by Vivien Green Fryd on Thomas Crawford's *Statue of Freedom* for the Capitol dome, and by Dennis Montagna on the little-known Ulysses S. Grant Memorial at the foot of the Capitol—also focus on Washington sculpture.) Of this group only Griswold's addresses contemporary issues. Yet his meditation brings the survey of the Capitol and the Mall full circle, because he discusses the Vietnam memorial in the context of this earlier history. As he notes, "The fact that the Mall grew, so to speak, over a long stretch of time is not inconsistent with the following crucial point: Regardless of the intentions of the designers of the Mall and its monuments at various historical moments, the area possesses an extraordinary cohesiveness from the standpoint of its symbol-

ism. It is as though an invisible hand has guided the many changes effected on the Mall, a communal logic imperceptible as a whole at any given time."

The building that anchors the east end of the Mall is the Capitol. In its heart is the Rotunda, where there are eight mural-sized paintings. A suite of four by John Trumbull was installed in 1826; the second suite, by four separate artists, were executed between 1840 and 1855. Sally Webster, in her analysis of this second suite, links their commission to the early writing of national history. These paintings, thought to be hopelessly inept formal constructions by traditional art historians, are now denounced as signifying this country's commitment to the theory of Manifest Destiny—imperialistic adventures against Native Americans and the usurpation of their lands. This total condemnation simplistically reduces all aspirations to a single motive and does not satisfactorily explain the role these narratives played in the country's search for self-definition. One way to achieve a better understanding of them, and thereby gain a fuller, more evenhanded view of this country's national ambitions, is to place them within the larger context of the early writing of national history.

Needless to say, monuments dealing with national values exist outside Washington; one of the most famous and beloved (probably second only to the Statue of Liberty) is Mt. Rushmore.[2] Jim Pomeroy's piece is a reflection of a contemporary artist's ongoing love-hate relationship with the "eighth wonder of the world." Pomeroy has been amassing information about Mt. Rushmore for over twenty years. Perhaps best known as the uncredited star of Alfred Hitchcock's film *North by Northwest*, Rushmore for most intellectuals and academics remains little more than a kitsch fandango, a true reflection of America's philistine taste and embrace of commercial Hollywood values, a tribute to monumentalism rather than refinement. Yet with the increasing dissemination of American material values throughout the world, scholarly examination of Mt. Rushmore is long overdue. Pomeroy's reflections can serve as a beginning. Although space forced us to select only its most salient excerpts, we recommend his entire essay, because it contains quotations from a variety of sources—from Cher (who thought it was sculpted by God) to Robert Smithson—the cumulative effect of which constitutes the monument's true meaning.

The remaining essay in this part, by James Young, provides a serious and sober discussion of the commissioning of Holocaust memorials in the United States. Considering the fact that the Jewish Holocaust happened in Europe, how do these projects—in New York, San Francisco, Boston, and elsewhere—relate to national values? The answer for most is obvious—we participated as allies, American soldiers were among the first to liberate the

Nazi concentration camps, and survivors and children of survivors live throughout the land. The issues raised by Young focus on the concept of a shared or public memory, which, like other civic enterprises, such as the writing of history or the creation of national icons, can never have the same meaning for everyone. Still, this effort to identify shared or common assumptions about the nation's purpose is basic to public art, and the ongoing debates that do get resolved, as well as the public art that gets built, are, as often as not, products of good will rather than consensus.

Notes

1. A provocative essay that deals with individualism is Mario Vargas Llosa, "Questions of Conquest: What Columbus Wrought and What He Did Not," *Harper's Magazine,* December 1990, pp. 45–53.

2. Two books on the Statue of Liberty, which treat this icon of freedom in a serious and scholarly manner and are good models for the study of other national monuments, are Marvin Trachtenberg, *The Statue of Liberty* (New York: Viking Press, 1976) and *Liberty, the French-American Statue in Art and History* (New York: Harper & Row, 1986).

1

The Self-made Monument
George Washington and the Fight to Erect a National Memorial

KIRK SAVAGE

The 555-foot obelisk on the Mall in Washington, D.C., is one of the most conspicuous structures in the world, standing alone on a grassy plain at the very core of national power—approximately the intersection of the two great axes defined by the White House and the Capitol. The structure itself lives up to its unrivaled site: it dominates the city around it not just by sheer height but also by its powerful soaring contours and stark marble face. This "mighty sign," as one orator called it a century ago, is the nation's monument to George Washington, "the Father of His Country"—a historical figure almost as impenetrable as the blank shaft that commemorates him.[1]

What can be made of the Washington Monument? The answer depends on the interpretation of Washington himself. For both the man and his monument were once the symbolic battlegrounds for long-standing disputes over national identity. Even in his own time Washington and the nation he led were largely products of the collective imagination. America was then—and to some extent remains—an intangible thing, an idea: a voluntary compact of individuals rather than a family, tribe, or race. When Washington took command of the revolutionary army, he gave the new nation a landmark, a visible center to which scattered settlements of people divided by cultural background and economic interest could pledge their allegiance. Necessity made Washington an instant icon, and from the beginning necessity buried the real figure beneath a mound of verse, oratory, and imagery, all vying to give shape to the icon and therefore to the nation.[2]

It is useful to think of Washington as a historical invention; history made him perhaps more than he made history. This essay attempts to interpret probably the most conspicuous, and certainly the most prob-

lematic, undertaking in that historical campaign: the effort to build him a national monument. The undertaking began in the eighteenth century (when Washington was still alive), ran into partisan warfare after his death, and floundered for decades in unending disputes over designs and intentions. The controversy is all the more striking if one looks at the achievements of local campaigns during the same period. States and cities had no trouble displaying their patriotism in a series of impressive monuments to Washington, including a statue by Antonio Canova in Raleigh, North Carolina (1821), a 220-foot column in Baltimore, Maryland (1829), and a colossal equestrian statue in Richmond, Virginia (1858). But the national enterprise forced an issue that could not be swept away by simple appeals to patriotism. If Washington was the founding father, what kind of nation did he found? Erecting a national monument to Washington ultimately demanded a symbolic construction of America.

The trouble originated, after Washington's death, in a profound ideological dispute over the nature of the republic. As new disputes followed, the campaign to unify around Washington's memory continued to betray significant fissures in the American self-image. Not even the Civil War could end the discord; it took another twenty years to bring the memorial to completion. Commentators at the time, and historians since then, have chosen to interpret this messy history as a pluralistic drive toward ultimate consensus. Frederick Gutheim, trying to sort out the design process, has argued that the monument as finally built "reflects the imprint, over many years, of so many forces that in the end we are less aware of individual genius than of that cumulative genius we call culture." Or as Americans claimed when the obelisk was finished in the 1880s, it was a work of "the people," a monument that seemed to make itself and to make America.[3]

Indeed, the obelisk seems to serve as the perfect expression of union—a great mass coalesced into a single gesture that belies all dissension. But this way of reading the monument speaks more of longing than of reality. The blank shaft was in no way built by consensus. It was instead the achievement of an engineer working in virtual secrecy, outside the political process and against the protests of the artistic community. In fact, Washington's monument could be finished only by obliterating his traces in the process, not only from the structure itself but also from the discussion surrounding it. The more we examine the "resolution" his monument represents, the more unsettling it looks and the more unsettled the critical reactions to it appear. The engineered unity of this soaring obelisk gave the nation an image of its own destiny, an image at once powerfully appealing and yet in many ways troubling to this day.

With an almost unerring instinct, Washington played a role fraught with paradox. He was the leader of a nation that had in theory renounced the notion of a leader. The republican theory of government, following Enlightenment ideals, held that men could govern themselves; to the extent that formal government was necessary at all, it was to be conducted by representation rather than prerogative. Even the federalists, who had less confidence in republican man than in strong, central authority, could not disavow the ideology of self-government. Washington's genius lay in his adaptation to his difficulty: he became the reluctant leader. He preferred Mount Vernon to power, or so he said; and the more he demurred or protested, the more power he got.[4]

Washington in myth embodied the very ideal of self-regulation on which the republican experiment rested; by governing the temptation to grasp power he became preeminently qualified to exercise it. Washington's own model of leadership was probably the "patriot-king" of English political theory, yet the one model that consistently appealed to his contemporaries came from the fabled past of republican Rome. It was the figure of Cincinnatus—the farmer who dropped his plow to lead the defense of Rome, only to relinquish command as soon as the danger had passed. Significantly, the example legitimized leadership only in times of emergency. Americans clung to the idea that Washington, like Cincinnatus, could not be persuaded to take power unless he was assured that the survival of the country depended on him; otherwise he would leave the people to govern themselves, as they were supposed to in a republic.[5]

If Washington could not solve the contradictions inherent in republican leadership, he served perhaps a more important role as a model of republican citizenship. To remain a national icon in a republic, a form of government incompatible with the whole idea of icons, Washington had to become the archetypal republican. Thus the most popular biography of Washington of his era, the life written by Parson Weems, was essentially a primer in the private virtues on which a self-governing republic depends: piety, temperance, industry, justice. Yet even in the role of moral exemplar, Washington could not avoid paradox. In their desire to broadcast Washington's virtues—and by extension their own republic's virtues—Americans were led into a self-defeating rhetoric. By making Washington's virtues so extraordinary that he surpassed all ancient and modern prototypes, rhetoric threatened to transform him into a demigod, beyond the aspiration of any ordinary individual. John Adams warned in 1785: "Instead of adoring a Washington, mankind should applaud the nation which educated him. . . . I glory in the character of a Washington, because I know him to be only

an exemplification of the American character."⁶ As Adams realized, the claim that Washington was representative (a Washington) and the claim that he was unique (the Washington) were obviously incompatible. Was Washington an "example" (the double meaning of the word *example* is significant), or was he an aberration? The question went to the heart of the problem of creating a suitable monument, and the answers implied different notions of "the people" and "the nation."

The first proposal for a monument to Washington avoided the republican paradoxes entirely and reverted to a grand monarchical prototype. At the close of the revolutionary war, in 1783, the Continental Congress voted to erect an equestrian statue, "the general to be represented in Roman dress, holding a truncheon in his right hand." This was precisely the representation favored by Louis XV, following the original imperial example of Marcus Aurelius. In 1791, when Washington was serving his first term as president, Pierre Charles L'Enfant incorporated the proposed equestrian into his plan of the capital—at the pivotal point "A" where the two central axes of his map converged at the river's edge. Thus the great commander would stand at the point of origin of the entire scheme, authority radiating outward from his image to the two houses of federal power and thence to the outlying plazas representing individual states.⁷

But this kind of imagery was too much at odds with the ideology of its day. As early as Washington's first term in office an opposition party was growing that used the charge of monarchism to embarrass the federalists, to question their loyalty to the republican cause. If the opposition could criticize official ceremony, Washington's image on coins, and public celebrations of his birthday, would not L'Enfant's plan be all the more exposed to attack? Even staunch federalist John Jay felt compelled to soften the provocative implications of the equestrian proposal. In a report to the Congress, in 1785, he suggested omitting the bas-reliefs of Washington's battle victories envisaged for the pedestal of the equestrian. "Would it not be more laconic," Jay wrote to Congress, "equally nervous, and less expensive, to put in the Place of these Devices, only a book inscribed—'Life of General Washington,' and underneath—'Stranger read it. Citizens imitate his example.'" Jay's desire for a "laconic" monument reflects a wider trend in taste toward neoclassical simplicity, a trend linked to a new veneration of republican Rome; the republican hero need not have his exploits trumpeted. Jay's proposal would also change the imperial model by presenting the leader explicitly for imitation, not reverence. The suggestion was less a solution than an uneasy compromise between republican ideas and monarchical imagery. The statue was never erected. The record of debate does not

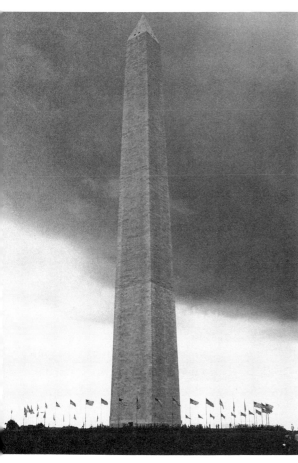

Robert Mills,
Washington Monument,
1848–1885, The Mall,
Washington, D.C.
(Photo: Kirk Savage)

Benjamin Henry
Latrobe, proposal for a
Washington
mausoleum, ca. 1800.
Watercolor, 11 × 21¼
inches. (Prints and
Photographs, Library
of Congress)

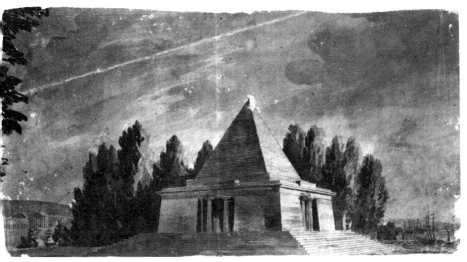

survive, but one can assume that there were more profound objections than mere cost. Even in painted portraits of Washington, images of equestrian command did not prove popular.[8]

Washington's death, on December 14, 1799, opened the way for a much more open confrontation with the issues that had quietly troubled the equestrian proposal. Between 1791 and 1799 the ideological differences between the federalists and the opposition republicans had grown and had polarized the groups into two distinct political parties. In the few days after Washington's death, however, the two parties set aside their differences and agreed on a program of commemoration. The unanimous resolution of December 24, 1799, called for a public tomb to be erected in the Capitol, despite Washington's express instructions for burial in Mount Vernon.[9] But what kind of tomb and how elaborate? Here the ideological tension exploded to the surface in a display of party politics that has since then largely escaped notice.

The dispute originated with a proposal, sponsored by the federalists, to enlarge the monument from the indoor tomb envisaged in the December resolution to a huge outdoor mausoleum in the form of a stepped pyramid 100 feet high. The design, by Benjamin Latrobe, was even more "laconic" than Jay's earlier proposal; yet Jay intended understatement while Latrobe's pyramid aimed for overstatement, summoning the ancient awe-inspiring geometry of the pharaohs to inflate Washington's claims to everlasting fame. Latrobe's idea was clearly indebted to the designs of French funerary architects, especially Etienne-Louis Boullée, who had already suggested the idea of gigantic pyramids for national heroes. Boullée's pyramids, too fantastic in scale to be buildable, were nevertheless important as conceptual experiments in the psychology of the "sublime."[10] His Egyptian cenotaph is meant to astonish and even terrify the beholder, who must imagine himself shrunk to nothingness below the immensity of the structure; the driving clouds and the sharp contrast of bright face against dark reinforce the effect by adding a natural drama to the architectural one. Latrobe's rendering of a pyramid for Washington, although brought down to a more realistic scale, exploits the same pictorial language in its play of light, its active sky, and even its looming backdrop of trees.

The republicans in Congress, sensitive to any sign of "royal display" or extravagance, reacted sharply to this enlargement in conception. To the federalists, however, the very sublimity of Latrobe's proposal was essential. "It is indeed of infinite importance to civil society," one federalist said on the House floor, "that the memory of that great man should be perpetuated by every means in our power." What stronger means, Henry Lee argued,

than a large and powerful monument, one that would "impress a sublime awe in all who behold it"? When the time for a vote came, Latrobe's patron Robert Harper gushed tellingly: "I am awfully impressed by the subject; I sink under the sublimity that surrounds it. No words can reach it; mine are totally inadequate."[11] His own "inadequate" words were carefully chosen to describe the feeling that a true patriot should experience when confronted with the immensity of Washington's virtue. This was the same feeling that the pyramid was intended to inspire in the spectator standing before it.

What were the federalists really up to? They claimed that a "sublime" monument would impress Washington's moral example more effectively than a modest tomb. Yet, without summoning overtly monarchical imagery, the whole thrust of Latrobe's proposal was to elevate Washington far above the common man, to establish the utter remoteness of his achievement. Surely Washington could not be considered an example for the common man to imitate when, standing below the looming pyramid, the latter felt himself "sinking," crushed beneath the "sublimity" of Washington's umblemished life. The federalists' own rhetoric betrayed a greater interest in pacifying the populace than in instructing it; this is especially apparent in their obsession with the security of the monument. For them the pyramid was above all a stronghold that could not be "broken and destroyed by a lawless mob or by a set of schoolboys." Although a republican himself, Latrobe appealed to his federalist patrons by emphasizing repeatedly the threat of vandalism to a less durable monument: "We know that even [Washington's] virtues are hated, by fools and rogues, and unfortunately that sort of animals crawl much about in public buildings."[12]

These sentiments were anathema to the republicans in Congress, zealous defenders of the self-governing ordinary man. If the monument "were made of glass," Nathaniel Macon claimed, "frail as it is, it would be safe." To the republicans, the federalists' desire for an ever larger monument rested on suspect motives. If the federalists were genuinely interested in promoting Washington's "example," why not dispense with the monument altogether and spend the money to educate the poor? "Then, indeed," Macon added, "we might flatter ourselves with having extended the empire of his virtues, by making those understand and imitate them who, uninstructed, could not comprehend them." In other words, a failure in virtue could only be a failure in education. Pure republicanism led Macon and others to question the very act of commemoration, for any monument— merely by singling out the hero from the great mass—undermined their basic assumption that virtue and power resided in the ordinary individual. The republicans were caught in a dilemma: how to commemorate Washing-

ton without reproaching the people. Some of them searched for answers, and by far the most extraordinary idea came from John Nicholas of Virginia, who called for nothing more than "a plain tablet, on which every man could write what his heart dictated. This, and this only, [is] the basis of [Washington's] fame."[13] Nicholas's tablet would deny that there was any legitimate distance between the hero and the common man. Instead of awing the populace, Washington here becomes one with it—literally nothing more than what the people make of him. Nicholas's proposal is a brilliant solution to the whole problem of representing authority in a republic. In this monument the leader retains his legitimacy only by dissolving himself into the all-embracing identity of the citizenry; once merged, the icon and the people together testify to the virtue of their republic.

The debate over Washington's tomb was really a contest between two ideologies, between opposing visions of republican man. In the highly charged political atmosphere of 1800–1801, the monument question became as divisive as the Alien and Sedition Laws or the other major issues that have traditionally been considered the litmus tests separating federalist from republican. The final proof is in the vote: on January 1, 1801, the roll call in the House on the pyramid proposal divided along party lines—the republicans voting 34 to 0 against and the federalists voting 45 to 3 in favor (the three dissenters being renegades who habitually voted with the other side).[14] The federalist victory was a Pyrrhic one, however, coming on the eve of Thomas Jefferson's inauguration and the republicans' assumption of the presidency. The measure soon died a quiet death when the two houses could not agree on a final version.

The discussion of 1800–1801 established a fundamental polarity that continued to shape the congressional debate for several decades as various unsuccessful attempts to revive the idea of a national tomb were made. Opponents clung to the old injunctions against "man-worship" and "ostentation," the most radical among them using the same theoretical argument that an enlightened citizenry—created by education and the printing press—had made monuments obsolete. "Where is [Washington's] monument?" asked one senator in 1832, "our answer is, in our hearts." For all the continuity of their rhetoric, however, the two sides by 1832 had actually regrouped in response to the major crisis of the time—the sectional conflict that threatened to split the union. The location of Washington's tomb took on a special significance; it could be used to sanctify the claims of one side over the other. Those congressmen who wanted to move Washington's remains from the family vault at Mount Vernon to a national tomb in the capital argued that it "would tend to consolidate the Union of these states"

by making the political center of the union at once a spiritual center, the sacred resting place of the founding father. But the opponents, led by states' rights advocates from the South, followed Virginian William Fitzhugh Gordon: "The way to cement the Union [is] to imitate the virtues of Washington; to remove not his body, but, if possible, to transfer his spirit to these Halls." Washington's spirit, Gordon clearly implied, did not rest in the halls of the federal government, but with his own people in his native state; there his true monument of virtue was preserved. These remarks are among the earliest indications of Washington's coming role in the propaganda war between North and South, when he would be claimed on the one hand a defender of union and critic of slavery and on the other hand a slaveholding planter and leader of rebellion.[15] Eventually both sides staked claim to his legacy through the medium of imagery: he decorated the confederate seal as well as the federal dollar.

Even as federal lawmakers guarded the republic against monuments and man-worship, local groups wholeheartedly campaigned for their own memorials to Washington. Sometimes the very men who had argued in Congress against the whole idea of monuments helped to erect splendid ones in their home states. Macon, who had once claimed, "monuments are good for nothing," actively helped North Carolina to procure the best possible statue of Washington, from the finest sculptor in Europe. Republican inhibitions about cost and scale did not restrain the local campaigners. In 1816 a writer in the *North-American Review,* commenting on various ideas for a Washington monument in Boston, frankly confessed that bigger was better: a column was superior to an equestrian statue because with the former "we might erect the largest and finest in the world," whereas there would be "a hundred [equestrians] to rival us."[16] Since the monument had to compete on the world stage, its proponents found it essential to discuss the European traditions, to compare types, to hold design competitions.

Baltimore carried the process through to a fitting conclusion, completing a giant column in 1829 after a design by Latrobe-trained Robert Mills. In appealing for funds, the sponsors of the project were careful to clothe the enterprise in republican rhetoric; they claimed that the monument would act to reverse "the decay of that public virtue which is the only solid and natural foundation of a free government." Neil Harris has argued, on the strength of rhetoric such as this, that the monument campaigns of this period represented attempts to shore up national values that were thought to be eroding in the collective pursuit of easy money and quick gain. The monuments themselves, however, testify eloquently against this thesis. It is true that Baltimore chose to depict Washington in his grand moment of

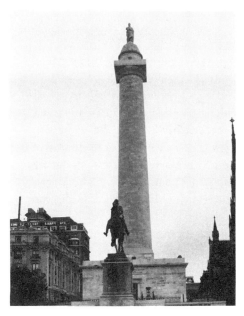

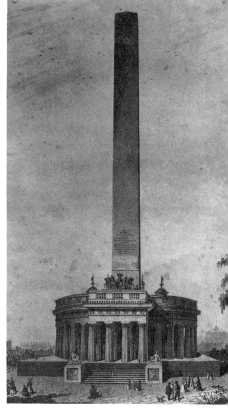

Robert Mills, *Washington Monument,*
1815–1829, Baltimore, Md. (Photo:
Kirk Savage)

Chs. Fenderich, certificate for
contributors to the Washington
National Monument Society, ca. 1846.
Lithograph, 23¼ × 17½ inches.
(Prints and Photographs, Library of
Congress)

republican virtue, resigning his military command; yet the act is presented as such a historical aberration that it merits elevation 220 feet off the ground, so high in fact that the pose is hardly discernible. A monument that ostensibly inculcates the old ideal of self-regulation actually signals its eclipse: the ideal is now celebrated precisely because it is unattainable by mortal men. The Baltimore project testifies to the same disease of "grasping accumulation" that these monuments were allegedly trying to cure. Baltimore elevated Washington's achievement in order to elevate its own column, to rear the "largest and finest" monument ever erected in the country.[17]

Nevertheless, Harris's thesis cannot be dismissed quite so easily. The coupling of a rhetorical appeal to simple republican values with a grandiose and extravagant monument reflects the double standards we have seen applied to federal and local monuments. Both inconsistencies are symptomatic of a profound moral ambiguity underlying republicanism in America through the Jacksonian era. The nation and its people were not content with the simple values and modest ambitions imposed by orthodox republicanism; it was a restless society constantly striving for more land, more wealth, more power. Just as Americans had not let Washington slumber in republican simplicity, but had competed to broadcast and elevate his reputation, so they increasingly competed for economic gain and wondered why the republican ideal of communal harmony was becoming ever more distant. The monuments to Washington sharpened this social tension because his ambiguous standing led American aspirations in two directions at once: backward to an ideal republic of stability and harmony; forward to a new era of national expansion, boundless wealth, and personal glory.[18]

Nowhere is the tension more evident than in the biggest monument campaign of all, the one that finally resulted in the national monument to Washington that we have today. The Washington National Monument Society from its inception was actually a local movement in the guise of a national one, springing to life in the same spirit of competition that animated the Baltimore project before it. The society was founded in 1833 by a few permanent residents of the capital, all of whom were in one way or the other active in promoting the unrealized city that was still a swampy backwater. They intended their monument to triumph over any conceivable competition: when they invited designs in 1836 they stipulated that the monument cost no *less* than the astonishing sum of one million dollars, all to be provided by private contributions. George Watterston, the moving force behind the organization, stated in print exactly what he envisaged: a stack of richly ornamented temples crowned by an obelisk reaching 500 feet

in elevation, in other words, "the highest edifice in the world, and the most stupendous and magnificent monument ever erected to man."[19]

Watterston made his suggestion to counter a proposal put forth by Washington's adopted son, George Washington Parke Custis, for a burial mound to be built by citizens from all over the country, led by elders of "revolutionary stock," who would gather at the capital to donate their labor. Custis saw the monument enterprise as an opportunity for a huge ritual reaffirmation of national faith, where the monument—like the nation—would be built by the willing toil of a people reunited around the original values of the Revolution. But Custis was a lone voice and, to Watterston, an absurd one. It was unrealistic to expect citizens to come a great distance "for the purpose of throwing a spadeful of earth," and "as to the revolutionary stock, all that remain of them, if they could contrive to get here at all, would not be able to elevate the mass five feet in twenty years." Above all other objections, the worst feature of the plan was that it would be ugly. "No; the monument to the great founder of our independence should be something that would exhibit not only the gratitude and veneration, but the taste and liberality of the People of this age of our republic."[20]

Watterston's statement marks a turning point in the discussion of the national monument, for until then the notion of taste had been considered irrelevant. It is true that Macon in 1800 had admitted that the pyramid "might indeed adorn this city," but it is more significant that the aesthetic consideration did not even begin to answer his objections to the enterprise.[21] Not until after the Civil War did Congress finally shift the focus of its debate from the political meaning of the monument to the artistic merit. From 1836 on, however, the monument society staked its enterprise on its extravagant good taste. The monument would not only underscore the old-fashioned virtues of Washington's republic but, more important, also advance a new set of cultural pretensions whose ideological fit in that republic was uncertain at best.

This conflicting mixture of intentions received an especially apt expression in the design finally chosen by the society in 1845, a proposal by Mills that bore a striking similarity to the architectural fantasy already suggested by Watterston. Mills distilled Watterston's stack of temples into a single, circular, Doric colonnade 100 feet high, surmounted by a 500-foot decorated obelisk; the colonnade was to enclose a vast rotunda that would be a "pantheon" of revolutionary heroes represented in murals and sculpture. As Mills himself was well aware, the Doric order had become emblematic of the republican character of Washington—strong, simple, unaffected, almost primitive in its straightforward accomplishment of the task set for it. Yet

in Mills's design, the Doric temple, huge in its own right, becomes the mere base for a massive obelisk—a form already familiar in America as a grave marker and even as a public monument (at Bunker Hill), but here blown up to unprecedented height. The iconography of republican simplicity is overwhelmed—and thus trivialized—by the towering ambition of the great shaft, planned as the tallest structure in the world. And to reinforce the effect, Mills had Washington appear above the portico not in the manner of Cincinnatus but in a chariot led by six horses, an imperial motif suggestive of the triumphant progress to which the monument looked forward.[22]

When the time finally came, on July 4, 1848, to lay the cornerstone for Mills's vast project—at the very site L'Enfant had chosen for his pivotal equestrian—Congressman Robert Winthrop of Massachusetts delivered an oration that betrayed the conflict underlying the whole enterprise. Speaking at the very beginning of the railroad era, Winthrop compared American liberty to a locomotive "gathering strength as it goes, developing new energies to meet new exigencies, and bearing aloft its imperial train of twenty millions of people with a speed which knows no parallel." It was a more modern image of forward progress than Mills's chariot, but a more unsettling one as well. Was the locomotive under control? After a long speech on Washington's character, Winthrop turned to this dark question and gave an equally disturbing answer. The nation was spinning apart; the very "extension of our boundaries and the multiplication of our Territories" brought a train of destructive political differences. The locomotive Winthrop had boasted moments earlier seemed to be pulling away irresistibly from Washington's republic, that world of stern virtue and simple ambitions. Yet all Winthrop could suggest was somehow to tow republicanism behind: "Let us recognize in our common title to the name and the fame of Washington, and in our common veneration for his example and his advice, the all-sufficient centripetal power. . . . Let the column which we are about to construct be at once a pledge and an emblem of perpetual union." In the end Winthrop disowned even this solution. Sounding a now familiar theme, he told Americans that they really had to build the monument in their own hearts, to make Washington's republic "stand before the world in all its original strength and beauty."[23]

Mills's design and Winthrop's interpretation of it were both ideologically problematic—implausible efforts to build a static republican ideal into the imagery of an aggressively expansionist state. It was this very combination, however, that attracted political enthusiasm, albeit from an unlikely and undesired source. On March 9, 1855, with the shaft only 150 feet high and the colonnade not even begun, the monument grounds were stormed

and seized by members of the Know-Nothings, a semiclandestine political party that aimed to rid the country of Catholics and foreigners. Threatened by social and economic changes beyond their control, and eager to blame those changes on recent Irish and German immigration, the ranks of the Know-Nothings swelled in the early 1850s with native-born laborers and artisans from the cities. They advanced themselves as the guardians of the revolutionary spirit and the true successors of Washington. For a brief, intoxicating period, the Know-Nothings dreamed of turning his monument into an emblem of their own political ascendancy, of their uncontested title to his memory.[24]

Whereas the earlier populists had rejected all ideas of a grand monument as antirepublican, the Know-Nothings staked their claim to Washington through the very extravagance of the project. In Mills's design they found a perfect expression for their own contradictory impulses toward prelapsarian "Doric" republicanism on the one hand and nationalist mania on the other. They vowed to raise the monument as originally planned into "the most remarkable monument ever erected to man . . . towering above all others." It was not the building that they wanted to change, only the builders. They resolved to take contributions only from "Americans," in other words, only from members of their party. But by the time they had seized the monument, the party was passing its peak, and the fund-raising campaign proved to be a disaster: three years yielded $51.66.[25] For almost twenty-five years after this debacle, the monument stood as a pathetic marble stump in the very heart of the capital. The Know-Nothings' failure marked a turning point in the long political history of the monument. In their bold attempt to reestablish a link with Washington and the original republic, they simply revealed how distant he had become. It was left to the Civil War to decide which nation would inherit his unfinished column and his dim legacy.

Even before the Know-Nothings delivered their near fatal blow to the monument, the suspicion was already beginning to emerge that the whole enterprise was a failure. For one thing, the critics ridiculed the design, particularly the union of Greek colonnade and Egyptian obelisk. Although Mills had French precedents for just such a combination—including one proposed monument by François Joseph Bélanger of about 1800 which is very close in elevation although more graceful—critics in the 1850s increasingly viewed the design as a national embarrassment, unthinkable in their own, more "advanced" age. They compared the project to a broom stuck in a handle, a rolling pin impaled on three sea biscuits, and other suggestive images. But there was a sense of spiritual failure too. Contributions fell far

short of the fantastic sums needed, and construction proceeded fitfully. In 1850, when the twelve-year-old Henry Brooks Adams made his first visit to Washington (later recounted in his autobiography), he was struck profoundly by the sight of the unfinished marble shaft sitting in the middle of a dusty, ragged capital. And when he traveled on to Mount Vernon, he was faced with a similar contradiction: the squalid road, symbolic of everything wicked in slave-bound Virginia, led straight to the man he was taught to venerate. Although Washington's obelisk was still going up, albeit slowly, in Adams's recollection the enterprise was already doomed—as if no monument could have bridged the gulf that separated Washington-the-eighteenth-century-hero from the corruption of nineteenth-century America.[26]

As the nation emerged from the Civil War into a disillusioning era of scandal and intrigue, the unfinished shaft only heightened this sense of historical disparity. The stump seemed to represent a nation that had lost its way. The symbolic impact of a huge, aborted monument to the founding father cannot be underestimated; it helps explain the rather desperate rhetoric with which some congressmen pleaded for federal funds to complete the obelisk when their predecessors had opposed such schemes a few decades earlier. "Complete it," one representative argued in 1874, "or look not back to a noble ancestry; but confess that your nation is in its decadence, and that its days are already numbered." Despite these vehement appeals, Congress rejected all efforts to finish the monument in time for the Centennial of 1876, even though it offered a rare moment to review and interpret the nation's past. There were strong voices in the press demanding that the monument be torn down or left to crumble; the *New York Tribune* called for the public to "give its energies instead to cleaning out morally and physically the city likewise named after the Father of His Country."[27]

A remarkable but deceptive turn of events took place during the centennial year. On July 5, 1876, the two houses of Congress impulsively and unanimously resolved "in the name of the people of the United States, at the beginning of the second century of the national existence, [to] assume and direct the completion of the Washington Monument."[28] Why the sudden turnabout? It was not because Congress had changed its attitude toward the past. Only after the anniversary of independence had passed, and the country had self-consciously stepped over the threshold from the old century into the new, did Congress seize the opportunity to take action. The timing suggests that the forces gathering on Winthrop's locomotive had finally triumphed: the monument was revived not to make sense of the past, but to launch the nation into the future.

While the Mills project had still reflected some ideological seesawing between retrospective and prospective viewpoints—between a yearning for traditional republican values and a vision of national empire—in 1876 the prospective view finally triumphed. By this time the ethic of enterprise and material success had carried Americans so far from their old republican identity that patriot and cynic alike seemed to be in essential agreement: the age of Washington was dead, irretrievable. The nation could unify around Washington's monument only after dismissing the question it had so insistently posed, the question of his legacy. Washington no longer mattered, not even in his own monument. From this point on, he dropped out of the debate, only to reappear trivialized in perfunctory appeals for a "fitting" or "worthy" memorial.[29]

As a consequence, the question of how to complete the monument became an aesthetic problem, the province of "men of taste." It was these men who took the most active interest both in Congress and in the press, they who set the terms of the debate. The participation of any such group as the Know-Nothings with an explicit political agenda was unthinkable. Yet the language of taste which dominated the new discussion disguised a political subtext. When the critics of the 1870s called for the monument to be "characteristically American," they had in mind a particular America defined by "culture"—in Alan Trachtenberg's words, "a privileged domain of refinement, aesthetic sensibility, and higher learning." And as Trachtenberg has argued, this definition of culture carried a distinctly political message. Culture represented no less than "an official American version of reality" which shielded Americans from other, more troubling realities, the realities of government scandal, the decline of rural America, the rise of urban poverty—everything that made the disparity with the original republic so painfully apparent. High culture, and the monument it hoped to create, would proclaim these realities "uncharacteristic," not truly American; they belonged instead to a netherworld of vulgarity and common labor.[30]

For the men of culture of the 1870s the obelisk became a cause célèbre because it touched their anxieties about this "other" America. While the critics of the 1850s had objected mainly to the combination of obelisk and colonnade, the criticism two decades later zeroed in on the shaft itself. The men of culture perceived it not only as a product of the artistic dark ages but also as quintessential low art, representative of an illegitimate and threatening vernacular culture. The obelisk's "plainness and height," *American Architect and Building News* sneered, "will doubtless assert itself to the common mind as a clear achievement (in the vernacular, a *big thing*)."

"Brutally, from its mere size," wrote critic Henry Van Brunt, summoning an image that evokes the specter of the other America rising to make itself heard, "[the obelisk] must force itself upon the attention of the beholder." Shrinking from those brutal realities of the vernacular, cultivated minds such as Van Brunt's instead demanded "elegant reserve and studious refinement"; the unadorned and unelaborated obelisk simply did not require the privileged skills of culture to appreciate and therefore could not legitimately represent America. If, as the *American Architect* argued, the monument were something more like Trajan's Column, "crowded with evidence of human thought, skill, and love," then "it would be a work of art, a true monument, a *denkmal* or think-token as the Germans call it."[31]

While the critics were united in the belief that the nation's most conspicuous monument must advance the claims of their official culture, they were by no means agreed on how to accomplish this. The most immediate problem centered on credentials. The architectural press naturally maintained that only an architect was qualified to redesign the partial shaft, while the sculptors' lobby had its own supporters, particularly in Congress. But a deeper problem afflicted even the most widely trained candidate for the job: there was no legitimate artistic tradition with which to represent American culture. To meet the demands of their own culture, designers had to raid other cultures. When they began to produce alternative designs for the shaft, some artists tried to incorporate indigenous models from native American civilizations, but most borrowed from a bewildering array of European architectural prototypes—from Italian Romanesque to English Gothic to beaux-arts tinged by "some of the better Hindu pagodas."

The whole problem of evolving a "national style," which plagued the culture campaigners of the late nineteenth century, was here compressed into one work. Critics could not decide between the various alternatives; they could quibble here and there on "technical" principles of design, but none of them could articulate an aesthetic or iconographic basis for determining the "characteristically American" beyond some rather elusive visual ideals. Van Brunt, for example, seemed to be searching for a middle ground between the raw "virility" of American vernacular culture and the "effeminacy" of European high culture, but he could not visualize it until he saw the skyscrapers of the Chicago school in the next decade.[32]

The artists and their patrons were also working at cross purposes. When Congress decided to appropriate money to complete the monument, it delegated the responsibility for construction to a joint commission of its own appointing, but it never made clear who had authority to choose the design. Instead of proposing a national competition as a way of achieving

at least a ceremonial unity of decision, Congress sat by while a few individual members jockeyed in and out of the public eye to advance their own candidates. The most active member, a senator named Justin Morrill who was involved in numerous public art projects, strung along several candidates at once, and the infighting among those candidates was intense, as their voluminous correspondence to Morrill and other potential allies demonstrates. Ultimately the congressional committees in charge became "so annoyed by Architects and interested parties" that they refused to make any decisions at all.[33]

Into this vacuum stepped Lt. Col. Thomas Casey of the Army Corps of Engineers, the man hired by the joint commission to supervise the construction of the monument. Casey was an engineer with vision. While deftly protesting to artists and reporters alike that he had no authority to design the monument, he did precisely that—in the process completely revising the terms of the enterprise. Casey had in mind a new kind of *denkmal* inconceivable to the culture campaigners: a technological marvel equipped with a passenger elevator and electric lights yet disguised as the most ancient of forms, ruthlessly simple and hermetically sealed. Casey refined his vision over several years, revealing it little by little in obscure technical reports. Generally, he couched his proposals as engineering solutions rather than design suggestions; thus the joint commission could safely claim that it was not "designing" the monument, only building it.[34]

Since the shaft was begun as an obelisk, the commission decided that it would continue building the obelisk until told otherwise by Congress. Initially, in 1878, Casey redesigned Mills's obelisk as a 525-foot tower with an iron-and-glass top. When in 1882 the joint commission could no longer put off a sculptor who had designed a series of bas-reliefs to decorate the base of the shaft, Casey confessed in a report that he wanted no such ornamentation to disturb the bare surface of his obelisk. The commission conveniently decided that it had no authority to ornament the obelisk, so Casey's wish prevailed. Casey then unfolded his own plan to strip off Mills's Egyptian ornament above the entrance doors, fill in the doors with marble of a matching bond, and create an invisible underground entrance. This the commission decided was within its authority to approve, apparently because the plan had no "artistic" elements.[35] For reasons of safety Casey had to scuttle the underground entrance, but he created the same effect by outfitting the only remaining opening in the base with a marble door, which when closed made the entrance unnoticeable. He also changed the plan for the top of the obelisk from his original iron-and-glass observatory to a more steeply pointing marble pyramidion, ostensibly because the combining of different

Proposal for completion of *Washington Monument,* attributed to Arthur Mathews, ca. 1879. From Walter Montgomery, ed., *American Art and American Art Collections,* vol. 1 (Boston: E. W. Walker, 1889), p. 365. (Prints and Photographs, Library of Congress)

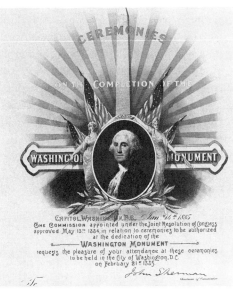

Invitation to the dedication ceremonies of the Washington Monument. From *Dedication of the Washington National Monument* (Washington, D.C.: Government Printing Office, 1885), frontispiece. (Collection of Kirk Savage)

surface materials under the first plan would have caused engineering diffi-
culties. Casey used this pretext to complete his own aesthetic vision, allow-
ing only two small openings in each face of the pyramidion—all fitted with
specially designed marble shutters that (like the door) created the illusion
of unbroken masonry.[36]

Backed by a joint commission that wanted results fast, Casey's strategy
worked beautifully. Since *design* in effect meant "decoration," Casey could
continue to maintain that he was avoiding design even as he put the finishing
touches on his monument. Fittingly, the *New York Times* called the final
result in 1884 "undesigned." Casey's obelisk was oddly reminiscent of the
old Doric ideal of Washington's character, which James Fenimore Cooper
had said was "not liable to the details of criticism." The plain, towering shaft
was in its own way unarguable; it simply could not be subjected to the kind
of critical scrutiny that the men of culture believed a true work of art
demanded. Casey in effect was proposing a new way of experiencing a
monumental work of art, in which power becomes paramount—the power
the structure at once holds over the spectator and shares with him. Casey's
inviolable obelisk (even more so if we imagine it closed with its original
marble door and shutters) seems to ward off the spectator, to deny even the
possibility of entrance; the phallic force of the shaft serves what the ancient
Greeks called an *apotropaic* function, a warning to all comers. At the base
of the monument there is nothing on the blank faces of the shaft to give it
human scale, nothing to interrupt the soaring lines that sweep the eye
upward to indefinite heights. The tiny door at the bottom, virtually crushed
by the shaft towering over it, is all that yields—but what it does yield is
exhilarating: an inner sanctum ruled by technology where the visitor is
ushered by machine power to an unrivaled height and a dizzying prospect.
From bottom to top the monument asserts its strength, and yet the visitor
thrills with the illusion of heroic command. At the Baltimore monument,
the spectator could only stare up at the figure of Washington high above;
in the nation's capital, the visitor can take the place of the hero himself and,
from the summit, can survey the whole apparatus of national power spread
out below.[37]

If we recall the twin poles of federalist and republican commemoration
with which the debate began—the "sublime" monument that awes the
people and the participatory monument created by the people—we see that
Casey's obelisk rather brilliantly synthesizes the two, or more precisely,
transcends them. The Washington Monument both overpowers and em-
powers, first diminishing the visitor into insignificance and then raising him
sky-high like a hero. In more ways than one, that frightening and exhilarat-

ing image from Winthrop's imagination—the locomotive—has become a mirror not only of the forces behind the monument but also of the monument itself. Both the railroad and the obelisk were monuments to American technology, or, in nineteenth-century terms, to "ingenuity" and "modern skill," and both were powerful symbols of the national destiny, or became so. The *New York Times,* after blasting the obelisk in December 1884, reversed itself only two months later for the monument's dedication, when an editorial admitted that there was "something characteristically American" in raising the tallest structure on earth, towering above even "the highest cathedral spires designed by the devout and daring architects of the Middle Ages." There was also a parallel between the monument's turbulent history and the country's "long period of trouble and tumult": all the time that the monument stood unfinished it was "awaiting the destiny of the Nation." Now the monument's fate and the nation's fate had converged in "a new era of hope and progress."[38]

And where did the individual stand? Here again the technological monument offered a powerful metaphor, an image of the individual caught and swept up in the nation's progress, riding it to new heights of personal freedom and happiness. The image was so appealing that *Harper's Weekly* could imagine the experience even before the monument opened. *Harper's* returned to the old comparison between the obelisk and Trajan's Column, but this time the column came out the loser because it lacked an elevator. Whereas the visitor to Trajan's Column could ascend only "by a weary flight of steps," in Washington's obelisk he would be "seized upon by the genius of steam, and raised . . . in a comfortable elevator almost to the copper apex at its top." Once at the top the visitor would "look down upon a land of freedom," home to "scenes of bitter struggle in the past, and now the quiet city, hid in groves and gardens, sleeping in the shades of perpetual peace."[39] The freedom and tranquility of the land below belonged by right to the visitor above, privileged as he was to survey the whole and to find his place within it.

This monument of might and progress had so much immediate resonance that it captured the admiration even of its critics. Instead of demanding special cultural skills to appreciate, the monument offered an image and an experience of much wider appeal—one that touched even a man like Van Brunt, who was forced to acknowledge the "vast amount of thought and skill" with which Casey finished the shaft. Not only was the obelisk a monument to be admired by the common man, but it also represented an achievement that could be more easily attributed to the common man, to "the people." While art was appropriated by an exclusive cultural sphere,

which claimed that achievement could result only from formal training and developed sensibility, the technological myth of the era—demonstrated, for example, in the legend of Thomas Edison—saw progress and invention as the achievement of self-taught, self-made men, exemplars of the old republican traits of independence and natural genius. It did not really matter that Casey failed to fit this profile (his personal background was rarely discussed, perhaps because he seemed much more a man of culture than a self-made independent). The important point was that his work was as much "a monument to the skill and enterprise of the American people as to the nobility and name which it perpetuates." This point was emphasized over and again in newspaper accounts that lavished print on every ingenious feat from the foundations to the marble shutters to "the most perfect electrical conductor known to science."[40]

It is not only ironic but also somehow troubling that a monument designed covertly, against enormous opposition, should so neatly reconcile so many competing ideals—ancient tradition and modern technology, republican values and national progress, communal harmony and individual enterprise. These are the conflicts of Washington's legacy—whether his name was mentioned or not—that had confused and divided earlier builders, campaigners, and critics. In one sense we might think of Casey's blank shaft as the ultimate monument to Washington because in its apparent simplicity it seems to formalize the long-awaited resolution. But the actual experience of the monument challenges the nature of this resolution. The obelisk is in no formal sense a monument of healing or reconciliation. In contrast to the more recent Vietnam memorial, it does not open its arms to visitors, offer them refuge, encourage them to reflect. If Casey's monument did indeed resolve conflict, it was a resolution more by sheer force than by symbolic embrace. It is impossible to know how the monument was truly experienced at the time, but there is reason to believe that despite all the rhetoric of harmony the monument had a more militant impact. In the engraving done for the monument's dedication, the obelisk is set like a sharply pointed blade into the cross arms of a dagger handle. The image of a dagger thrust in the air stands in stark contrast to the feelings of "peace and amity" that the monument was supposedly inspiring after the nation's "long night of disunion."[41]

This disturbing image might make us wonder now, as Winthrop seemed to wonder in his difficult speech of 1848, whether the forces represented by this monument are really under control, and, if so, who is engineering them. Is the engineer in fact "the people"? The monument's answer is not so reassuring, neither in its history nor in its realization. Casey

is hardly the appropriate archetype, the process he commandeered hardly democratic. And as much as his obelisk still seems to belong to us, as much as the experience of heroic command seems to be our own, the monument continually challenges us with its own power, within and without. Try as we will, we cannot know what authority it represents, or to what end it is represented.

In the century since its completion, Washington's monument has lost much of the symbolic appeal it once held; the Statue of Liberty, erected only a year later, has easily surpassed the monument in the national imagination. Recently the one-hundredth anniversary of the obelisk was marked with relatively little fanfare, while the centennial of Miss Liberty became one of the most extravagant spectacles of our time. The uncertainty of Washington's "example" still haunts his monument. Instead of resolving the issue, Casey's obelisk evaded it; even as the monument proclaimed allegiance to American ideals, its assertion of political and technological might undermined a most cherished ideal—that of the self-reliant, self-regulating individual who stands, with Frédéric-Auguste Bartholdi's statue, at the mythic core of our republic. If the obelisk is indeed a "mighty sign" of the national destiny, its implications leave us as much in doubt as in hope. Ironically the blank marble walls of this huge memorial resist patriotic promotion and mythmaking and force us back on the old questions about our republic.

Notes

The author thanks Svetlana Alpers, Margaretta Lovell, Elizabeth Thomas, and Dell Upton for reading and commenting on earlier versions of this essay.

1. The interpretive literature on the Washington Monument is scanty. Two sketchy accounts are found in Frederick Gutheim, "Who Designed the Washington Monument?" *AIA Journal* 15, no. 3 (March 1951): 136–41; and Ada Louise Huxtable, "The Washington Monument, 1836–84," *Progressive Architecture* 38, no. 8 (August 1957): 141–44. A discussion of some of the alternative designs is in Robert Belmont Freeman, Jr., "Design Proposals for the Washington National Monument," *Records of the Columbia Historical Society*, vols. 73–74 (Washington, D.C., 1973–74), pp. 151–86. For a recent and stimulating interpretation of the monument in the context of the Mall, see Charles L. Griswold, "The Vietnam Veterans Memorial and the Washington Mall: Philosophical Thoughts on Political Iconography," *Critical Inquiry* 12, no. 4 (Summer 1986): 693–96. None of these, however, attempts to place the monument in the context of the historical campaign to commemorate Washington and the controversy that campaign generated.

2. On Washington as icon, see, among others, Marcus Cunliffe, *George Washington: Man and Monument* (New York: Mentor Books, 1982); William Alfred Bryan, *George Washington in American Literature, 1775–1865* (New York: Columbia University Press, 1952); and Wendy C. Wick, *George Washington, an American Icon: The Eighteenth-Century Graphic Portraits* (Charlottesville: University Press of Virginia, 1982).

3. Gutheim, "Who Designed the Monument," p. 136.

4. For biographical details, see Cunliffe, *George Washington;* my interpretation owes much to his. The scholarly debate on the nature of American republicanism is still alive and has revealed significant variants in the ideology; my interest is in how Washington himself, by virtue of his unique position, magnified those tensions inherent in republicanism.

5. On Washington and the patriot-king, see Ralph Ketcham, *Presidents above Party: The First American Presidency, 1789–1829* (Chapel Hill: University of North Carolina Press, 1984), pp. 89–91. The Cincinnatus myth is the subject of Gary Wills, *Cincinnatus, George Washington, and the Enlightenment: Images of Power in Early America* (Garden City, N.Y.: Doubleday, 1984). In his admiration for the Cincinnatus ideal, Wills does not examine how the ideal reveals strains inherent in the very notion of republican leadership.

6. Mason L. Weems, *The Life of Washington,* ed. Marcus Cunliffe (Cambridge, Mass.: Harvard University Press, Belknap Press, 1962); Adams to John Lebb, September 10, 1785, as quoted in Bryan, *Washington in Literature,* p. 30. Adams's own views toward Washington are complex and atypical of the federalists who generally engaged in the kind of shamelessly inflated rhetoric that Adams abhorred.

7. *Journals of the Continental Congress, 1774–1789,* ed. Worthington Chauncey Ford, Gaillard Hunt, John C. Fitzpatrick, and Roscoe R. Hill, 34 vols. (Washington, D.C.: Government Printing Office, 1904–37) 24:492; J. P. Dougherty, "Baroque and Picturesque Motifs in L'Enfant's Design for the Federal Capital," *American Quarterly* 26, no. 1 (March 1974): 23–26.

8. Donald H. Stewart, *The Opposition Press of the Federalist Period* (Albany: State University of New York Press, 1969), pp. 487–88, 519–21; *Journals of Congress,* 29:86; Wills, *Cincinnatus,* p. 82.

9. See, for example, John C. Miller, *The Federalist Era, 1789–1801* (New York: Harper and Brothers, 1960), pp. 99–125; and *Annals of Congress,* 6th Cong., 1st sess., p. 208.

10. The design is described in a letter from Latrobe to Congressman Henry Lee, April 24, 1800, in John C. Van Horne and Lee W. Formwalt, eds., *The Correspondence and Miscellaneous Papers of Benjamin Henry Latrobe,* vol. 1 (New Haven: Yale University Press, 1984), pp. 162–63. On the basis of this and other evidence, drawings formerly thought to be for the Richmond theater monument are now conclusively identified as designs for the Washington mausoleum. For Boullée's pyramids, see Richard A. Etlin, *The Architecture of Death: The Transformation of the Cemetery in Eighteenth-Century Paris* (Cambridge, Mass.: MIT Press, 1984), esp. pp. 109–15, 125–29.

11. *Annals of Congress,* 6th Cong., 2d sess., pp. 859, 802, 863.

12. *Annals of Congress,* 6th Cong., 2d sess., p. 801; Latrobe to Robert Goodloe Harper, April 24, 1800, as quoted in Van Horne and Formwalt, *Corre-*

spondence and Papers, 1:160–61. Latrobe's letter is such a masterpiece of federalist condescension, targeting French revolutionaries and the popular mobs they inspired, that it is hard to believe that he was ever republican. Clearly he knew how to please his patrons.

13. *Annals of Congress,* 6th Cong., 2d sess., pp. 804, 800.

14. *Annals of Congress,* 6th Cong., 2d sess., p. 875. By the time of the vote, the Latrobe proposal had been superseded by an even grander pyramid proposal designed by George Dance; a design of his which shows two pyramids has been published in the monograph by Dorothy Stroud, *George Dance, Architect, 1741–1825* (London: Faber and Faber, 1971), pl. 76a, but this may not be the final design submitted to Congress since it does not correspond to the verbal descriptions found in the record of the debates. For the party affiliations of the voting representatives, see Manning J. Dauer, *The Adams Federalists* (Baltimore: Johns Hopkins University Press, 1953), pp. 323–25.

15. *Register of Debates in Congress,* 22d Cong., 1st sess., pp. 375, 1784. Attempts to find a national tomb were made in 1816, repeatedly in the 1820s, and finally in 1832, for the centennial of Washington's birth. For Washington's dual image during the war, see Bryan, *Washington in Literature,* pp. 74–82.

16. R. D. W. Connor, "Canova's Statue of Washington," Publications of the North Carolina Historical Commission, Bulletin No. 8 (1910), pp. 14–27; Macon quoted in *Annals of Congress,* 6th Cong., 2d sess., p. 803; "Monument to Washington," *North-American Review* 2, no. 6 (March 1816): 338.

17. Sponsors' fund-raising appeal published in *Port Folio,* n.s., 3, no. 6 (June 1810): 465; Neil Harris, *The Artist in American Society: The Formative Years, 1790–1860* (New York: Simon and Schuster, 1966), pp. 193–96. It is even suggested that a real estate scheme was the original motive for the monument in J. Jefferson Miller II, "The Designs for the Washington Monument in Baltimore," *Journal of the Society of Architectural Historians* 23, no. 1 (March 1964): 19. Another motive is suggested by Alexis de Tocqueville, who argues that in a democracy one of the few acceptable outlets for self-assertion is the public monument: "In democratic communities the imagination is compressed when men consider themselves; it expands indefinitely when they think of the state," or, we might add, when they think of Washington (Alexis-Charles-Henri de Tocqueville, *Democracy in America,* ed. Phillips Bradley, vol. 2 [New York: Alfred A. Knopf, 1945], p. 56).

18. My view of the period is indebted to Marvin Meyers, *The Jacksonian Persuasion: Politics and Belief* (Stanford: Stanford University Press, 1957), esp. pp. 9–10, 22–23, 106–7.

19. For the profile of the original members of the society, see Frederick L. Harvey, *History of the Washington National Monument and Washington National Monument Society* (Washington, D.C.: Government Printing Office, 1903), pp. 21–23, 25–26. The context of the society's efforts is described in Constance M. Green, *Washington: Village and Capital, 1800–1878* (Princeton: Princeton University Press, 1976), pp. 170–73. Clipping from *Washington National Intelligencer,* February 11, 1836, signed W— (this was a standard byline for Watterston as seen in his papers at the Library of Congress [hereafter cited as LC]). The clipping is in the vertical file at the Martin Luther King, Jr., Memorial Public Library, Washington, D.C.

20. Clipping, signed W——, *Washington National Intelligencer,* February 11, 1836. My knowledge of Custis's proposal is gleaned from Watterston's response.

21. *Annals of Congress,* 6th Cong., 2d sess., p. 804.

22. The Mills design is undated and may have been conceived anytime between 1836 and 1845, when on November 20 the Board of Managers adopted it (Proceedings of the Board of Managers, Records of the Washington National Monument Society, Record Group 42, National Archives [hereafter cited as Society Records]). The traditional date of 1836, traceable to Harvey, is unfounded. The design was described in a society broadside probably written by Watterston (a draft in his hand survives in the Watterston Papers, LC) and reprinted in Harvey, *History of the Monument,* pp. 26–28. The imperial motif is discussed in John Zukowsky, "Monumental American Obelisks: Centennial Vistas," *Art Bulletin* 58, no. 4 (December 1976): 576. Zukowsky does not identify the chariot driver as Washington but the broadside published by the society does.

23. The oration is reprinted in Harvey, *History of the Monument,* pp. 113–30. Congress did donate the site for the monument (after years of reluctance) but considered it a private undertaking and refused to appropriate any funds. For a recent analysis of the cultural reaction to the railroad in America, see Leo Marx, "The Railroad-in-the-Landscape: An Iconological Reading of a Theme in American Art," *Prospects* 10 (1985): esp. 90–92.

24. Details of the Know-Nothing takeover and of the famous "Pope's stone" episode are found in Harvey, *History of the Monument,* pp. 52–64. For more general discussion, see Michael F. Holt, "The Politics of Impatience: The Origins of Know-Nothingism," *Journal of American History* 60, no. 2 (September 1973): 309–31; and Jean H. Baker, *Ambivalent Americans: The Know-Nothing Party in Maryland* (Baltimore: Johns Hopkins University Press, 1977), esp. pp. 30–37.

25. Harvey, *History of the Monument,* pp. 58–64.

26. The broom image comes from James Jackson Jarves, *Art-Hints: Architecture, Sculpture and Painting* (London, 1855), p. 308; the rolling pin from *Leslie's Illustrated* 3, no. 72 (April 25, 1857): 321. Other critiques include Horatio Greenough, "Aesthetics at Washington," in *Form and Function: Remarks on Art, Design, and Architecture,* ed. Harold A. Small (Berkeley: University of California Press, 1969), pp. 23–30; and *Crayon* 6, pt. 9 (September 1859): 282. The Bélanger design is published in Richard G. Carrott, *The Egyptian Revival: Its Sources, Monuments, and Meaning, 1802–1858* (Berkeley: University of California Press, 1978), pl. 31. Henry Adams, *The Education of Henry Adams,* ed. Ernest Samuels (Boston: Houghton Mifflin Co., 1874), pp. 44–48.

27. *Congressional Record,* vol. 2 (June 4, 1874), p. 4580. *New York Daily Tribune,* July 1, 1875, p. 6; similar sentiments are expressed in the *Washington Chronicle,* February 1, 1873 (clipping in vertical file, Martin Luther King, Jr., Memorial Public Library). The climate of opinion in the 1870s is painted by Winthrop in his dedication address of 1885 (*Dedication of the Washington National Monument* [Washington, D.C., 1885], p. 48).

28. *Congressional Record,* vol. 4 (July 5, 1876), p. 4376.

29. Typical of the new attitude toward Washington is an editorial in *American Architect and Building News* 2, no. 103 (December 15, 1877): 397, which says, "no doubt an obelisk is consistent with Washington's character, and so, we may say, are

a pair of cavalry boots"; the important point was that a better "form" could be found than either. In my discussion of prospective and retrospective viewpoints, I am adapting Erwin Panofsky's terminology from his *Tomb Sculpture* (New York: Harry N. Abrams, 1964).

30. Alan Trachtenberg, *The Incorporation of America: Culture and Society in the Gilded Age* (New York: Hill and Wang, 1982), pp. 143–44. The phrase "characteristically American" is drawn from a critical piece by James Jackson Jarves, "Washington's Monument," *New York Times,* March 17, 1879, p. 5, and it is echoed by numerous writers including Henry Van Brunt, William Wetmore Story, and the editors of *American Architect,* who made their meaning plain in calling for a monument "more in accordance with our intelligence and our culture" (*American Architect and Building News* 4, no. 138 [August 17, 1878]: 54).

31. *American Architect and Building News* 4, no. 135 (July 27, 1878): 25. The criticism contains many references to the "peril" the obelisk poses to the nation's reputation, the impending "calamity," the national "emergency." Henry Van Brunt, "The Washington Monument," *American Art Review* 1, pt. 1 (1879): 12, 8.

32. Henry Van Brunt, "The Washington Monument," *American Art Review* 1, pt. 2 (1879): 65, 61; his article provides a broad survey of the alternative proposals for finishing the partial shaft. For the evolution of his criticism, see the introductory essay by William A. Coles in *Arhictecture and Society: Selected Essays of Henry Van Brunt* (Cambridge, Mass.: Harvard University Press, Belknap Press, 1969).

33. Morill was in frequent contact with expatriate sculptors Story and Larkin Mead; Story's proposal for a Florentine-Venetian tower came very close to being accepted, while Mead pushed two plans at once, one with the obelisk and one without. Meanwhile Morrill was also working with architect Albert Noerr on a completely different proposal. Extensive correspondence survives in the Justin Morrill Papers, LC, as well as in the papers of William Wilson Corcoran, president of the joint commission. Corcoran to Story, March 13, 1879, Corcoran Papers, LC.

34. Many of the details of Casey's involvement are described in Louis Torres, *"To the Immortal Name and Memory of George Washington": The United States Army Corps of Engineers and the Construction of the Washington Monument* (Washington, D.C.: Government Printing Office, n.d.); however, Torres misses the covert aspect of Casey's activity. Casey's public posture of no authority is seen, for example, in Casey to Mead, July 25, 1882, Society Records, and in a newspaper interview with the *Washington Evening Star,* February 21, 1885, p. 3.

35. Proceedings of the joint commission, March 29, April 24, 1882, Society Records. At this point the joint commission, on Casey's recommendation, suggested that Congress appoint a separate commission to design a "terrace" below the shaft, which could incorporate all the desired ornamentation and settle the question once and for all. Congress again failed to act, however, and the joint commission eventually approved Casey's preferred plan for a natural lawn terrace—on the grounds that it was less expensive (Casey was adept at making his own aesthetic choices compelling for reasons of economy) (Proceedings of the joint commission, December 18, 1884, Society Records; *Evening Star,* February 21, 1885).

36. Casey to Brig. Gen. Horatio Gouverneur Wright, January 19, 1884, Society Records. Some histories of the monument credit George Perkins Marsh with the "design" of the final form. Marsh was an antiquarian and diplomat living in Italy

who provided measurements of ancient obelisks and other aesthetic suggestions, including the idea of window coverings to match the marble. There is no doubt that he influenced Casey, but Casey's vision was ultimately his own: Marsh approved of ornamenting the shaft and had no interest in the monument's technological aspect; see Marsh's letters printed in Harvey, *History of the Monument*, pp. 299–302.

37. "The Washington Monument," *New York Times*, December 7, 1884, p. 8; James Fenimore Cooper, *Notions of the Americans Picked Up by a Travelling Bachelor*, vol. 2 (New York, 1828), p. 193. The memorial stones on the interior wall, accessible from the stairs that wind around the elevator shaft, provide another component of the experience. Mostly donated by states and cities, often using local rock, these blocks are inscribed and sometimes sculpted; they link the monument to other places throughout the country and thereby add another dimension to the commanding prospect seen from the summit.

38. "The Washington Monument," *New York Times*, February 22, 1885, p. 6.

39. Eugene Lawrence, "The Washington Monument," *Harper's Weekly* 28, no. 1458 (November 29, 1884): 789.

40. Henry Van Brunt, "The Washington Monument," in *American Art and American Art Collections*, ed. Walter Montgomery, vol. 1 (Boston, 1889), p. 355; Trachtenberg, *Incorporation*, pp. 65–66; *American Architect and Building News* 17, no. 479 (February 28, 1885): 102. Although the article was not written by the editors, its very appearance in *American Architect* indicates a dramatic shift in the climate of opinion. The sentiment is echoed almost word for word in Van Brunt's final remarks on the monument in *American Art and Art Collections*, 1:368. *Leslie's Illustrated* 59, no. 1,526 (December 20, 1884): 278. For other descriptions of the monument's "ingenuity," see *Washington Evening Star*, December 6, 1884, February 21, 1885; *Washington Post*, February 22, 1885; and many other newspaper accounts.

41. *Boston Evening Transcript*, February 24, 1885, p. 7.

2

Writing History/Painting History

Early Chronicles of the United States and Pictures for the Capitol Rotunda

SALLY WEBSTER

Never before or since has history occupied such a vital place in the thinking of the American people as during the first half of the nineteenth century.[1]

The writing and teaching of United States history began in earnest in the 1830s, the same decade legislation was passed authorizing the addition of four more murals to the Capitol Rotunda. George Bancroft, often acknowledged as this country's first professional historian, published volume 1 of his *History of the United States* in 1834. At the same time, educators and history writers, such as Emma Willard and William Goodrich, oversaw the publication and dissemination of their textbooks on U.S. geography and history.[2] Although seldom mentioned in the context of national history, William Dunlap's two-volume *History of the Rise and Progress of the Arts of Design in the United States,* which detailed, through personal accounts, the careers and experiences of the country's first artists, was also published in 1834. Thus when discussion began regarding commissions for the four remaining panels in the Capitol Rotunda, Congress could turn to these authorities to confirm both subjects and painters.

Over the past 150 years, the Rotunda paintings, when not ignored, have suffered endless critical attacks on both their style and their content. Called "professional mediocrities" by Virgil Barker in the 1950s, they have been denounced recently as the signifiers of oppressive expansionist policies of an imperialistic country.[3] Yet either to destroy or to move them is unthinkable, because they stand in the same relationship to this nation's art and history as the Statue of Liberty, the Lincoln Memorial, and Mt. Rushmore. It is time to begin to construct an evenhanded interpretation of the paintings themselves, and the events and ambitions they represent.

Not surprisingly, the stories of the four Rotunda paintings—Columbus, Pocahontas, the Pilgrims, and Hernando de Soto—were included in

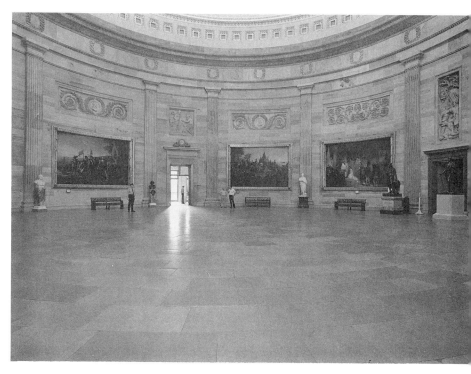

Interior of the Rotunda, United States Capitol, Washington, DC. Paintings that are visible: John Vanderlyn, *Landing of Columbus*, 1847; William H. Powell, *Discovery of the Mississippi by De Soto*, 1853; John Chapman, *Baptism of Pocahontas*, 1840. All 12 × 18 feet. (Photo: Courtesy of the Architect of the Capitol)

Bancroft's *History* and the textbooks of Willard and Goodrich. In contrast to John Trumbull's depictions of the Revolutionary War, the signing of the Declaration of Independence, and the resignation of George Washington installed earlier in the Rotunda, these historical narratives reflect an important shift in national politics. An evolution from the semiaristocratic, landholding, republican rule of the revolutionary generation—Washington and Jefferson—to the more populist and democratic ideology of the generation of the 1830s; a result of the expansion of white male suffrage and the election in 1828 of the westerner Andrew Jackson. "History [by then]," according to the modern historian David Van Tassel, "was less and less the story of a few great men and more the collective biography of a people."[4]

Because Trumbull won his commission before final plans for the Rotunda had been completed, he was able to have a decisive impact on the interior design of the space, and he christened it the Hall of the Revolution in honor of the subjects of his paintings—*Surrender of Lord Cornwallis at Yorktown, Virginia, October 19th, 1781; Declaration of Independence in Congress, at the Independence Hall, Philadelphia, July 4th, 1776; Surrender of General Burgoyne at Saratoga, New York, October 17th, 1777;* and *General George Washington Resigning His Commission to Congress as Commander in Chief of the Army at Annapolis, Maryland, December 23rd, 1783.*[5] President James Madison, who had the official authority for the choice of artworks for the Capitol, made the selection. As one of his last official acts, Madison, in consultation with the artist, selected two military and two civil subjects. All had historical significance. The defeat of Burgoyne at Saratoga represented a critical turning point in the war, while the surrender of Cornwallis at Yorktown marked the end of hostilities. Of the civil subjects, the signing of the Declaration of Independence was Trumbull's first choice, for he had spent several years in the 1790s traveling up and down the eastern seaboard painting the portraits of thirty-six of the forty-seven signers from life; the resignation of Washington was, according to the artist, "one of the highest moral lessons ever given the world" and thus had international implications.[6]

The value of Trumbull's efforts lies in the fact that his paintings are a somewhat accurate re-creation, in this precamera era, of the key events of this nation's earliest history. Yet by the time these works were installed in 1826, the country's political temper had changed. Trumbull's paintings embodied the ideals of an earlier generation, whose ambitions were recorded by the history writers Benjamin Rush, Joel Barlow, Jedidiah Morse, Noah Webster, and Aaron Bancroft.[7] As noted by the modern historian Bert James Loewenberg, this early generation of republican hagiographers were dedi-

cated to the "reform of education" and "the teaching of history. The former would insure the gains to liberty that the revolutionary heroes had won; the latter would preserve the glorious record they had made."[8]

When the time came to commission another four paintings, Trumbull's contemporary accounts of the Revolutionary War were not followed by other, modern historic events but by stories centuries old, which represented an eclectic group of celebrated legends illustrative of critical moments, often religious in nature, in the lives of sixteenth- and seventeenth-century heroes and heroines. These were the tales recorded by Bancroft in the first volume of his *History of the United States* and popularized by Willard, Goodrich, and other writers of textbooks. At the time he began writing his *History,* Bancroft, son of the Unitarian minister Aaron Bancroft, one of the founders of the Worcester-based American Antiquarian Society, was undergoing a change in political allegiance from the National Republican leanings of his Boston contemporaries to the Democratic Party of Andrew Jackson. The 1830s was a time of almost unprecedented national foment, when the power and privileges of New England and Virginia politicians were challenged by western and southern interests. It was an era in which political descendants of the founding fathers such as Charles Sumner worried that the ascent of the popular will would result in "riots, conflagration, bloodshed and murder."[9] In contrast, Bancroft's entire enterprise was dedicated to "the people" and "the equal rights of man." He asserted that "the people" established the Constitution and that in this country "every man may enjoy the fruits of his industry."[10] In effect, Bancroft's work, like the second suite of Rotunda paintings, reflects the evolution in national politics from Republican sovereignty to popular rule.

On June 23, 1836, a resolution of both the Senate and the House of Representatives called for a "joint committee [to] be appointed to contract with one or more competent American artists for the execution of four historical pictures upon subjects serving to illustrate the discovery of America; the settlement of the United States; the history of the Revolution; or of the adoption of the Constitution . . . the subjects to be left to the choice of the artists under the control of the committee."[11] By February the following year, four artists had been selected: John Vanderlyn, Robert Weir, Henry Inman, and John Gadsby Chapman.[12]

The political wrangling and intrigue that the Rotunda commission generated has been documented elsewhere.[13] Also, some recent writers have connected these themes of exploration and early colonization to the country's expansionist policies, war with Mexico, and the self-serving interests of the theory of Manifest Destiny.[14] Yet to focus solely on these issues is to

construct a view that does not satisfactorily answer the questions Why were these particular subjects chosen? And who, in fact, were the artists qualified to undertake this important national enterprise? Who were the successors to Benjamin West, John Singleton Copley, and Trumbull? In 1834, when these commissions were being debated in Congress, a number of names were put forward—Thomas Sully, John Vanderlyn, Samuel F. B. Morse, John G. Chapman, Robert Weir, Rembrandt Peale, Charles Leslie, John Trumbull, Frederick S. Agate, and Samuel Stillman Osgood—all artists included in Dunlap's *History of the Rise and Progress of the Arts of Design in the United States.*

Foremost among them, however, was Washington Allston, who had also studied with West in London. According to congressional testimony, Allston was held in such high esteem that some members thought he, like Trumbull, should be offered all four panels, and he was finally offered two, along with his choice of subjects. By the time this resolution passed in 1837, Allston was still in his fifties, yet he was physically and emotionally exhausted from trying to complete his putative masterpiece *Belshazzar's Feast* (1817–1843, Detroit Institute of Arts), a work in which Allston desired to embody both formally and conceptually the European lessons of the old masters.[15] Although he courteously declined Congress's invitation, he advised them to consider obtaining the services of his friend and colleague Samuel F. B. Morse.

Contrary to Allston's diffidence, Morse was highly desirous of a commission, which he felt was his due as one of the foremost supporters and promoters of the fine arts in America. Ten years earlier Morse had been a founding member of the National Academy of Design in New York and winner of the prestigious commission to paint the marquis de Lafayette on the occasion of his triumphal return to the United States at the time of the celebration of the country's fiftieth birthday. In 1831 Morse went back to Europe, but instead of London, where he had spent his student years, he went to Paris, where he painted his didactic *The Gallery of the Louvre* (1832–1833, Terra Museum of American Art, Chicago). However, he failed to get the Rotunda commission for reasons that are still not clear, including the speculation that former president John Quincy Adams, then a member of Congress who doubted the competence of native artists, bore him animosity. As others have noted, not only was this a blow to his professional pride but it convinced Morse to abandon the fine arts altogether and pursue instead his other interests, which ultimately secured him more fame than he might ever have gained from his work as a painter.[16] In 1837 he invented the telegraph, devising the code that still bears his name. Two years later, with

plans and equipment he had obtained from his friend the French inventor and showman Louis J. M. Daguerre, he introduced the principles and techniques of photography to the United States.

As it turned out, two of Morse's New York colleagues, John Gadsby Chapman and Henry Inman, were each awarded a commission. Chapman, who is best known today for his *American Drawing Book* (1847), one of the most popular nineteenth-century practical books on art, began his study of art during the 1820s with Charles Bird King in Washington, DC. But the most important influence on his early career was a four-year trip to Europe with Morse in the late 1820s. He aspired to be a history painter, but lacking commissions he of necessity turned to book illustration and established himself as one of the foremost draftsmen of his day, contributing etchings and engravings to "a great number of periodicals and books of all sorts— histories, novels, children's stories, gift books and annuals, grammars, selections of poetry and even church manuals."[17]

Equally influential in gaining Chapman a Rotunda commission was his southern ancestry and friendship with Henry Alexander Wise, who represented Virginia in the House of Representatives and was a member of the Joint Committee on Public Buildings, charged with the Rotunda Commission selection process. Regional representation, then, as always, was a concern and was affirmed by Chapman's choice of subject, the *Baptism of Pocahontas at Jamestown, Virginia, 1613,* which he completed in 1840. He drew on early documents, particularly the works of Captain John Smith, who not only was the most important writer of early Virginia history but, as legend has it, was rescued from death by Pocahontas.

Needless to say, there is no acknowledgment of the arrogance implicit in the white man's converting the Native American to Christianity. Yet surprisingly, in the official description of the work, Chapman recognized the brutalities and injustices of the "daring and desperate adventurers who left their home and native land for no other purpose than to exterminate the ancient proprietors of the soil and usurp their possessions."[18] Also, this painting tacitly pays tribute to the contributions made by both Native Americans and women to the history of this country. As further noted in the official description of the picture, Pocahontas was "the great benefactress, the tutelary genius of the first successful Colony planted within the limits of the United States."[19]

In the ongoing competition between New England and Virginia for control of the historical and political destiny of the United States, this last statement could not go unchallenged, and the subject of the second Rotunda commission, the *Embarkation of the Pilgrims at Delft Haven, Holland, July*

22nd, 1620, is a direct reference to this historical one-upmanship. Completed and installed in 1843, it was painted by Robert W. Weir who, as professor of drawing at the United States Military Academy from 1834 to 1876, also had political connections in Washington. Weir had studied with Inman and, like Chapman, traveled and studied in Italy during the 1820s. He had at first considered another subject, the storming of Stony Point during the American Revolution, a convenient topic because Stony Point is only slightly south of West Point. But he later abandoned this idea, probably because recent historic events drew too much controversy.[20]

Instead he turned to documents from earlier colonial history, including Nathanial Menton's *New England Memoriall* [sic] (1669), which was, in turn, inspired by the yet unpublished *History of Plimouth* [sic] *Plantation* by Menton's uncle, the early governor of the Plymouth colony William Bradford, who, along with his wife, is one of the central characters in Weir's tableau. (Weir could not directly consult Bradford's *History of Plimouth Plantation*, which, thought to have been lost, was not published until 1856.) Bradford's history of the Massachusetts Bay Colony stands in the same rank with Smith's history of Jamestown. Thus these two subjects—Pocahontas and the Pilgrims—are screens through which the larger historical purpose can be seen—the identification of the two most important colonies, Virginia and Massachusetts, the colonies that led the American Revolution and that as states would control the White House until 1828. (Overt acknowledgment of the ascendancy of Jacksonian democracy did not come until the appointment of a "western artist," William H. Powell, to complete the commission vacated by Inman's death in 1846.)

The third painting was by John Vanderlyn; his *Landing of Columbus at the Island of Guanahani, West Indies, October 12, 1492* was begun in 1839 and installed in 1847. Of all the painters, Vanderlyn was by far the best known, and, of all the subjects, Columbus's legend would have been the most familiar. Vanderlyn, like the other two painters (and, in fact like all American artists who aspired to professional status) had gone to Europe for study and instruction. Yet Vanderlyn, who was really a member of Allston's and Morse's generation, eschewed London and, on the advice of his patron Aaron Burr, went to Paris, where he stayed for almost twenty years. He had vied with Trumbull for one of the first Rotunda commissions, so by the 1830s Vanderlyn, old and bitter, felt entitled.[21]

From the early days of the Republic, Columbus's exploits were linked to the fortunes and destiny of the United States. One of the first writers to establish this association was Joel Barlow, who revised his epic poem *The Voyage of Columbus* (1787) while attached to the diplomatic mission in

Paris. In this later work, known as the *Columbiad* (1807), the embattled mariner is rendered as a modern Aeneas and Barlow's opening lines, "I sing the Mariner who first unfurl'd an eastern banner o'er western world," mimics both the rhythm and the opening lines of Virgil's epic. However, it was not Barlow's poem that Vanderlyn drew from but two contemporary sources by Washington Irving: *Life and Voyages of Christopher Columbus* and *Voyages and Discoveries of the Companions of Columbus* (1831). During this time Irving was consul to Spain, where he spent most of his time reading original accounts of Columbus's voyage.

In fact, unlike the other paintings, which are not literal transcriptions of the written word, Vanderlyn's relies heavily on Irving's description of Columbus's first landing in the New World. The artist, following the author's description of the island of Guanahani (San Salvador), creates a landscape setting "of great freshness and verdure . . . covered with trees like a continual orchard. . . . everything appear[ing] in the wild luxuriance of untamed nature." The natives are drawn as "perfectly naked . . . lost in astonishment at the sight of the ships." But the painting's central subject is the landing of Columbus and his men, which is described by Irving as follows: Dressed in scarlet, Columbus "drew his sword, [and] displayed the royal standard. . . . His followers . . . thronged around him. . . . Those who had been the most mutinous and turbulent during the voyage, were now most devoted and enthusiastic."[22]

Given the vividness of Irving's re-creation of Columbus's life, Vanderlyn's reliance on this source is not surprising. Furthermore, Irving's book became the source of many other artists' interpretations of the Columbus myth, including those of Eugène Delacroix, Emanuel Leutze, and the sculptor Randolph Rogers, whose ten bronze plaques adorn the east door of the Capitol.

The history of the fourth Rotunda painting is different from that of the other three. Originally, the commission went to the New York portrait painter Henry Inman, who, along with Morse and others, had been active in the establishment of the National Academy of Design. He spent nine years on his proposed *The Emigration of Daniel Boone to Kentucky* and accepted $6,000 of the $10,000 commission, but, according to William Gerdts, the work had not been begun at the time of his death in 1846.[23] Although friends of Morse put forward his name as a qualified artist, and Inman's student Daniel Huntington offered to complete Inman's proposal, the commission, at the behest of western congressmen, went instead to another of Inman's pupils, the lesser-known William H. Powell, who early in his career had secured the support and patronage of Nicholas Longworth of Cincinnati.

According to Powell, his subject, *Discovery of the Mississippi by De Soto, A.D. 1541* (completed in 1853 and installed in 1855) was selected by members of Congress.[24] Coming in 1847, at the height of enthusiasm for this country's commitment to its "manifest destiny," the relationship between this policy of western expansionism and de Soto's "discovery" of the Mississippi is hardly coincidental. Like Inman's original proposal, Powell's western subject makes emphatic the expansion of national geographical and territorial boundaries that was becoming self-evident with the admission to the union of Texas in 1845 and the Oregon and Mexican territories by the end of the decade. How big was the nation to be? In 1783, at the end of the Revolutionary War and after the treaty with Great Britain, it extended from Maine to Georgia, from the Atlantic to the Mississippi. By 1830 it included Florida and most of the midwestern states to the Rocky Mountains. As the nation's history was being written and painted in the 1840s, the United States took its final, continental form, from the Atlantic to the Pacific, from Mexico to Canada.

Today we are in the middle of a fierce debate about the meaning of the nation's history. On one side are the opinions of many academics, or those currently in charge of interpreting the nation's past, who claim that, since the time of Columbus, exploration, colonization, and nationalization reflect a eurocentric desire to conquer, dominate, and destroy the native populations and exploit the lands of the Americas. In sharp contrast are those who argue, in an equally unreflective way, that we must revere and laud the nation's early history. In the twentieth century, the concept of Manifest Destiny, with the international leadership provided by the United States after World War II and beyond, continues to be very potent for many citizens; so are the nation's early legends recorded in the history books and painted on the walls of the Capitol Rotunda. Can this chasm between the academy and the "people" be bridged?[25] Can a more evenhanded, open-ended, nonjudgmental, encompassing interpretation of the past be constructed—one more representative of the tangled ambitions and personal desires of the broad cast of characters who participated in the earlier centuries of this country's development? It is time to begin a rereading of the past, a reading that is neither exclusionary nor selective, one done from many perspectives that reflects a desire to understand rather than to condemn.

Notes

1. George Callcott, *History of the United States 1800–1860, Its Practice and Purpose*, Baltimore: Johns Hopkins University Press, 1970, p. 25.

2. See Nina Baym, "Women and the Republic: Emma Willard's Rhetoric of History," *American Quarterly* 43, no. 1 (March 1991): 1–23.

3. Virgil Barker, *American Painting, History and Interpretation*, New York: Macmillan, 1950, p. 465. For these later opinions see note 14.

4. David D. Van Tassel, *Recording America's Past, an Interpretation of the Development of Historical Studies in America, 1607–1884*, Chicago: University of Chicago Press, 1960, p. 114.

5. See Helen A. Cooper, *John Trumbull, the Hand and Spirit of the Painter*, New Haven: Yale University Art Gallery, 1982; and Irma B. Jaffe, *John Trumbull, Patriot-Artist of the American Revolution*, Boston: New York Graphic Society, 1975.

6. Cooper, *John Trumbull*, p. 90.

7. Morse was the father of the painter Samuel F. B. Morse; Bancroft was the father of the historian George Bancroft.

8. Bert James Loewenberg, *American History in American Thought, Christopher Columbus to Henry Adams*, New York: Simon & Schuster, 1972, p. 206.

9. Lilian Handlin, *George Bancroft, the Intellectual as Democrat*, New York: Harper & Row, 1984, p. 128.

10. George Bancroft, *History of the United States of America from the Discovery of the Continent*, v. 1 (1834), New York: D. Appleton, 1883, pp. 1–3.

11. "A Resolution to furnish the Rotundo [*sic*] with paintings," no. 8, 24th Congress, 1st session, approved June 23, 1836.

12. Report of the Select Committee, "Paintings for the Rotundo," no. 294, 24th Congress, 2nd session, February 28, 1837.

13. See Lillian B. Miller, *Patrons and Patriotism: The Encouragement of the Fine Arts in the United States, 1790–1860*, Chicago: University of Chicago Press, 1966, pp. 45–57.

14. See William H. Truettner, "The Art of History: American Exploration and Discovery Scenes, 1840–1860," *American Art Journal*, Winter 1982, pp. 4–32 (a revised and expanded version of this essay appeared in the exhibition catalog *The West as America, Reinterpreting Images of the Frontier, 1820–1920*, Washington, DC: National Museum of American Art, 1991); Matthew Baigell, "Territory, Race, Religion, Images of Manifest Destiny," *Smithsonian Studies in American Art*, Summer–Fall 1990, pp. 3–22; Albert Boime, *The Magisterial Gaze, Manifest Destiny and American Landscape Painting (c. 1830–1865)*, Washington, DC: Smithsonian Institution Press, 1991; and Vivien Green Fryd, *Art and Empire: The Politics of Ethnicity in the United States Capitol, 1815–1860*, New Haven: Yale University Press, 1992. An exception is William H. Gerdts and Mark Thistlethwaite, *Grand Illusions, History Painting in America*, Fort Worth, TX: Amon Carter Museum, 1988.

15. The work had taken on mythical proportions not only in the artist's imagination but in the opinions of his friends who for many years supported the enterprise both emotionally and financially. It was as if in one work the artist could

catapult not only his own reputation but the aesthetic reputation of this provincial country and make it fairly competitive with the venerable traditions of the past.

16. See Paul J. Staiti, "Ideology and Politics in Samuel F. B. Morse's Agenda for National Art," in *Samuel F. B. Morse, Educator and Champion of the Arts in America,* New York: National Academy of Design, 1982, pp. 7–54; and Staiti, *Samuel F. B. Morse,* New York: Cambridge University Press, 1989.

17. William P. Campbell, *John Gadsby Chapman, Painter and Illustrator,* Washington, D.C.: National Gallery of Art, 1962, p. 11.

18. *The Picture of the Baptism of Pocahontas,* "painted by order of Congress, for the Rotundo of the Capitol, by J. G. Chapman of Washington," Washington, D.C.: Peter Force, 1840, p. 3.

19. *Picture of the Baptism of Pocahontas,* p. 5.

20. According to Miller, *Patrons and Patriotism,* pp. 48 and 51, in 1828, at the time of Andrew Jackson's campaign for president, "a resolution [was] introduced into the House [which] called for the employment of Washington Allston . . . to fill a panel in the Rotunda with a painting of the Battle of New Orleans (1813)," Jackson then being heralded as the hero of New Orleans. Allston's friend and supporter Richard Dana wrote to his friend Gulian Verplanck: "all H.'s [James A. Hamilton, representative from South Carolina and supporter of Jackson] talk about Allston and the canvass, was nothing more or less than *canvassing* for President." In 1834, when the congressional debates continued about the Rotunda commissions, Henry Wise, representative from Virginia, proposed an amendment to the joint resolution "that the selection of subjects shall be confined to a date antecedent to the treaty of '83 [Treaty of Paris]." In "Paintings for the Rotundo," *Gales & Seaton's Register,* December 15, 1834, p. 793.

21. Indeed with works such as *The Death of Jane McCrea by the Indians* (1803, Wadsworth Athenaeum, Hartford, CT), *Marius on the Ruins of Carthage* (1807, M. H. de Young Museum, San Francisco, CA), and the nude *Ariadne Island of Naxos* (1812, Pennsylvania Academy of Fine Arts, Philadelphia, PA), Vanderlyn occupied an important place in the pantheon of American artists.

22. Washington Irving, *Life and Voyages of Christopher Columbus* (1828); rept. New York: A. L. Burt, 1902, pp. 87–88.

23. William H. Gerdts, *The Art of Henry Inman,* Washington, DC: National Portrait Gallery, 1987, p. 43.

24. "Fine Arts, Powell's Painting of De Soto," *Putnam's* 3 (January–June 1854): 118.

25. An important essay that deals with this contemporary issue is Steven Watts, "The Idiocy of American Studies: Poststructuralism, Language, and Politics in the Age of Self-Fulfillment," *American Quarterly* 43 (December 1991): 625–60.

3

Selections from
Rushmore—Another Look

JIM POMEROY

The highway narrows past Keystone (three miles from Rushmore), the billboards disappear, and the wilderness encroaches. The road winds gracefully as clearance, visibility, and grade demand a respectful twenty miles per hour. Teasingly, the mountain is revealed and abruptly obscured. At the entrance, rangers direct cars to rows in a vast semicircular terraced lot, with Rushmore at the focus. After parking, visitors walk through a token "forest" to discover, once again, the mountain framed in Ponderosa Pine, rising 500 feet above the coin operated binoculars. Smaller than expected, the carving stands out crisp, clean, white against the weathered granite hulk. Standard National Park Service low key, "rough hewn" signs direct the pilgrims to restrooms, canteen, restaurant, and a tastefully appointed souvenir shop the size of a supermarket. The Park Service maintains a tourist center with a modest display of mountain carving hardware and a large hall filled with rows of benches facing a wall of tinted glass, the sculpture visible beyond. Two video monitors placed in the middle of this giant window constantly repeat Rushmore's story. Several American flags hang from the ceiling and outside on the terrace. A gauntlet of state and territory banners has been added along the path from the parking lot in observance of the Bicentennial.

Later, the nightly program is presented in the amphitheater. A patriotic chat from a ranger, *Four Faces on a Mountain,* a twenty minute film, and mass singing of the Star-Spangled Banner are climaxed by the garish lighting of the carving. A bright shadowless spot flattens the faces, exposing inconsistent strata and destroying Gutzon Borglum's calculated and dramatic modeling. A vast sigh swells from the 1300 viewers. Scale, hype, kilowatts, and days in a Winnebago demand gratification. The program ends with an hour-long traffic jam.

A man climbs a mountain because it is there.
A man makes a work of art because it is not there.
 —Carl Andre

What does it mean when that work of art *is* a mountain?
One of the principal motivations for this study is a new context
emerging from recent developments in the history of art—based on ideas
like earthworks, conceptual, and performance art. Rushmore's impact paral-
lels that of an earthwork through evocation of the sublime—the profound,
awe filled result of the romantic encountering of darkness, great dimensions,
powerful forces, and the terrifying sense of overwhelming solitude. The
modern sublime is usually effected through massive yet subtle manipulation
of local entropy—a relative delay in the natural processes of growth and
ultimate decay. Mel Henderson, Joe Hawley, and Alf Young's San Francisco
Bay dye marker text piece *Oil* faded in a matter of minutes; Christo's
projects are visible for a few days; Robert Smithson's *Spiral Jetty* and
Michael Heizer's *Double Negative* may last a lifetime. Mt. Rushmore is
designed to endure two million years.

Compared with Christo's twenty-three-mile *Running Fence* or Walter
DeMaria's square-mile drawing *Las Vegas Piece,* Borglum's sixty-foot heads
are diminutive. Viewed from the air, the sculpture is lost in the wooded hills,
found only through association with its gigantic parking lot. The lot itself
is far more impressive aerially—like a weird extraction from Ed Ruscha's
Los Angeles. Nevertheless, Rushmore is classically sublime. It is an obvious
precedent for many artists now working in large scale. Claes Oldenburg, for
one, clearly plays on our familiarity with gross incongruity as typified in Mt.
Rushmore, Statue of Liberty, and Macy's Thanksgiving Parade.

As this analysis progressed, subsequent events constantly changed
previous concepts. The notion of viewing Mt. Rushmore, albeit ironically,
as an earthwork has set off a veritable avalanche of unanticipated insight:
comparison with works by Smithson, Henderson, Heizer, DeMaria,
Christo, and Oldenburg was expected to produce a parodic reading of
Rushmore as modernism; instead, revelations followed involving not only
considerations of contemporary art strategies but also some larger hypothe-
ses regarding myth and ideology.

Given: One large granite carving, partially buried, realistically depicting four
adult caucasian males. Physiognomic and gestural description, from left to
right.

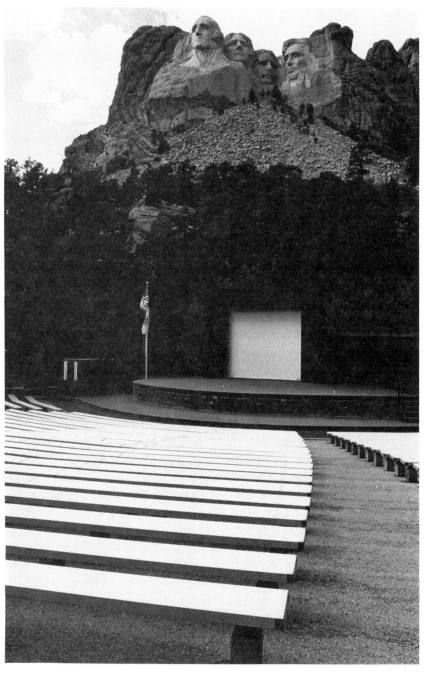

Gutzon Borglum, *The Shrine of Democracy*, 1927–1941. Mt. Rushmore, Black Hills, South Dakota. Seen from Mt. Rushmore Amphitheater, 1976. (Photo: Jim Pomeroy)

Figure 1, Buttresses the quartet, late middle age, good health, strong square shoulders, straight posture, stern jaw, high forehead, level gaze—passionless, stable.

Figure 2, Placed behind and right of Figure 1, body hidden, full young face, pursed lips, head is tilted slightly upward, looking into the distance—untroubled, thoughtful.

Figure 3, Rearmost of the group, middle age, plump square face implies robust physique, close cropped hair, low forehead, eyes squint through spectacles, mustache, strong chin—aggressive, stubborn, resolute.

Figure 4, Farthest right, turned left, enfolding the composition, long face prematurely aged, skin tightly drawn over a prominent bone structure, deep set eyes stare down slightly below level, large lower lip, wide mouth, short beard, large forehead, figure seems burdened or bent, apparently endured a great deal of stress—patience, stamina, contemplation, wisdom. No signature or other information.

March 6, 1941, Gutzon Borglum died, leaving the expedient completion of his unfinished Black Hills Monument, *The Shrine of Democracy,* to his son Lincoln. A nation bracing for war was unwilling to spend further on already overdue portraiture, a project plagued with perpetually insufficient funds. When the blackout lifted, Mt. Rushmore was firmly etched in our cultural unconscious.

Everyone recognizes Mt. Rushmore. In company with the Liberty Bell, Statue of Liberty, Capitol Dome, Astrodome, Golden Gate Bridge, Contract Bridge, Goodyear Blimp, Hoover Dam, Martin Luther King, transistors, Chevrolets, Mickey Mouse, Washingtons crossing Delawares, Coke, Neil Armstrong, polio vaccine, Lauren Bacall, football, and pantyhose, it matrices a composite—a consensus fantasy that supplies kinship, as "Americans," with parameters, territories, lineage, castes, roles, and history in palatable natural form. Everyone knows the monument at Rushmore but few people can identify *The Shrine of Democracy,* remember its creator, Gutzon Borglum, or place the monument in South Dakota. Fewer yet can name the four carved presidents or recall their unique political contributions.

How can one of the most pervasive symbols in our culture function with vast gaps of information regarding intention, authorship, location, and vintage? Seemingly, it's an icon up for grabs. Used profusely, the image sells everything from government bonds to vegetables. It comprises an entire genre of graphic humor—fifth head jokes alone make up a large inventory.

Mt. Rushmore is no longer considered a work of art; and it's frequently used as subject matter itself by painters, sculptors, and filmmakers—a handy prop, with guaranteed results.

It is, then, an important image marking a definite place in American cultural consciousness. How is it possible that an image, which seems to have so little historical specificity or widespread knowledge about the construction of the work itself, can be an image of such plenitude and breadth, working at several levels without appearing forced or contrived? There's been no cover-up, information is available, yet it's simply unnecessary, ignored.

What then does Rushmore signify? How does this image function, effect an impression, negotiate a reading? What systems of representation make it such that questions of origin and motivation never occur? These questions probe mechanisms of cultural appropriation, specifically the issue of myth. Myth's basic function is to naturalize problematic, contradictory elements of a culture—to speak ideology, which itself is constituted by a large set of shifting relative values drawn from a constantly permuting history. Myth is a form of language, where entities once endowed with specific representational properties operate on a higher unitary level, abbreviated, streamlined, to voice, as if naturally, a construct by interacting with other units, codes, signs, systems in the fabrication we see as reality. Increased repetition and systematization reinforce this naturalness. This process is structural to all cultures—it's only that frequently myth mobilizes cultural aspects which we consider negative and destructive—in this case, patriarchy, romanticism, nationalism.

Repeated usage in advertising, humor, art, and propaganda displays a consistency in the selection of certain properties of Mt. Rushmore as a symbol which can then be transferred to other systems. The recurring choices are the ones which emphasize permanence, security, stability, law, father, masculinity, grandeur, power, tradition, ingenuity, large scale, antiquity, and cultural wealth. They are used either straightforwardly or facetiously without loss of effectiveness through violation of iconic decorum.

The same qualities are found associated with certain other objects or systems functioning as symbols: Greco-Roman art and architecture, classical music, conspicuous materials and labor, Roman numerals and togas, Latin and Greek text, wigs, ancient ruins, castles in picturesque landscapes, French vocabulary, Old English, Sphinxes and pyramids, chariots, Shakespeare, et cetera. Frequently these overlaps transfer intrasymbolically. The images with shared qualities assume like attributes.

Large diverse samples over long duration filter congruencies which

might form a profile. Usage defines form which in turn determines usage and so on . . .

Frequent users of the Rushmore image include federal and state governments, financial interests, public utilities, alcohol and tobacco companies, religious institutions, military, paramilitary, and veterans' organizations. Record companies, commercial film and television, satire magazines, and the fashion and snack food industries are characteristic of institutions habitually using it as parody. These patterns are found extensively within the highly developed mass media, to either bolster postures of stability or reinforce an illusion of change.

A corollary consideration is the notion of Rushmore as Kitsch, occasionally employed in humor and art. Kitsch and "camp" are devices which seemingly separate the viewer from a mass audience—the intended consumer. The Kitsch approach is a subjective, snob appeal orientation—a perverse attraction, self-indulgent, masturbatory. Kitsch is not an analytical term and can only be defined by the individual ascribing to it. It's a vague notion, a cultural flea market, anthropology in drag. Dealing with Rushmore as Kitsch merely shifts one into a different stratum of the same population. It ignores the presence of the myth and consequently affirms myth's pervasive potency. Kitsch is a bourgeois commodity, recycling cultural traits—charging them with unsophisticated lower class taint while relishing their currency value. The practice constitutes a latent recognition of the invisible totality of ideology.

I do not mean to deny importance to art and humor. On the contrary, taken seriously, they provide probably the most incisive exposition of hidden cultural value and process—like dreams and fantasies momentarily unveiling an unresolved psyche.

What mechanisms allowed Rushmore to assume transferred character? It's important here to know something about Borglum's intentions and how the project was completed. The monument differs from its original conception in two important aspects:

1. The figures were meant to be exposed to the waist, in full detailed costume, including two hands, carved in the round.
2. The sculpture was meant to be accompanied by a text.

Models showing the complete clothed figures display few of the previously listed symbolic qualities. The Presidents appear merely large, grotesque, and anachronistic. Stone Mountain, Georgia's *Heroes of the Confederacy* (a much more ambitious carving started by Borglum in 1923) is not as well known because these properties of its construction—complete de-

tailed figures and horses linked to one specific historical period—make it less available to mythic extrapolation.

Borglum felt strongly that a text was necessary as an integral part of the memorial to emphasize clearly the monument's connection to the "civilization" which produced it. He had three different plans for this—the first was a great tablet inscribed in the face of the mountain (where Lincoln is now carved) bearing brief significant chapters from American history, composed by living presidents. That plan was dropped when Borglum insulted Coolidge by editing his entries. Another five sets of histories were chosen through a national competition sponsored by the Hearst Newspapers. Borglum rejected the Jury's choices and the entablature idea as well.

His third idea, actually begun in 1938, was a grandiose scheme for a great stairway and a vast "Hall of Records" located in the small canyon directly behind the carving. That work halted under government pressure to expend all time and monies to finish the heads. The threat of war, Borglum's advanced age, and frustration over his perpetual postponements were the reasons for the failure of federal support to this final plan for a text. (Borglum's honorarium, 25 percent of all funds spent on the project, was obviously little incentive to economy or efficiency.) Borglum's widow and son have, so far, unsuccessfully lobbied to finish the figures, stair, and hall.

Without an accompanying text the Rushmore symbol is open to multiple interpretation. Its use in advertising is an example of how interpretation evolves. Tentatively at first, the image appears usually supported with copy or more familiar symbols until it becomes culturally associated with specific abstract properties, and can function unaided, getting across its message by mere product juxtaposition.

Rushmore's modern state is ironically reminiscent of the eighteenth century English Garden. Although its "monumental" attraction has contaminated its surroundings—encouraging the parasitic growth of souvenir stands, motels, gas stations, cafes, and large numbers of popular and totally incongruous establishments along the divided highway leading into the Black Hills—immediate proximity, land comprising the monument itself, is "preserved." This park contains a lot for 800 vehicles, a tourist center, commercial concessions, and a 1300 seat amphitheater. (Borglum's mountain studio and National Park Service administration and maintenance buildings are concealed.)

Incredible labor has gone into fabricating the illusion of a natural setting. Yet numerous roads and trails off limits to tourists, the few sites available to view the monument, and the overtly indigenous design of buildings, walks, terraces, and guardrails reveal a tightly controlled experi-

ence. Climbing Mt. Rushmore is prohibited. It cannot be perceived directly, intimately as one deals with sculpture (including the Statue of Liberty) but from distant, chosen places passively, always looking up, in the manner reserved for sacred, inviolable reverence.

This hallowed ambience is accentuated through contrast with commercial situations like the Hall of Presidents Wax Museum, Marine Life Aquarena, Reptile Garden, and the Horseless Carriage Museum, businesses which thrive on the hordes of sightseers streaming to view Mt. Rushmore.

The disposition and construction of the Park Service's garden naturalizes the sculpture, but its state of incompletion enhances the effect of naturalness even further. The unfinished carving, awash with debris, easily affords a reading as a fragment, an artifact, a ruin. Its unfinished state also suggests a more romantic vision: the figure released from its imprisoning dross.

Ready-made antiquity, uncovered in virgin wilderness—a funny way to look at drive-in art, complete with snack bar and official souvenir stand.

In 1975 Borglum's family opened his ranch-studio, thirty miles south, as a museum. Two buildings, in beautiful prairie, display photos, mementos, sketches, models, tools, and over one hundred sculptures. Not only is it the most important archive of Borglum's life and his work on Rushmore, but it's an accurate example of any major sculptor's studio from the early twentieth century. The memorial had over two million tourists in 1975— only five thousand visited the ranch. Admission fees didn't even cover maintenance. The family closed the studio and is trying to sell it.

The success of the roadside businesses and the demise of the studio-museum seem to imply that Rushmore's popularity has little to do with Borglum's intentions in making *The Shrine of Democracy*.

This poses an equation which fits Rushmore as another curious freak neatly into a Black Hills set filled with Badlands fossils, granite needles, great cement dinosaurs, gravity houses, Tudor castles, ghost towns, Sitting Bull caves, Amazon pythons, Stanley steamers, and a wax reconstruction of the Last Supper. Again, a set of images with shared qualities assuming like attributes.

Most people don't travel to South Dakota to look at Rushmore. Obviously they don't have to, they get enough of it at home. There it's even further divorced from its ambience, history, and intent; and like Wonder Bread, it's enriched.

Another idea developed during research and discussion: Rushmore was a well known project between 1927 and 1941, as Borglum skillfully provided himself and the monument with constant publicity. *Life, Scientific Ameri-*

can, Art Digest, Popular Mechanics, Saturday Evening Post, The New York Times, and many other periodicals printed major illustrated articles detailing plans and work. Already Rushmore was a dominant myth, but that myth was even then moving beyond its original function and was becoming linked with totally different concerns. Rushmore was associated with other big projects of the '30s—Boulder Dam, TVA, and the Golden Gate Bridge—reinforcing ideas like Yankee ingenuity, impossible accomplishment, precision engineering, utilization of great power on a huge scale, new technology, man taming nature, and better living through science and industry. (An interesting aside—Rushmore was carved with the technology of mining—dynamite and pneumatic drills—the same methods used to extract gold from the Black Hills after the Sioux were forced from their land in 1876, territory recognized in the treaty of 1868.) Pictures of emerging giants belittling workers and scaffolding were common fare for the daily press. Borglum was prominent as a romantic figure, capricious, bombastic, extraordinary. Against overwhelming odds, he succeeded in capturing exquisite nuances of character on a gross scale to the delight of a well informed mass audience. Dedications were frequent. Every two or three years he'd drag the current president and/or governor out to the Black Hills, perform an elaborate ceremony, and unveil another face from behind a giant flag. For Coolidge's 1927 visit he dynamited 21 trees as both salute and road clearing.

Development of the monument, its plans, changes, problems, objectives were public information. Progress was visible as a great artist carved his nation's history for eternity. In October 1941 that myth ended the instant the last scaffolding was removed from the mountain. The new myth was born at the moment the last trace of modern man disappeared from a visage of some other era. As war rationing sharply cut tourism, the imperative production of a strong national identity accelerated Rushmore's iconographic growth. The abstract image systematically replaced the documentary image. Dead Borglum's silence assured it.

What constitutes Rushmore's myth? Its cultural identification reads as follows:

1. The artist is unknown, it is unsigned
2. The time of its origin is unknown
3. It is bizarre
4. It is found in mountain wilderness
5. It is a fragment, buried in debris, a ruin
6. It is very large
7. It depicts four western European males

8. It is carved in a classical manner
9. It recalls Athens, Rome, Egypt, other ruins
10. It must be very old

These assumptions are not lies—merely extracts from general parlance, standard usage. Obviously distorted, they nonetheless accurately picture what this image really is. Distilling this data offers a clearer reading of Rushmore's importance. Rushmore is a time machine out of control, sliding up and down history somewhere between Homer and the New Deal. It aligns compatibly with European historicity and transfers qualities of permanence and antiquity to the desired self-image of the culture appropriating them. It's important to invent alternative pasts for a culture that finds it hard to accept the real one. It's paradoxical that a Shrine of Democracy is placed in the center of land acquired through well documented rape—the most blatant example from 500 years of genocide and hemispheric conquest. Rushmore implies that the European has always been here. It obscures a shameful memory and eases racial guilt much the same way an individual represses thoughts reminding him of a painful experience.

Borglum tried to build a monument for the future, instead Rushmore speaks from a fictional past. It displaces "alien" identity (like Mesa Verde, the Ohio Mounds, Chichén Itzá) and stamps a foreboding landscape with still more graffiti from a culture unsure of its masculine virility. Rushmore is dwarfed by its environs, except when it's experienced at those few designed points of vantage, yet that tiny, contrived sublime produces a subliminal resonance reverberating throughout a nation demanding a little Muzak to muffle the sound of a telltale heart.

Afterword

It's now September 1991. Robert Smithson's *Spiral Jetty* has slipped beneath the rising waters of the Great Salt Lake, Michael Heizer's *Double Negative*'s sharply delineated geometries are assuming the more chaotic contours of eroding ravines, and Christo's curtains and wrappings have been dismantled, rolled up, and sold off to souvenir collectors or rag pickers. Carl Andre's macho remark, "A man makes a work of Art because it isn't there," sounds sour, petulant, boorish, chauvinist, and embarrassing.

Populations and politics change—taste permutes, technology evolves, and marketing aggressively expands. Earthworks are no longer the innovative engineering of the avant-garde—they're now trendy embellishments for corporate parks, aesthetic makeovers to accommodate refuse disposal sites,

or clever arrangements of crops planted for liquor advertisements. Post-Reagan America is increasingly style oriented, image conscious, and upwardly mobilized. Fifty years after work stopped in South Dakota, Mt. Rushmore remains, practically in mint condition. In fact, it seems to get stronger and more potent as time slips away. A new climate will do that for an old idea.

Rushmore's motivation as a national tourist attraction was conceived of to fulfill the embodiment of ethnocentric fantasy. Recent research by Alex Heard has disclosed correspondence during the 1920s from Gutzon Borglum to D. C. Stephenson, the Grand Dragon of the Ku Klux Klan, which details a deep racist conviction in Nordic moral superiority, urging stringently selective immigration policies.[1] "In addition to Jews and blacks, he especially disliked Catholics and the 'wretched refuse' who are welcomed with raised torch by the Statue of Liberty." There can be little doubt that these attitudes played a significant role in the configuration of the monument.

Launching Rushmore as a heavily promoted independent venture, Borglum quickly scurried to coerce sponsorship of a loaded, patriotic offer the government couldn't afford to refuse. Coolidge complied. The enterprise thrived during the Hoover administration while most of the economy was flushing down the drain. Carving continued throughout the Depression, but Borglum received no funds from official programs such as the Works Progress Administration. He characteristically relied upon old cronies in the Treasury Department and backdoor manipulation of Congress through lobbying and publicity management. These strategies avoided questions of taste, style, content, and the strict budgetary review to which all federal grants are usually held accountable. Jobs through the WPA were fixed contracts at subsistence wages—not Borglum's style of sweetheart deals, which rewarded the entrepreneurial showman for padding expenses and postponing the finish. Borglum was very careful to protect *The Shrine of Democracy* from the responsible exercise of democracy.

While the Federal Art, Writers', Theatre, and Music projects and the documentary photography of the Farm Security Administration were under frequent attack by conservative factions, Rushmore lurched from one escalated appropriation to the next until the project achieved acceptable, posthumous completion in 1941 (with a total expenditure of around $980,000). National, and resultant state and local, support of the arts disappeared at about the same time and was not revived until the founding of the National Endowment for the Arts and the National Endowment for the Humanities in 1965. While wartime priorities were given as convenient

justification for eliminating the New Deal programs, the thirty-five-year hiatus before reestablishing an official cultural agency suggests that these programs in fact succumbed to the onslaught of the reactionary fervor which resurfaced after the war as McCarthyism. Artists and intellectuals were prime targets, and the American government was not to be openly involved with the business of expressive subsidy. Meanwhile, the industry of commemorative fabrication continued unabated—lucrative (and insider) commissions for hackneyed memorials to war heroes, favorite sons, and patriotic allegories seemingly will never go out of fashion.

Although Mt. Rushmore's visibility in popular culture has never waned, the monument had to weather four decades of presidential indifference before administrations especially sympathetic to theatrical homilies, show business spectacle, and sledgehammer sentimentalism ascended to the podium. With campaign promises to protect the Flag and swear the Pledge of Allegiance, George Bush recognized the PR value of reaffirming the importance of his own office and sought to dedicate finally the presidency's greatest advertisement. Although Borglum had managed to dedicate Rushmore six times from 1927 through 1939, including two ceremonies with presidents in attendance, another ritual was deemed necessary to christen the finished heads, fifty years late, on July 3, 1991. This anniversary has been seized upon as an opportunity to propel completion of the Hall of Records, "as Borglum intended," and an organization has been formed to raise the estimated $40 million necessary to do the job. We haven't heard the last of a bad idea.

In an atmosphere uncomfortably reminiscent of reactionary politics in the '30s, '40s, and early '50s, public support of the arts and humanities is under siege. As a major exhibition critical of the mythology of the American West is assailed in Congress, proposals questioning post-Columbian hegemony on the five-hundredth anniversary of "discovery" are defunded by NEH administrators. Since Ronald Reagan's election, the United States has engaged in three lopsided wars distinguished by exponential increases in the deployment of technology and the suppression of information (all wrapped up in a yellow ribbon—a confusing, new belligerent banner). New appointments to the Supreme Court do not encourage an optimistic forecast in regard to choice or expression. Commercial television proliferates, literacy declines, voter apathy mounts, and presidential campaign rhetoric is reduced to photo opportunities, sound bites, and spin control. It is therefore not surprising to see increasingly prevalent appearances of vigorously streamlined iconography.

Some new manifestations of Rushmore's iconic utility are less benign

than usage observed previously: New Philippine president Corazón Aquino requested that a colossal concrete portrait of deposed dictator Ferdinand Marcos remain as a memorial to his reign of tyranny and corruption (after exuberant celebrants crowned it with giant devil's horns). Rushmore was invaded by a monster biker rally featured on the front page of the *New York Times* while South Dakota ran out of beer. The site of Borglum's first effort in large-scale carving, *The Heroes of the Confederacy*, at Stone Mountain, Georgia, was taken over last year for exclusive use by a Klan mass meeting, patrolled by gangs of Neo-Nazi skinheads who threatened unwelcome visitors with violence. This last event chillingly recontextualizes the intended humor of T-shirts sold at both Rushmore and Stone Mountain gift shops which depict a sculptural group in high relief boisterously singing the heavy metal, head-banger chant "We will, we will Rock you!"

Note

1. Alex Heard, "Mt. Rushmore: The Real Story," *New Republic*, July 15–22, 1991, p. 16.

4

Holocaust Memorials in America

Public Art as Process

JAMES E. YOUNG

The reasons for Holocaust memorials and the kinds of memory they generate vary as widely as the sites themselves. Some are built in response to traditional Jewish injunctions to remember, others according to a government's need to explain a nation's past to itself. Whereas the aim of some memorials is to educate the next generation and to inculcate in it a sense of shared experience and destiny, other memorials are intended to attract tourists. In addition to traditional Jewish memorial iconography, every nation has its own institutional forms of remembrance. As a result, Holocaust memorials inevitably mix national and Jewish figures, political and religious imagery.

In Germany, for example, memorials to this time recall Jews by their absence, German victims by their political resistance.[1] In Poland, countless memorials in former death camps and across the countryside commemorate the whole of Polish destruction through the figure of its murdered Jewish part. In Israel, martyrs and heroes are remembered side by side, both redeemed by the birth of the state. As the shape Holocaust memory takes in Europe and Israel is constrained by political, aesthetic, and religious coordinates, that in America is no less guided by both American ideals and experiences of this time.

Whereas European memorials located in situ often suggest themselves rhetorically as the extension of events they would commemorate, those in America gesture abstractly to a past removed in both time and space. If memorials in Germany and Poland composed of camp ruins invite visitors to mistake them for the events they represent, those in America inevitably call attention to the great gulf between themselves and the destruction. The

"meaning" in American memorials is not always as self-evident as it is in those constructed at the camps, places of deportation, or destroyed synagogues. In this sense, American memorials seem to be anchored not so much in history as in the ideals that generated them.

In America, the motives for Holocaust memory are as mixed as the population at large, variously lofty and cynical, practical and aesthetic. Some communities build memorials to remember lost brethren, others to remember themselves. Some build memorials as community centers, others as tourist attractions. Some survivors remember strictly according to religious tradition, others recall the political roots of their resistance. Veterans' organizations sponsor memorials to recall their role as liberators. Congressmen propose monuments to secure votes among their Jewish constituencies. Even the national memorial to the Holocaust now under way in Washington, DC, was proposed by then president Jimmy Carter to placate Jewish supporters angered by his sale of F-15 fighter planes to Saudi Arabia. All such memorial decisions are made in political time, contingent on political realities.[2]

In the pages that follow, I will neither survey the hundreds of public Holocaust memorials in America nor offer a strictly aesthetic critique of the handful I examine. For, as I have suggested elsewhere, neither a purely formal nor a historicist approach accommodates the many other dimensions at play in public monuments.[3] Rather than merely identify the movements and forms on which public memory is borne, or asking whether these memorials reflect past history accurately or fashionably, I pursue what Peter Burger has called a "functional analysis of art," adapted here to examine the social effects of public memorial spaces.[4] This is to suggest that the "art of public memory" encompasses not just these memorials' aesthetic contours or their places in contemporary artistic discourse. It also includes the activity that brought them into being, the constant give-and-take between memorials and viewers, and, finally, the responses of viewers to their own world in light of a memorialized past. By reinvesting these memorials with the memory of their own origins, I hope to highlight the process of public art over its often static result, the ever-changing life of the monument over its seemingly frozen face in the landscape.

The First American Memorial: Forever Unbuilt

At a massive public ceremony in October 1947, New York mayor William O'Dwyer dedicated a site in Riverside Park between Eighty-third and Eighty-fourth streets and marked it with a plaque reading: "This is the site

for the American memorial to the Heroes of the Warsaw Ghetto Battle, April–May 1943 and to the six million Jews of Europe martyred in the cause of human liberty." The plaque remains to this day, but the memorial was never built. As is often the case, the subsequent story surrounding the unbuilt memorial can be more instructive than a finished memorial could ever have been.

After several false starts, including ground-breaking ceremonies in 1952 for a gigantic, 80-foot-high set of tablets, two memorials by the sculptor Nathan Rapoport were submitted by the Warsaw Ghetto Resistance Organization to the city arts commission for consideration in 1964. One was the "Scroll of Fire," later erected by B'nai B'rith in Israel, and the other was a sculpture of Artur Zygelboim, engulfed by flames, about to pitch forward—a reference to his 1943 suicide in London to protest the world's indifference to the plight of Jews in Poland. After rejecting the Zygelboim sculpture as too tragic for recreational parkland, too distressing for children, sculptor and member of the city arts commission Eleanor Platt declared the "Scroll of Fire" (two towering cylinders, leaning against each other and emblazoned with pictographs portraying the Ghetto Uprising) to be "excessively and unnecessarily large." She continued, "Even if it were to be smaller and in better taste, artistically, I believe that by approving it or the Zygelboim sculpture, we would set a highly regrettable precedent."[5]

In the eyes of Rapoport and his sponsors, however, the crux of Platt's response came in her concluding remarks, which incensed the Jewish community. "How would we answer other special groups who want to be similarly represented on public land?" she asked. Stunned by her reference to "special groups," the sponsors were further bewildered by Parks Commissioner Newbold Morris's opinion that "monuments in the parks should be limited to events of American history." For, as they looked around them, they found numerous examples of other immigrant groups' former national heroes immortalized in stone and bronze, from Central Park to Washington Square. Eventually, Rapoport's "Scroll of Fire" was erected in Israel, where national memory had always been defined by that of Jews everywhere, a continuum of generational memory transcending geographical borders.

But these American survivors of the Warsaw Ghetto continued to wonder what the difference was between "events of American history" and those of "Americans' history." Like that of many American immigrants, their historical memory included both old and new worlds. In a culture composed of immigrants, they assumed that their "foreign" experiences would come to be regarded also as American, that, as part of their European past, the Holocaust would become part of America's past. As a land of

immigrants, the survivors had hoped, America would also be a land of immigrant memories, of pasts that are "foreign" only insofar as they transpired in other lands but American in that they constitute the reason for having come to America in the first place. If the survivors' history was not a part of the public memory, could they still regard themselves as part of the public?

The New York Holocaust memorial was never built at its assigned place in Riverside Park. The round stone remains, however, largely unknown to most New Yorkers, protected by a short cast-iron fence. Once a year, around the nineteenth of April, wreaths of flowers appear inside the iron enclosure. Undeterred, the Warsaw Ghetto Resistance Organization (WAGRO) continued its search for funds and an acceptable design. In the mid-1960s, with the city's blessings, a new site on the lower tip of Manhattan across from Ellis Island and the Statue of Liberty was chosen as more suitable for a truly civic monument. An umbrella committee calling itself Memorial to the Six Million Jewish Martyrs, Inc. and comprising some twenty major Jewish organizations then commissioned a model from the celebrated architect Louis Kahn. In October 1968, Kahn's model of six great glass blocks was exhibited to wide acclaim at the Museum of Modern Art. A season of fund-raising dinners was kicked off to raise the $1.5 million necessary to install the monument.

Five years later the committee had raised $17,000, barely enough to pay the architect for his model. Kahn died in March 1974, and the following May the executive committee announced that fund-raising efforts had been stymied by a worsening economic recession, Israel's recent wars, and the crisis of Soviet Jewry. Fearful that a drive to fund memory of the past could be at the expense of endangered Jews in the present, the memorial committee suspended further work on the New York monument.[6]

San Francisco: When Contemporary Art Goes Public

The city of San Francisco has long prided itself on its architectural and natural landscape, and the often spectacular blend of the two. So when Mayor Dianne Feinstein's Holocaust Memorial Committee conceived of its project in 1981, members set their sights high: theirs would be both a memorial and a work of public art great enough to stand on its own. The aim would be to acquire not merely a flame or a stone "but a major work of art for the city."[7] In the words of Henry Hopkins, then representing the San Francisco Museum of Modern Art and a committee member, "the

memorial should serve a dual audience: those who would go to see it because of the subject, i.e., a memorial, and those who would go to see it because it would be a great work of art and thus would learn about the Holocaust and its implications for mankind."[8] There was no way to foresee that such a monument might succeed valiantly in its constituent parts—as memorial and as art—yet divide the community and generate nearly as much controversy as memory.

With its lofty goals in mind, the committee acquired a prime site from the city parks commission in Lincoln Park's Legion of Honor—a shoulder of land set amidst pine and cypress trees overlooking the Pacific Ocean just west of the Golden Gate. Added to this spectacular site, the committee compiled a promising list of prospective memorial artists, including some of the most distinguished sculptors of the century: Henry Moore, Joan Miró, Isamu Noguchi, Louise Nevelson, Max Lieberman, Menashe Kadishman, Robert Graham, Ya'akov Agam, and George Segal. Of those invited to participate, however, only Agam, Kadishman, Graham (with Lawrence Halprin), and Segal submitted designs. The rest either declined (some respectfully, others dismissively) or ignored the invitation altogether.

Deliberations began with Agam's proposal, which was rejected out of hand for being, in the words of one committee member, "too Agam-ish, too kitschy and light-weight." And, while the committee admired Kadishman's 40-foot memorial column, they balked at its prohibitive cost and were sure that the parks commission would never allow such a tower to dominate the Legion of Honor. The short list came down to a conceptually innovative memorial tunnel proposed by Robert Graham, designed with landscape architect Lawrence Halprin, and an installation by George Segal, who had turned reflexively to his hallmark white plaster figures. Although at first intrigued by Halprin and Graham's negative-space concept, committee members feared that, in its secluded location, the memorial tunnel could prove dangerous, inviting both crime and physical accidents.

Still, the committee remained divided between Graham and Halprin's "black hole" and the design by Segal, although by then Segal had grown reluctant. He had long mulled over possible aesthetic responses to the Holocaust, but the loss of nearly all his parents' European family during the war and the prospect of immersing himself in such memory led the artist to resist the committee's repeated requests to consider a design.

Then a painful turn of current events interceded in the memorial committee's behalf. On his return home from mounting an exhibition in Tokyo, Segal agreed to stop over in San Francisco to look at the proposed memorial site. It was early June 1982, and, as far as Segal could tell from

Japanese television, Israel had just invaded Lebanon. Shaken by events and anxious to hear more details on his arrival in the States, the politically dovish artist recoiled from the tone and language invoked by American newscasters to describe the war. "I was horrified for the first time in my life to hear anti-Semitic words coming out of American mouths," he related afterward. "In that instant, I decided to do the [Holocaust] piece. . . . It seemed precisely the wrong moment for me to abandon my support for the state of Israel and my fellow Jews, despite my objections to Begin and Sharon."[9]

Barely three months later, the committee received photographs of Segal's completed memorial environment: a tableau of eleven cast-white figures behind a barbed-wire fence, one standing, the others sprawled in a heap. The artist had placed one tattered, plaster-white figure (an Israeli survivor as his model) behind a barbed-wire fence, his left hand resting on the wire as he looks out. Behind him, plaster-white bodies lay splayed in a pile, rife with both biblical and formal allusions: a woman with her head against a man's rib, a partly eaten apple in her hand; a father fallen near his son, both sacrificed; a man with outstretched arms, seemingly crucified. Radiating outward, the pile of corpses formed a rough star from one angle, a cross from another. On visiting the artist's New Jersey studio, committee members found that the work seemed to fit in with their original conception: it would be both high, cutting-edge art and an explicitly defined space for Holocaust memory. The committee agreed unanimously that it had found its design and returned to San Francisco to raise funds for its installation.

Once the design became known, civic response was swift and predictably fractious. As new committees formed to raise funds, others were called to stop the monument's installation. Whereas survivors hoped for a place they could mourn lost loved ones, a substitute grave site, other groups bewailed the want of similar monuments to mark their losses. Some art historians, such as Peter Selz, scorned what he called the monument's "wax-work representation," while others, such as Selz's Berkeley colleague Brian Wall, applauded both the artist and his aesthetic conception.[10] Because part of the brilliance in Segal's earlier cast-white sculpture had been its formalization of the banal moments in life, other critics felt that his medium was at direct cross-purposes with his Holocaust theme, the least banal of subjects. Did it trivialize memory, they wondered, or expand the breadth of the sculptor's medium? For dissenting critics, the particularization of Segal's life-size figures reduced both the scale of meaning and possibilities for memory in ways that abstraction would not have done.[11]

On arrival today at the turnaround at the Legion of Honor, the visitor is struck by a seeming dissonance between the Holocaust theme and its beautiful setting. During the Jewish Museum dedication in New York, more than a year before the sculpture's installation in San Francisco, the artist addressed this question directly. "That contrast may in itself speak volumes—about the beauty of the world and the dark underside of human nature," he said, adding later that "I intend this work in part as a memorial to all people who have been victims of that dark underside of human nature."[12] The issue may be less one of "agony in paradise" than the particular effect of the setting on the piece itself, which turns out to be considerable.

In fact, Segal has made two memorials, one an indoor sculpture, the other an outdoor monument. The plaster model of *The Holocaust* was first unveiled to the public on 10 April 1983 at the Jewish Museum as a part of Yom Hashoah commemorations there. The museum has since acquired the original plaster models for its permanent display. In their interior setting at the museum, the white plaster casts invite us to contemplate their forms as objets d'art, part of the artist's larger corpus. The lone survivor stands by himself, estranged from the heap of corpses lying behind him and separated from us by the barbed-wire fence. Stooped slightly forward, he stares straight ahead at no one, at nothing. Enclosed overhead and spotlighted, he remains still and mute, encumbered by an interior memory too recent, too painful to articulate. At the memorial's Jewish Museum dedication, Segal reiterated this point. "It is fitting," he said, "that silent art represent the muted voices that were forever stilled in the Holocaust."[13]

The deathly stillness is now made palpable, affirmed and highlighted, in the indoor installation, even as it concentrates our attention on the forms themselves, made ghostly and strange by the white plaster. Without color, with only line and shadow, these forms become emblematic and mythical. Surrounded by nothing but its dark borders, the installation remains all-absorbing: memory is defined as an interior, symbolic process. But in the glory of the California sunshine and spectacular view, memory is externalized, swallowed up by the very vastness of its setting. The human forms in particular, so all-absorbing and thereby monumental in their indoor environment, are miniaturized in such landscape, reduced and made less striking. Indeed, it could be said that we often seek out such beautiful surroundings precisely to lose ourselves in them, places where our thoughts and preoccupations are made to look small and inconsequential by comparison.

In such a context, these figures seem to refer not to their material, or to themselves, or to the ghastly moment of liberation; instead, they are

drawn outside themselves by the landscape, made to be less about themselves than they are part of their surroundings. Whereas in the museum they inspire quietude, stillness, and contemplation, at the Legion of Honor they become part of the great outdoors—the song of birds, rustle of trees, thwack of golfers, roar of cars, make them too much a part of the present moment. Rather than lingering on the installation, the eyes of visitors are apt to join the survivor's own gaze over a spectacular landscape of sloping green grass, a golf course, the ocean, and sailboats—framed by trees on one side and the Golden Gate on the other. Whereas indoors the survivor seemed to be looking inward and asking us to do likewise, by his position in the park he looks out—and invites us to join him, yet another tourist transfixed by the view.

Like many communities before and after it, San Francisco has found that its effort to build a site for shared memory could not help but expose the many conflicting and contested assumptions underlying "public memory." Few communities are prepared for this kind of controversy, and most are embarrassed by it, ashamed that such a seemingly unifying cause as public memory should betray so much real disunity. In the heat of argument, bruised friendships, and fractured political alliances, most communities are ill-prepared to acknowledge the value of the process itself. Largely unfazed by the argument, possibly even invigorated by it, the artist was able to take this long view of the process during a site inspection a year before the monument's dedication. "What's at stake," he commented, "is the quality of the response, in the area of public education. Sculpture functions as a community memory. It's a civilized root to educate young people, to reinforce freedom and tolerance and respect for individuals. I don't mind all the discussion."[14] As Segal seemed to recognize early on, debate is also a form of memory.

Although his medium is not typical of Holocaust memorials in America, the liberation motif in Segal's monument is. This is the single experience shared by both survivors and American soldiers during the war: one that conforms conveniently to America's most powerful self-idealization. For the young American GIs who liberated Dachau and Buchenwald, the Holocaust experience excludes the conditions in Europe before the war, the wrenching breakup of families, deportations to ghettos and camps—even the killing itself. They were witnesses not to the process of destruction but only to its effects. Because the "American experience" of the Holocaust in 1945 was limited essentially to the moments of liberation, it may not be surprising that one of the most widely visited monuments to this era in America— entitled *Liberation*—would be located in Liberty State Park, New Jersey,

George Segal, *The Holocaust*, 1982, Lincoln Park, San Francisco. (Photo: Ira Nowinski)

Nathan Rapoport, *Liberation*, 1985, Liberty State Park, New Jersey. (Photo: Anti-Defamation League, B'nai B'rith)

within sight of America's greatest ideological icon, the Statue of Liberty—all part of a topographical triad including Ellis Island.

In this work by Nathan Rapoport, a young, solemn-looking GI walks forward, his eyes on the ground, cradling—almost like a pietà—a concentration camp victim. With skeletal chest showing through shredded prison garb, his arms spread, and his eyes staring vacantly into the sky, the victim exemplifies helplessness. Commissioned by the state of New Jersey in 1984 and sponsored by a local veterans' association, this monument is consonant with both the specific experiences of Americans in the war and traditional self-perceptions of the nation's role as rescuer in war and sanctuary for the world's "huddled masses." As such, *Liberation* has become an obligatory photographic stop on the campaign trail for national candidates, including George Bush, Dan Quayle, and Jesse Jackson in 1988.

Boston: An American Process

After visiting *Liberation,* a Boston survivor decided to initiate a similar memorial in his city to thank the American soldiers who had liberated him at Buchenwald. But, when he turned to other survivors for support, he found unexpected resistance. "Maybe some were liberated by Americans," a fellow survivor complained, "but my family and I were never liberated at all. They were killed at Auschwitz while American bombers flew overhead, and I barely survived the death marches to Germany." While other survivors sympathized with their friend's motive, they also feared that in *Liberation* a millennium of Jewish civilization in Europe and all the lives lost would be reduced to this one degrading moment they shared with American liberators. Bitter arguments ensued, community support withered, and the project was put on hold.

Yet Boston will soon have its Holocaust memorial. Moreover, the chain of events that followed even suggests itself as an object lesson in American memorial building. For what began as one survivor's thwarted memorial mission eventually grew into a sophisticated and self-reflexive public art project. Still in process, the New England Holocaust memorial provides a uniquely instructive glimpse of the inner workings—the tempestuous social, political, and aesthetic forces—normally hidden by a finished monument's polished, taciturn exterior.

For a short time after "liberation" was rejected as its motif, the Boston memorial project seemed doomed. But in fact, once relieved of its singular theme, the proposal for a Holocaust memorial was revived—and soon took on a second life. With the community's contested memory in mind, the New

England Holocaust Memorial Committee chose to conduct an open competition for a memorial to occupy yet another prime piece of city-ceded land. Located between Faneuil Hall and City Hall, this long strip was both problematic and promising. For years, it had served somewhat as a no-man's-land, a traffic island created accidentally by the city's urban renewal project of the 1960s. With cars whizzing by on both sides, some feared a memorial set there would get lost in the traffic's noise and tumult, hardly the setting for quiet meditation. It was, however, centrally located and right alongside the Freedom Trail, visited by some 16 million tourists a year. No matter what shape the memorial here finally takes, it will be located both spatially and metaphysically in the continuum of American revolutionary history. Almost thirty years after New York City forbade the survivors their place in American history, Boston would now integrate the Holocaust into the very myth of American origins.

In the fall of 1990, announcements in several trade journals proclaimed the opening of an international competition for the New England Holocaust Memorial. More than 1,000 potential designers registered for the competition, of whom 520 finally submitted designs. Entrants hailed from seven countries and included architects, artists, sculptors, and landscape designers. The range of responses was extraordinary: one entrant, a professor of art and design from North Carolina, had made this a semester-long class project, studying in detail the event, public art, and memorial design before submitting a meticulously researched team design. Others included teams of artists and architects from New York City, the principals from prestigious architecture firms, young, old, trained, and amateur. In several other cases, the entrants underwent profound personal and spiritual changes. Many wrote to say that the experience itself had brought a new depth to their work, a greater appreciation of their medium's limitations. Were the monument itself never built, the committee might still console itself for having generated this kind of massive memory work on the part of 520 souls.

In the end, a jury of acclaimed architects, curators, critics, and cultural historians chose seven finalists. Of the conceptual monuments not selected, perhaps the most original was New York architect Hali Jane Weiss's echo chamber. Based on the premise that some subjects simply elude the systems of knowledge and logic practiced by writers and architects, "this memorial design," wrote Weiss, "recedes from form so that the ineffable can enter in its own way. Conceptually, it juxtaposes fact and mystery, loss and regeneration, technology and nature, the ordinary and the sacred."[15] In fact, the execution would have been as profoundly subtle as its concept was ambi-

tious: a blend of sound and sense, visitor presence and victim absence. This design would have left the park's trees and lawns largely untouched, only the ground plane changed.

Using about one-third of the park space, a large, dark rectangle would be set flush in the earth, embedded with thirty-six small flames encased in thick, clear glass, randomly spaced throughout the area. Visitors' footfalls would reverberate loudly, with every step, punctuating their movement over the surface of the memorial. Like an enormous drum, the surface would, in Weiss's words, "echo from the wound of people walking across it. The low-tuned reverberations in the sound chamber resonate in the non-verbal chamber of our being. The steel confronts our internal voids and the slate, grass and light begin to fill them." Visitors would attract undue attention to themselves, each step a slow drumbeat to accompany their funereal procession.

Although its conceptual ingenuity made it a favorite with several of the more academic art and architectural historians, the "echo chamber" was not chosen partly because of its very subtlety. In the end, the jury selected the most audacious memorial design, by the most prominent architect of the final seven. The design, by San Francisco architect Stanley Saitowitz, along with Ulysses Kim, Tom Gardner, and John Bass, calls for six 65-foot-high armor-strength glass towers, set in a row, each illuminated from below by a black granite pit filled with electrically heated volcanic rocks. Visitors will be able to walk on a path leading through the bases of these towers, over the iron grates covering gleaming pits of light, beneath the hollow chambers of glass pillars. From a distance at night, the towers will cast a bright glow, illuminating the sky above and the faces of buildings nearby. Their glow can be expected to attract curious passersby in other parts of the city the way old-fashioned spotlights once did. It will be unavoidable, filling the empty park with light and life, pits of fire and pillars of ice.

From the beginning, Saitowitz and his colleagues envisioned the memorial as a process that included an almost ritualistic preparation of the site. Construction would, in the original plan, begin on Holocaust Remembrance Day with the "brutal cutting of all the trees on half the site." The remaining stumps would recall both the lives of Jews interrupted by death (as did the iconography of broken trees in Polish Jewish tombstones) and the destruction of life that usually precedes its memorialization—a truism for all memorial markers. We would be reminded that destruction is part of memory construction here.

Jurors were struck by both the experiential and the symbolic potential in this design. They felt that the scale of the towers and their material would

mediate between soaring steel and glass skyscrapers on one side and the older, colonial brick architecture of Faneuil Hall on the other, between new Boston on the west and old Boston on the east. The jurors were also moved by its abstractly symbolic references to Jewish culture, the ways its universal forms and light would include, rather than exclude, other groups. By suggesting a number of possible references—including a menorah, a colonnade, candles—the six pillars would not insist on any single meaning. By remaining open in significance, the space's forms would sustain their liveliness in the minds of both the present and later generations.

As I write, the memorial-building project in Boston proceeds apace. It may be years before funding is completed, years more before the Boston Redevelopment Authority approves a final version. Between now and the publication of this book, debate will persist, some of it angry, some restrained: do we etch the numbers in the glass, or not? And what about the trees? How do we guard the memorial from vandals? There will be further fund-raising glitches and dinners, lectures and controversies. Some of its supporters will abandon the project, while its former detractors join in building. By the time they're built, the glass towers may well be half their proposed height, may not even be lighted except on commemorative days. Many of the controversies will be charted in the memorial's evolving forms, others forgotten or ignored by it. Each of its changes will function to chart the process itself, the ebb and flow of public sentiment and will. These, too, will become part of the memorial's performance. To the extent that it continues to evolve and show the twists and turns of public needs and concerns, the New England Holocaust Memorial will remain memory forever in process.

Notes

1. For a much fuller account of the profound and complex ways public art in Germany addresses that nation's historical past, see James E. Young, "The Counter-Monument: Memory against Itself in Germany Today," *Critical Inquiry* 18 (Winter 1992), pp. 267–97. This article, as well as the present essay, is drawn from the author's study *The Texture of Memory: Holocaust Memorials and Meaning in Europe, Israel, and America* (New Haven and London: Yale University Press, 1992).

2. For more on the political dimension of memorials, see Michael Berenbaum, "On the Politics of Public Commemoration of the Holocaust," *Shoah* (Fall–Winter 1981–82), p. 9. Also see Berenbaum's recent collection of essays, *After Tragedy and Triumph: Modern Jewish Thought and the American Experience* (Oxford and New York: Oxford University Press, 1991), pp. 3–16. For further details on the contro-

versy surrounding the establishment of the U.S. Holocaust Memorial Commission, see Judith Miller, *One by One by One: Facing the Holocaust* (New York and London: Simon & Schuster, 1990), pp. 255–66.

3. See James E. Young, "The Biography of a Memorial Icon: Nathan Rapoport's Warsaw Ghetto Monument," *Representations* 26 (Spring 1989), pp. 69–106.

4. See Peter Burger, *The Theory of the Avant Garde*, trans. Michael Shaw (Minneapolis: University of Minnesota Press, 1984). Burger defines the "functional analysis of art" as an examination of the artwork's "social effect (function), which is the result of the coming together of stimuli emanating from within the work itself and a sociologically definable public" (p. 87).

5. Quoted in "City Rejects Park Memorials to Slain Jews," *New York Times,* 11 February 1965, p. 1; and in "2 Jewish Monuments Barred from Park," *New York World Telegram and Sun,* 10 February 1965, p. 1.

6. From a letter dated May 1974 to friends and colleagues, signed by the executive committee of the Memorial to the Six Million Jewish Martyrs, Inc.

7. Quoted by Thomas Albright, "The Holocaust Memorial: A Critical View of the Concept for S.F. Sculpture," *San Francisco Chronicle,* 16 April 1983, p. 36.

8. From "Statement of Purpose," Mayor Dianne Feinstein's Committee for a Memorial to the Six Million Victims of the Holocaust, p. 2.

9. From Michael Brenson, "Why Segal Is Doing Holocaust Memorial," *New York Times,* 8 April 1983, p. C-16; and Matthew Baigell, "Segal's Holocaust Memorial," *Art in America,* Summer 1983, p. 136.

10. See "Editor's Mailbox," *San Francisco Examiner,* 11 August 1983.

11. See, in particular, Albright, "The Holocaust Memorial"; and Allan Temko, "The Virtues and Flaws of the Segal Sculpture," *San Francisco Chronicle,* 8 November 1984.

12. From William Wilson, " 'The Holocaust' Unveiled in San Francisco," *Los Angeles Times,* 9 November 1984, p. 13.

13. Douglas C. McGill, "A Muted Dedication for 'Holocaust,' " *New York Times,* 4 January 1986.

14. See Beth Coffelt, " 'The Holocaust' and the Art of War," *San Francisco Sunday Examiner & Chronicle* Magazine, 23 October 1983, p. 12.

15. This and other statements from the Boston competition are drawn from documents provided the author by the New England Holocaust Memorial Committee.

5

The Vietnam Veterans Memorial and the Washington Mall

Philosophical Thoughts on Political Iconography

CHARLES L. GRISWOLD

My reflections on the Vietnam Veterans Memorial (VVM) were provoked some time ago in a quite natural way, by a visit to the Memorial itself. I happened upon it almost by accident, a fact that is due at least in part to the design of the Memorial itself. I found myself reduced to awed silence, and I resolved to attend the dedication ceremony on 13 November 1982. It was an extraordinary event, without question the most moving public ceremony I have ever attended. But my own experience of the Memorial on that and other occasions is far from unique. It is almost commonplace among the many visitors to the VVM—now the most visited of all the memorials in Washington—a fact so striking as to have compelled journalists, art historians, and architects to write countless articles about the monument. And although philosophers traditionally have had little to say about architecture in general or about that of memorials in particular, there is much in the VVM and its iconography worthy of philosophical reflection. Self-knowledge includes, I hazard to say, knowledge of ourselves as members of the larger social and political context, and so includes knowledge of that context.

Architecture need not memorialize or symbolize anything; or it may symbolize, but not in a memorializing way, let alone in a way that is tied to a *nation's* history. The structures on the Washington Mall belong to a particular species of recollective architecture, a species whose symbolic and normative content is prominent. After all, war memorials by their very nature recall struggles to the death over values. Still further, the architecture by which a people memorializes itself is a species of pedagogy. It therefore seeks to instruct posterity about the past and, in so doing, necessarily

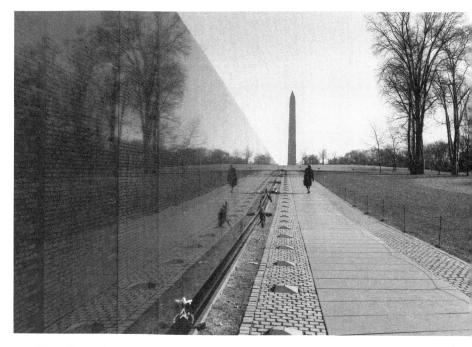

Maya Lin, *Vietnam Veterans Memorial,* 1981, detail, east wall, The Mall, Washington, DC. (Photo: Stephen S. Griswold)

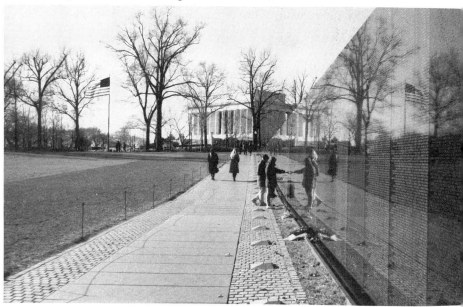

Maya Lin, *Vietnam Veterans Memorial,* 1981, detail, west wall, The Mall, Washington, DC. (Photo: Stephen S. Griswold)

reaches a decision about what is worth recovering. It would thus be a mistake to try to view such memorials merely "aesthetically," in abstraction from all judgments about the noble and the base. To reflect philosophically on specific monuments, as I propose to do here, necessarily requires something more than a simply technical discussion of the theory of architecture or of the history of a given species of architecture. We must also understand the monument's symbolism, social context, and the effects its architecture works on those who participate in it. That is, we must understand the political iconography which shapes and is shaped by the public structure in question. To do less than this—if I may state a complex argument in hopelessly few words—is to fall short of the demands of true objectivity, of an understanding of the whole which the object is. To understand the meaning of the VVM requires that we understand, among other things, what the memorial means *to* those who visit it. This is why my observations about the dedication of the VVM and about the Memorial's continuing power over people play an important role in this essay.

The VVM has been extremely controversial, though no more so than many other monuments in the same area (the Washington Monument being a case in point).[1] In spite of the controversy, no major memorial on the Washington Mall has been built in so short a time from the moment fund-raising began to the moment the last stone was in place—about three-and-a-half years for the VVM. I have no intention of arguing here for or against the war the VVM memorializes. But it is not possible to discuss the Memorial satisfactorily without understanding why it has stirred such discussion. The heart of the debate concerns the question of whether war memorials should take a stand for or against the cause over which the given war was waged—that is, it concerns the extent to which memorials should unite war and politics. None of the structures on the Mall can claim to unite war and politics as the Alamo and Gettysburg do, for no blood was actually spilt here in pitiless battle. The Mall's land is not sanctified in that sense, nor indeed in the sense definitive of the monumental Arlington National Cemetery, which is connected to the Mall by the Arlington Memorial Bridge. No one is buried on the Mall itself.[2] The Mall's memorials connect (and occasionally separate) war and politics on a purely symbolic level and in a fascinating variety of ways. The VVM's stand on this issue is, as we shall see, singular and subtle.

I think it fruitful to approach the VVM in a somewhat roundabout way. I shall begin in section 1 with some general remarks about the Mall, of which the VVM is a part, and then in section 2 I will discuss several monuments in the immediate vicinity of the VVM. Two reasons recommend

this approach. First, the geometry of the VVM clearly connects that memorial with two of the monuments on the Mall, those dedicated to Lincoln and Washington. Its presence in the Mall's Constitution Gardens in itself warns us against considering it in complete isolation from its context. Second, in order to understand just how radically different this memorial is, it is helpful to consider exactly what it is *not,* and this is effectively accomplished by contrasting it with the other memorials near it. With this preparation, I turn in section 3 to a consideration of the VVM itself, the heart of my reflections.

1

If we take the White House, Capitol, and the monuments to Lincoln and Jefferson as our reference points, the area thus defined is quadrilateral in shape or, more precisely, trapezoidal. At the west end of the area sits the Lincoln Memorial, and opposite it at the east end the Capitol. Bisecting the area vertically, we have the White House to the north and the Jefferson Memorial to the south. For the sake of convenience I shall extend the usual nomenclature and shall refer to this whole area as the "Mall." For all practical purposes, the center of the Mall is marked by the towering Washington Monument. The other four structures, marking the far reaches of the trapezoid both laterally and vertically, are like planets in orbit around this obelisk. All of this gives the Mall a formal unity. But the area derives its substantive unity not so much from its geometrical properties as from its purpose, memorializing. The Mall is *the* place where the nation conserves its past in this particular way, simultaneously recollecting it (albeit rather selectively), honoring it, and practicing it (in the White House and Capitol). The presence of the many museums along the Mall emphasizes this fact; they adorn this monumental precinct with America's scientific and artistic heritage. The arts and sciences thus come into close proximity with the seat of government, as if to self-consciously proclaim their mutual influence. We are to infer that the history of American power is that of a cultured and progressive people.

On the Mall, then, matter is put to rhetorical use. It is made to educate and edify the citizens of the present as well as form those of the future by persuading them to live out the virtues of the past. It is memory in stone, earth, and water, a patrimony articulated by measured expanses and the interplay of symmetrically arranged symbols. The word "monument" derives from the Latin *monere,* which means not just "to remind" but also "to admonish," "warn," "advise," "instruct." It follows that the Mall says a great deal, in what it portrays and in what it omits to portray, about how

Americans wish to think of themselves. In still another formulation: the Mall is a sort of political mandala expressing our communal aspirations toward wholeness.

The Mall in its present shape is a fairly recent creation.[3] The ability of a group to think of itself as a nation depends on a consensus existing among its citizens about what it means to be a unified whole. This consensus emerged only gradually in American history. The debate about how the united states ought to be united is coeval, of course, with the American Founding. The meaning of *E Pluribus Unum* (a phrase engraved on the spherical pedestal supporting the statue *Freedom* that caps the dome of the Capitol) has been hotly contested in the history of American political thought. The existence and character of the Mall demonstrate that the Federalists have very much won the battle. The fact that the Mall grew, so to speak, over a long stretch of time is not inconsistent with the following crucial point: Regardless of the intentions of the designers of the Mall and its monuments at various historical moments, the area possesses an extraordinary cohesiveness from the standpoint of its symbolism. It is as though an invisible hand has guided the many changes effected on the Mall, a communal logic imperceptible as a whole at any given time. The intricate ecology of symbolism that articulates the Mall's "substantive unity," as I called it earlier, is not contradicted by the fact that no one consciously designed the Mall with the totality of that symbolism in mind. The Mall provides us with a striking example of a whole that is, in good measure, self-organizing.[4]

Of course the city of Washington did not grow without *any* unified design. The land for the original ten-mile-square district, which George Washington did much to select, was authorized by Congress in 1790; the basic outlines of the city were set out in 1791 by Pierre-Charles L'Enfant, whom Washington chose for this task. The federal government moved to Washington from Philadelphia in 1800. The city has a rather Parisian scale to it or, more accurately, it possesses a distinctly Roman, and thus imperial, sense. The broad avenues up which the country's newly elected leader now travels like an emperor returning from a victorious war, the centrality of the obelisk (recall the many obelisks in Rome), the pervasiveness of the symbol of the eagle (even if it represents, in our case, a particular species of American eagle), the fasces on the front of the Lincoln Memorial (as well as on Lincoln's chair in the Memorial), a separate and palatial dwelling for the chief executive, as well as the physical separation of the Capitol into Senators' and Congressmen's wings (the "Senate" being of Roman origin)— all of these are reminders of Rome. Even the term "Capitol" derives from

the Latin word *(Capitolium)* that referred to the temple of Jupiter in ancient Rome. Indeed, the domes of the Capitol, the Jefferson Memorial, the National Gallery of Art and National Museum of Natural History (both located on the Mall's Constitution Avenue), as well as the prominent rotunda in each, derive from the Pantheon.[5] And instead of the Colosseum down the street from the seat of government, Washington has its similarly placed Robert F. Kennedy Memorial Stadium.

In L'Enfant's design, the Capitol is close to the geographic center of the District of Columbia. The main avenues of the city meet at the Capitol, like spokes of a wheel at the hub. The Capitol, as the home of Congress, embodies the basic tenet of democracy, that the people ought to govern themselves. Thus the symbolic center of the district, and so of the nation, is the rule of the people. The foundation for this view is, in the tradition at the heart of American political theory, the doctrine of individual rights, that is, freedoms; and from this derives the doctrine that rule over the people is legitimized only by the voluntary consent of individuals. Correspondingly, the dome of the Capitol is capped by the huge statue (erected in 1863 during the Civil War) symbolizing freedom.[6] It is worth noting that this statue, as well as the Capitol, faces to the east. Traditionally, most great temples have faced the east, toward the rising sun, the source of dawn, light, renewal, hope, resurrection. In this way the sun illuminated the statue of the god within pagan temples. The Lincoln Memorial too faces east; as in the case of the Capitol, the directionality suggests hope for the "unity from out of many" that is life (as opposed to the dissolution that is death). I shall have more to say later about the directionality of the various memorials on the Mall.

But the center of the district, in another sense, is not the Capitol but the monument erected for the country's "father" and the district's eponym. The Washington Monument, as the center of the Mall, is in its own way also the symbolic center of Washington's city and so of the nation he did so much to found. It is not fanciful to detect, then, a certain tension between the center of the Mall and one of the "planets" at the east end of the trapezoid, a planet that nevertheless competes with its sun for the title of "center of the city." There is a tension, that is, between the founder and the system he founded, the rule of one man and the rule of the people, the president and the Congress. Certainly the Washington Monument—an obelisk much taller than the obelisks of antiquity—is the visual center of the city; it can be seen from virtually every vantage point, particularly since local regulations severely limit the height of structures in the city. Since one can ascend to its peak, the Washington Monument is also a sort of observa-

tion tower from which everything in the city can be seen. In both of these ways the Monument is the center of things. Nevertheless, the Capitol usually serves as the city's signature, as it were; it is the localizing logo on everything from city billboards to commercial enterprises to local news programs. But the tension between these symbols is lessened by several peculiarities of the Washington Monument itself which I would now like to discuss in detail. The importance of the Washington Monument for my purposes is intensified by the fact that it is one of the two monuments to which the VVM points. In keeping with my roundabout approach to the VVM, however, I shall also comment in the next section on several other relevant monuments and memorials.

2

The selection of the design for the Washington Memorial was hotly debated for quite some time. After all, just how should the nation's first commander-in-chief and president—in a real sense, its Founder—be remembered? The answer amounts to a philosophical position on the matter. Take, for example, the famous nonequestrian statue of Washington, now exiled to the Smithsonian's National Museum of American History—Horatio Greenough's 1840 rendition in the style of Antonio Canova's 1822 statue which was destroyed in a fire—in which Washington is portrayed bare-chested in a toga and sandals. This statue is an almost embarrassing allusion to Zeus, as well as to Washington's apotheosis after the manner of Roman emperors.[7] In any event, the original design of the Washington Monument called for a fantastically ornate base, and the 1879 redesign for an exterior so elaborate that the Monument would have been unrecognizable as an obelisk. Lack of funds prevented anything more than the bare obelisk from being erected. The absence of any vegetation around it emphasizes the simplicity of the Monument. It rises directly from the barely covered mound of earth.

Although the Washington Monument is a memorial to a man, there is no trace of him in the Monument. He is completely sublated in the symbol representing him. Hence it is different in kind from the Mall's other memorials to men. The Washington Monument is iconic only in a rather abstract sense, and in representing Washington it is not a means for a further symbol. By contrast, the Lincoln and Jefferson Memorials are, as it were, houses for the statues residing within, and to that extent each is a means to a further end. The symbolism they possess independently of their function as beautiful houses is limited; they are not in themselves icons. In any event, no statue resides in the obelisk; hence the connection between it and

Washington himself is not especially obvious.[8] The obelisk represents a ray of the sun, and the sun-god is the source of life, warmth, light. The obelisk is a heliocentric monument. Thus, as I have already noted, the other monuments may be said to rotate around the Washington Monument like planets in its orbit. The VVM, by contrast, is a chthonic memorial. As a ray from the sun the obelisk both reaches upward to the sun and connects the sun with the earth. Washington is thus the enlightener, transmitter of life to humanity, a brilliant beam in an otherwise dark world. Looking at the monument one's eye is naturally drawn upward toward the bright divine orb of which the divine man is a part. The obelisk connotes immortality, which is an imitation of the eternity of the heavens. We cannot ignore, moreover, the blatantly phallic nature of this monument, a characteristic which heightens the contrast between it and the Capitol. The latter's dome is of an obviously female nature. The male/female contrast is to be found in other cities as well (for example, consider the contrast between the obelisk and dome in St. Peter's Square in Rome). Washington was a man of action rather than words; the Capitol is the home of endless talk, a trait traditionally, albeit tendentiously, associated with womanliness.

Obelisks originated in a civilization reputed even among the ancients to be very old, namely that of Egypt. The founder of the New World republic is thus tied to the very origins of political life, a seeming paradox repeated elsewhere on the Mall: the American Revolution is conceived of as a turn backward as well as a turn forward, a return to origins as well as to the new. Of course, the intention was always to memorialize Washington in the way that would make the city named after him resemble the great capitals of Europe. No great city would be complete without its obelisk, as the treasures conveyed to Paris following Napoleon's looting of Egypt served to remind everyone. Thus the Washington Monument also expresses the belief that America is equal in its greatness to the old European nations. The American Founders, then, are not meant to be *radical* innovators. The architecturally represented origins of political life in the case of the Washington, Jefferson, and Lincoln memorials are, I add, all pagan.

Further, the Washington Monument has a characteristic that no other on the Mall possesses: it looks exactly the same from all angles. Correspondingly, it is not oriented toward any of the four points on the compass. For this reason as well the Washington Monument is divinely indifferent to the perspective of the beholder, like the unshadowed light itself. This indifference is emphasized by the fact that there is no writing on its sides, and so no sequence in which the eye must "read" the obelisk.[9] The Washington Monument can be seen as a whole all at once, from any side. Lincoln and

Jefferson, by contrast, are surrounded by their own words, and their memorials have a front and back. The Washington Monument does not carve out a space particular to itself, a space into which the beholder is drawn and thus disconnected from the surroundings. It is not an absorbing monument in the way the VVM is. This helps to explain why, although people look and refer to this monument, they rarely sit and contemplate it and infrequently celebrate or demonstrate at its base. None of this contradicts the fact that the Washington Monument also serves as the center of the Mall, if not of the city. It is a space-defining, orienting structure even as (or perhaps because) it is indifferent to this or that perspective.

The other memorial to which the VVM points is dedicated to Lincoln. The architecture of this monument is (except for the flat roof and the plan) mostly Greek. The monument itself serves in good part as a home for the statue that dwells within; its meaning thus conveys the classical pattern of a hero whose deeds have won him immortality and divinization. The singularly appropriate inscription behind Lincoln's statue reads "IN THIS TEMPLE AS IN THE HEARTS OF THE PEOPLE FOR WHOM HE SAVED THE UNION THE MEMORY OF ABRAHAM LINCOLN IS ENSHRINED FOREVER." Like Athena in the Parthenon on the Acropolis, Lincoln the savior and healer lives in his temple, a god awaiting offerings. Perhaps the two urns outside the temple are meant to contain eternal flames symbolizing the god's presence in his home. To reach the icon of Lincoln one must ascend a considerable number of (oversize) steps, as is appropriate when one approaches a hero-god. Similarly, the statue to Jefferson occupies the heights at the summit of a series of steps. To get to the heart of the VVM, by contrast, one must descend, not ascend. The Doric columns of the Lincoln Memorial are tilted slightly inward, a fact that enhances one's impression of the building's monumental elevation. Inside, Lincoln is seated—almost wearily, it seems to me—like Zeus high on his throne, looking down on his relatively puny visitor. The visitor's sight, however, is drawn up no higher than the level Lincoln occupies, unless it be to read the inscription behind and slightly above him. In a Gothic cathedral, by contrast, the upward emphasis continues as far as the eye can see. Here, as at the Jefferson Memorial, the visitor's focus on the graven image of the hero-god contributes to the predominantly pagan effect of the monument, though there are also nonpagan overtones.

The air of dignified mourning conveyed even by the choice of vegetation surrounding the temple—cypresses are by tradition funereal trees— reminds us that Lincoln's mortal life was ended by assassination. The interior of the monument is open only from one side; hence there is a

somber darkness inside. The adversity faced by Lincoln is evident not only from the quotations on the wall inside his temple (the Gettysburg Address and his Second Inaugural Address) but from Lincoln's face. It is the face of a just and compassionate judge who has seen much bitterness, a face hardened by war and difficult choices—and in particular by a war between brothers, the sort that is always full of the greatest hate. Lincoln's face is etched with the lessons taught by destructive war; it is thus quite unlike that of Jefferson's statue.

Lincoln's temple also expresses the hope for the rebirth of peace among brothers which union would bring. Thus it is worth emphasizing that Lincoln faces east, as did the statues of the gods in their temples. At the same time, the bitter context from which Lincoln emerged is symbolized by the fact that his temple resides at the west end of the Mall. The sun sets in the west; it is the place where light is extinguished, where souls are taken upon dying. The sunset represents, furthermore, the struggle between light and darkness, good and evil.[10] This struggle provides the context for Lincoln's apotheosis; hence it is appropriate that he be the western god who looks east. As though looking back on this struggle, Lincoln gazes out of his temple and across the Mall into the impassive face of General Grant.

Lincoln's temple is, then, a monument to national unity achieved by the martyrdom of Lincoln himself. The overtones of Christ's dying for the sins of man are unavoidable. Indeed, the principles praised by Lincoln, above all that of universal equality, are not Greek but Christian. The Lincoln Memorial, precisely because of its somberness and its emphasis on sacrifice as well as on the healing of dissolution, differs radically from the monuments on the Mall to two of the nation's Founders, Washington and Jefferson. Washington and Jefferson are not healers so much as life-givers. By the time of Lincoln the age of the Founders was over; their optimism had been severely tested by the worst sort of internal conflict; costly reinstitution of the Founding had become necessary. The Washington and Jefferson monuments represent the opening chapter in our history; the Lincoln monument perhaps a middle chapter; and the Vietnam Veterans Memorial graphically represents a very recent chapter of our past in a way that points to, indeed cites, the two earlier ones. The great moral message of the Lincoln Memorial—which is subdued in, if not lacking from, the Washington and Jefferson monuments—makes it the natural place for people to proclaim and demonstrate their views. To be precise, it is not the interior of this monument that is suited for the gathering of the people (and in this it again differs from the Gothic cathedral) but its steps on the exterior.

Before passing on to the Jefferson Memorial, I note that the Arlington

Memorial Bridge (dedicated in 1932) extends from the Lincoln Memorial southwest across the Potomac to General Lee's house. Thus it symbolizes Lincoln's effort to save the union by reuniting North and South. Lincoln, not Lee, is memorialized on the Mall, showing which of them prevailed in their conflict (in the District of Columbia as a whole, twenty-five statues remember Union officers but only two memorialize Confederate officers).[11] That Lincoln should, as it were, extend a bridge to his former enemy shows his "malice toward none" and "charity for all."

The Jefferson Memorial is the most delicate of the memorials on the Mall. Its graceful architecture speaks not of war but of reason, not of mourning but of life. To be sure, the circular design traditionally connoted, among other things, a tomb; the Jefferson Memorial has antecedents in Rome's Mausoleum of Augustus, that of Hadrian, and the so-called Temple of Vesta by the Tiber. Still earlier antecedents are the Greek *tholoi.*[12] Unlike the Lincoln Memorial, if the Jefferson Memorial suggests death, it does so in so delicate and allusive a way as to virtually dissolve any sense of loss the observer might otherwise feel. The music of the Memorial's proportions is pleasing to the eye and the mind. Again, the design is Roman; the dome resembles that of the Roman Pantheon, a building Jefferson admired very much (though the Memorial lacks the oculus, or round "eye," which opens the structure to the sky). The dome of the Pantheon symbolized the vault of the heavens. In this New World pantheon symbolized by the Jefferson Memorial, the gods are reason, the rights of man, and the freedom of the individual from political and religious tyranny.[13] I add that both the Lincoln and Jefferson Memorials have a front and a back; hence neither is indifferent to perspective in the way that the Washington Monument is.

The contributions that Jefferson wished to have written on his epitaph were the authorship of the Declaration of Independence, the founding of the University of Virginia, and the Virginia Statute of Religious Freedom— Jefferson did not mention his two terms as president. The statue of Jefferson in the Memorial holds a scroll on which the Declaration is written. The Jefferson Memorial is clearly a hero-cult monument, but the demigod within is a cultural or intellectual hero, rather than a military or executive hero. Jefferson did not serve in the field of battle or command troops in a war, as Washington and Lincoln did. In this regard the memorial to Jefferson has something in common with another presidential memorial, the Kennedy Center (the city's cultural center). The statue of Jefferson is standing; unlike Lincoln, he has not been tired by the trials of civil war. The eyes look straight ahead (unlike those of Lincoln) with confidence, and one foot is

slightly forward. The general impression given is that of gentle aggressiveness, purposive but controlled movement forward.

The dignity of civic virtue and intelligence—in short, the dignity of man as distinguished from the beasts—is clearly evident in this statue. Man can stand on his own two feet, guided by principles self-evident to reason and supported by the inherent orderliness of the natural world in which he exists. The light penetrates inside the Memorial from all sides, in contrast to the Lincoln Memorial. The rays of the sun symbolized by the obelisk are permitted to enter everywhere; Jefferson is open to the outside world and stays in touch with it. In this the Memorial is quite unlike the inside of a cathedral in which even the light is altered by stained glass windows, an invitation to forget the outside world so as to better remember incorporeal spirit within.[14] The Jefferson Memorial is not a temple.[15]

Jefferson wears a smile which resembles that of Mona Lisa—not the sort of expression a sunlike god or martyred savior would wear, but not a merely human grin either.[16] He is not smiling at any particular thing; rather, it is an expression that might accompany the activity of reflection and perhaps of listening. It is an almost philosophical smile. Correspondingly, Jefferson's statue faces north. The north is the region of darkness, a place of depth, mystery, questions, and all things interior. It represents the direction toward which the mind of the philosophical Jefferson would naturally be drawn. At the same time, Jefferson's belief that the mind can enlighten itself is reflected in the location of his memorial on the southern edge of the Mall. The south is the place of the sun, illumination, warmth, *physis*, the visible look (*eidos*, idea), the intelligible shape of things.

At Jefferson's feet are the capitals of two columns, one decorated with corn—the symbol of the New World—the other with the traditional design of Corinthian capitals. The vegetation outside includes the famous cherry trees, row after row of them—beautiful symbols of spring, of rebirth and natural order. This memorial is not a shrine in the sense that the Lincoln Memorial is, and it does not convey a clear moral principle as Lincoln's does. It is inspiring, but not moving in the way that Lincoln's memorial is. It recalls abstract principles and arguments rather than bitter deeds or exhausting foundings. Perhaps this is the reason that the VVM does not point to it. It is as though the VVM asks whether America's involvement in Vietnam was true to Lincoln's justice and healing as well as to Washington's founding intentions, struggles against foreign tyrants, and military genius, rather than whether it was true to Jefferson's thoughts about higher education and the freedom of religion.

* * *

With the basic symbolism of the Mall in mind, we can prepare ourselves further for the VVM by looking very briefly at several war memorials in its immediate vicinity, beginning with those that are most unlike it and progressing to those more akin to it. The most obviously unlike the VVM is the Marine Corps Memorial, dedicated in 1954 and popularly called the Iwo Jima Memorial. It is a classic war memorial. The soldiers strain every muscle toward one end only, the raising of the flag. The monument shouts this imperative: Honor your country, act as nobly as these men have. It is modeled on a photograph of an event that occurred on 23 February 1945. The inscription on the side reads "IN HONOR AND MEMORY OF THE MEN OF THE UNITED STATES MARINE CORPS WHO HAVE GIVEN THEIR LIVES TO THEIR COUNTRY SINCE 10 NOVEMBER 1775." Vietnam too is listed on the monument's side. The focus is not so much on individuals but on one branch of the military—an obvious difference between it and the VVM. I note also that the VVM is explicitly dedicated not just to those who died but to all those who fought. The symbolism of the Marine Corps War Memorial is not abstract, as is that of the Washington Monument; its iconography is literal as well as unambiguous and immediately intelligible. In these respects it is also very unlike the VVM.

The memorial to the Seabees (just across Arlington Memorial Bridge, on the appropriately named Avenue of the Heroes section of Memorial Drive which leads to Arlington National Cemetery) proceeds along the same lines. The Seabees are builders and rebuilders rather than destroyers, as is evident from the panels on the wall behind the statues. This memorial conveys a kind of giving warmth. The Seabee and the boy (who is clearly foreign) almost seem engaged in a gentle dance. The contrast between the boy's vulnerability and the soldier's tremendous strength heightens the goodness to which the soldier's great power has been turned. The Seabee's uncovered chest follows the pattern of what is called heroic nudity. Like the Iwo Jima Memorial, this monument focuses on those who fought in a particular branch of the service. In this sense both monuments are generic.

Across the street from this memorial is another, curiously called The Hiker, erected to commemorate our cause in the Spanish-American War and dedicated in 1965. The no-nonsense woodsman-turned-soldier is quaint to us, but the message is clear. A bronze plaque on the pedestal depicts a woman in supplicant pose before two American servicemen; she evidently represents the countries just "liberated" by them. American servicemen are the force of good.

The memorial to Ulysses S. Grant (dedicated in 1922) is far more ambiguous in its meaning, and so it bears a closer resemblance to the VVM

than do any of the war memorials just discussed. I would not go so far as to call it an antiwar monument; but it certainly neither glorifies war nor is heroic in any way. Grant looks distinctly ghostlike on top of his horse. The horse itself is not in heroic pose. Its tail is between its legs, indicating that the wind is coming from behind and so that it is stationary and not attacking. Grant is watching a battle plainly heard by the horse, a battle which Grant's side may or may not be winning. But there is no emotion on his face. Glory, the statue seems to say, is evanescent. The group of statues on his right depict Union troops on the attack. Here again the accent is not on glory. The sculptor of this monument, Henry Merwin Shrady, went to extremes to ensure complete realism, and in this he succeeded. The tremendous tension and effort of the human figures' forward movement says more about them as men than about the virtues of their cause. In fact, one of them is about to be trampled to death by the horses of his comrades, only one of whom notices the imminent tragedy. To Grant's left is another group of statues, this time artillerymen pulling a caisson through deep mud. It is hard to say whether they are attacking or retreating; the emphasis is on the severe strain of war.

The Grant Memorial as a whole does not convey a moral lesson, and in this it resembles the VVM. One thinks, first, of all the death and dying suffered in war. Perhaps this characteristic of the Grant Memorial is due in part to the nature of the war it portrays. In a fight against one's brothers it is more difficult to feel without ambiguity that one is engaged in a battle between good and evil, a battle in which there can be a clear-cut winner and loser. This is the only memorial on the Mall explicitly showing battle scenes; on the whole the Mall is very unwarlike. Appropriately enough, the Grant Memorial sits on the western front of the Capitol and looks west, out across the Mall, in the direction of the Lincoln Memorial as well as Lee's house and the vast cemetery next to it. Recall that the west represents, via the sunset, the conflict between opposing forces—the battle which Grant, high upon his horse, studies. In the Mall complex the whole great oppositional struggle of war, and particularly of the Civil War, is oriented to the west. The presence of the facing Lincoln and Grant Memorials on the Mall, indeed on the same east–west axis, virtually establishes the Civil War as *the* critical event recollected on the Mall. The VVM too, let us note, sits at the western end of the Mall, and the war it recalls ignited much bitter dispute between Americans—bitterness second only, perhaps, to that which accompanied the Civil War.

The Second Division Memorial (1936) glorifies a division of the army but in a peculiarly symbolic way. The whole syntax of heroic images is

compressed into a flaming sword of justice, held by a hand cut off from its body. This is an architectural version of synecdoche; the flaming sword in the sky stands for divine justice. The abstractness of this memorial distinguishes it from those we have examined but ties it to the VVM. The names of various places the division has fought are inscribed on the walls. The Memorial is dedicated "to our dead," as in the case of the Iwo Jima Memorial.

The most thoroughly symbolic of all Washington's war memorials lies just across the Potomac alongside the George Washington Memorial Parkway. The Navy-Marine Memorial was dedicated in 1934 to those who perished at sea in the service of their country. The seven delicately balanced gulls represent the souls of the dead. The symbolic representation of the disembodied soul as a bird is ancient and possesses a very rich history. There is no literal suggestion whatever in this war memorial as to its theme or purpose, and in this it is most like the VVM.

3

We are finally prepared to consider the Vietnam Veterans Memorial. The VVM initially seems extremely simple in its design, and in this as well as in its not being a means to a further symbol it resembles the obelisk to which it points. Like that obelisk, it is not really beautiful in the way that the Jefferson Memorial is. The VVM basically consists of two walls of polished black granite meeting at a 125-degree, 12-minute angle and tapering off at each end. These tips point like arrowheads to the Washington and Lincoln monuments. The angle is not, then, just any angle. The monument is utterly symmetrical. Its two halves are, when considered in abstraction from the directions they point, identical except in the names inscribed and the dates of death. The wall supports nothing and is not supported by any other structure; there is no internal tension in the design. Since the wall's back is against the earth, the Memorial is in no way indifferent to the position of the beholder.

Most of the other memorials on the Mall are either classical in design or have classical antecedents. It is difficult to find any allusion in the VVM to a historical style except by visual incorporation of the two monuments to which it points. Furthermore, unlike all the other memorials discussed so far, the VVM is invisible from a distance, particularly as one approaches it from the north (the outlines of the Memorial are visible when one reaches the flagpole and statues located between it and the Lincoln Memorial to the southwest). It demands that you enter into its space or miss it altogether.

When approaching the Memorial from the northeast, the first thing one sees is a stand manned by Vietnam veterans soliciting support for the search for servicemen listed as missing in action. Another such stand presently exists on the southwestern approach to the monument. I mention this because it points to a fact which is not physically part of the architecture of this memorial but which is nevertheless revealing of it: it is a living monument in a way that is not true of the others I have discussed. It is almost impossible to visit this monument without encountering Vietnam veterans. And they generally are not just sitting and chatting but are usually involved very emotionally and publicly in the Memorial. I have seen many stand and weep there. The designer of the Memorial wanted it to serve as an occasion for therapeutic catharsis, and in this she has succeeded.[17] One can sit and have lunch at the Jefferson Memorial, fly a kite at the Washington Monument; one can smile at the gentleness of the Seabees' Memorial; children can play on the nearby statue of Einstein;[18] but one cannot treat the VVM with informality or familiarity.

One must, then, come upon the VVM suddenly. It is quite possible to happen upon it almost by accident, as I did. Once there, however, one is led into it gently.[19] One sees a few names whose order is initially not clear; then more names; then many more. There are no steps at this memorial, making it easily accessible to handicapped veterans. One walks down an incline to its heart, which is precisely where the incline is reversed and climbs up again. The centralizing axis of the monument is horizontal (whereas that of the other memorials I have discussed, with the possible exception of the Grant Memorial, is vertical). The slowness of one's exposure to the Memorial is merciful, for initial surprise turns slowly, rather than all at once, to shock as one realizes what one is looking at: the nearly 58,000 names of those Americans who died and are missing in action as a result of this war.

Since one walks down into the embrace of the Memorial, it engulfs the visitor even though the open sky is always overhead and a large wide open space faces the monument. Yet one does not have the experience of descending into a tomb or grave; the VVM does not close the visitor in, not even in the way that the Lincoln Memorial may be said to do so. The walls of the mural-like monument face south—the direction of warmth and life—so as to catch the maximum sunlight. In the descent toward the center of the monument there may be a delicate allusion to the ancient *tholos* tomb (such as the "tomb of Agamemnon" at Mycenae), buried in the earth and approached by an angled, graded passage downward. Yet even if this allusion is present, it is not strong enough to give the VVM a tomblike feeling. I do not deny that the inscription of the names on the polished black granite

closely resembles the gravestones in so many American cemeteries, a resemblance accentuated by the presence of flowers and small flags which visitors to the VVM frequently leave at its base; the VVM is to that extent a sort of national gravestone. But I do wish to emphasize that the VVM is not tomblike or morose, and also that it possesses complex dimensions of meaning not exhibited by any ordinary gravestone. The suddenness of the visitor's entry into the Memorial's space, the demand that one give one's complete attention to it even while remaining in a completely natural setting (without even a roof overhead), the impossibility of avoiding it once there— all these effects would be lost if the Memorial stood on higher ground, in plain view from a distance.

The logical (and chronological) beginning of the monument is neither of the two tips at which one necessarily enters into its space, but rather the point at which the two walls intersect. Thus as one starts at the geographic beginning of the Memorial (either of the two tips), one is actually starting partway through the list of names. The rows of names begin at the intersection of the two walls, on the top of the right-hand wall, and follow each other with merciless continuity, panel by panel, to the eastern tip of that wall, which points to the Washington Monument. The sequence resumes at the western tip, which points to the Lincoln Memorial, and terminates at the bottom of the left-hand wall. Thus the list both ends and begins at the center of the monument. When one has read halfway through the list all the way to the eastern tip, one's eyes are naturally drawn to the Washington Monument. The visitor who continued to read the names in the proper sequence would be forced to turn and walk to the other end of the Memorial and so to see the Lincoln Memorial. One's reading of the VVM, in other words, is interrupted halfway through by the sight of the two other symbols. The monument thus invites one to pause midway and consider the significance of the names in the light of our memories of Washington and Lincoln. Moreover, in reading the names on the Memorial one is necessarily reading from west to east, from the direction of death to that of resurrection and new life. However, one is forced to double back toward the west in order to finish reading the catalog of names. The complexity of the monument's directionality is further illuminated by the following: although the face of the VVM is directed to the south, the Memorial also resembles the tip of an arrow which is pointing north, to the region of the dark and the mysterious. The VVM thus shares with the Jefferson Memorial a probing of reasons and fate, an effort to grasp in thought recalcitrant reality.

I cannot help but mention that the peculiar way in which the VVM begins and ends—with the names of the first and last Americans to die in

Vietnam—reminds us of a rather sad fact about the Vietnam War. That conflict had neither an official start (in sharp contrast, for example, with President Roosevelt's statesmanlike appeal for a declaration of war on Japan) nor an official end (there were no real celebrations, no parades for the returning veterans, just silence). But the disturbing inarticulateness of the Vietnam War, which is in one sense embodied in the organization of the VVM, is in another sense overcome by the VVM's intricate symbolism and, indeed, simply by the existence of the Memorial on the Mall. Its very presence there bespeaks national recognition of and respect for the veterans' service, and to that extent articulates a certain settling of accounts.

The list of names both ends and begins at the center of the monument, suggesting that the monument is both open and closed: open physically, at a very wide angle, like a weak "V" for "victory" (a "V" lying on its side, instead of with its arms pointing upwards); but closed in substance—the war is over. This simultaneous openness and closure becomes all the more interesting when we realize that the VVM iconically represents a book. The pages are covered with writing, and the book is open partway through. The closure just mentioned is the closure not of the book but of a chapter in it. The openness indicates that further chapters have yet to be written, and read. It is important that the back of the monument is to the earth, for the suggestion that the Vietnam War is a chapter in the book of American history, and that further chapters remain in the book, would be lost if the wall were above ground, backed by thin air. The wall lies against the earth, indeed against the hallowed earth at the core of the nation's capital. Our future lies there, in our nation's soil as it were. This is the soil of the Constitution Gardens, of the memorializing Mall, of the spiritual heart of the country. By inviting us to understand the Vietnam War in this context, the VVM accurately reflects the etymological meaning of "monument" I have already mentioned: the VVM asks us not just to remember that war, it admonishes us to write the next chapter thoughtfully and with reflection on the country's values, symbols of which are pointed to by the Memorial itself.

Two short inscriptions on the Memorial tell why these names are being memorialized. Both are written at the point where the two walls meet, one at the apex of the right-hand one, after the date "1959" (in which the first American was killed), and the other on the bottom of the left-hand one, after the date "1975" (when the last American was killed). The first of these inscriptions reads "IN HONOR OF THE MEN AND WOMEN OF THE ARMED FORCES OF THE UNITED STATES WHO SERVED IN THE VIETNAM WAR. THE NAMES OF THOSE WHO GAVE THEIR LIVES AND OF THOSE WHO REMAIN MISSING ARE INSCRIBED IN THE

ORDER THEY WERE TAKEN FROM US." The second reads "OUR NATION HONORS
THE COURAGE, SACRIFICE AND DEVOTION TO DUTY AND COUNTRY OF ITS VIETNAM
VETERANS. THIS MEMORIAL WAS BUILT WITH PRIVATE CONTRIBUTIONS FROM THE
AMERICAN PEOPLE NOVEMBER 11, 1982." I have already noted that the other war
memorials we have looked at honor those who died, not all those who
fought. The point is emphasized even by the monument's title: it is a
memorial to the Vietnam *veterans,* not the Vietnam War. It honors every-
one who fought there without qualification, thus suggesting that they had
not previously been honored by the American people. The Memorial is a
source of pride to Vietnam veterans, and this explains why it is a living
memorial. Clearly the vets view it as *their* memorial, a way of proclaiming
and redeeming the honor of *their* service to the country. It is as though just
having fought in that war deserves praise, as though doing so was above and
beyond the call of duty. Perhaps the war's eventual unpopularity, along with
the ambiguity of its purposes and of the nation's commitment to fulfilling
its stated aims, gives weight to this suggestion.

It should be obvious by now that there is nothing heroic about this
memorial. It suggests honor without glory. The VVM is not inspiring in the
usual way that memorials are. The focus throughout is on individuals, not
on a flag (no flag was included in the original design, and the flagpole added
subsequently in no way violates the VVM's space), or on a sword of divine
justice, or on good deeds rendered to those we died to protect, or anything
else of the sort.[20] Even the appearance of a mechanical and impersonal order
is avoided. Such an order would have arisen if the names were alphabetized
or divided into categories according to the branches of the armed forces (the
monuments to the Second Division, Seabees, and Marines, by contrast,
focus on one of the services). The chronology of this war is marked by the
death of individuals. In this sense it is appropriate that the VVM sits at the
west end of the Mall, given the symbolism of the four directions. And a
visitor searching for a particular name is forced to read a number of other
names, so paying attention once again to individuals.

It is true that the monument speaks first of all, but by no means
exclusively, of loss and pain. As the Memorial's architect pointed out, it is
physically a gash in the earth, a scar only partially healed by the trees and
the grass and the polish.[21] The VVM is not a comforting memorial; it is
perhaps because of this, rather than in spite of it, that it possesses remark-
able therapeutic capacity. When people find on the VVM the name they've
been looking for, they touch, even caress it, remembering. One sees this
ritual repeated over and over. It is often followed by another, the tracing of
the name on a piece of paper. The paper is then carefully folded up and

taken home, and the marks of the dead left in stone thus become treasured signatures for the living.

Usually the names of individuals who die in a war are listed on a monument in their hometown. The VVM makes the loss of these individuals a matter of national concern. This has been one of the main causes for the controversy over the monument. Some persons (such as President Reagan's first Secretary of the Interior, James Watt) insisted that the cause for which these individuals died be praised. As a result of the pressure brought to bear, a realistic statue of three soldiers (two of them white, one black) sculpted by Frederick Hart, and a flagpole, have been added in the area between the VVM and the Lincoln Memorial (the dedication ceremony was held on Veterans Day, 11 November 1984). They are thus at some distance from the VVM and function as a kind of entrance device for those approaching from the southwest or as an exit device for those leaving in the same direction. Neither addition in any way interferes with one's contemplation of the VVM except to the extent that one might catch a reflection of the flagpole in the surface of the Memorial. For all practical purposes, the visitor to the VVM must literally turn his back to these additions.

The soldiers seem to have just emerged from the trees and to be contemplating the names inscribed on the VVM. The look on their faces is not heroic; in this respect they recall the statuary of the Grant Memorial. Since the flagpole is itself some fifty feet in the direction of the Lincoln Memorial from the statue, the two additions do not, so far as I can tell, form a substantive unity. The inscription at the base of the flagpole reads "THIS FLAG REPRESENTS THE SERVICE RENDERED TO OUR COUNTRY BY THE VETERANS OF THE VIETNAM WAR. THE FLAG AFFIRMS THE PRINCIPLES OF FREEDOM FOR WHICH THEY FOUGHT AND THEIR PRIDE IN HAVING SERVED UNDER DIFFICULT CIRCUMSTANCES." Seals of the five armed services (Coast Guard, Army, Marine Corps, Navy, Air Force) also adorn the base. The statue and flagpole add a conventional, representational dimension to the nation's memorializing of the Vietnam veterans. Yet the physical and aesthetic distance between these two additions and the VVM is so great that there exists no tension between them. All three finally just seem to be separate memorials. Their presence on the same plot of land will eventually seem, I think, like faint echoes of the old and bitter debates about the Vietnam War, briefly reignited in the recent discussions about the political iconography suitable to memorializing it.

In any event, by emphasizing the sacrifice so many individuals have made, the VVM surely asks us to think about whether the sacrifice was worthwhile and whether it should be made again. The VVM is, in my

opinion, fundamentally interrogative; it does *not* take a position as to the answers. It implies some terrible questions: Did these individuals die in vain? Was their death in keeping with our nation's best traditions as symbolized by the nearby monuments? For what and when should Americans die in war? That the person contemplating the monument is implicated in these questions is also emphasized by another crucial aspect of this memorial, namely that the polished black granite functions as a mirror. This fact gives added depth to the monument and mitigates any sense of its being a tomb. In looking at the names one cannot help seeing oneself looking at them. On a bright day one also sees the reflections of the Washington or Lincoln Memorials along with one's own reflection. The dead and living thus meet, and the living are forced to ask whether those names should be on that wall, and whether others should die in similar causes. You are forced to wonder where you were then and what role you played in the war. Nineteen sixty-nine, perhaps one of your college years: as you studied books, these people were dying one after the other.

The VVM compels us to contemplate difficult questions with a clear awareness of the inevitable cost in human life. The Memorial does not claim that life is the most precious of all things, but it does force us to wonder when it is worth giving up. In looking at the polished walls of the VVM, the visitor is facing north. The viewer enters by reflection into the depth of the Memorial, beyond the southern sunlight which shines off the surface, into the northern region of dark mysteries and difficult questions. The Washington and Lincoln Memorials are continually present as one enters that region; they help to give shape and direction to our questions.

The invitation to contemplate the Vietnam War and the whole issue of America's involvement in similar wars is accented in yet another way. Set directly in nature, the monument is undisturbed by the turbulence and constant fermentation of human affairs. The landscaped grounds in front of the Memorial function like the bowl of a theater in which one may sit and observe. The VVM is thus simultaneously an extraordinarily moving monument as well as one which demands the detachment of thought from emotions. The Memorial presents, in the context of the Mall's Constitution Gardens, the tremendous human cost of the Vietnam War, and on *that* basis asks us to think about whether such a war is just. The monument performs the valuable service of reminding us to question, without forcing any simple answers upon us.

The *interrogative* character of the Memorial requires that it not commit itself overtly to answering these questions. Hence the seemingly apolitical nature of the monument and its separation of war and politics. Appropri-

ately absent from the dedication of the Memorial were sectarian politics and politicians (with the exception of Senator John Warner, who was welcomed warmly thanks to his support of the VVM). The dedication was organized and run by the veterans themselves. The healing value of the dedication and the Memorial would have been compromised if either had become an official government event. The presence of the president, for example, would surely have stirred up bitter feelings for and against the war, and served as an occasion for the expression of a good deal of anger which many feel toward the government for its conduct of the war and treatment of its veterans.

I mention all this because it reminds us that a main purpose of the Memorial is therapeutic, a point absolutely essential for an adequate understanding of the VVM. This purpose was not explicitly called for in the design competition but is implied by one of the rules which guided it, namely that the monument make no overt political statement. It was generally understood that what the nation needed was a monument that would heal the veterans as well as the rest of us, rather than exacerbate old wounds and reignite old passions. The interrogative character of the monument's architecture must be understood in the light of that purpose, and this purpose cannot be understood in abstraction from the severe conflicts of the times. In a way that is true of the Civil War but not of the two World Wars, the Vietnam War split the American people into warring factions united only by their hate for each other.

But this does not mean that neutrality is the state of health that the VVM's therapy is ultimately intended to produce. For the Vietnam veterans, that state of health is, at the very least, the sense of wholeness made possible by a reaffirmation of the values for which the nation stands. That is, the monument's neutrality about the merits of the Vietnam War is intended to make possible proclamation of the honor of the veterans' service in Vietnam, and rejection of the suspicion that they did something shameful by answering their country's call. As part of one of the inscriptions on the VVM states, "Our nation honors the courage, sacrifice and devotion to duty and country of its Vietnam veterans." With this monument the veterans can reaffirm their pride in having served their country and so their pride in being Americans. Within that framework, furthermore, veterans and nonveterans alike are encouraged by the VVM to contemplate the difficult questions raised by America's involvement in the Vietnam War, and that too is a salutary effect of the monument. Thus at the VVM veterans can reconcile their doubts about the conduct and even the purposes of the war with their

belief that their service was honorable, and nonveterans can retain the same doubts but also affirm the veterans' sacrifice. The VVM is not, then, therapeutic in a simply "psychological" way; its therapy depends on an understanding of certain overreaching values. Precisely that understanding was evidenced at the dedication of the Memorial, a day that was genuinely and openly patriotic, a day on which many veterans expressed their love of the United States. The striking and—given the long debates about the Vietnam War—unexpected expressions of patriotism which one still witnesses at the VVM would not be possible if the monument were explicitly heroic or took a side in the arguments about the war.

That the author of the winning design of the VVM turned out to be a woman of oriental extraction too young to have experienced the Vietnam War herself looks like another instance of the unifying work of the "invisible hand" evident in the Mall as a whole. Even with respect to the designer of the VVM, the unexpected has conspired to reconcile the seeming contraries of east and west, male and female, youth and experience. Even here, the theme of healing is evident.

In sum, the monument has in fact accomplished the goal that those who have objected to it also praise: the goal of rekindling love of country and its ideals, as well as reconciliation with one's fellow citizens. In this crucial sense the VVM is not "neutral"—far from it. It neither separates war and politics completely nor proclaims a given political interpretation of the Vietnam War. This accomplishment of the Memorial tends to be missed by its critics. Differently put, the architecture of the VVM encourages us to question America's involvement in the Vietnam War *on the basis of* a firm sense of both the value of human life and the still higher value of the American principles so eloquently articulated by Washington and Lincoln, among others. This is the key to the Memorial's therapeutic potential. Because they have failed to understand this, critics of the VVM have held that the Memorial would quickly become a rallying place for all sorts of "anti-American" groups. This prophecy has not—and I think will not—come true. On the other hand, the VVM has not—and again I believe will not—become a rallying place for unreflective and unrestrained exhibitions of a country's self-love. For these reasons the VVM is a remarkably philosophical monument, quite in keeping with America's admirable tradition of reflective and interrogative patriotism. The VVM embodies the ability of Americans to confront the sorrow of so many lost lives in a war of ambiguous virtue without succumbing to the false muses of intoxicating propaganda and nihilism.

The patriotism expressed during the Memorial's dedication was in-

formed by the healthy willingness to question the decisions of the politicians of the day about where and when Americans should die for their country. The monument's ability to engender declarations of patriotism is quite in keeping with such an interrogative character. If the Memorial momentarily separates war and politics, it is in order to give us a more secure foundation for understanding both.[22] The sentiments of those who attended and addressed the Memorial's dedication were clear: America is worth dying for, but she must not fight a war when there is no popular consensus for doing so, and she must not fight without the intention to win decisively. Correspondingly, she must not fight under conditions where it is impossible to win.

But, as I have said, the overwhelming sentiment felt at the Memorial's dedication was patriotic, and so therapeutic. Even as the speakers expressed fears of entangling foreign alliances, most everyone seemed to feel that America is still like a ray of the sun in a somber world. In this way the ceremony and the Memorial once again served the cause of union. Complete strangers embraced each other. I repeatedly heard people saying "welcome home" to veterans, as though they had not been back all the while. I shall never forget the sight of Vietnam veterans who, though looking somewhat tired in their tattered combat fatigues, proclaimed by their very costume that they were proud to have accepted the call of their country. One veteran was dressed partly in combat fatigues and partly in the sort of leather attire favored by motorcycle gangs. His lined face and disheveled hair spoke of countless trials and difficulties undergone since returning home. He stood there silently during the dedication staring at the ground with one arm raised high, holding for all to see a miniature American flag. At the conclusion of the ceremony he joined in the refrain of "God Bless America." Those words swept boldly through the chill air, expressing the belief that, in spite of everything, America remains fundamentally good.

Notes

A draft of this paper was presented on 27 March 1984 at the Iowa State University. A two-page article containing a few of the remarks made here about the VVM was published by Public Research Syndicated on 11 May 1983. I would like to thank Professors Gina Crandell, Robert Ginsberg, William MacDonald, Joel Snyder, and David Thompson for their helpful criticisms of the paper. I also acknowledge with gratitude the encouragement and help I received in composing this piece from my colleague Dale Sinos and from Francis V. O'Connor; their invaluable suggestions have contributed to every page of this essay. My final words of thanks must go to

Lisa Griswold, who so patiently accompanied me on innumerable visits to Washington's memorials, and to Stephen Griswold, whose photographs illustrate this essay.

1. The Continental Congress voted in 1783 to erect an equestrian statue of Washington near the place where the obelisk now stands. No statue was erected and in 1833 the Washington Monument Society was formed. Construction began in 1848, after years of debates and delays, and stopped partway through in 1854. In 1876 (after the Civil War) Congress appropriated the funds to proceed, and the bare obelisk was completed in late 1884 (the dedication ceremony took place on 21 February 1885). The original design for the monument was, however, never fulfilled. For an exhaustive account of the Washington Monument, see F. L. Harvey's *History of the Washington National Monument and Washington National Monument Society* (Washington, D.C., 1903). I note that in 1783 the House voted to commemorate Washington with a mausoleum shaped as a pyramid rather than with the equestrian statue, but the bill did not pass the Senate. In 1836 a public design competition was sponsored by the Society; the one criterion was that the design should "harmoniously blend durability, simplicity, and grandeur" (pp. 25–26).

2. The one exception is James Smithson, who is buried in the Smithsonian Institution's "Castle." On the area denoted by the term "Washington Mall," see the beginning of section 1.

3. The Jefferson Memorial was dedicated in 1943; the Grant and Lincoln Memorials in 1922. The Capitol took on something like its present appearance with the reconstructions in the 1850s and 1860s; and the entire Mall area was not fully landscaped, cleared of extraneous buildings, and the streets named after presidents, until after World War II.

4. The notion of a "self-organizing whole" has not been terribly popular among philosophers, with weighty exceptions such as Aristotle and Hegel, thanks to the powerful attraction of the sort of unity a single *episteme* or *techne* promises. Consider Descartes' statement:

> One of the first of the considerations that occurred to me was that there is very often less perfection in works composed of several portions, and carried out by the hands of various masters, than in those on which one individual alone has worked. Thus we see that buildings planned and carried out by one architect alone are usually more beautiful and better proportioned than those which many have tried to put in order and improve, making use of old walls which were built with other ends in view. In the same way also, those ancient cities which, originally mere villages, have become in the process of time great towns, are usually badly constructed in comparison with those which are regularly laid out on a plain by a surveyor who is free to follow his own ideas. Even though, considering their buildings each one apart, there is often as much or more display of skill in the one case than in the other, the former have large buildings and small buildings, indiscriminately placed together, thus rendering the streets crooked and irregular, so that it might be said that it was chance rather than the will of men guided by reason that led to such an arrangement. And if we consider that this happens despite the fact that from all time there have been certain officials who have had

the special duty of looking after the buildings of private individuals in order that they may be public ornaments, we shall understand how difficult it is to bring about much that is satisfactory in operating only upon the works of others. [*Discourse on the Method of Rightly Conducting the Reason and Seeking for Truth in the Sciences,* trans. Elizabeth S. Haldane and G. R. T. Ross, *The Philosophical Works of Descartes,* 2 vols. (Cambridge, 1972), 1:87–88]

Descartes goes on to make the same point with respect to religion, laws, morals, science and the accumulation of knowledge, and finally his own search for "secure foundations."

5. For a thorough discussion of the Pantheon and later imitations (as well as earlier precedents) see William L. MacDonald, *The Pantheon: Design, Meaning, and Progeny* (Cambridge, Mass., 1976).

6. James M. Goode notes that the statue was originally crowned by a Liberty Cap worn in Rome by freed slaves, but that this "was changed after objections by then Secretary of War Jefferson Davis, who asserted that the headdress embodied a not-very-subtle Yankee protest against slavery" (*The Outdoor Sculpture of Washington, D.C.* [Washington, D.C., 1974]. p. 60). The issue of individual freedom is very much at stake in the statue's symbolism.

7. See Garry Wills, "Washington's Citizen Virtue: Greenough and Houdon," *Critical Inquiry* 10 (Mar. 1984): 420–41. Wills remarks that "Greenough took for his model what the neoclassical period believed was the greatest statue ever created, by the greatest sculptor who ever lived—the Elean Zeus of Phidias" (p. 420). For a fascinating discussion of eighteenth-century portraiture of Washington, see Wendy Wick's *George Washington, an American Icon: The Eighteenth-Century Graphic Portraits* (Charlottesville, Va., 1982). The prints reproduced on pp. 139, 141, and 142, in which Washington's death is lamented, contain representations of obelisks. In her introduction to the volume, L. B. Miller points out how quickly and extensively Washington became a national icon. He was frequently compared to Roman heroes, "whom Washington himself so much admired" (p. xiv). Washington's honesty, simplicity, love of agrarian pursuits, prudence, restraint, reasonableness, lack of ambition, military abilities, and strength made him seem the perfect embodiment of Roman Republican virtues. I add that the fact that the memorial to Washington is Egyptian also reflects the fact that he was a Mason (the Masons were very much involved in the selection of the monument's design and in the dedication). Consider too the pyramid on the one dollar bill.

8. For an interesting distinction between three kinds of symbolism in architecture, namely, (1) that in which the structure's symbolism is not a means to anything else (as in obelisks), (2) that in which the outside structure is a means to a further symbol enclosed within (as in classical architecture), and (3) that in which the outside structure has its own inherent symbolism but is also a means (as in Romantic architecture), see Hegel's *Aesthetics,* trans. T. M. Knox (Oxford, 1974), vol. 2, pt. 3, sec. 1 ("Architecture").

9. In his lengthy oration delivered during the formal ceremonies held at the Capitol in connection with the dedication of the Washington Monument, the Honorable Robert C. Winthrop took note of the absence of the customary writing on the side of the obelisk. He suggested that "no mystic figures or hieroglyphical

signs" and "no such vainglorious words as 'Conqueror,' or 'Chastiser of Foreign Nations,' nor any such haughty assumption or heathen ascription as 'Child of the Sun'" are appropriate to the Washington Monument. Those who look at the memorial will be reminded of Washington's own "masterly words," the understanding of which "requires no learning of scholars, no lore of Egypt, nothing but love of our own land" (*The Dedication of the Washington National Monument with the Orations* [Washington, D.C., 1885], p. 61). Winthrop also suggests that the composition of a single massive structure out of many individual blocks (in contrast with the Egyptian obelisks which were monoliths) symbolizes "our cherished National motto, E PLURIBUS UNUM" (p. 52). Further, the memorial rises above the city as Washington "rose above sectional prejudices and party politics and personal interests." The memorial's height shows that Washington's name and example are more exalted than any other in American history, like a bright star and guiding light "for all men and for all ages" (pp. 53–54).

10. I am indebted to the independent art historian Francis V. O'Connor for ideas concerning the symbolic content of the four directions. These ideas have proved valuable in interpreting the environmental iconography of the various public monuments discussed in this essay. Dr. O'Connor's theory of directional symbolism is developed in "An Iconographic Interpretation of Diego Rivera's *Detroit Industry* Murals in Terms of Their Orientation to the Cardinal Points of the Compass," published in the exhibition catalog *Diego Rivera: A Retrospective* (New York, 1986), pp. 215–29. The ancient and intimate connection between the founding of a town or city in accordance with a conception of the order of the universe is documented in Joseph Rykwert's *The Idea of a Town: The Anthropology of Urban Form in Rome, Italy, and the Ancient World* (Princeton, N.J., 1976). Rykwert comments:

> The rite of the founding of a town touches on one of the great commonplaces of religious experience. The construction of any human dwelling or communal building is in some sense always an *anamnesis*, the recalling of a divine "instituting" of a centre of the world. That is why the place on which it is built cannot arbitrarily or even "rationally" be chosen by the builders, it must be "discovered" through the revelation of some divine agency. And once it has been discovered, the permanence of revelation in that place must be assured. The mythical hero or deity attains the centre of the universe or the top of the cosmic mountain by overcoming epic obstances. The ordinary mortal may find this place anagogically through the agency of ritual. In the case I am considering, through the ritual of orientation. [P. 90]

In the final paragraph of the book, Rykwert also notes that

> It is difficult to imagine a situation when the formal order of the universe could be reduced to a diagram of two intersecting co-ordinates in one plane. Yet this is exactly what did happen in antiquity: the Roman who walked along the *cardo* knew that his walk was the axis round which the sun turned, and that if he followed the *decumanus*, he was following the sun's course. The whole universe and its meaning could be spelt out of his civic institutions—so he was at home in it. We have lost all the beautiful certainty about the way the world works. [P. 202]

I am arguing that the organization of the heart of the city named after the quasi-mythical hero Washington exhibits a complex unity on the symbolic level, a unity tied to ancient perceptions of the cosmos' order. I do not, however, claim that this unity is the product of conscious design.

11. See Goode, *Outdoor Sculpture,* p. 27.

12. See MacDonald, who adds that "the idea of circularity in monumental architecture descended chiefly from two sources, religious buildings and tombs. . . . The tradition of roundness was very strongly entrenched in funerary architecture" (*The Pantheon,* pp. 44, 45).

13. The adaptability of a Roman design to Jefferson's New World is not as odd as it seems. Consider MacDonald's perceptive reflection that

> Symbolically and ideologically the Pantheon idea survived because it describes satisfactorily, in architectural form, something close to the core of human needs and aspirations. By abstracting the shape of the earth and the imagined form of the cosmos into a grand, immediately assimilated image, the architect of the Pantheon gave mankind a symbol that transcends religion, class, and political conviction. In contrast to Gothic architecture, for example, the Pantheon's religious associations are ambiguous, if they exist at all. Because it was not freighted with any sectarian or localized meaning, and because of the universality inherent in its forms, it was unendingly adaptable. It is one of the very few archetypal images in western architecture.
>
> The theme [of the Pantheon], of course, was unity—the unity of gods and state, of people and state, and the unity of the perpetual existence and function of the state with the never-ending revolutions of the planetary clockwork. The grid underfoot, in appearance like the Roman surveyor's plan for a town, appeared overhead in the coffering, up in the zone of the mysteries of the heavens. To unify unities is to produce the universal, and this is perhaps the Pantheon's ultimate meaning. [*The Pantheon,* pp. 132, 88]

One need only substitute "society" for "state" here to bring the point close to the Jeffersonian outlook.

14. This contrast between classical and Gothic architecture is made by Hegel, *Aesthetics,* p. 686.

15. I note in passing that Jefferson designed his own grave marker, a six-foot-high obelisk placed on a three-foot-square base.

16. Consider, by contrast, Gilbert Stuart's famous "Atheneum" portrait of the unsmiling Washington (1796).

17. The designer is Maya Lin, who at the time was a twenty-one-year-old student at Yale University (the designer of the Grant Memorial too was young and unknown). Lin is quoted as saying that she intended the memorial "to bring out in people the realization of loss and a cathartic healing process" (*U.S. News and World Report* [21 Nov. 1983], p. 68). In her statement submitted as part of the design competition, Lin wrote, "Brought to a sharp awareness of such a loss, it is up to each individual to resolve or come to terms with this loss. For death is in the end a personal and private matter and the area contained within this memorial is a quiet place, meant for personal reflection and private reckoning" ("Design

Competition: Winning Designer's Statement," reproduced by the Vietnam Veterans Memorial Fund, Inc.).

18. The memorial to Einstein is directly north of the VVM (indeed, the VVM almost points directly to it) just across the street and next to the National Academy of Sciences. On the border of the nation's memorials lies a reminder of the critical role of science in shaping our past. The connection between the Vietnam War and the products of science is especially intimate. And the nuclear weaponry that science and Einstein produced have, of course, huge consequences for the nation's future. Given Einstein's efforts to find a cure for the disease of war, his proximity to the Mall and its memorials is all the more symbolic.

19. Access to the monument is provided by a path running its length, the grassy area in front being roped off for now to preserve it from the crowds of people who continually visit the Memorial.

20. The seemingly neutral status of the Memorial was dictated by the criteria set down for the design competition. The criteria were that the monument (1) be reflective and contemplative in character, (2) be harmonious with its site and surroundings, (3) provide for the inscription of the names of the nearly 58,000 who gave their lives or remain missing, (4) make no political statement about the war, and (5) occupy up to two acres of land. Most objections to the VVM are thus objections to the criteria for the competition. I am suggesting that Lin's design fulfills these criteria in a way that responds to those objections. The design competition was open to all United States citizens over eighteen years of age. The jury of seven internationally known architects and one writer/design critic was selected by the Vietnam Veterans Memorial Fund. A total of 1,421 entries were submitted to the competition. They were judged anonymously (identified to the jurors only by number). After deliberating, the jury unanimously recommended Lin's design to the eight directors of the Vietnam Veterans Memorial Fund, who in turn accepted the nomination unanimously. The proposal then had to go through the lengthy federal approval process. After a rancorous and heated debate between supporters and opponents of the design, it was finally agreed to add a sculpture of three servicemen and a flagpole to the memorial site, so that the heroism of the veterans and the nobility of their cause might be more palpably, and traditionally, represented. These additions are now in place. I shall discuss them briefly later. The VVM was constructed entirely with private contributions.

21. Lin is quoted in R. Campbell's "An Emotive Place Apart" as saying that "I thought about what death is, what a loss is . . . a sharp pain that lessens with time, but can never quite heal over. A scar. The idea occurred to me there on the site. Take a knife and cut open the earth, and with time the grass would heal it. As if you cut open the rock and polished it" (*American Institute of Architects Journal* 72 [May 1983], p. 151).

22. Thus my interpretation of the VVM differs from that of William Hubbard, "A Meaning for Monuments," *Public Interest* 74 (Winter 1984): 17–30. Hubbard does not take into account the therapeutic potential of this memorial. His criticism of the VVM culminates in the following:

> Little wonder, then, that the sheer emotional impact of the Vietnam Veterans Memorial satisfies us. Not having the idea that artworks can provide guidance in human dilemmas, we do not sense the absence of such guidance here. We take

from the monument not a resolution of our conflicting emotions over the war, but an intensified, vivified version of those emotions. [P. 27]

Yet, as I have argued, the Memorial does not just demand emotion, it demands that emotion be checked by reflection guided by the symbolism of the VVM (symbolism partially sustained by the VVM's relationship to the rest of the Mall). The Memorial is interrogative in the way that Hubbard himself suggests all memorials should be (p. 28). His failure to consider the complex symbolism of the VVM leads him to erroneously assimilate the VVM to modernist architecture whose purpose is not to be *about* something in the world so much as to *be* a thing in the world (p. 26).

Politics, Patronage, and Public Art

Patronage, however enlightened, is always an expression of self-interest. Public art, in overt and covert ways, embodies the ideals and aspirations of its patron, be it a national government,[1] a local community, an individual, or a corporation. Art in the public domain is part of a complex matrix where personal ambitions as well as larger political and economic agendas often merge. On many levels and in many ways, these non-art factors influence and even determine the appearance, siting, and interpretation of public art. The significance and use of public art in a democracy cannot be understood without a careful analysis of patronage and the motives behind it.

The connection between patronage, politics, and public art is most evident in the traditional genre of monuments and memorials. Celebration of individuals is easily associated with the interests of those depicted or their immediate circle, those most like them. War memorials traditionally celebrate the victorious in battle, and symbolic civic monuments are easily linked to ideals promoted by their supporters. However, even though a monument's subject suggests political motivation and the interpretation may appear obvious, a closer look at some well-known examples reveals that the true message may be more subtle or subversive.

Sculptures relating to the Civil War presented a special problem in this country, especially when they were situated in Washington, DC. In the interest of national unity, the issues of Northern victory or Southern defeat had to be avoided or addressed obliquely. Nevertheless, the personal politics of the patrons could not help but be incorporated in the works they either commissioned or supervised. As Vivien Green Fryd shows in "Political Compromise in Public Art: Thomas Crawford's *Statue of Freedom*," the

statue atop the Capitol was under the jurisdiction of Jefferson Davis, then secretary of war, who directly influenced not only the appearance of Crawford's sculpture but its actual meaning. Sensitive to issues of slavery and westward expansion, the future president of the Confederacy in effect edited the sculpture to avoid any antislavery connotations during the growing national unease preceding the Civil War. That the work was finally installed by Abraham Lincoln "to symbolize the nation's reunification under northern hegemony" shows the complex relationship between public art and politics, the former having a political life of its own, often far from the original patron's intentions.

As Dennis Montagna indicates in "The Ulysses S. Grant Memorial in Washington, DC: A War Memorial for the New Century," traditional Civil War monuments often reminded viewers of those who died or expressed a desire to "return to peace and the growing national development and prosperity that the conflict had interrupted." By the early 1900s, when Henry Merwin Shrady's large, complex, multifigured memorial to Grant was commissioned, there was a new focus on "the territorial, commercial, and technological expansion of the nation and . . . the need of a sophisticated military system to achieve these ends." Thus a defining event in the nation's history was reinterpreted to reflect current interests.

It was not until the 1930s that sponsorship of public art became national policy, and then only as part of the larger economic relief programs undertaken in response to the Depression of 1929. Marlene Park and Gerald Markowitz's "New Deal for Public Art" is a good historic overview of these complicated, multifaceted government efforts. Too often these programs, the WPA/FAP (Works Progress [later Projects] Administration/Federal Art Project) and the Treasury Department's Section of Fine Art, are regarded in a vacuum and treated as an aberration, a response to a particular problem in the nation's history, instead of being seen as part of an ongoing dialogue about the federal government's support of the arts. With the siege mentality that presently exists at the National Endowment for the Arts and the National Endowment for the Humanities, it is particularly important that a better understanding of earlier debates and programs inform present-day policies and strategies.

In fact, the WPA programs served as models for federal programs instituted during the 1960s that supported public art, among other things. The General Services Administration (GSA) had a percent-for-art component in its building program intermittently between 1963 and 1972 and steadily thereafter.[2] With a small percentage (usually around one percent) of building costs allocated for art, the program is based on the assumption that

art is a necessary and desirable part of architecture and, by extension, of the built environment.

The NEA's Art in Public Places program operates differently, offering matching funds to local organizations for art intended for specific sites.[3] Art is thus purchased or created in response to local demand and becomes the property of the local patron rather than the federal government. These programs, usually associated with the social reform initiatives of the Kennedy and Johnson administrations, were, as John Wetenhall demonstrates in "Camelot's Legacy to Public Art: Aesthetic Ideology in the New Frontier," actually implemented during the Nixon administration, when they were deemed to be popular and therefore politically expedient. At the time of this writing, under different administrations and budget constraints, both federal programs are being rethought in terms of policy, cost, and implementation.

Federal support for public art set a precedent for the proliferation of public art programs around the country, some supported with public money and some with private funds. Rosalyn Deutsche, in "Public Art and Its Uses," sees public art in the context of land use and urban design policies. Specifically at Battery Park City, she links the public art policy to the upscaling of the entire project and attacks it as a mask for the monied interests at work in a late-capitalist society.

Private patronage of public art presents a complex range of problems.[4] A recent survey of patterns of corporate collecting attributes motivation primarily to public relations.[5] A blue-chip art collection inside or outside headquarters is a sign of prestigious respectability. By transferring a museum aura to the corporation, it alters corporate identity in a subliminal way. It also transforms art into an advertising tool, an enhancer of the corporate image, and as such potentially neutralizes its power. As critic Nancy Princenthal has observed, Richard Serra's *Core* at General Mills headquarters in Minneapolis, like Jonathan Borofsky's *Man with Briefcase,* "frames the corporate structures behind it and is framed by them; it is a kind of logo."[6]

It is reasonable to view corporate support for art with some skepticism. Corporations are in the business of making money and spend it only when they perceive it to be in their best economic interest. Similarly, governments sponsor art only when they perceive it to be in their best political or economic interest. This does not necessarily mean that the resulting art is not also a true public amenity. However, the responsibility remains with the viewer to filter out auxiliary messages, to judge the art on its own terms, and to consider its appropriateness to the site.

Notes

1. A basic study of patronage of the arts in the early years of the country is Lillian B. Miller, *Patrons and Patriotism: The Encouragement of the Fine Arts in the United States, 1790–1860* (Chicago: University of Chicago Press, 1966).
2. For a history of the GSA's commissioning practices, see Donald W. Thalacker, *The Place of Art in the World of Architecture* (New York: Chelsea House and R. R. Bowker, 1980); Lois Craig and the Staff of the Federal Architecture Project, *The Federal Presence: Architecture, Politics, and Symbols in United States Government Building* (Cambridge, MA: MIT Press, 1977); JoAnn Lewis, "A Modern Medici for Public Art," *Art News,* April 1977, pp. 37–40; and Kate Linker, "Public Sculpture II: Provisions for the Paradise," *Artforum,* Summer 1981, pp. 37–42.
3. A survey of projects commissioned by the NEA is provided by John Beardsley, *Art in Public Places* (Washington, DC: Partners for Livable Places, 1981). For a comparison of the commissioning practices of the GSA and the NEA, see Judith H. Balfe and Margaret J. Wyszomirski, "Public Art and Public Policy," *Journal of Arts Management and Law,* Winter 1986, pp. 5–29.
4. The following ideas are extrapolated from Harriet F. Senie, *Contemporary Public Sculpture: Tradition, Transformation, and Controversy* (New York: Oxford University Press, 1992), ch. 6.
5. See Rosanne Martorella, *Corporate Art* (New Brunswick and London: Rutgers University Press, 1990).
6. Nancy Princenthal, "Corporate Pleasures," *Art in America,* December 1988, pp. 38–41.

6

Political Compromise in Public Art

Thomas Crawford's Statue of Freedom

VIVIEN GREEN FRYD

The United States Capitol dome and its colossal bronze statue are fre-quently seen on the nightly television news and in political cartoons as signifiers of the U.S. government. Neither photographs of the Capitol nor cartoons, however, provide clear details of the statue on the dome, which is often misidentified in the media and by the general public as an Indian. Thomas Crawford's *Statue of Freedom* is in fact a difficult monument to discern, in part because of its location, far above the viewer's eye, but also because the artist was forced to make a number of compositional and iconographic changes to satisfy his patron, the U.S. government, represented by two men, Captain Montgomery Meigs (1816–1889), from the U.S. Army Corps of Engineers and the financial and engineering supervisor of the Capitol extension between 1853 and 1859, and his boss, Secretary of War Jefferson Davis (1808–1889). Crawford's *Statue of Freedom,* commissioned in 1855 and erected during the Civil War, in 1863, will be for us a "case study" in the role played by patrons in shaping and compromising the ideological content of public art.[1]

To understand the active role Meigs and Davis took in influencing the iconography and the meaning of Crawford's *Statue of Freedom,* we must first examine the monument's various stages of development. The idea for a statue on the pinnacle of the newly designed dome first arose in a drawing by the architect of the Capitol, Thomas U. Walter.[2] In this drawing, Walter had conceived of a female personification of Liberty, holding her traditional pole surmounted by the liberty cap. Upon learning of Walter's ideas, Meigs contacted Thomas Crawford (1813–1857), an American sculptor living in Rome, who was already engaged in a number of works for the new Senate

105

and House wings.[3] "We have too many Washingtons, and we have America in the center of your Senate pediment," Meigs reasoned in a letter to Crawford, noting also that "Victories and Liberties are rather pagan emblems." Nevertheless, the engineer concluded, "Liberty I fear is the best we can get. A statue of some kind it must be."[4]

Crawford followed the engineer's advice and proposed "Freedom Triumphant in War and Peace." In this first design, Freedom does not have the pole, cap, or any other emblems traditionally associated with Liberty. Instead Crawford's modest, softly rounded female figure wears a wreath on her head composed of wheat sprigs and laurel. "In her left hand," Crawford elaborated, "she holds the olive branch, while her right hand rests on the sword which sustains the shield of the United States." The sculptor also placed wreaths on the base to show, as he explained, "the rewards Freedom is ready to bestow upon the distinction in the arts and sciences."[5] Crawford thus merged Peace, identified by the olive branch, and Victory, identified by the laurel leaves, with Liberty, creating an iconographic "synthomorphosis," that is, a fusion of stock allegorical imagery.[6]

Four months later, Crawford submitted an altered design known only through his verbal description in a letter to Meigs. In this design, he abandoned the theme of Peace and established more clearly the work's signification of Liberty, creating the basis for the final monument. Positioning what the sculptor now identified as "armed Liberty" on a globe that is surrounded by wreaths placed below "emblems of Justice"—the *fasces*— Crawford added three emblems: "a circlet of stars around the Cap of Liberty"; the shield of the United States, "the triumph of which is made apparent by the wreath held in the same hand which grasps the shield"; and a sword held in her right hand, "ready for use whenever required." Crawford finalized the statue by placing stars upon her brow "to indicate her heavenly origin" and by locating the figure above a globe to represent, in his words, "her protection of the *American* world."[7]

In this second design, the artist added the liberty cap, eliminated the olive branch and its reference to peace, and retained the sword. The addition of the globe as the "American world" corresponded with the vision of America as a great empire that would influence other nations to adopt her republican form of government. The orb also suggests an association with the nation's expanded notion of manifest destiny, envisioning the nation's global power during an age of aggressive expansion beyond the continental limits of the United States into the Caribbean and Cuba.[8] Crawford's "armed Liberty" thus reflects the militaristic rhetoric of the 1850s and matches the administrative responsibilities of Jefferson Davis as the secre-

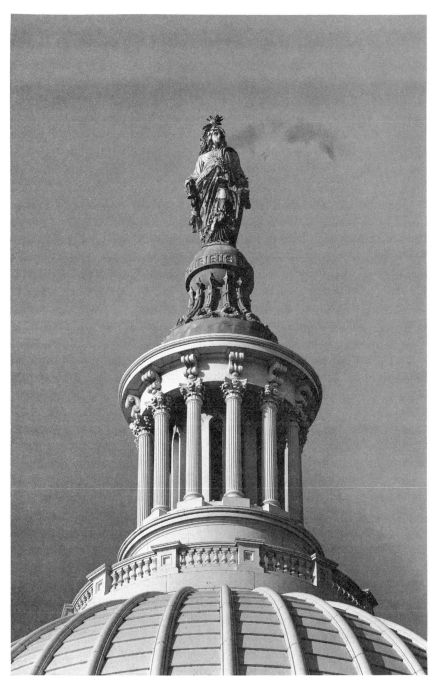

Thomas Crawford, *Statue of Freedom,* cast by Robert Mills, 1863, bronze, 19 feet 6 inches. United States Capitol dome. (Photo: Courtesy of the Architect of the Capitol)

tary of war who advocated the acquisition of Cuba and Nicaragua.[9] Earlier, as a Democrat in the House of Representatives, Davis had embraced the concept of manifest destiny and had advocated Oregon's occupation, arguing, "It is the onward progress of our people towards the Pacific, which alone can arrest their westward march; and on the banks of which . . . the pioneer will sit down to weep that there are no more forests to subdue."[10] He furthermore had advocated the acquisition of California and the decision to enter into war with Mexico, giving up his seat to fight in the Mexican War.

Jefferson Davis essentially approved of Crawford's second design, except for one aspect: he objected to the presence of the liberty cap, arguing that "its history renders it inappropriate to a people who were born free and would not be enslaved." This statement gains in significance when we realize that the secretary of war was a plantation and slave owner from Mississippi who argued vehemently in behalf of the slave system and the extension of slavery into newly acquired lands. From our post–civil rights perspective, Davis's purposeful refusal to acknowledge that blacks in the South and on his own cotton-growing plantation were not born free indicates a dangerous irony and racism that we must recognize influenced the meaning of the statue on the dome of the United States Capitol. Davis suggested that instead of the liberty cap, "armed Liberty wear a helmet," given that "her conflict [is] . . . over, her cause triumphant."[11] Consequently, Crawford dispensed with the objectionable cap, putting in its place "a Helmet . . . the crest [of] which is composed of an Eagles [sic] head and a bold arrangement of feathers suggested by the costume of our Indian tribes."[12] It is the feathered helmet that leads to the inaccurate identification of the statue as an Indian. Crawford furthermore placed the initials of our country on "armed Liberty's" chest, having rays of light issue from the letters.

Shortly we will examine how Davis's objections resulted in Crawford's fusion of three allegories. We must first address the secretary of war's rejection of the liberty cap, however, for this takes on political implications in relationship to the dissension between the North and South over slavery, which would eventually erupt into civil war. Earlier, Crawford had intended to include the liberty cap in his group for the cornice of the Senate door, which originally was to represent Liberty and Justice. Jefferson Davis, however, rejected the cap. As Captain Meigs explained to the artist, "Mr. Davis says that he does not like the cap of Liberty introduced into the composition. That American Liberty is original & not the liberty of the freed slave—that the cap so universally adopted & especially in France during its spasmodic struggles for freedom is derived from the Roman

custom of liberating slaves thence called freedmen & allowed to wear this cap."[13] Consequently, Crawford transformed Liberty into the more innocuous personification of History in his cornice sculpture.

In the statement previously quoted, Davis, the future president of the Confederacy and, we will remember, a slave owner, expressed knowledge about the practice of manumission in ancient Rome. During the Roman ceremony, freed slaves covered their newly shorn heads with the *pileus* cap while magistrates touched them with a rod (the *vindicta*).[14] Before the Roman Empire, the cap symbolized emancipation from personal servitude rather than constitutional political liberty. Emancipated slaves in Rome wore a cap to hide their shaved heads.

Although Davis provided accurate explanations for the liberty cap's original function and meaning in ancient Rome, eighteenth-century iconography books, such as Cesare Ripa's *Iconologie,* had codified Liberty as a female personification who holds a scepter in one hand and the liberty cap in the other.[15] Paul Revere employed the figure with a pole surmounted by the cap, possibly for the first time in the American colonies, in 1766 on the obelisk for the celebration of the repeal of the Stamp Act.[16] Twenty-four years later, Samuel Jennings used Liberty in his *Liberty Displaying the Arts and Sciences* (Henry Francis du Pont Winterthur Museum) not as a symbol of political freedom but as a reference to the possible emancipation of blacks in the United States. Jennings executed this painting for the Library Company of Philadelphia in support of the directors' abolitionist activities. In the work, he juxtaposed a benign and beautiful white woman as Liberty with the slaves in the lower-right-hand corner. In the background, a group of African-Americans dance around the liberty pole in celebration of their freedom.[17]

This first abolitionist painting in America emphasizes the meaning of the liberty cap in the United States. Because it had referred to manumission in ancient Rome, the cap in the United States resonated with tacit implications in regard to the slaveholding South. Consequently, the liberty cap and staff that the Frenchman Augustin Dupré depicted on the coin *Libertas Americana* (Massachusetts Historical Society) in 1783 disappeared from the first American pattern dime of 1792.[18] For the newly established country, which depended upon the link between the North and South for its existence, some Americans considered the symbols of Roman manumission too loaded in content to be included on American coins.

Abolitionist organizations such as the ones that the directors of the Library Company had founded in the eighteenth century became revitalized in the 1830s and again in the 1840s, when the newly acquired Mexican

territories exacerbated the differences between North and South. In 1846 Pennsylvania Democrat David Wilmot attached to an appropriation bill a proviso prohibiting slavery in all new territories acquired from Mexico. Although this measure failed to pass both houses, debates over slavery extension further hardened differences between northerners and southerners, eventually leading to the threat of secession by South Carolina and other southern states in 1849. After eight months of acrimonious debate, the Compromise of 1850 temporarily allayed dissension.

This discussion provides the framework for our comprehension of why Jefferson Davis opposed the use of the liberty cap in Crawford's cornice figures and in his dome statue. The plantation owner, champion of southern rights, and former representative and senator from Mississippi utilized his position as the individual in charge of the Capitol extension between 1853 and 1857 to reject any potential antislavery implications. At the same time, Meigs, a northerner who considered slavery an "eternal blot" on the concept of liberty in the United States, communicated Davis's opinions and acted as an intercessor on behalf of southern concerns by making sure that the liberty cap and slavery remained out of sight in the Capitol artworks. This army officer had befriended a number of powerful southern politicians, among them Robert Toombs of Georgia and R. M. T. Hunter of Virginia, and he needed their support, as well as that of his boss, during the times when Thomas U. Walter and, later, Secretary of War John Floyd challenged his position as supervisor of the Capitol extension.[19] Davis's rejection of the liberty cap as an antislavery symbol and Meig's adherence to his superior's desires thus contributed to Crawford's decision to change the symbolism and meaning of his artworks.

Now that we have examined the iconographic evolution of Crawford's statue and the reasons for these changes, it is necessary to study the monument from a slightly different perspective. Jefferson Davis's rejection of the liberty cap and recommendation of a "helmet" for the *Statue of Freedom* led to Crawford's conflation of three traditional allegories in his third and final version; these are Liberty, Minerva, and America. To understand how Crawford fused these allegories, we must briefly review the iconographic evolution of each personification.

America as a female personification of a geographic location came to symbolize the New World in the form of an Indian queen. Wearing a feathered skirt and a headdress, this America often held a club or a bow and arrow. The United States adopted this iconographic type on three congressional medals commissioned between 1787 and 1791 and on the *Diplomatic Medal* (Massachusetts Historical Society) of 1790.[20] Before and during the

Revolutionary War, America and Liberty combined to become America as Liberty, in which the Indian princess with tobacco leaf skirt and headdress held the cap and pole, as in Paul Revere's masthead for *The Massachusetts Spy*. That Secretary of War Davis advised Crawford to add the plumes of eagle feathers to the helmet indicates that he knew the tradition of associating America with Liberty and intended the sculptor to combine the two allegories in the statue.

Crawford's synthomorphic approach is further evident in the work's association with Minerva, the ancient Roman goddess of war and of the city, protector of civilized life, and embodiment of wisdom and reason. A majestic and robust female figure, *Statue of Freedom* in fact emulates Phidias's fabled *Athena Parthenos*, a work reconstructed by Quatremère de Quincy (and entitled "Minerve du Parthenon") in *Restitution de la Minerve en or et ivoire, de Phidias, au Parthénon*, published in 1825, which Crawford must have consulted.[21] Phidias's *Athena Parthenos* was the guardian deity over that earliest and most archetypal democracy, Athens, and hence an appropriate prototype for the American female colossus who stands in protection over the United States. Although Crawford's image is less complex, both the ancient and the modern work include the helmet, the breast medallion, the shield along the side, and the sword. (Crawford replaced the image of Medusa in Minerva's breastplate with the initials "U.S.A.") Even the fluted cloak that gathers from the lower right to the left shoulder corresponds in these two matron types whose immobility, severity of facial expression, military accoutrements, and colossal size express sternness and control, very different from the serenity and suppleness of Crawford's first design, "Freedom Triumphant in War and Peace." Not so in Crawford's final militant, motionless, and massive female colossus. Crawford depicted a placid image in his *Armed Liberty*, in part to show that Liberty's battles had been won in North America, enabling her to stand watch over the Union and the world to enforce the sword wherever and whenever necessary. Minerva, in fact, takes on special implications for the statue's vehement stance over the globe of the world.

Jefferson Davis probably intended *Statue of Freedom* to be interchangeable with Minerva when he suggested the helmet, for the secretary of war knew the goddess's iconography, evident in his detailed drawing of a profile bust of Minerva with a helmet made in 1828, while he was a student at West Point. Furthermore, Thomas Crawford, Montgomery Meigs, and Jefferson Davis must have been familiar with the traditional association between America and Minerva evident in images such as the 1789 Washington peace medal by Joseph Richardson, Jr. (Henry Francis du Pont Winterthur Mu-

Thomas U. Walter, Original
sketch for statue and U.S.
Capitol elevation, 1855, salted
paper photo print. (Prints and
Photographs, Library of
Congress)

Thomas Crawford, *Freedom
Triumphant in War and
Peace*, 1855, engraving from
Thomas Hicks, *Eulogy on
Thomas Crawford*, New
York: privately printed, 1865.
(Prints and Photographs,
Library of Congress)

Jefferson Davis, *Minerva*,
1828, drawing. (Photo:
Courtesy of the West Point
Museum, United States
Military Academy)

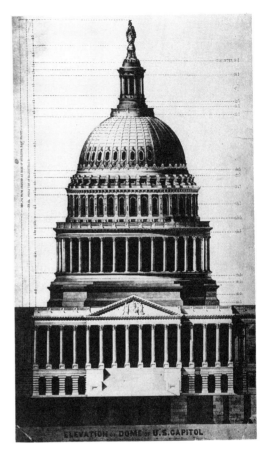

seum), the frontispiece for the Reverend Samuel Cooper's *History of North America* (1789), and John J. Barralet's 1815 engraving *America Guided by Wisdom* (Henry Francis du Pont Winterthur Museum). In Barralet's popular engraving, the two personifications are separate figures in close association. The other two images—the Washington peace medal and the frontispiece to Cooper's book—fuse America and Minerva into one allegory.

As we have seen, the iconographic evolution that Crawford followed in his *Statue of Freedom* resulted from the politically motivated advice of Montgomery Meigs and Jefferson Davis. Slavery proved to be an explosive and divisive issue that affected not only politics but works of art on the United States Capitol building. Thomas Crawford allowed his statue to fall victim to southern suppression of potentially threatening symbols. As a result, he created a monument of compromise manifest even in the title; the work is identified by government publications as *Statue of Freedom* rather than its more appropriate title, *Armed Liberty*. Politics eroded the work's meaning, and, with each concession made by the artist, the work's iconography became more obscured. What is ironic is that during the Civil War Crawford's *Statue of Freedom* resonated with additional meaning that applied directly to the division between the North and the South. In particular, President Lincoln had the monument hoisted onto the Capitol dome in 1863, to symbolize the nation's reunification under northern hegemony, a meaning that Jefferson Davis, now president of the Confederacy, obviously had never intended.

Notes

This essay derives from a chapter in my book, *Art and Empire: The Politics of Ethnicity in the U.S. Capitol, 1815–1865* (New Haven and London: Yale University Press, 1992).

1. Because Crawford had died before the statue's completion, Robert Mills cast the model in bronze. For general information about Crawford, see Robert L. Gale, *Thomas Crawford: American Sculptor* (Pittsburgh: University of Pittsburgh Press, 1964); and Lauretta Dimmick, "A Catalogue: The Portrait Busts and Ideal Works of Thomas Crawford (1813–1857)" (Ph.D. Diss., University of Pittsburgh, 1986).

2. Walter to Rest Fenner, May 25, 1869, Library of Congress Manuscript Division.

3. Meigs had first asked Randolph Rogers for proposals, but he was too preoccupied with his bronze doors for the Capitol Rotunda and hence declined the commission. See Meigs to Rogers, March 19, 1855, Meigs Letterbook, Office of the

Architect of the Capitol. For information on Rogers's doors and the other works Crawford executed for the U.S. Capitol building, see Fryd, *Art and Empire.*

4. Meigs to Crawford, May 11, 1855, Meigs Letterbook.

5. Crawford to Meigs, June 20, 1855, Meigs Letterbook.

6. I derive the term *synthomorphosis* from Marvin Trachtenberg in *The Statue of Liberty* (New York: Viking Press, 1976), 65.

7. Crawford to Meigs, October 18, 1855, Meigs Letterbook.

8. Literature on manifest destiny and westward expansion is extensive. Most helpful are Albert Katz Weinberg, *Manifest Destiny: A Study of Nationalist Expansionism in American History* (Chicago: Quadrangle Books, 1963); Frederick Merk, *Manifest Destiny and Mission in American History* (New York: Vintage Books, 1966); Henry Nash Smith, *Virgin Land: The American West as Symbol and Myth* (Cambridge and London: Harvard University Press, 1970); and Richard Slotkin, *The Fatal Environment: The Myth of the Frontier in the Age of Industrialization 1800–1890* (Middletown, CT: Wesleyan University Press, 1985).

9. For information on Davis, see Clement Eaton, *Jefferson Davis* (New York: Free Press, 1977).

10. Dunbar Rowland, ed., *Jefferson Davis Constitutionalist: His Letters, Papers and Speeches,* vol. 1 (Jackson: Mississippi Department of Archives and History, 1923), 34.

11. Davis to Meigs, January 15, 1856, Meigs Letterbook.

12. Crawford to Meigs, March 19, 1856, Meigs Letterbook.

13. Meigs to Crawford, April 24, 1854, Meigs Letterbook.

14. Yvonne Korshak, "The Liberty Cap as a Revolutionary Symbol," *Smithsonian Studies in American Art* 1 (Fall 1987): 53–69; and Thomas Wiedemann, *Greek and Roman Slavery* (Baltimore and London: Johns Hopkins University Press, 1981).

15. Cesare Ripa, *Iconologie* (New York and London: Garland, 1976), 99.

16. Korshak, "Liberty Cap," 54.

17. For more information on this work, see Robert C. Smith, "Liberty Displaying the Arts and Sciences," *Winterthur Portfolio* 2 (1965): 84–105.

18. Korshak, "Liberty Cap," 62.

19. Russell F. Weigley, *Quartermaster General of the Union Army: A Biography of M. C. Meigs* (New York: Columbia University Press, 1959), 117, discusses Meigs's friendship with southern statesmen and his assessment of slavery.

20. Information on the iconographic development of America is extensive. Most helpful are the following: E. McClung Fleming, "The American Image as Indian Princess, 1765–1783," *Winterthur Portfolio* 2 (1965): 65–81; Fleming, "From Indian Princess to Greek Goddess: The American Image, 1783–1815," *Winterthur Portfolio* 3 (1967): 37–66; Hugh Honour, *The New Golden Land: European Images of America from the Discoveries to the Present Time* (New York: Pantheon Books, 1975); and Joshua C. Taylor, "America as Symbol," in *America as Art* (Washington, DC: Smithsonian Institution Press, 1976), 1–36. See also Vivien Green Fryd, "Hiram Powers's *America:* 'Triumphant as Liberty and in Unity,'" *American Art Journal* 18 (1986): 54–75.

21. He also could have been inspired by the replica of the ancient goddess in Antoine Etex's sculpture *Peace* (1815), carved on the Arc de Triomphe in Paris, a city he visited in 1845.

7

The Ulysses S. Grant Memorial in Washington, DC

A War Memorial for the New Century

DENNIS R. MONTAGNA

April 27, 1922, marked the centennial of the birth of Ulysses S. Grant, the commander of the Union armies during the Civil War and two-term president of the United States. On that day, the federal government dedicated their memorial to Grant in Washington, DC. Placed at the foot of Capitol Hill, at the east end of the National Mall, the monument stands on axis with the Washington Monument and the U.S. Capitol, and is the largest and most prominently placed outdoor sculpture in a city filled with monuments.

The monument is formed by a raised marble plaza more than 250 feet wide and 70 feet deep. At its center is a bronze equestrian statue of Grant, two and one-half times life size, resting on a 22-foot-tall pedestal. Bronze relief panels on the pedestal's left and right dies depict marching infantrymen. Four recumbent lions on pedestals of their own flank the Grant equestrian. Emotionally charged sculptural groups atop pedestals at both extremities of the broad plaza complete the ensemble. In them, sculptor Henry Merwin Shrady presented the cavalry and artillery of the American army as these units rushed into battle, and he depicted all the pathos, suffering, and human sacrifice that accompanied such an event.

In the cavalry group, a young captain leads the charge at full gallop with sword upraised. To his right, a fellow soldier tumbles headlong over the mount that has been shot from beneath him. The rider directly behind the ill-fated one covers his eyes with his forearm, shielding from view the impending trampling of his compatriot. Four other horsemen, oblivious to the plight of the stricken rider, gallop in the tightly packed group. A young bugler sounds the charge, an older sergeant bears the company standard, and two more youthful cavalrymen round out the group.

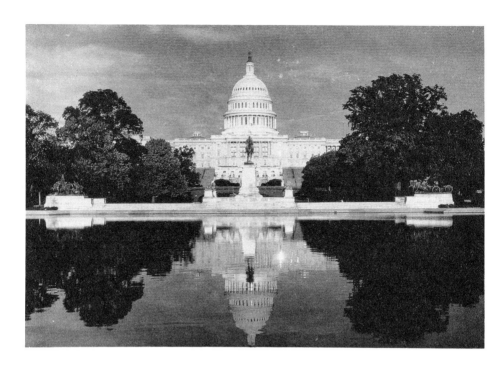

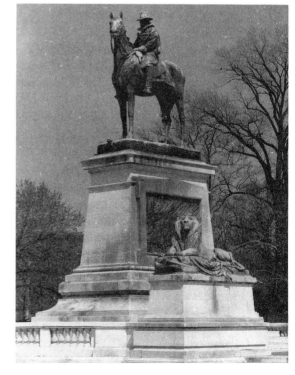

Henry Merwin Shrady and
Edward Pearce Casey,
Ulysses S. Grant Memorial,
1901–1924, bronze and
marble, Washington, DC.
(Photo: United States
Capitol Historical Society)

Henry Merwin Shrady and
Edward Pearce Casey,
Ulysses S. Grant Memorial
(detail of the equestrian
portrait of Grant),
1901–1924, bronze and
marble, Washington, DC.
(Photo: Dennis Montagna)

In the artillery group, Shrady presented another scene of military pathos. Lacking the cavalry's component of human sacrifice, the artillery embodies a sense of great struggle and endurance on the parts of both soldiers and horses. Traversing rough and muddy terrain, a field artillery unit pulled by a four-horse team comes to a halt. Three soldiers ride atop the caisson holding tightly to whatever support the caisson provides and bracing themselves against one another. The left and center figures bear pained expressions on their faces, while the right one leans forward and displays a more stoic demeanor. Two of the gun carriage's four horses have riders, who struggle to bring the team to a halt, obeying the signal of the guidon who rides beside them. To render even greater dynamism, the sculptor allowed the lead horse to break free from its reins and press forward as his counterparts come to a halt.

As a total composition, Grant is depicted as the calm, taciturn center of the maelstrom that swirls before him. The *New York Sun*'s critic described the design by Henry Merwin Shrady and Edward Pearce Casey as "one of fierce movement and eager, straining activity, presided over by the calm, unruffled Grant. . . . Firm and quiet astride a spirited and alert horse, the figure of the General [is] the only quiet one in the stirring scene."[1]

When its design was finalized in 1903, the Grant Memorial's patrons envisioned it as the anchor of the proposed "Union Square," an American Place de la Concorde. The square's central monument, flanking fountains, and formal plantings would have provided a grand terminus to the National Mall—the primary organizing feature of the planned redesign of Washington's ceremonial core, then being advanced by Daniel Burnham, Charles McKim, and the other members of the Senate Park Commission. But the rest of Union Square never came to fruition, and today the monument is virtually unknown. Dwarfed by Capitol Hill looming behind it and by an immense, fan-shaped reflecting pool constructed in front of it in 1970, the Grant Memorial has had its significance and its intended role as the counterpart to the Lincoln Memorial planned for the other end of the Mall obscured.

At the beginning of the twentieth century, the Civil War and the image of its popular, victorious commanding general represented a rich and eminently usable past when put into the service of contemporary national values. An examination of the cultural and political contexts in which it was created reveals that the designers and patrons of the Grant Memorial used the imagery of the Civil War to embody turn-of-the-century ideas advocating military preparedness and the nobility of self-sacrifice for the nation's well-being.

The United States' entry into the world of international power politics, the unprecedented role American armed forces played in imperial exploits in the Caribbean and in the Far East during these years, and the concurrent expansion and professionalization of the American army had a profound impact on American life and thought. In keeping with changing national ambitions, the Civil War received new interpretations, and new monuments commemorating the event received updated iconographies. The selection of the design conceived by Shrady and Casey ensured that the Grant Memorial in Washington would become the most important of a new breed of Civil War memorials created to serve the needs of a new age.

In February 1901, the U.S. Congress appropriated $250,000 to erect a memorial in Washington to Ulysses S. Grant. The Society of the Army of the Tennessee, an influential Civil War veterans' organization, persuaded Congress to fund the memorial. The appropriation represented the largest government expenditure for a fine arts project up to that time and led to the creation of the three-member Grant Memorial Commission, empowered to select a site, commission a sculptor and/or an architect to design and carry out the work, and supervise the monument's construction and formal dedication. General Grenville Mellen Dodge, president of the Society of the Army of the Tennessee, chaired the commission. Rhode Island Senator George Peabody Wetmore, chairman of the Senate Committee on the Library of Congress, and Secretary of War Elihu Root served as commission members by virtue of their official positions.

In 1902 the Grant Memorial Commission selected the design proposed by little-known New York sculptor Henry Merwin Shrady and architect Edward Pearce Casey from among twenty-seven designs submitted by twenty-three sculptors and architects. Nearly all the sculptors who entered the competition had submitted iconographically similar designs, which focused variously on the Union's preservation, the strides made by the nation now at peace with itself, or the reconciliation of hostile sentiments between the North and South. All these themes had found countless expressions in public sculpture during the previous thirty-five years. However, Shrady and Casey's winning design stood apart from its competitors because it made no reference to the war's resolution, or to the peace and material progress that followed the nation's reunification in 1865. Instead, with its portrayal of Grant sitting solemnly astride his horse, surrounded by his cavalry, artillery, and infantry, charging into battle, the monument provides a portrait of war's carnage untempered by any suggestion of its resolution.

During the years that immediately followed the Civil War, many Americans embraced the conventional progressive idea that as a culture

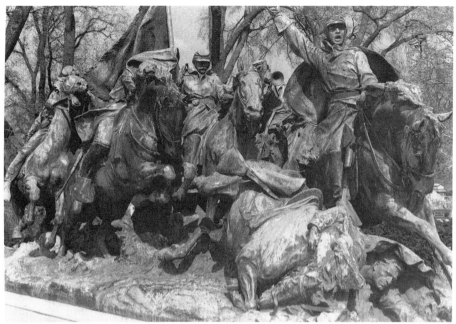

Henry Merwin Shrady and Edward Pearce Casey, *Ulysses S. Grant Memorial*
(detail of cavalry group), 1901–1924, bronze and marble, Washington, DC.
(Photo: Dennis Montagna)

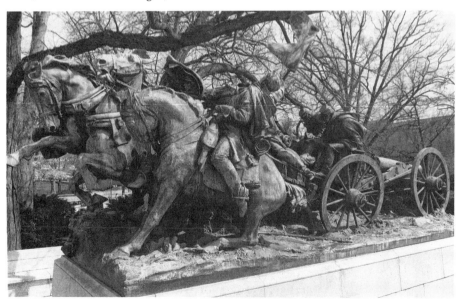

Henry Merwin Shrady and Edward Pearce Casey, *Ulysses S. Grant Memorial*
(detail of artillery group), 1901–1924, bronze and marble, Washington, DC.
(Photo: Dennis Montagna)

reached ever higher levels of civilization, the barbarity of warfare became anachronistic. They reasoned that new, increasingly complex interdependent social organizations of modern production and commerce would give rise to the dominance of the rational modern man, notable for his self-control and ability to solve disputes peacefully. Such a view of the blessings of material progress can be found at the heart of many Civil War monuments that celebrated the nation's return to peace and the growing national development and prosperity that the conflict had interrupted. The *Soldiers National Monument* at Gettysburg (1865–1869), the *Peace Monument* in Washington, DC (1874–1877), and the 300-foot-tall *Indiana Soldiers and Sailors Monument* (1895) in Indianapolis all exemplify this general iconographic type.

However, by the end of the century, many Americans worried that their culture would become too civilized. They feared that the disappearance of a warrior mentality would render the nation helpless to defend itself should that need arise—that increasing cosmopolitanism would lead to national impotence. While these ideas found expression in many forms, they were perhaps most clearly and pessimistically expressed by Brooks Adams in his *Law of Civilization and Decay* (1895).[2] In this treatise, Adams prophesied the downfall of dominant civilizations as they become more consolidated and highly structured. He feared that modern culture was supplanting the emotional or "imaginative man," typified by artists and soldiers, with the "economic man," typified by industrialists and capitalists. When this shift is accomplished, Adams argued, the culture atrophies, having lost its vitality. Soon-to-be-President Theodore Roosevelt wrote a critique of Brooks Adams's *Law of Civilization and Decay* in 1897. He agreed with Adams' sentiments about the negative aspects of increasing civilization and wrote that

> there is a certain softness of fibre in civilized nations which, if it were to prove progressive, might mean the development of a cultured and refined people quite unable to hold its own in those conflicts through which alone any great race can ultimately march to victory. . . . If we lose the virile, manly qualities, and sink into a nation of hucksters, putting gain above national honor, and subordinating everything to mere ease of life; then we shall indeed reach a condition worse than that of ancient civilizations in the years of their decay.[3]

An editorial in the Washington *Evening Star* in 1908 reiterated earlier efforts to secure military instruction for all America's youth as it warned of the dangers of complacency born of the prosperity and ease of modern life: "In this age of frenzied finance and no less frenzied politics, there comes to some of our American people an iridescent dream of international peace. It

is well that our President, Colonel Theodore Roosevelt, a soldier of the Spanish war, has the correct perspective, that he can see beyond this panorama of peace the possibility of war."[4]

By the last years of the nineteenth century, Americans began to reevaluate the Civil War and to see it not as a lamentable and tragic interlude but as the most dramatic of the many struggles the nation had faced and would continue to face, as it strove to achieve its place as a world power. The *Grant Memorial* in Washington, and many other monuments of the era, reflected the idea that dramatic sculptural images of the Civil War, designed with a pronounced narrative format, could equate that event with current concerns regarding military preparedness and commercial expansion overseas and with more general ideas about the importance of national growth and ambition.

As the twentieth century began, Great Britain and the United States were both enmeshed in troublesome colonial wars, wars in which they were having considerable difficulty subduing ill-trained, numerically inferior colonial and native forces. Before the three-year Boer War ended in 1902, Great Britain had put nearly 450,000 troops into the field to subdue 40,000 Dutch farmers.[5] The United States had endured similar trials as they fought, until 1902, the Filipinos who had been their allies against the Spanish in 1898. Observers of these events wondered and worried about the military fate of these two highly industrialized nations, if they were to be faced with a more capable adversary, such as Germany or Japan.

By inculcating the values of loyalty and self-sacrifice for the good of the nation in its male citizens during their formative years, civic leaders hoped to create an efficient, disciplined fighting force. These ideas seem to have had particular resonance in the United States, a nation with a very small standing army that would heavily depend on mobilizing troops drawn from the general populace in time of military need.

Some Americans based their embrace of military ideals on general philosophical principles that warfare can ennoble the participants, rather than on specific perceived threats to national security. However, the fear of being conquered from without or undermined from within is thinly veiled in paeans to the virtues of warfare as a tonic for society. Writing in the *North American Review* in 1894, essayist Sarah Grand observed that a prevalent belief of the time found that the relative ease of modern life could lead to national malaise. She wrote, "Idleness and luxury are making men flabby, and the man at the head of affairs is beginning to ask seriously if a great war might not help to pull themselves together."[6]

President William McKinley expressed similar sentiments about war's

value to the nation as he rode with General Grenville Dodge in his carriage to the 1901 dedication of the sculptor Franklin Simmons's Logan Memorial in Washington. Reflecting back on the recent war with Spain, he credited the conflict with going a long way toward ending the animosities between North and South that had persisted since the end of the Civil War, as Americans from throughout the nation had joined together to fight a shared enemy.[7]

Within such a philosophical climate, memories of the Civil War found new currency and new interpretations. Government leaders, popular writers, and sculptors all drew clear and frequent parallels between the Civil War and the nation's later military actions—the Spanish-American War in 1898, the so-called Philippine Insurrection, which lasted until 1902, and any future military struggles the nation might embark upon. At the turn of the twentieth century, a prevailing mood encouraged the territorial, commercial, and technological expansion of the nation and recognized the need of a sophisticated military system to achieve these ends. The government leaders who selected Shrady and Casey's design for the Grant Memorial as a focal point for the new ceremonial core of the city not only shared but also espoused these expansionist sentiments.

Moreover, General Dodge and Secretary of War Elihu Root, the key members of the Grant Memorial Commission, were concurrently working vigorously to defend the overseas role of the American army against its critics and to secure the army's enlargement and professionalization to enable it to respond better to the new demands that the twentieth century would likely place upon it. A close examination of the backgrounds and beliefs of the Grant Memorial's designers reveals that they understood and shared their patrons' vision.

Grenville Dodge had been a Civil War general of some repute and a one-term congressman from Iowa, but he achieved fame and wealth as a businessman and railroad entrepreneur in the decades after the war. His renewed interest in military matters came in 1885 with the death of his longtime friend Ulysses S. Grant. At this time, Dodge became active in affairs of the Society of the Army of the Tennessee and refought the Civil War in long discussions with General Sherman and other aging companions. Clearly, Dodge felt little sympathy for the efforts during these years to encourage a lasting reconciliation between North and South. He viewed attempts to end the sectionalism that had persisted since the Civil War as "placing the enemies of the country as of the same value with those who fought to save it."[8] Resolving to make sure Americans remembered who the real heroes were, Dodge threw himself into various monument projects.

First, he served on the committee that built Grant's Tomb, and by the mid-1890s he was chairing committees and raising funds to erect numerous monuments, most notably to General Sherman in New York and Washington, as well as the Grant Memorial.

With the onset of the Spanish-American War, Dodge became concerned with foreign as well as domestic enemies. Focusing increased attention on business prospects in the Philippines, the railroad he would soon build in Cuba, and current military affairs, he became a leading exponent of the movement to enlarge the standing army beyond the 28,000-man ceiling in force since the late 1870s. In an 1898 letter to Secretary of War Russell Alger, critical of the time lost in training a largely volunteer army for duty in Cuba, Dodge wrote, "Think what you could have done if you had had 100,000 men in the regular army ready to move a month ago."[9] The next year, Dodge chaired a blue ribbon panel that investigated the conduct of the war with Spain, concluding in his report to the War Department that the army was in dire need of major reorganization if it were to serve the imperial needs of modern America. Like-minded Elihu Root had become President McKinley's secretary of war that same year, 1899, and planned a major overhaul of the army's structure and a substantial increase in its size. In an address entitled "The American Soldier," delivered that year to Chicago's Marquette Club, Root called for public support of his efforts to enlarge and restructure the regular army. Adopting a metaphor of industrial efficiency, Root said,

> The American soldier today is a part of a great machine which we call military organization; a machine in which, as by electrical converters, the policy of government is transformed into the strategy of the general, into the tactics of the field and into the action of the man behind the gun. Through the machine he is fed, clothed, transported and armed, equipped and housed. The machine today is defective; it needs improvement.[10]

Dodge and Root had already forged a working relationship before assuming the task of selecting a design and site for the Grant Memorial. In addition to serving jointly on the commissions to erect monuments to other Civil War leaders—Generals Sherman and Sheridan among them—in February 1901, aided by Dodge's influence with key congressmen, Root received appropriations to more than double the size of the regular army. During that same month, Congress approved funding for the Grant Memorial, a project the two men oversaw while planning the nation's military future.

As secretary of war, Root also served as the chief official defender of the highly criticized American troops fighting a guerrilla war with the Filipinos for control of the islands won from Spain. In his essay "The

American Soldier" (1899), Root wrote of the hardships his troops were enduring and, as Roosevelt would do in his 1902 address to Philadelphia's Union League, passionately equated the Philippine Campaign with the American Civil War in an effort to turn the tide of adverse public opinion. Root's essay helps us to understand the cultural context out of which emerged the Grant Memorial and other contemporary memorials embodying similar ideals. With words that find their sculptural equivalents in the representation of struggle and hardship found in the Grant Memorial, Root wrote:

> I stood last month on the battlefield of Gettysburg. . . . How dear to the heart of every true American is the name and the fame of every hero who fought upon that field. My friends, today our brothers are lying in the trenches of Luzon, and today lying tongues are spreading vile slander concerning the American soldiers in Luzon. The day will come when the fair fame of these, our brothers of today, is as dear to the American people as that of the heroes of Gettysburg. We are a peaceful, not a military people, but we are made of fighting fiber and whenever fighting is . . . the business of the hour, we always do it as becomes the children of great, warlike races.[11]

In an address at Canton, Ohio, in 1900, Root again invoked memories of the Civil War in defense of American military policies overseas. As he campaigned for the reelection of President McKinley, he chastised Democrats who "have invented a new issue which they call 'Imperialism.' " He railed:

> Imperialism! The word has a familiar sound. Jefferson was denounced as an imperialist; Lincoln was denounced as an imperialist; Grant was denounced as an imperialist; and to all three of these great and liberty-loving men the party of opposition made the country resound with loud campaign outcries that they were about to strangle the liberties of the country by military force, just as they are now clamoring against President McKinley. Is there any more in the cry now than there was in the days of Jefferson, of Lincoln, and of Grant?[12]

Throughout the three years the conflict lasted, newspaper accounts of atrocities committed by American troops grew more numerous and graphic. In 1902 Root finally ordered the courts-martial of several officers, in part to placate critics of the War Department. In April 1902, a few days after the acceptance of Shrady and Casey's design for the Grant Memorial, Dodge defended American troops in the Philippines in a letter to the editor of the New York Post. As had Root, Dodge asked his readers to remember the Civil War when they thought about American troops fighting overseas and wrote

that the Filipinos deserved whatever they got, that war is war and, had Grant been in command, he would have acted in the same manner as the officers standing trial. Furthermore, it was the Americans, he argued, who had "suffered untold cruelties, assassinations, burning by slow fires, burial alive, mutilation, and atrocities," yet performed their duty "without resentment or complaint."[13] To his own Society of the Army of the Tennessee, he said, "This army can have no sympathy with that small element in our country which always criticizes it, when in trouble. They seem to be so constituted mentally that their support always goes out to the enemy and their hopes lie in our defeat. . . . There can be no neutrals—only patriots and traitors. Every man must be for the United States or against them."[14]

That Shrady and Casey had designed a monument to Grant that would be able to speak to the aspirations of America's military leaders at the turn of the century may be due in large part to their having shared that vision. The two men were members of the Seventh Regiment of the New York National Guard, a group of socially elite citizen-soldiers who had distinguished themselves during the Civil War as defenders of Washington, DC, and later for their role in putting down the railroad strikes of 1877.

Edward Pearce Casey's military sensibilities derived from a distinguished family tradition. His paternal grandfather, Silas Casey (1807–1882), graduated from West Point in 1826 and embarked upon a distinguished forty-two-year military career. Edward's father, Thomas Lincoln Casey (1831–1896), was a West Point graduate in 1853 and taught engineering at the academy before assuming command of the Pacific coast's engineer corps. During the Civil War he supervised the creation of coastal defenses in Maine. In 1877 he received the prestigious appointment to superintend construction of federal buildings. In this capacity, he became a brigadier general and supervised the construction of the most important late-nineteenth-century buildings in Washington, among them the State, War and Navy Building, the Washington Monument, and the Library of Congress.[15]

Shrady's preoccupation with military ideas and issues resulted from his own interest rather than from family tradition. The eighteen-year-old Shrady joined the Seventh Regiment in 1889, and, as a member of Company B, he drilled at its Park Avenue armory each week and spent two weeks every summer training at the National Guard camp in Peekskill, New York. As a member of the regiment, Shrady participated in an important monument dedication before his career as a sculptor of monuments began. In 1897 he marched in the parade that accompanied the inauguration of Saint-Gaudens's *Shaw Memorial* in Boston.[16]

In her memoirs, Shrady's daughter, Julester, recalled, "He was always

fascinated by the military," and "he also had a failing for Sousa military marches."[17] Moreover, the themes he chose for his first works as sculptor, *Artillery Going into Action* and *The Empty Saddle*, both modeled in 1899, suggest that his attraction to military subjects resided at the core of his artistic work. In addition, these works prefigure key elements of vigor and pathos that would characterize his soldier groups for the Grant Memorial. The small bronze *Artillery*, depicting soldiers of the Spanish-American War era rushing into battle, might even be seen as a study for the Grant Memorial's artillery group. *The Empty Saddle*, depicting a quietly grazing cavalry horse, is more accurately a representation of the death of the rider, a story told by the full military pack still in place and the rifle still in its sheath. Only the rider and his saber are missing.

Shrady's active involvement in military affairs continued during the years he worked on the Grant Memorial. His daughter recalled that, in preparation for modeling the artillery group, Shrady joined an artillery regiment of the New York National Guard to "get the feel of it" and that he remained in the battery until 1913.[18] She further noted that her father had been disappointed at not being able to take part in the First World War. Perhaps as a substitute for more active involvement, Shrady helped to organize the Elmsford, New York, Home Guard in 1917 and reached the rank of major by the end of the war. He also taught field artillery at his alma mater, Columbia College, at this time.[19]

In keeping with the growing contemporary desire for public monuments that would convey the strenuous life of the nation, Shrady's sculptural groups for the Grant Memorial and his other major works called for and elicited a largely visceral response. His equestrian monument to George Washington (1901–1906), designed for the Brooklyn approach to the Williamsburg Bridge, depicts the general bundled up against the cold of Valley Forge, and his *General Alpheus Williams* (1915–1921), in Detroit, portrays its subject huddled over a map he is trying to read in a windstorm.

Although Shrady may have lacked the academic training that other competing sculptors possessed, he and his collaborator, Casey, understood the military life and ambitions of the nation in ways their competitors probably did not. The two men designed a memorial to General Grant that also paid dramatic homage to the suffering and sacrifice of the common soldiers of the Civil War. Originally conceived as a reviewing stand for military parades, the monument's design served to equate the modern soldier with his Civil War forebears, much as did the analogies made by Roosevelt, Root, and Dodge as they defended the American army against its critics during the first years of the twentieth century. A memorial that

suggested that warfare would be, or should be, a thing of the past would not have served the didactic and inspirational purposes that its patrons believed the times demanded.

Notes

1. *New York Sun*, 20 April 1902.

2. Brooks Adams, *Law of Civilization and Decay: An Essay on History* (London and New York: Macmillan, 1895). See also Adams's *War as the Ultimate Form of Economic Competition* (1903). Brooks Adams (1848–1927) was the great-grandson of President John Adams and the brother of Henry Adams.

3. Theodore Roosevelt, "The Law of Civilization and Decay," *American Ideals and Other Essays Social and Political* (New York and London: G. P. Putnam's Sons, 1899), 336 and 354. This essay was first published in January 1897 in *The Forum*.

4. J. Walter Mitchell, *Evening Star* [Washington, DC], 10 April 1908.

5. Michael Rosenthal, *The Character Factory: Baden-Powell's Boy Scouts and the Imperatives of Empire* (New York: Pantheon Books, 1986), 3. See also J. A. Hobson, *Imperialism: A Study* (London: James Nisbet, 1902).

6. Sarah Grand, "The Man of the Moment," *North American Review* 158 (May 1894): 626.

7. Stanley Hirshson, *Grenville M. Dodge, Soldier, Politician, Railroad Pioneer* (Bloomington and London: Indiana University Press, 1967), 241.

8. Ibid.

9. Dodge to Alger, 26 May 1898, quoted in Hirshson, *Grenville M. Dodge*, 233.

10. Elihu Root, "The American Soldier," an address at the Marquette Club in Chicago, 7 October 1899. Published in *The Military and Colonial Policy of the United States: Addresses and Reports by Elihu Root* (Cambridge: Harvard University Press, 1916), 3–4.

11. Ibid.

12. Elihu Root, "The United States and the Philippines in 1900," an address at Canton, Ohio, 24 October 1900, in *Military and Colonial Policy*, 34–35.

13. Dodge to *New York Evening Post*, 17 April 1902.

14. Dodge to Hugh J. Gallagher, 27 November 1900, quoted in Hirshson, *Grenville M. Dodge*, 240–41.

15. *National Cyclopaedia of American Biography*, 4 (1897), 279.

16. Unpublished memoirs of Julester Shrady Post, Lexington, KY.

17. Ibid.

18. Shrady Post memoirs, Lexington; James E. Austin to H. M. Shrady, 25 April 1913, Shrady Papers, family estate, White Plains, NY.

19. Shrady Post memoirs, Lexington; *National Cyclopaedia of American Biography*, 30 (1943), 546–47.

8

New Deal for Public Art

MARLENE PARK AND GERALD E. MARKOWITZ

Perhaps what was most remarkable about the 1930s was the optimism. Despite the real suffering that Americans endured because of the Great Depression, the belief grew that an energetic and expanding government could work for the individual and the local community to alleviate misery, restore political faith, and improve the very structure of society. The attitude is perfectly symbolized in the play and film *Dead End*, in which slum kids, aided by an architect and a city planner, are given a "break," a second chance in life. At the same time that industry was faltering and banks were closing—they were still closing in 1939—New Deal administrators were developing fresh ideas and formulating new programs, some lasting and some short-lived. As FDR told a campaign audience in 1932, "It is common sense to take a method and try it. If it fails, admit it frankly and try another. But above all, try something."[1] Roosevelt's administration, in fact, tried to deal with everything: rural poverty and backwardness, agricultural overproduction, soil erosion, unemployment, malnutrition, municipal bankruptcies, bank closings, and dilapidated housing. The proliferating New Deal agencies worked to find new solutions to these problems. Like other historic movements, the New Deal had a characteristic ideology and tone, which were reflected in its programs. Though federal welfare, or relief, was begun at that time, the essence of the New Deal was putting people, even artists, to work.

One of the most important tendencies of the New Deal was the centralization of power in Washington, and especially in the presidency. Through his masterful use of radio, FDR was able to reach people directly and personally. Through the creation of the Executive Office of the President, power was centralized not only in Washington, but in a small group

of appointed officials who helped the President make important decisions. The federal government exerted its power in many ways, and particularly by creating the various alphabet agencies that mediated or regulated nearly every sphere of American life. Those agencies determined the amount of acreage farmers planted, the manner in which securities were traded on the New York Stock Exchange, the way unions conducted elections, and the provision of electricity to poor farmers. They even provided art. No government had made such decisions before. These new federal initiatives shifted power and influence away from local and state governments to the national government, and people increasingly looked to Washington to propose legislative remedies for America's ills.

Yet Washington also wished to use its new power to extend democracy. Though such goals were inadequately pursued and implemented, the New Deal did extend traditional democratic rights to blacks and Indians. To benefit the poor, the New Deal broadened the concept of democracy and based it in the economic sphere. FDR declared in one fireside chat that liberty had to include "greater security for the average man than he has ever known before in the history of America."[2] The New Deal's accomplishment fell far short of its rhetoric. Unemployment remained well over 10 percent until the economy was spurred by World War II, and one-third of the nation remained "ill-housed, ill-clad and ill-nourished" even after Roosevelt declared war on poverty in 1937. Political power was extended somewhat with the growth of labor unions in the late thirties, but the halls of Congress remained the province of the well-to-do, and segregation remained the law, written or unwritten, of the land.

The New Deal did not originate from one idea or from a single movement, but rather from a coalition of interests that involved compromises for all concerned. Nationalist reformers saw state and local governments' inability to cope with the Depression as an opportunity to expand the power of the national government and to promote the earlier Progressive Party's idea of uniting the country around a conscious social ideal. Some enlightened business leaders supported the New Deal as a way to save capitalism and make the economy move again. Many social reformers worked to alter the relationship of the individual to the federal government and to ensure a minimum standard of living for all Americans. Other groups, such as labor, conservationists, and public housing advocates, seized on the general reform atmosphere to attack more particular problems. Many socialists and communists supported major parts of the New Deal because they felt that it was moving society away from an individualist ethic toward a more socially conscious one that could lead to a collectivist future.

One of the ironies of the New Deal was that while Roosevelt was pursuing a relatively moderate course that preserved the basic structure of American capitalism, many businessmen were denouncing "that man in the White House" for leading a revolution against private property. When FDR took office, the banks were in a state of utter collapse and bankers were the object of derision and scorn, but he did not nationalize the banks. Instead, he reformed the banking system to ensure fiscal stability and public confidence. The Depression seemed to many proof that capitalism was in its death throes, and they blamed private capital for destroying the economy, but the trend toward big business continued during the New Deal, and big corporations acquired more power at the expense of small and medium-sized ones. Despite all the programs to aid the poor, income distribution remained relatively constant during the thirties.

Although the system was preserved, we should not ignore the radical notions that were incorporated into New Deal policy. For example, the state clearly assumed the role of protector in a way it had not done before. Whatever the inadequacies of particular programs or agencies, their very existence established the principle that the national government should take responsibility for the unemployed, the old, the sick, the poor, and the displaced. Government would henceforth guarantee a minimum standard of subsistence for all people. Declaring that "government has a final responsibility for the well-being of its citizenship," Roosevelt said that if private enterprise could not provide work or sustenance for the people, they had "a right to call upon the Government for aid; and a government worthy of its name must make fitting response."[3]

Another major reform that the New Deal initiated was the recognition of the right of unions to exist and to bargain on more or less equal terms with capital. This acknowledgment of labor's importance and role in society occurred within the context of a tremendous upsurge of worker militancy that included violent demonstrations and sit-down strikes. In 1935 almost a third of the American unionized labor force was involved in strikes. At the end of 1936, workers at two Fisher Body plants in Flint, Michigan, sat down in the factory for six weeks, until an agreement was reached with General Motors. In 1937 steelworkers struck Little Steel, a group of medium-sized companies, and at a Memorial Day meeting of strikers in South Chicago, police fired upon the workers and their families, killing ten and wounding fifty-eight. Roosevelt did not order federal troops or the National Guard to protect property rights, as previous presidents had done, but instead supported legislation that would assure "labor of the untrammeled right, not privilege, but right to organize and bargain collectively with its employers."[4]

While not revolutionary in intent or effect, this was a major structural change in American law and labor relations.

A more ephemeral change, and one not as long lasting, was the shift of emphasis away from individualism toward collectivity. In the 1930s people were fighting against what Roosevelt characterized as "those forces which disregard human cooperation and human rights in seeking that kind of individual profit which is gained at the expense of his fellows."[5] With the economy in ruins, the entrepreneur and the "robber baron" were less popular figures than in previous periods of American history. Roosevelt sought to achieve a balance between individualism and collectivism: "In our personal ambitions we are individualists. But in our seeking for economic and political progress as a nation, we all go up, or else we all go down, as one people."[6] During the decade of the Depression, the Common Man and "the people" became popular ideals. Carl Sandburg's long poem "The People, Yes" was an expression of this idea. And Roosevelt, always the master of political rhetoric, declared in one campaign speech: "Always the heart and the soul of our country will be the heart and soul of the common man."[7]

In keeping with these ideals, the New Deal committed itself to the largest art program ever undertaken by the federal government. To the educated New Dealer, who was no philistine, the fine arts went hand in hand with a strong economy, the two together creating a distinctly American culture. Art, it was thought, might actually help the people to weather the Depression by giving them meaningful and hopeful communal (and governmental) symbols. Besides, artists were out of work and hungry, too. As Harry Hopkins said, "Hell! They've got to eat just like other people."[8] Many even feared that if the Depression continued for very long, a generation of artists would be lost and a fatal blow would be dealt to American culture. New Dealers developed the most innovative and comprehensive program for government art patronage in American history. Administration officials, prodded by unemployed artists, initiated a series of art projects to provide work for artists and to bring art to people of every age and circumstance. Between 1933 and 1943 the government employed and commissioned over ten thousand artists, many young or virtually unknown, some established and famous, but most in desperate need. They produced a staggering amount of work: 100,000 easel paintings, 18,000 sculptures, over 13,000 prints, and more than 4,000 murals, not to mention posters and photographs. In the process they created a public art expressing the ideals, fulfilled and unfulfilled, of that era.

The New Deal sought to change the relationship between the artist

and society by democratizing art and culture. Art project officials wrote that the mass of people were "underprivileged in art," and they endeavored to make art available to all, whether poor children in urban slums or shopkeepers in small towns. The projects were a uniquely American blend, combining an elitist belief in the value of high culture with the democratic ideal that everyone in the society could and should be the beneficiary of such efforts. As Edward Bruce, the head of the Treasury Department's Section of Fine Arts, wrote in support of the art projects:

> Our objective should be to enrich the lives of all our people by making things of the spirit, the creation of beauty part of their daily lives, by giving them new hopes and sources of interest to fill their leisure, by eradicating the ugliness of their surroundings, by building with a sense of beauty as well as mere utility, and by fostering all the simple pleasures of life which are not important in terms of dollars spent but are immensely important in terms of a higher standard of living.

The dividends of the government investment in art would be "in material wealth, in happiness, contentment, and well-being."[9]

In addition to the democratic ideals of federal patronage, New Dealers expected that the art projects would help create a national culture. Roosevelt asserted that government support had infused a new national spirit into the land that contrasted favorably with the view Americans had of their art in the past. He said:

> A few generations ago, the people of this country were taught by their writers and by their critics and by their teachers to believe that art was something foreign to America and to themselves—something imported from another continent and from an age which was not theirs—something they had no part in, save to go to see it in a guarded room on holidays or Sundays.
>
> But recently, within the last few years, they have discovered that they have a part. They have seen in their own towns, in their own villages, in schoolhouses, in post offices, in the back rooms of shops and stores, pictures painted by their sons, their neighbors—people they have known and lived beside and talked to. They have seen, across these last few years, rooms full of paintings by Americans, walls covered with all the paintings of Americans—some of it good, some of it not good, but all of it native, human, eager and alive—all of it painted by their own kind in their own country, and painted about things they know and look at often and have touched and loved.[10]

The art projects were clearly an ambitious cultural and social experiment and were buffeted by the same political winds as the other New Deal experiments. The Roosevelt administration's initial foray into art patronage was successful but short-lived. During the winter of 1933–34, the Public

William H. Calfee, *Chicken Farm,* 1942. Mural sketch for Selbyville, Delaware, Post Office. (Photo: Courtesy of the National Archives)

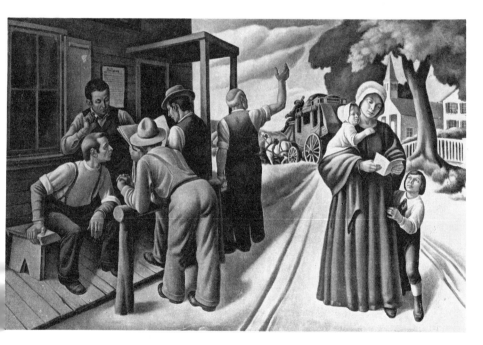

Daniel Celentano, *The Country Store and Post Office,* 1938. Mural for Vidalia, Georgia, Post Office. (Photo: Courtesy of the National Archives)

Works of Art Project (PWAP) employed artists, including painters, sculptors, and printmakers, who were in need of work and had professional credentials. Administered by Edward Bruce, PWAP was part of the first national work-relief effort, the Civil Works Administration, but because work-relief was extremely controversial and accepted only as a stop-gap measure, funding was ended in the spring of 1934. Support for new, more permanent programs increased as it became clear that the Depression represented a long-term crisis and that short-term emergency measures were not enough. The New Deal set up a number of more ambitious projects, which had different administrators, goals, and constituencies, but which functioned together to give comprehensive support and encouragement to art and artists. The largest and most famous of these, the Works Progress (later Projects) Administration's Federal Art Project (WPA/FAP, 1935–43), sought to aid artists by employing those who were already on relief. It focused on large cities, where most of the artists lived, and the work produced went to state and municipal, rather than federal, institutions. The WPA/FAP employed as many artists and artisans and served as much of the public as it could. To provide decorations for federal buildings, the Treasury Department, which at that time built and administered those buildings, also directed two art programs. One, the Treasury Relief Art Project (TRAP, 1935–39), like the WPA/FAP, largely employed artists on relief. The other . . . was the longest lived of these agencies, the Treasury Department's Section of Painting and Sculpture, later the Section of Fine Arts.

The Section was organized by order of the Secretary of the Treasury, Henry Morgenthau, Jr., on October 16, 1934.[11] The original idea for the Section came from Edward Bruce, who proposed that a "Division of Fine Arts" be established in the Treasury Department and that the President, by executive order, set aside one percent of the cost of new federal buildings for their embellishment. Under this plan, the new Division would produce pictorial records of the Civilian Conservation Corps (CCC) camps, the Public Works Administration's (PWA) projects, the Tennessee Valley Authority (TVA), and national parks. The initial funding for administrative expenses was to come from funds that the PWA held, but disagreements between Morganthau and Secretary of the Interior Harold Ickes, who controlled PWA funds, killed the plan. In the end Morganthau and Bruce agreed on a less ambitious plan to decorate new federal buildings. In the nine years of its existence, the Section gave out almost fourteen hundred commissions. On June 30, 1943, because of the war effort, the program was officially concluded, though some murals were painted under the Public Building Service as late as 1949.[12]

The leaders of the Section were typical New Dealers in that they were not part of an entrenched bureaucracy, but brought new ideas and new idealism to their work. Like Harry Hopkins and Frances Perkins, who came from a social work background to develop programs to help the hungry and unemployed, the Section leaders all had a background in art. Edward Bruce (1879–1943) and Edward Rowan (1898–1946) were painters, and Forbes Watson (ca. 1880–1960) was an art critic. They worked extremely well together. Bruce formulated general policy and ran interference with Roosevelt and Morgenthau; Watson continued to be an important art critic and publicized the Section's work in countless newspaper and magazine articles; and Rowan made the day-to-day artistic and administrative decisions.

Bruce, the son of a Baptist minister and of a writer of children's stories, wanted from childhood to be a painter but for financial reasons took a B.A. from Columbia College in 1901 and an LL.D. from Columbia Law School in 1904. After practicing law for several years he moved to Manila and then to China, where he became president of the Pacific Development Company. When the company failed in 1922, he decided to pursue his first love and become a professional painter. He went to Italy, studied with Maurice Sterne, and painted mainly landscapes, which he exhibited successfully in 1925 and 1927. In 1929 he returned to New York, and in 1932 he painted a mural in the board room of the San Francisco Stock Exchange. In 1933 he was called to serve as a silver expert on the United States delegation to the London Economic Conference. Upon his return to Washington, he organized and directed the first federal art project, the Public Works of Art Project, in the winter of 1933–34 and organized and became Chief of the Section in 1934. As Drew Pearson and Robert S. Allen described him, he was "a natural lobbyist, convivial, gay, handsome, a convincing speaker—a perfect choice to head new programs."[13] Watson's background was equally varied. After graduating from Harvard and Columbia Law School, he became an art critic for the Brooklyn *Eagle* and the New York *Evening Post* and the *World* while also serving as owner, editor, and publisher of *The Arts.* He was the author of *American Art Today* and a book on Winslow Homer, and in 1936 he and Bruce published a book on the Section, *Art in Federal Buildings.* Rowan graduated from Miami University and received a master's degree in art history from Harvard. He was a well-known watercolorist and exhibited often. As director of the Little Gallery, a community fine arts center in Cedar Rapids, Iowa, between 1928 and 1934, and as a member of the Stone City Art Colony in the summer of 1932, he was associated with the midwestern Regionalists. Before joining the Section, he was assistant director of the American Federation of Arts.[14] Under the leadership of these

men, the Section extended the ideals of the Roosevelt administration into areas that political and social legislation could not reach. For though its staff consisted of only nineteen people, including secretaries, a carpenter, and two photographers, it had an impact in virtually every congressional district of the United States.

We can see in the workings of the Section all the grand ideas of the New Deal applied to government patronage and to the creation of public art. Like the New Deal itself, the Section was essentially conservative in that it preserved the notion of the artist as an entrepreneur who contracted for a particular job. Unlike the WPA/FAP artists, who were given work on the basis of financial need and were employed directly by the government, the Section artists competed for individual commissions and signed contracts for the completion of particular murals or sculptures. Whereas the WPA/FAP artists were often assigned to a group supervised by a master artist and often felt the importance of their collective effort, on the whole the Section artists worked alone in their studios and delivered their product before they received final payment. Yet the use of anonymous competitions avoided favoritism and gave opportunities to young and unknown artists. And in a time of extraordinary ideological conflict, the Section commissioned artists of every political persuasion, awarding contracts to artists identified not only with the Democratic and Republican parties, but also to socialists, communists, and every other variety of radical political artist. Though commissioning only three black artists, the Section gave many commissions to women. Over one-sixth, or about 150, of the 850 artists working for the Section were women. The Section made special efforts to commission Native American and western artists who had never before been recognized by the federal government. Whereas the WPA/FAP stressed creativity and experimentation, the Section stressed the quality of the product. In defining quality in a more or less traditional way, it excluded the avant-garde styles. Its goal was to create a contemporary American art, neither academic nor avant-garde, but based on experience and accessible to the general public.[15] Bruce wrote in 1934: "I think the mere fact that the Government has organized this Section and undertaken this work is bound to have a very beneficial effect on the whole art movement in the country, and especially along the lines of taking the snobbery out of art and making it the daily food of the average citizen."[16]

The New Deal sought to make the national government's presence felt in even the smallest, most remote communities. The Section, for its part, was committed to making art a part of daily life, not only in cities but also in small towns and rural areas across the country.[17] The means for realizing

this vision were eleven hundred new post offices, places where art would be seen daily by ordinary citizens conducting the normal business of their lives. The post office was "the one concrete link between every community of individuals and the Federal government" that functioned "importantly in the human structure of the community."[18] Usually on a street near the center of town, running perpendicular or parallel to Main Street, these rectangular brick buildings, slightly set back, perhaps to make room for the flag pole, brought to the locality a symbol of government efficiency, permanence, service, and even culture. Thus, the post office became the emblem of the new policy.

The federal government could have chosen to make the post offices symbols of its power by decorating them with murals depicting national heroes or with emblems such as eagles, flags clutched in their talons, their wings outstretched over the postmaster's door. Instead, it chose to make the murals mirrors of local communities, stressing the primacy of the welfare of the ordinary citizen. In 1934 Bruce said that the main objective was "to keep away from official art and to develop local cultural interests throughout the country."[19] Most of the artists agreed with this conception. One sculptor, Carl L. Schmitz, explained why a realistic subject was more appropriate than a symbolic one for a small Kentucky post office:

> I think that persons entering the building, would get more local pride out of a design having to do with their own activities than a mythological figure which the average man does not even understand and which may give him the feeling of the majesty and might of his government, rather than the feeling of his own personal relation to it and the concern of the government towards him.[20]

Schmitz in fact articulated one of the dilemmas that the New Deal created: the diminution of democratic control in the face of expanded national power. At the time its proponents argued that any loss of local control would be more than compensated for by what the New Deal would accomplish. The Section believed that people would naturally like art if it was of high quality, and that they would accept the artistic intrusion into their daily lives if the art was relevant to their lives: a family enjoying a picnic, a farmer putting cows into the barn, citizens marching in a hometown parade, laborers washing up after work, men unloading a packet boat on the Mississippi, New Englanders maple-sugaring in a winter landscape, glass blowers practicing their craft, women curing tobacco on a small farm, families and friends picking oranges, neighbors talking over the fence, spectators at a stock sale, and children waiting for rural mail delivery.

In the peacefulness and productivity of this imagery, one sees no trace

of the conflicts engendered by this extraordinary, perhaps unprecedented, experiment in government patronage. But administrators, artists, local officials, and others had conflicting assumptions about what art was, about its audience, and about the artist's role. New Dealers assumed that art was a necessary, desirable, and essential part of any culture and as such should be fostered by the government. Conservatives assumed that art should be the province of an elite, and radicals that it should be both government-sponsored and a weapon for social change. The audience and the artist's responsibility were defined accordingly: the artist should serve the society as a whole, should continue to serve educated and discriminating patrons, or should unite with the working class in its battle against capitalism. We see all these assumptions at work in the various Section commissions.

Conflicting values shaped public art in the 1930s: the desire for quality in art and the commitment to make art democratic; the effort to create an art embodying national ideals and values and the wish to make art relevant to people in various regions of the United States; an allegiance to traditional artistic values and a willingness to create contemporary styles. If no consensus was achieved, these positions were articulated clearly and repeatedly in the discussions of and controversies over Section murals and sculpture.

Yet despite the tensions between conservatives and radicals, despite the sometimes conflicting desires for an art that was both high and popular, national but regional, the government-sponsored art of the 1930s, in retrospect, seems amazingly, almost naively uniform. Although artists held widely differing political ideas, they shared even deeper assumptions. Almost to the man and woman, they believed in progress. Whether by hard work and self-reliance or through dialectical processes, society moved ever upward. Science and technology were unmitigated goods and completely in harmony with nature and the past. Unquestionably the greatest event in North American history was the arrival of the European, whose pioneering efforts showered improvements not only upon his descendants but upon everyone. Even those few murals showing strife between races (Native American vs. European, never African American vs. European) or injustice between classes (Worker vs. Boss) carried the implicit message that such conflict was in a very distant past, was necessary for progress, or was an aberration, a wrong which had been or soon would be righted. Issues of gender and sex do not even appear, women, on the whole, being happily engaged in their role of motherhood and creators of the domestic arts. As in the Hollywood Production Code of the same era, homosexuality did not exist. Strangest of all, the USA was not a country of ethnic and racial rivalries, not even a melting pot, but a nation, a people, made up, as

proponents of all ideologies agreed, of something called "the common man." To him and to this national ideal the public art of the 1930s was consecrated.

Notes

1. Quoted in Dixon Wecter, *The Age of the Great Depression* (New York, 1975), p. 52.
2. Second "Fireside Chat" of 1934, September 30, 1934, Franklin D. Roosevelt, *The Public Papers and Addresses of Franklin D. Roosevelt* (New York, 1938), vol. 3, p. 422.
3. Annual Message to Congress, January 3, 1938, Roosevelt, *Public Papers* (New York, 1941), vol. 6, p. 14.
4. Speech to Teamsters Convention, September 11, 1940, Roosevelt, *Public Papers* (New York, 1941), vol. 9, p. 409.
5. Address Delivered at Green Bay, Wisconsin, August 9, 1934, Roosevelt, *Public Papers* (New York, 1938), vol. 3, p. 372.
6. Second Inaugural Address, January 20, 1937, Roosevelt, *Public Papers* (New York, 1941, 1969), vol. 6, pp. 5–6.
7. Campaign Address at Cleveland, Ohio, November 2, 1940, Roosevelt, *Public Papers* (New York, 1941), vol. 9, p. 553.
8. Quoted in Robert E. Sherwood, *Roosevelt and Hopkins* (New York, 1948), p. 57.
9. Bruce, memorandum in support of project to employ artists under Emergency Relief Appropriation Act of 1935, enclosed in Bruce to Roosevelt, May 1, 1935, Record Group 69, Box 432, National Archives, Washington, D.C. See also Jane De Hart Mathews, "Arts and the People: The New Deal Quest for a Cultural Democracy," *Journal of American History* 62 (1975): 316–39, especially p. 325: "These three elements then comprised the concept of a cultural democracy: cultural accessibility for the public, social and economic integration for the artist, and the promise of a new national art."
10. Extract from the address by President Roosevelt at the dedication on March 17, 1941, of the National Gallery of Art, Washington, D.C., Section of Fine Arts, Special Bulletin, National Archives, Record Group 121, entry 122. (Hereafter the record group and entry numbers will be abbreviated: e.g., 121/122.) See Francis V. O'Connor, *Federal Support for the Visual Arts: The New Deal and Now*, 2d ed. (Greenwich, Conn., 1971), pp. 137–43, for a guide to the Section records in the National Archives. See note 20 for further explanation.
11. C. J. Peoples, Treasury Department Order, October 16, 1934, 121/124, folder "W."
12. There are several important published and unpublished studies that the reader should consult. There are four sources in particular for the location of Section murals and sculptures, for reproductions of some of them, and for information about the color sketches. In 1936 Edward Bruce and Forbes Watson published the first book on the Section, *Art in Federal Buildings* (Washington, D.C.). It contains reproductions, plans, and descriptions of many of the early commissions.

In 1941 the *American Art Annual* published a "Geographical Directory of Murals and Sculptures Commissioned by Section of Fine Arts, Public Buildings Administration, Federal Works Agency," vol. 35 (July 1938–July 1941): 623–58. The only complete listing was compiled by Karel Yasko in the 1971–72 Fine Arts Inventory for the General Services Administration in Washington, D.C. Mr. Yasko keeps a computerized list on the condition of the murals and sculptures. There are some Section color sketches in the National Museum of American Art in Washington, D.C., but the largest collection is in the University of Maryland. In 1979 Virginia Mecklenburg published an illustrated catalogue of them. See *The Public as Patron: A History of the Treasury Department Mural Program Illustrated with Paintings from the Collection of the University of Maryland Art Gallery* (College Park, Md.).

Two major studies deal with the Section. The first, by Belisario R. Contreras, is a careful administrative history of the Treasury Department Art Programs— PWAP, Section, and TRAP. His work chronicles the establishment of the Section, the difficulties of the Section's commissions in the Federal Triangle, its achievement of permanent status in 1938, and the effect of World War II. See "The New Deal Treasury Department Art Programs and the American Artist: 1933–1943" (Ph.D. dissertation, American University, 1967). The second is Karal Ann Marling's *Wall-to-Wall America* (Minneapolis, 1982). Marling argues that "the Section was not an art program. It was, in the final analysis, a social program that employed artists" (p. 25), and that "Section art looks pretty dismal" (p. 293); her "book is about taste in the Depression decade" (p. 3). . . . She considers mainly the controversies engendered by the Forty-Eight State Competition, which was not in fact typical of Section competitions. By limiting the material she chose to consult, Marling overlooks the many distinguished Section murals, the Section's relation to the New Deal, and its broader ideas, whether nationalism, competing conceptions of history, or the extension of cultural democracy.

The most ambitious studies place the Section in the context of federal patronage during the 1930s and on the whole prefer both the methods and results of the WPA/FAP. The earliest is Erica Beckh Rubenstein's "The Tax Payers' Murals" (Ph.D. dissertation, Harvard University, 1944). In 1969 Francis V. O'Connor published the results of his comparison of New Deal and postwar patronage, *Federal Support for the Visual Arts,* mentioned in note 10. O'Connor's work includes charts giving statistics, lengthy bibliographies including contemporary articles, and a guide to the archival sources. In 1973 Richard McKinzie published his well-illustrated and lively account, *The New Deal for Artists* (Princeton). In 1984 Contreras published a general survey, *Tradition and Innovation in New Deal Art* (Lewisburg, Pa.). . . . For bibliographies of all the federal art projects, see Francis V. O'Connor's *Federal Art Patronage Notes,* vols. 3 (Summer 1979) and 4 (Summer 1983).

For photographic material, in addition to the National Archives and the Archives of American Art, also consult Erica Beckh Rubenstein's materials in the Franklin Delano Roosevelt Library at Hyde Park, New York, and John C. Carlisle's slide sets, produced by Interphase II Productions in Merrillville, Indiana.

13. Drew Pearson and Robert S. Allen, "Washington Merry-Go-Round," n.d., Bruce MSS, Reel D 84, Archives of American Art, Smithsonian Institution, Washington, D.C.

14. A biography of Bruce, by Olin Dows, appeared in the *Dictionary of American Biography*, Supplement 3, 1941–1945 (New York, 1973). Information about Watson's life is derived from two obituaries, one in the Summer 1960 *Art Students League News*, and the other in the *New York Times*, June 1, 1960. The clippings are in the New York Public Library artists' files. Rowan's biography appeared in the 1947 edition of *Who's Who in American Art*.

15. Bruce wrote to Arthur Millier on December 12, 1934: "in this project I am working for the long pull to get the maximum Federal support for the art movement in this country, and in the early stages of it I do not want to have the beans spilled by having too conservative or too radical work done." Bruce MSS, Reel D 88, Archives of American Art.

16. Bruce to Admiral Peoples, November 14, 1934, Bruce MSS, Reel D 89, Archives of American Art.

17. Bruce wrote to Eleanor Roosevelt in a letter of December 7, 1939, that the Section was refused permission to put murals in sixteen out of eighteen postal stations in New York City: "I believe it was considered that the postal stations were located in sections where art would not be appreciated. In other words, poor people don't rate art." Bruce MSS, Reel D 90, Archives of American Art.

18. New Deal art records, General Services Administration (GSA), Washington, D.C.

19. Bruce to Maurice Sterne, June 25, 1934, Bruce MSS, Reel D 89, Archives of American Art.

20. Carl Schmitz to Inslee Hopper, April 16, 1940, 121/133, Covington, Kentucky. (Entry number 133 refers to the "case files concerning embellishment of federal buildings." It is arranged alphabetically by state and within each state by city.)

9

Camelot's Legacy to Public Art
Aesthetic Ideology in the New Frontier

JOHN WETENHALL

Speaking at John F. Kennedy's inauguration, Robert Frost announced to the nation, "Summoning artists to participate / In the august occasions of the state / Seems something for us all to celebrate."[1] Had he known the new president's cultural agenda, Frost might have tempered his enthusiasm. Kennedy had none. Although during the campaign both Kennedy and Richard Nixon had given lip service to supporting the arts, Kennedy's presidency began with little more than his personal admiration for artists themselves.[2] Yet, by the end of its one thousand days, the Kennedy administration had thoroughly revised the federal attitude towards the arts, transforming national cultural policy from a special interest to a public concern.

The Kennedy inauguration began a series of official events during which the president's inclusion of the cultural world drew far greater approval than anyone could have expected. Frost had hoped, on that cold and gusty January day, to proclaim a new era for artists in America:

It makes the prophet in us all presage
The glory of a next Augustan age . . .
A golden age of poetry and power
Of which this noonday's the beginning hour.

But the snowy white glare at the lectern shone too brightly for the aging poet to read beyond his first few lines, so he recited from memory *The Gift Outright,* a poem about pioneering and promise. Many still remember how Lyndon Johnson bent to shield the lectern with his top hat, as though in courteous deference to the great poet. The press reported the scene with sympathy and humane respect, and it made a lasting impression on the

president.[3] Before long, Kennedy would welcome cultural leaders to state occasions, direct a cabinet officer to reform federal architecture, and commission a comprehensive study on government and art. By the end of his brief presidency, he would personally redefine the artist's value to the nation. Bolstered by positive public response to episodes such as Frost's, the Kennedy administration set out to clarify the nebulous cultural boundaries between public welfare and private benefit. For art professionals in our era, the New Frontier would establish the ideological foundation for the government's active cultural role that persists to this day. For contemporary historians attuned to power politics, class action, or conspiratorial intrigue, Kennedy's cultural program also offers a sobering lesson on just how unplanned, unforeseen, and publicly responsive policy formation can sometimes be.

Since World War II, federal arts initiatives had repeatedly failed.[4] In the late 1940s, Lloyd Goodrich formed the Committee on Government and Art to lobby for a revised national arts policy, which many then felt served only the interests of conservative academicians. To Goodrich's distress, the government's own Commission of Fine Arts conducted the study (essentially studying itself) and in 1953 published a report in celebration of the *status quo.*[5] By neglecting to restructure current policy, the commission effectively endorsed the procedures that supplied commissions to beaux-arts architects and sculptors, while leaving policy to state and local governments. During this period, congressmen also proposed measures to create a federal arts commission, distribute grants, and build a cultural center for Washington, DC. Even President Dwight D. Eisenhower, in his 1955 State of the Union address, endorsed the arts-commission proposal, but his bill died in committee, like most of the rest.[6] Only the cultural center passed during the decade.

During the Truman and Eisenhower administrations, cultural opponents regularly lambasted federal arts support as a return to WPA boondoggling, a meddling threat to the "rugged individualism" of artists, and an expensive subsidy for the quasi-subversive "isms" of modern art. Cultural supporters, on the other hand, asserted that a concerned government could geographically "democratize" culture, revitalize financially ailing institutions, restore educational balance with the heavily subsidized sciences, and compete with the Soviet cultural offensive in Europe. Although such arguments collectively contributed to the eventual establishment of the National Endowment for the Arts in 1965, none then created the urgency necessary to revise common assumptions of the arts as mere "luxuries." Meanwhile, antimodern sentiment ran high: in 1949 Representative George Dondero

Robert Frost receiving the Congressional Medal of Honor from President John F. Kennedy, March 26, 1962. (Photo: Courtesy of the National Archives, John F. Kennedy Library)

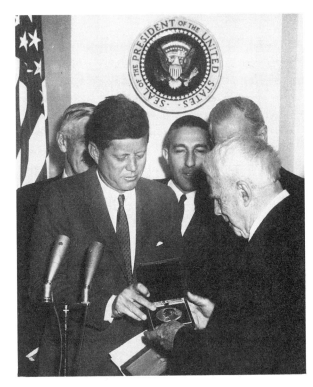

President John F. Kennedy meeting with August Heckscher and his son, June 18, 1963. (Photo: Courtesy of the National Archives, John F. Kennedy Library)

indulged in a series of public tirades accusing modern artists of being agents of communism; in 1952 Congress debated legislation to destroy Anton Refregier's murals in San Francisco's Rincon Annex Post Office because of controversial content; in 1956 conservatives in Dallas created such a ruckus over alleged leftist contributors to the *Sport in Art* exhibition that *Sports Illustrated* never sent it to the Melbourne Olympics; and shortly afterwards, the United States Information Agency adopted a policy not to exhibit art dated after 1917, the year of the Russian Revolution.[7] As the Kennedy years began, federal arts policy, both domestic and international, appeared at an ideological standstill.

In the months that followed the inauguration, Jackie Kennedy's White House galas became newsworthy spectacles, and JFK endeared himself to the intellectual community by holding a dinner in honor of Nobel Laureates. He entertained the French minister of culture, André Malraux; he initiated a series of readings, recitals, and theatrical performances for his cabinet; and he fulfilled, in a modest way, President Eisenhower's desire for cultural awards by reinstating the Presidential Medal of Freedom. In November 1961 a concert of chamber music by Pablo Casals, who had previously refused to perform in the United States in protest of its recognition of Franco's fascist regime, was held in the White House to national acclaim. Over time, such glamorous cultural coups gradually materialized in the public mind as the enlightened fulfillment of Frost's "next Augustan age," more popularly christened "Camelot."

Aside from ceremonies and state occasions, the Kennedy administration first actively engaged in cultural policy in August 1961, when the president personally asked Secretary of Labor Arthur Goldberg to mediate the Metropolitan Opera strike, which threatened to cancel the upcoming season. The dispute concerned salary: the American Federation of Musicians wanted $268 per week while the Met offered only $170, with raises of $3 each year. After negotiations deadlocked, Goldberg called both sides to Washington, where they agreed to binding arbitration. His eventual settlement in December allotted the union only $180, $185, and $190 over the next three years. But Goldberg publicly acknowledged that a genuine threat of financial insolvency restricted the Metropolitan's ability to pay fair wages, thus recognizing musicians, through their low salaries, as personal subsidizers of the opera.

Goldberg's well-publicized intervention nationally exposed the precarious financial underpinnings of cultural institutions at that time and also established a precedent for federal participation in cultural affairs. In addition,

the Metropolitan decision itself marked the first comprehensive policy statement by the executive branch since the Commission of Fine Arts' report of 1953.[8] The Goldberg ruling redefined the causes of America's cultural crisis as problems not of decline, but of growth—"a growth so rapid, so tumultuous, so eventful as to be almost universally described as an explosion. The specifics have no parallel in history." Goldberg argued that new financial strains on institutions rendered their exclusive dependence on private philanthropy effectively impractical. In response to this crisis, he proposed a "six-point partnership" among the public, traditional benefactors, private corporations, labor, local government, and the federal government, all working to "provide a stable, continuing basis of financial support."[9] He recommended matching grants for local cultural facilities, tax incentives to encourage private donations, and the establishment of a federal advisory council to study future "six-point" cooperation. In sum, Goldberg advocated a new federal responsibility equal to that of health, education, and welfare.

Goldberg cleverly countered long-standing conservative objections that cultural intervention would lead to governmental control. Reinterpreting the issue in relation to the Cold War, he reported that

> many persons oppose Federal support on grounds that it will inevitably lead to political interference. This is by no means an argument to be dismissed and the persons who make it are to be honored for their concern for the freedom of artistic expression. In an age in which a third of the globe languishes under the pathetic banalities of "Socialist realism" let no one suppose that political control of the arts cannot be achieved. . . .
>
> The answer to the danger of political interference . . . is not to deny that it exists, but rather to be prepared to resist it.
>
> An artist may be well fed and free at the same time. That an artist is honored and recognized need not mean he is any less independent.[10]

Goldberg's call to establish federal cultural support without political interference contained an implicit challenge to democracy. He urged America to support free expression in public opposition to communist art that mindlessly illustrated the values of the socialist state—the Socialist Realism that, by this time, had become a recurrent theme of editorial denunciations.[11] This commitment to artistic liberty, despite the personal ideologies of political leaders, or even of their constituencies, continued to frame cultural issues, leading to President Johnson's establishment of the National Endowment for the Arts in 1965.

President Kennedy assembled the Ad Hoc Committee on Government Office Space in the autumn of 1961 to recommend solutions to the scarcity

of administrative facilities in Washington. Under the direction of Secretary Goldberg, the committee soon expanded its inquiry to the dilapidated condition of Pennsylvania Avenue and the increasingly perceived mediocrity of federal building design. By May 1962, the committee had completed its report, in part recommending an independent commission on Pennsylvania Avenue to oversee its eventual rehabilitation. For the future of public art in America, the report included a section, "Guiding Principles for Federal Architecture," that spelled out a new, quality-conscious federal attitude towards architecture, and that led directly to a mandate for fine art in public buildings.[12]

Prefaced with ideals of "dignity, enterprise, vigor, and stability," the "Guiding Principles" offered to revitalize governmental architecture through a three-point policy: (1) that distinguished building design be acquired from the finest American architects; (2) that no official style be allowed to develop; and (3) that attention be paid to building sites for both location and beauty. In effect, the "Principles" recommended abolishing the prior "old-boy" system of federal commission, which had exclusively favored the beaux-arts style and relegated sculpture and mural painting to classical pastiche or superficial ornament. Originally, the Ad Hoc Committee on Government Office Space had drafted a fourth guiding principle, which would have required the government to spend up to one percent of a building's cost on art, with special emphasis on the work of living American artists.[13] The final report omitted this fourth principle because General Services Administrator Bernard Boutin (a committee member) anticipated its publication by instituting the policy on his own. Owing to the economic pressures of the Vietnam War, the policy lapsed in 1966, but revived again under the Nixon administration in 1973 and continues today as a major vehicle for commissioning modern public sculpture.[14]

The ideals of the "Guiding Principles" were not altogether new.[15] Government officials and members of the Commission of Fine Arts had for years spoken about high standards of federal design, however low those standards may have been. What distinguished the committee's approach is that its report articulated the economic benefits of outstanding architecture and insisted that the architectural profession, not the government, establish those standards. With regard to the economics of building, Goldberg's committee insisted that cost cutting at the expense of quality was, in the long run, counterproductive: "The belief that good design is optional . . . does not bear scrutiny, and in fact invites the least efficient use of public money."[16] On design, the committee encouraged government officials to

solicit "the finest contemporary American architectural thought," and proposed the aesthetic principle that "design must flow from the architectural profession to the Government, and not vice versa." In effect, the government reversed the terms on which it had previously sought architectural design, tacitly dismissing beaux-arts styles for the progressive, internationally acclaimed aesthetic of modern architects.[17] In practice, bureaucrats watered down these new resolutions, but their principles survived to become manifest in the GSA's Art in Architecture policy of the following decade.

In the background of the "Guiding Principles" lay a heightened awareness—perceived during the early 1960s by architectural critics, journalists, and policy makers—that urban America had become ugly and that federal architecture had set an example for conformity and the mundane. The publication of Jane Jacobs's *Death and Life of Great American Cities* (1961) and Peter Blake's *God's Own Junkyard* (1964) indicates the growing critical dissatisfaction in urban renewal, cheap building, litter, and environmental decay.[18] In the press, the committee's report unleashed a torrent of popular condemnation of federal design standards. The *New York Times* blasted bureaucratic planners as "a true-blue band of academicians, conservatives and Congressional arbiters of taste, waving a flag in one hand and a classical column in the other."[19] Wolf Von Eckardt, in *The New Republic,* ridiculed federal buildings as "pusillanimous compromises between neo-classic nostalgia and barren functionalism."[20] And the editors of *Architectural Forum* applauded the committee for at last challenging "the Beaux Arts clique that had banished good architecture from the capital city for many decades, and made Washington a cemetery of neo-classic plaster casts, stacking ennui alongside tedium."[21] This critical disgust carried over into a new optimism for the "Guiding Principles," and encouraged federal officials to pursue long-overdue aesthetic reforms.

The Kennedy administration's decision to appoint a special consultant on the arts in December 1961 was itself unprecedented in the government's growing commitment to culture. Max Isenbergh, an official at the State Department, first presented the idea of a White House cultural adviser in a policy paper entitled "A Strategy for Cultural Advancement," which he had prepared for an informal luncheon meeting on July 20, 1961, with Arthur Schlesinger, one of the president's senior advisers, and Philip Coombs, Assistant Secretary of State. After slight modifications, he retitled the proposal "A National Cultural Policy" and submitted it to cabinet members at a dinner that September 15.[22] This proposal recommended the

appointment of an executive steering committee to reevaluate the entire range of government's relation with the arts, including federal responsibilities, possible legislation, improvement of existing programs, American participation in the international cultural sphere, financial aid to institutions, the beautification of Washington, DC, and potential economic support for the art world, either through tax relief or subsidies.

Isenbergh's reasons for creating a policy concerned both domestic politics and foreign relations. First, the spectacle of the inauguration, Robert Frost's "next Augustan age," and publicized White House galas had created a mood of expectation within the art community that still awaited action. Next, in the face of international tensions (the Bay of Pigs invasion had been thwarted in April 1961, and that summer brought the Berlin Crisis), efforts to improve cultural life would "boost national morale" and set "the vision of a worthy goal beyond the current crises." Last, federal support for the arts would reinforce America's "standing as a leader" among its allies, while "to the nations of the Soviet bloc, it would show devotion on our part to a humanism transcending political differences, a demonstration which holds more promise than any other approach tried thus far of bringing forth affirmative response on their side."

Based on Isenbergh's report, presidential advisers recommended naming a special assistant for culture within the White House. In order to downplay expectations within the art community, Schlesinger asked only for a temporary outside consultant (rather than a full-time special assistant) and suggested that the president appoint August Heckscher, partly on the strength of an essay that he had written in 1960 for Eisenhower's Commission on National Goals.[23] President Kennedy approved and in December 1961 formally invited Heckscher to conduct a federal "inventory" of all cultural activities "from the construction of post offices to the imposition of taxes."[24] The president wanted a "quiet inquiry, without fanfare," which Heckscher agreed to complete within six months by commuting from New York to Washington two days a week. Instead, he spent the next year and a half in the position, not only accumulating voluminous information for his report but also serving as the administration's cultural liaison, and by his presence, bringing to the administration the expectations and good will of the art constituency.

The circumstances attending the Heckscher appointment demonstrate the methodical thought that guided cultural policy. In practice, the president had little to do with forming these plans, which he received from advisers such as Schlesinger. As Heckscher later recalled, Kennedy listened to plans skeptically, "but if he could be convinced that it would receive a good public

reception, would do something really useful for the cause, and . . . would not involve undue expenditure of funds, he would say, 'Go ahead with it.' "[25] The Kennedy cultural program, then, was not a comprehensive plan but a careful and pragmatic series of experiments instituted by high-level advisers, who, propelled by public response, formed their policies gropingly. According to Heckscher, "The President would take a step and then if the reaction was good, he would be encouraged and would be willing to take another."[26]

August Heckscher published his findings and recommendations on June 17, 1963, in a report entitled *The Arts and the National Government.*[27] Not since the Commission of Fine Arts' report of 1953 had the government released such a comprehensive survey, but whereas the commission had simply catalogued aesthetic activities in celebration of the *status quo*, Heckscher evaluated government's relation to the arts across departmental lines and against standards of artistic excellence. Heckscher recognized the cultural explosion that Goldberg had identified, perceived a weakening of artistic institutions, and criticized government for inadvertently imposing "obstacles to the growth of the arts and to the well-being of the individual artists." The report surveyed the acquisition of art by museums, embassies, and for public buildings, specifically endorsing the percent-for-art idea. Heckscher censured governmental design standards (from coins and stamps to federal buildings) and advocated the widespread use of independent panels of experts for aesthetic advice. Elsewhere, the report called attention to the inadequate condition of America's cultural facilities, suggested educational reforms, decried the run-down appearance of the national capital, and even offered tax reforms. In conclusion, Heckscher recommended: (1) that the office of special consultant become a full-time position; (2) that the president convene a Federal Advisory Council on the Arts; and (3) that a National Arts Foundation be created "on the model of the existing foundations in science and health."

The Heckscher report changed the federal relationship to art in three ways. First, it expanded the government's previous definition of art as drama, dance, painting, and sculpture to embrace cultural heritage, urban planning, environmental concerns, and, ultimately, the quality of American life. By broadening issues, Heckscher elevated the arts from a special interest to the wider national domain. Second, the report dismissed as irrelevant the old argument that government should not interfere with art, simply because the government *already* affected the arts. Heckscher reframed past concerns from whether to form a policy, to how best to pursue existing obligations. The *status quo* no longer sufficed because for the government to neglect aesthetic issues only lowered standards, in ef-

fect encouraging mediocre art and poor design. Third, by considering the national environment, the report articulated a federal responsibility for culture based on a broad concept of public welfare, fundamentally tied to the values of society. Heckscher labeled the talent of artists "vitally important to the nation" and compared cultural progress to advances in fields such as education, where "government's responsibility is fully recognized." By considering issues of free time, urban living, and Americans' growing attitude that "life is more than the acquisition of material goods," the report essentially related cultural prosperity to the future worth of the nation: "The United States will be judged—and its place in history ultimately assessed—not alone by its military and economic power, but by the quality of its civilization."

The Kennedy administration's efforts to articulate the place of art in the national interest culminated in a speech by the president himself, delivered at Amherst College on October 26, 1963 (less than one month before his assassination). The president regarded the address as especially personal because it would dedicate a library in memory of Robert Frost, the poet who symbolized the New Frontier for art. Three days earlier, in accordance with normal White House practice, Kennedy received a draft of his remarks from his speechwriter Ted Sorensen.[28] That text marched through a competent, if uninspired, remembrance of Frost, praised the importance of colleges, and announced various measures to assure a learned generation for the future. The president rejected Sorensen's text and dictated a new version, written in only two days by Arthur Schlesinger, which he carefully revised on the plane to Massachusetts.[29] Although his prior cultural policies had been formed by advisers, the president selected the Amherst address as his personal manifesto on government and art.

Kennedy's speech began with extemporaneous comments on the moral responsibilities of graduates from elite institutions. Then, after introducing Frost's "road less travelled," the president reverted to his carefully prepared text, inspired by the theme of "poetry and power" that the aging poet had intended for his inaugural. Frost's imagery was soon merged with a rumination on the necessity of the free artist in a great society:

> The men who create power make an indispensable contribution to the Nation's greatness, but the men who question power make a contribution just as indispensable, especially when that questioning is disinterested, for they determine whether we use power or power uses us.
>
> Our national strength matters, but the spirit which informs and controls our strength matters just as much.

Where the policymakers of the 1950s had treated culture in limited categories of theater, music, and the visual arts, and where the administration's statements by Goldberg and Heckscher had presented art as a means to enrich the quality of life in America, Kennedy went further to link art with the very creation of national values. No longer, though, would government dictate these values to the artist; rather, it would examine its own values by the standards of art. In this way, private art served a public purpose:

> For art establishes the basic human truth which must serve as the touchstone of our judgment.
> The artist, however faithful to his personal vision of reality, becomes the last champion of the individual mind and sensibility against an intrusive society and an officious state. The great artist is thus a solitary figure. He has, as Frost said, a lover's quarrel with the world. In pursuing his perceptions of reality, he must often sail against the currents of his time. This is not a popular role.

There can be no question but that in his era of Cold Warriors, Kennedy saw in the freedom of the artist a fundamentally American value. He could foresee that its expression would not be flattering or soothing or comforting or even pretty, but he fully understood the alternatives. Given international precedent, to limit creativity could only align American art lockstep on the totalitarian course. He had even intended to say this directly. At a point in the speech that emphasized democracy's unique claim to the independent artist, implying "it may be different elsewhere," the president's reading text continued, "In Soviet Russia, Chairman Khrushchev has informed us, 'It is the highest duty of the Soviet writer, artist and composer, of every creative worker, to be in the ranks of the builders of communism, to put his talents at the service of the great cause of our Party, to fight for the triumph of the ideas of Marxism-Leninism.' "[30] According to Schlesinger, Kennedy deleted this section on the plane ride to Amherst only because he feared jeopardizing impending arms talks with the Russians.[31]

Kennedy's view was essentially modern, not in its preference for a particular style but in its underlying philosophy. In recognizing individuality of creation, he anticipated the future of governmental arts policy beyond the simple establishment of support, to the time when that which was supported might harshly confront popular opinion. This was not a matter for compromise, for he saw in the private expression of the uninhibited artist an essential purity of purpose, from which he traced a thread, through the policymakers of the nation, to the principles for which it stands:

> If sometimes our great artists have been the most critical of our society, it is because their sensitivity and their concern for justice, which must motivate

any true artist, makes [the artist] aware that our Nation falls short of its highest potential. I see little of more importance to the future of our country and our civilization than full recognition of the place of the artist.

If art is to nourish the roots of our culture, society must set the artist free to follow his vision wherever it takes him. . . . In free society art is not a weapon and it does not belong to the sphere of polemics and ideology. Artists are not engineers of the soul. It may be different elsewhere. But democratic society—in it, the highest duty of the writer, the composer, the artist is to remain true to himself and to let the chips fall where they may. In serving his vision of the truth, the artist best serves his nation.

In actual governmental policy, however, the Kennedy administration never really achieved that much. The White House dinners were largely symbolic; Goldberg's Metropolitan decision established a precedent but not a coherent policy; and Heckscher's report merely offered suggestions. The contribution of the Kennedy administration lay not in legislation but in doctrine: the New Frontiersmen demonstrated a sensitivity to the rising concerns for culture in America; they formed practical recommendations; and, most important, they endowed the cultural agenda with a vocabulary of idealism that left a legacy of national values to the legislation that would follow.

One week before the Heckscher report's publication, the president issued an executive order to form an Advisory Council on the Arts; but bureaucratic delays prevented the naming of council members until after the assassination. In the months that followed, President Johnson appointed an advisory council and, in September 1965, signed legislation that established the National Endowments for the Arts and the Humanities.[32] Ideologically, these foundations derived directly from the New Frontier. They continued to expand the federal responsibility towards the arts through an alliance with humanistic studies and, by association, American education. Through their administrative independence, the endowments insulated individual projects from political control, relying on the panels of experts so strongly endorsed by Heckscher. They also manifested the respect for individual free expression that had become so necessary to demonstrate publicly given the backdrop of the Cold War. Finally, through New Frontier ideology, artists achieved governmental recognition as national resources and as symbols of America's commitment to excellence. In the three short years of Camelot, the artist had ascended from a potential subversive to "the last champion of the individual mind and sensibility against an intrusive society and an officious state."[33]

The arts endowment adopted an Art in Public Places program in 1967

and helped to formulate the GSA's revised Art in Architecture policy of 1973. Both programs became major commissioners of modern public art in America that, in many ways, gave physical form to the individualistic concerns of prior cultural policy. Today, the proliferation of public art in America has created a network of consultants, commissioners, and other professionals committed to spreading the work of contemporary artists throughout the public domain. Many respond to these efforts with complaints, objecting that public art wastes money and means nothing.[34] Too often, cultural advocates parry criticism with accusation, dismissing opponents as "philistines," while they justify their public service with mushy platitudes about the necessities of art. Now Senator Helms, his supporters, and those who compromise with him pose new threats to federal aesthetic neutrality. In this disturbing context, the uncertain, slowly evolving policies of the Kennedy administration illustrate how such specific measures as grants for artists or percent-for-art policies truly derive from the broader concerns of national interest, and how those concerns first articulated in the New Frontier still provide the ideological foundation for arts policy today.

Notes

The author gratefully acknowledges the advice of Albert Elsen and the archivists at the John F. Kennedy Library in Boston, principally Barbara Anderson and Megan Desnoyers. Also, the National Museum of American Art, Washington, DC, provided logistical assistance, and the John F. Kennedy Memorial Library Foundation generously underwrote this study with a research grant.

1. See: Arthur M. Schlesinger, Jr., *A Thousand Days,* New York, 1971 (first published 1965). Documentary materials on the arts collected by Schlesinger are in the John F. Kennedy Library, Schlesinger Papers, Writings: *A Thousand Days: Background Material,* "The Arts," boxes 2, 3. Schlesinger was interviewed by the author in October 1986.

2. See: "The Candidates and the Arts," *Saturday Review* (October 29, 1960), pp. 42–44.

3. Special articles were devoted to Frost in the *New York Times* and the *Washington Post,* whose headline read, "Frost's Poem Wins Hearts at Inaugural." At the suggestion of Kay Halle, a wealthy supporter from Georgetown, the White House sent inaugural invitations to leading artists, writers, and musicians. Although the press hardly mentioned this gesture, Halle sent the president an album of cards by the guests, many suggesting how further to assist the arts. See: August Heckscher, recorded interview by Wolf von Eckhardt, December 10, 1965, Kennedy Library Oral History Program. August Heckscher (the president's special consultant on the arts) was interviewed by the author in March 1987.

4. For a comprehensive history of arts legislation in America, see: Gary Larson, *The Reluctant Patron: The United States Government and the Arts, 1943–1965*. Philadelphia, 1983.

5. *Art and Government: Report to the President by the Commission of Fine Arts*, Washington, DC, 1953. Documents relating to the study are in the National Archives, Washington, DC, RG 66, "Commission's Survey of Government and Art." Among the many articles criticizing federal policy of the time, see: Lloyd Goodrich, "Government and Art: History and Background," *College Art Journal* (1949), pp. 171–75; and Charlotte Devree, "Is This Statuary Worth More Than a Million of Your Money?" *Art News* (April 1955), pp. 34–37.

6. "Annual Message to the Congress on the State of the Union, January 6, 1955," *Public Papers of the President of the United States: Dwight D. Eisenhower, 1955*, Washington, DC, p. 28. President Eisenhower's remarks led to an Advisory Committee bill that was drafted by Assistant Secretary of Health, Education, and Welfare Nelson Rockefeller in February 1955.

7. Among the many articles on resistance to modern art in the 1950s, see: "The Artists and the Politicians," *Art News* (September 1953), pp. 34–37, 61–64; Charlotte Devree, "The U.S. Government Vetoes Living Art," *Art News* (September 1956), pp. 34–35, 54–56; William Hauptman, "The Suppression of Art in the McCarthy Decade," *Artforum* (October 1973), pp. 48–52; and Jane De Hart Mathews, "Art and Politics in Cold War America," *American Historical Review* (October 1976), pp. 762–87. The USIA reversed its policy in 1959, when it sent Lloyd Goodrich's exhibition of contemporary American art to Moscow.

8. The *New York Times* reproduced Goldberg's "six-point partnership" on December 15, 1961. See also: *The Defense of Freedom: The Public Papers of Arthur J. Goldberg*, ed. Daniel Patrick Moynihan, New York, 1964. (Moynihan, Goldberg's assistant at the time, drafted much of the decision's text.) For a critical view of Goldberg's position, see: Russell Lynes, "The Case against Government Aid to the Arts," *New York Times Magazine* (March 25, 1962), pp. 26, 84–88; and W. McNeil Lowery, "The Ford Foundation and the Visual Arts," unpublished speech presented in Los Angeles, January 10, 1962, John F. Kennedy Library, August Heckscher Papers, box 24, "Foundations and Monuments" (hereafter Heckscher Papers). See also: *Economic Conditions in the Performing Arts*, Hearings before the Select Subcommittee on Education of the Committee on Education and Labor, U.S. House, 87th Congress, New York: November 15, 16, 17, 1961, San Francisco: December 7, 8, 1961, Washington: February 5, 6, 1962; and Rockefeller Brothers Fund, *The Performing Arts: Problems and Prospects*, New York, 1965.

9. *New York Times*, December 15, 1961.

10. Ibid.

11. For instance, the *New York Times Magazine* (November 12, 1961) featured a pictorial essay on Soviet art entitled, "Art Imitates the Party Line," pp. 20–21.

12. "Guiding Principles for Federal Architecture" in *Report to the President by the Ad Hoc Committee on Federal Office Space*, May 23, 1963. In addition to Goldberg, the Ad Hoc Committee comprised Luther H. Hodges, Secretary of Commerce; David E. Bell, Director, Bureau of the Budget; Bernard J. Boutin, Administrator, General Services; and Timothy J. Reardon, Jr., Special Assistant to the President.

13. See: Daniel P. Moynihan to August Heckscher, March 27, 1962, Heckscher Papers (cited n. 8), box 30, "Executive Branch—Federal Building: Design & Decoration, 3/30/62–6/15/62." The fourth principle read: "4. A modest portion of the cost of each new Federal office building, not to exceed one percent of the total expense, shall be allocated for the purchase of fine arts to be incorporated in the general design. Emphasis should be placed on the work of living American artists, representing all trends of contemporary art, but this practice should not preclude the purchase of works of earlier periods where this would be appropriate. In commissioning the work of living artists, competitions should be encouraged."

14. Documents relating to the formation of the General Services' art-in-architecture policy are in the Art in Architecture Program records at GSA headquarters in Washington. On the 1960s program, see especially: the "Background FA" file. On the GSA policy that began in 1973, see: Donald W. Thalacker, *The Place of Art in the World of Architecture,* New York, 1980.

15. The GSA modeled its policy after the Treasury Department's Section of Painting and Sculpture of the New Deal era. The Commission of Fine Arts' 1953 report (cited n. 5), p. 45, indicates that after World War II, GSA officials continued to operate under percent-for-art guidelines. The Ad Hoc Committee on Government Office Space did not initiate a new policy, but insisted on a rigorous application of an old principle fallen into disuse.

16. Ad Hoc Committee *Report* (cited n. 12).

17. The GSA soon awarded contracts to internationally respected architects such as Walter Gropius, Mies van der Rohe, Minoru Yamasaki, and Marcel Breuer.

18. Jane Jacobs, *The Death and Life of Great American Cities,* New York, 1969 (first published 1961); and Peter Blake, *God's Own Junkyard: The Planned Deterioration of America's Landscape,* New York, 1964. Senator Harrison Williams brought the theme of America's ugliness to the Senate floor (*Congressional Record—Senate,* October 4, 1962, vol. 108, pt. 16, pp. 22112–18) in introducing a bill (S. 3788) to establish a National Council on Architecture and Urban Design. Williams characterized federal architecture as "more and more mundane, repetitious and lifeless," maintaining that, "If at the end of our efforts to make our cities safe and sound, they remain dull and lifeless, then they have in a very real sense failed." Appended to Williams's remarks are numerous articles that demonstrate the widespread nature of the urban-ugliness theme.

19. "A Washington Renaissance," *New York Times,* June 8, 1962.

20. Wolf Von Eckardt, "The Architects and the Bureaucrats," *The New Republic* (June 18, 1962), pp. 27–28.

21. "At Last: Leadership from Washington," *Architectural Forum* (August 1962), p. 79.

22. August Heckscher, "The Quality of Culture in American Life," in the President's Commission on National Goals, *Goals for Americans: Programs for Action in the Sixties,* New York, 1960, pp. 127–46. "A Strategy" is in the Heckscher Papers (cited n. 8), box 38, "National Arts Programs and Policies: Important Documents, 12/8/58–9/23/61." The second version, from which quotations in the text have been taken, is in the Kennedy Library, White House Central Files (WHCF), box 4, "AR Arts."

23. Kennedy Library, Arthur Schlesinger, Jr., "Memorandum for Mr. Pierre E.

G. Salinger, Subject: The Cultural Offensive," September 27, 1961, WHCF, box 4, "AR Arts" (cited n. 22). Schlesinger conveyed the recommendations to the president in a memorandum of November 22, 1961, "Moving Ahead on the Cultural Front," WHCF, box 4, "AR Arts." The memorandum not only summarizes the reasons for an art consultant but also documents the relation between the ceremonial occasions at the White House and the formation of policy.

24. John F. Kennedy to August Heckscher, WHCF, box 4, "AR Arts" (cited n. 22); also in Heckscher Papers (cited n. 8), box 6.

25. Heckscher oral history (cited n. 3).

26. Ibid. Kennedy was not himself an avid follower of the arts. Heckscher recalled that the president's support for culture originated from a genuine respect for the discipline required of the individual artist; see: "Kennedy: The Man Who Lives On," address at the Larchmont Temple, November 20, 1964, in Heckscher oral history (cited n. 3).

27. August Heckscher, *The Arts and the National Government: A Report to the President*, Washington, DC, 1963. See also: August Heckscher, "Public Works and the Public Happiness," *Saturday Review* (August 4, 1962), pp. 8–10, 46.

28. Kennedy Library, Sorensen Papers, box 72, "Amherst Honorary Degree, 10/26/63." The version given to the president was dated October 23, 1963.

29. Copies of the president's reading text and Schlesinger's draft, both edited in the president's own hand, are in the Kennedy Library, Papers of President Kennedy, President's Office Files, Speech Files, box 47, "Remarks at Amherst College, 10/26/63." For the final version, see: *Public Papers of the President of the United States: John F. Kennedy 1963* (series cited n. 6), "Remarks at Amherst College upon Receiving an Honorary Degree, Oct. 26, 1963," pp. 815–18.

30. Ibid. Just prior to this speech, beginning on September 30, 1963, the *New York Times* art critic John Canaday published a series of six articles on Soviet "Socialist Realism," the first of which appeared on page 1 as "Art in the Soviet: Review of a Paradox." The preceding December, the *New York Times* had also publicized Khrushchev's denunciation of the first post-Stalin exhibition of abstract art in Moscow, twice on the front page: "Khrushchev Scolds Abstract Painters" (December 2, 1962); and "Soviet Orders Disciplining for Cultural Avant-Garde" (December 4, 1962).

31. Schlesinger interview.

32. In an interview with the author (cited n. 3) August Heckscher speculated that Kennedy would have moved more slowly and cautiously than Johnson in promoting an arts foundation. Kennedy's good standing with the cultural community probably afforded him more time to deliberate, whereas Johnson, eager to please Kennedy's former constituency, simply moved the legislation through channels.

33. "Remarks at Amherst College upon Receiving an Honorary Degree" (cited n. 29).

34. For the case against public art policy, see Douglas Stalker and Clark Glymour, "The Malignant Object: Thoughts on Public Sculpture," *The Public Interest* (Winter 1982), pp. 3–21; Edward C. Banfield, *The Democratic Muse: Visual Arts and the Public Interest*, New York, 1984; and Tom Wolfe, "The Worship of Art: Notes on the New God," *Harper's Magazine* (October 1984), pp. 61–68.

10

Public Art and Its Uses

ROSALYN DEUTSCHE

The following text is an excerpt from an article entitled "Uneven Development: Public Art in New York City," which originally appeared in October 47 (Winter 1988). Using Battery Park City in lower Manhattan as a case study, "Uneven Development" explored the relationship that was established in the 1980s between public art and urban redevelopment projects. The article criticized the prevailing tendency in art discourse to adopt a positive attitude toward redevelopment and to celebrate public art as "socially responsible" and uniformly beneficial when it contributes to the "beauty" or "utility" of its newly redeveloped and gentrified urban sites. What needs to be questioned, the essay argued, is the social function of redevelopment itself and of the functionalist rhetoric surrounding it: the claim that objective, natural, or universal needs determine the uses of space neutralizes the political conflicts that actually shape urban spaces. "Uneven Development" drew on urban theory to analyze contemporary urban redevelopment as such a political struggle. Part of a global spatial restructuring that facilitates new forms of oppression and exploitation, redevelopment transforms cities in the interests of private profit and state control. The third section of "Uneven Development," which discusses the role of the so-called new public art in contemporary urban processes, is reprinted here with minor revisions.

Most existing aesthetic approaches can neither account for current conditions of public art production nor suggest terms for an alternative, possibly transformative practice. Even when they comprehend some of the problems of the public sphere or entail sophisticated materialist critiques of aesthetic perception, they are generally formulated with an inadequate knowledge of

158

urban politics. Needless to say, traditional art-historical paradigms cannot explicate the social functions of public art—past or present—since they remain committed to idealist assumptions that work to obscure those functions. Maintaining that art is defined by an independent aesthetic essence, prevailing doctrines hold that, while art inevitably "reflects" social reality, its purpose is, by definition, the transcendence of spatiotemporal contingencies in the universal, timeless work of art. Conventional social art history provides no genuine alternative. Frequently attracted to the study of public art because of what they perceive to be its inherently social character, social art historians, in keeping with the discipline's empiricist biases, confine themselves to describing either the iconography or the historical "context" of individual works, restricting meaning to the work's overt subject matter and relegating social conditions to the status of a backdrop. They thus preserve the idealist separation of art—its ontological status intact—from discrete social "environments" with which art merely "interacts." In addition, art history mystifies the "social environment" just as it does the work of art. With few exceptions, all tendencies within art history are informed by notions of the city as a transhistorical form, an inevitable product of technological evolution, or an arena for the unfolding of exacerbated individualism.[1]

More significantly, the present role of public art in urban politics also calls into question ideas informing some of the more critical perspectives on public art. Beginning in the late 1960s, contemporary art and criticism questioned modernist tenets of artistic autonomy by exploring art's social functions. In part, the critique was initiated by shifting attention away from the "inside" of the artwork—supposed in mainstream doctrine to contain fixed, inherent meanings—and focusing instead on the work's context—its framing conditions. Site-specificity, a technique in which context was incorporated into the work itself, originally developed to counteract the construction of ideological art objects, purportedly defined by independent essences, and to reveal the ways in which art is constituted by its institutional frame. Over the years, in what is now a familiar history, site-specificity underwent many permutations. Most fruitfully, context was extended to encompass the individual site's symbolic, social, and political meanings as well as the discursive and historical circumstances within which artwork, spectator, and site are situated. Insofar as this expansion stressed the social or psychic relations structuring artwork and site, exclusive concern with the physical site often signaled an academic fetishization of context at the aesthetic level. Critical site-specific art, as opposed to its academicist progeny, continued, however, not only to incorporate context as a critique of the artwork but

also to attempt to intervene, through the artwork, in its site. The reciprocity between artwork and site altered the identity of each, blurring the boundaries between them and preparing the ground for a greater participation of art in wider cultural and social practice. For public art, the alteration, rather than affirmation, of the site required that the urban space occupied by a work be understood, just as art and art institutions had been, as socially constructed spaces.

One of the most radical promises embodied in the public art that attempted to defetishize both art and urban space was the potential for artists and critics to articulate their aesthetic opposition to the spaces of art's reception with other elements of social resistance to the organization of the city. Such a step does not mean that art must relinquish its specificity as a political practice—as some realist or "activist" positions imply—but, rather, entails the recognition that art's identity is always modified by its encounter with its sites. It is, for example, insufficient to support site-specificity by simply stating that a work like Richard Serra's *Tilted Arc* intervenes in the city in order to redefine space as the site of sculpture;[2] the significance of the work's intervention also depends on the way in which art itself is redefined in the process. Without addressing the stakes of urban redefinition, *Tilted Arc* exhibits a combination of specificity and generalization that is symptomatic of the split it maintains between critical aesthetic issues and critical urban problems. On the one hand, the sculpture is undoubtedly wedded concretely to its site: it establishes its difference from surrounding architecture, engages and reorients spatial patterns, invites viewers into the space of the work, and traces the path of human vision across the Federal Plaza. Perhaps, as Douglas Crimp argues, positing *Tilted Arc* as an example of radicalized site-specificity, it metaphorically ruptures the spatial expression of state power by destroying the plaza's coherence.[3] It might also, as Crimp less speculatively suggests, reveal the condition of alienation in bourgeois society. These are the most provocative claims that have been made for *Tilted Arc* as a practice that addresses the material conditions of art's existence, and, although they identify a radical potential for public art, they tend, as an interpretation of Serra's work, toward exaggeration. For in its own way *Tilted Arc* still floats above its urban site. The lingering abstraction of the sculpture from its space emerges most clearly in the attitude the work and its supporters adopt toward urgent questions about the uses of public space.

Indeed, "use" was elevated to a central position in the debates about public art generated by the hearings convened in 1985 to decide whether Serra's sculpture should be removed from its site. The proper use of the site

became a banner under which crusades against the work were conducted; supporters countered with alternative uses. *Tilted Arc*'s most astute defenders problematized the assumptions about utility that justified attacks on the sculpture, challenging, as does the work itself, simplistic or populist notions of natural, self-evident uses. Yet, in proposing aesthetic uses for the space, isolated from its social function in specific circumstances, supporters substituted one ideological conception of use for another, perpetuating, as did the work's detractors, a belief in essential—noncontingent—uses of space. Moreover, the notion that *Tilted Arc* bestows on the Federal Plaza an aesthetic use that is simply accessible to all users ignores questions recently posed in numerous disciplines about differences among users and, further, about users as *producers*—themselves not unitary—of the environment. Phenomenological readings, placing subjective experience of space outside the sociomaterial conditions of the city, fail to see that the primary object of their study is already ideological. As French urban sociologist Raymond Ledrut writes: "The situation of man confronting the city involves other things than schemas of perceptive behavior. It introduces ideology."[4] Precisely because the ideology of spatial use was, in fact, never introduced, discussions about the work, despite the prominence they accorded to questions of use, remained aloof from critical public issues about the uses of space in New York today: oppositions between social groups about spatial uses, the social division of the city, and the question of which residents are forcibly excluded from using the city at all. These issues occupy the heart of urban politics. They were also the hidden agenda of neoconservative assaults on *Tilted Arc,* which, represented as an impediment to the beneficial uses of public space, became a foil for other kinds of public art that celebrate the dominant uses of space. Yet these questions remained unexcavated during the hearings because, confined within the boundaries of critical aesthetics, discussions failed to address the function of public art in contemporary urbanism—the social processes producing the city's tangible form. While they frequently entailed complicated materialist critiques of art's production and of aesthetic perception, they obstructed an interrogation of the conditions of production of New York's urban space.

Opening the question requires that we dislodge public art from its ghettoization within the parameters of aesthetic discourse, even critical aesthetic discourse, and resituate it, at least partially, within critical urban discourse. More precisely, such a shift in perspective erodes the borders between the two fields, disclosing the existence of crucial interfaces between art and urbanism in the subject of public art. The need for criticism to conceptualize this meeting ground is especially urgent now, since neoconser-

vative forces are appropriating that task in order to promote a type of public art that complies with the demands of redevelopment. "In fact," to quote just one journalist who has established the "new criterion" for public art, "public art needs to be seen as a function not of art, but of urbanism. It needs to be thought of in relation to, rather than insulated from the numerous other functions, activities and imperatives that condition the fabric of city life."⁵ The problem we face, then, is not so much the absence of any consideration of the city in current discourse about public art; it is rather the fact that this discourse perpetuates mythologized notions about the city. Typically, it claims to oppose cultural elitism while remaining committed to artistic quality, a claim that parallels the assertion that the redeveloped city provides quality public space. Consistent with these allegations, journalists promote a type of public art that is fully incorporated into the apparatus of redevelopment. My desire to approach contemporary public art as an urban practice is, then, an abstraction for heuristic purposes, but one that is motivated by the imperative, first, to respond to concrete events changing the function of public art and, second, to contribute to the formation of an alternative. An oppositional practice, however, must possess an adequate knowledge of the dominant constructions within which it works. In the case of public art it depends therefore on a critical perception of the city's metamorphosis and of the role public art is playing within it.

In 1988, Ed Koch, then the mayor of New York City, planned to deliver a speech before the American Institute of Architects' convention. Renewing a governmental commitment to urban aesthetics, he would declare that "once again, public art has become a priority."⁶ Koch never gave the prepared talk; he replaced it at the last minute with a question-and-answer session in which, responding to a question about Grand Central Terminal, he also substituted a utilitarian stance for his earlier speech's aesthetic approach to city space: the absolute purpose of the terminal to fulfill transportation needs negates—as any "reasonable" person knows—the right of homeless people to reside there.⁷ Yet the two talks are not as dissimilar as they might seem. For the statement in Koch's original speech, about his administration's interest in public art, was not just designed to draw attention to an increase in the number of public art commissions. It indicated an enhanced support for a qualitatively different kind of public art. And even though the statement about art was contained within a speech on aesthetics—the beautiful city—it could equally have supported the mayor's later remarks about utility—the well-managed city.⁸ In fact, the new public art illustrates the marriage of the two images in the redevelopment process.

What distinguishes the "new" public art in the eyes of its proponents

and, further, what renders it more socially accountable than the old is precisely its "usefulness." "What is the new public art?" asked an art journalist in one of the earliest articles reporting on the new phenomenon:

> Definitions differ from artist to artist, but they are held together by a single thread: *It is art plus function,* whether the function is to provide a place to sit for lunch, to provide water drainage, to mark an important historical date, or to enhance and direct a viewer's perception.[9]

From this indiscriminate list of functions it is difficult to ascertain precisely how the new public sculpture differs from previous types. Nineteenth-century war memorials, after all, commemorate important events, and *Tilted Arc,* against which the new art opposes itself, directs a viewer's perception. Yet advocates do specify, albeit confusedly, a quality that distinguishes the work of new public artists:

> All share a dedication to extra-aesthetic concerns. Use—not as in criticality but as in seating and tables, shade and sunlight—is a primary issue.[10] We are putting function back into art again.[11] This architectural art has a functional basis. Unlike most traditionally modern works of painting and sculpture, which modern artists were careful to define as "useless" in comparison to other objects of daily life, recent architectural art is often very much like a wall, a column, a floor, a door or a fence.[12]

Scott Burton—whose work, primarily pieces of furniture designed for public places, epitomizes the phenomenon—repeatedly declared that "utility" is the principal yardstick for measuring the value of public art.[13]

The new art, then, is promoted as useful in the reductive sense of fulfilling "essential" human and social needs.[14] Just as Koch designated Grand Central Terminal a place for travel, this art designates places in the city for people to sit, to stand, to play, to eat, to read, even to dream. Building on this foundation, the new art claims to unify successively a whole sequence of divided spheres, offering itself in the end as a model of integration. Initially setting up a polarization between the concerns of art and those of utility, it then transcends the division by making works that are both artworks and usable objects. Further, it claims to reconcile art, through its usefulness, with society and with the public benefit. Use, we are told, ensures relevance.

> As an artist working toward the social good, he [the public sculptor] produces works that are used by the populace, that inhabit its plazas, that are part of its plans for urban design and economic redevelopment—works that rapidly leave the environment of art to enter the realm of artifacts.[15]

Just as function is limited to utilitarianism, social activity is constricted to narrow problem solving, so that the provision of "useful" objects automatically collapses into a social good. "The social questions interest me more than the art ones," said Scott Burton, describing his furnishings for the Equitable Assurance Building, whose function in raising real estate values remains thoroughly unexamined. "I hope that people will love to eat their lunch there."[16] And, he continued, "Communal and social values are now more important. What office workers do in their lunch hour is more important than my pushing the limits of my self-expression."[17]

The conflation of utility with social benefit has a distinctly moralistic cast: "All my work is a rebuke to the art world,"[18] Burton stated. Critics agree: "[Scott Burton] challenges the art community with neglect of its social responsibility. . . . Carefully calculated for use, often in public spaces, Burton's furniture clearly has a social function."[19] All these purported acts of unification, predicated as they are on prior separations, conceal underlying processes of dissociation. Each element of the formula—art, use, society—first isolated from the others, has individually undergone a splitting operation in which it is rationalized and objectified. Art possesses an aesthetic essence; utilitarian objects serve universal needs; society is a functional ensemble. They all surmount specific histories, geographies, values, relations to subjects and social groups, to be reconstituted as abstract categories. Individually and as a whole, they are severed from social relations, fetishized as external objects. This is the real social function of the new public art: to reify as natural the conditions of the late capitalist city into which it hopes to integrate us.

The supreme act of unification with which the new public art is credited, however, is its interdisciplinary cooperation with other professions shaping the physical environment.

> The new public art invariably requires the artist to collaborate with a diverse group of people, including architects, landscape architects, other artists and engineers. So far, most of the public artists have had few problems adjusting to the collaborative process; indeed, many have embraced it with enthusiasm.[20]

"Few might have guessed that these collaborations would so seriously affect the art, design and planning professions in such a short time,"[21] writes one critic with surprise. Yet, given the fact that the new public art rallies all the notions that currently inform the planning of redevelopment, it is hardly surprising, if not in fact completely predictable, that such work should be fully integrated into the process of designing New York's redeveloped

spaces. Presented as beautiful, useful, public, and expertly produced, it advertises these environments as images of New York's "ascendancy."[22] Indeed, the rise of collaborative public art accompanied the acceleration of urban redevelopment almost from its inception. In 1981 John Beardsley concluded his survey of "community-sponsored" art projects, *Art in Public Places*, by identifying a recent shift in artistic attitudes. "A new kind of partnership is emerging between contemporary artists and the nation's communities," he explained in a chapter entitled "New Directions: Expanding Views of Art in Public Places,"

> with the result that artists are increasingly involved in significant development efforts. In part, this is a consequence of new initiatives within cities. As an element of major building programs in the last decade and a half, some have sought the participation of artists in developing innovative solutions to public design problems.[23]

Since their emergence in the late 1970s, public art collaborations have grown to such an extent that they now dominate accounts of public art. "This is a season," writes Michael Brenson,

> that is bringing the issue of artistic collaboration to a head. Over the past few years a great deal of hope has been invested in the partnership between sculptors and architects, and between sculptors and the community. There is a widespread feeling that this is the future of public sculpture and perhaps for sculpture in general.[24]

The consistent invocation of "the community" in passages such as these typifies the terminological abuses pervading discussions of public art and endowing the new type with an aura of social accountability. That Beardsley's book consistently describes government-funded art as "community-sponsored" is especially ironic since the "new initiatives within cities" and "major building programs" he mentions as the impetus for collaborations frequently constitute state interventions in the environment, interventions that destroy minority and working-class communities and disperse their residents. *Community* conjures images of neighborhoods bound together by relations of mutual interest, respect, and kinship; *community-sponsored* connotes local control and citizen participation in decision making. But it is community, as both territory and social form, that redevelopment destroys, converting the city into a terrain organized to fulfill capital's need to exploit space for profit. If anything, clashes, rather than confluence, between communities and state-imposed initiatives are more likely to characterize urban life today.

Inaccuracies of language, demonstrating indifference to the issues of

urban politics, resemble other distortions pervading discourse about public art collaborations, distortions that confuse the issues of aesthetic politics as well. Like the appropriation of urban discourse, these misrepresentations use the vocabulary of radical art practice to invest the recent marriage of art and urban planning with a social justification. The new public art is deemed to be antiindividualist, contextualist, and site-specific. Collaborative artists may voice a lack of concern with private self-expression and, thereby, an opposition to the autonomy and privilege of art. As part of urban design teams, they also reject notions of public art as "decoration," because, as they contend, they are not merely placing objects in urban spaces but creating the spaces themselves. If writers such as Beardsley single out "new initiatives within cities" as one factor contributing to the growth of public art collaborations, they find a second crucial factor in developments within contemporary art itself.

> In part, it [the shift to public art partnerships] follows as well from the increasingly interdisciplinary character of contemporary art. . . . There is a pronounced shift in these projects from the isolated object to the artwork integrated with its environment and from the solitary creator to the artist as a member of a professional team.[25]

Of course, the new public art is born of recent tendencies within urbanism and art practice. To say so tells us very little. Genuine explanation hinges on understanding the nature of each of these developments and of their interaction. The new art's promoters misconceive both sources of the new public. The difference between their version of site-specificity and its original meaning is obvious and needs only to be summarized here.

Commitment to developing an art practice that neither diverts attention from nor merely decorates the spaces of its display originated from the imperative to challenge the neutrality of those spaces. Contextualist art intervened in its spatial context by making the social organization and ideological operations of that space visible. The new public art, by contrast, moves "beyond decoration" into the field of spatial design in order to create, rather than question, the site, to conceal its constitutive social relations. Such work moves from a notion of art that is "in" but independent of its spaces to one that views art as integrated with its spaces and users but in which all three elements are independent of urban politics. Simply combining twin fetishisms, this public art is instrumental for redevelopment. One critic, for instance, delineating "a right way and a wrong way to insert art in public places," has written, regarding a collaborative art project in New York that she believes exemplifies the "right way," that it

represents the gentrification of site art—it's been successfully, even brilliantly, tamed, its sting removed. You can sometimes miss the good old days when artists were fierce individualists wrestling the wilderness to its knees, like Dan'l Boone with the bear; the "otherness" of art out on the American desert touched some mythic nerve. But times have changed. The two traditions—the gentrified and the wild—can't be mixed.[26]

This statement constructs false dualisms that displace genuine differences. What has been eliminated from the new "site-specific" art is hardly "individualism," as opposed to teamwork, but political intervention in favor of collaboration with the forces of power. The measure of just how depoliticized this art has become—and how political it actually is—under the guise of being "environmentally sensitive" is the author's assumption that gentrification is a positive metaphor for changes in art practice. As anyone really sensitive to New York's social landscape realizes, however, the prior symbolization of gentrification as the domestication of wild frontiers profoundly misapprehends the nature of the phenomenon. Gentrification only appears to result from the heroic conquest of hostile environments by individual "pioneers"; in truth, as Neil Smith writes, "It is apparent that where the 'urban pioneers' venture, the banks, real-estate companies, the state or other collective economic actors have generally gone before. In this context it may be more appropriate to view the James Rouse Company not as the John Wayne but as the Wells Fargo of gentrification."[27] The depiction of gentrification—a process that replaces poor, usually minority, residents of frequently well-established neighborhoods with middle-class residents—as the civilization of wild terrains is not only naive about economics but an ethnocentric and racist conceit as well. The use of this conceit in art criticism epitomizes the arrogance inherent in aesthetic practices claiming to respond to urban environments while lacking a commitment to comprehend them.

Instead, absorbing dominant ideology about the city, proponents of the new public art respond to urban questions by constructing images of well-managed and beautiful cities. Theirs is a technocratic vision. Insofar as it discerns a real problem—the loss of people's attachment to the city—it reacts by offering solutions that can only perpetuate alienation: the conviction that needs and pleasures can be gratified by expertly produced, professionally "humanized" environments. The incapacity to appreciate that the city is a social rather than a technical form renders this perspective helpless to explain a situation in which the system that produces, for purposes of profit and control, a city dissociated from its users, today, for the same reasons, literally detaches people from their living space through eviction

and displacement. Under these circumstances, the technocratic view is left with limited options: encouragement of these actions, disavowal, or dismissal of homelessness as an example of how the system fails rather than, more accurately, how it currently works. A belief in society's "failure" can generate a resigned abandonment of the most troubling facts of city life, justifying support for the use of the city for economic growth, perhaps modified by degrees of regulation. One urban designer, dedicated to institutionalizing urban design as a technical specialty and arm of public policy, freely acknowledges, for instance, that gentrification and historic preservation displace "earlier settlers" in city neighborhoods. He suggests measures to "mitigate the adverse effects of social change in historic districts. However," he succinctly concludes, "the dynamics of real estate in a private market always mean that someone profits at someone else's expense. On balance, the preservation and restoration of old neighborhoods has to be considered valuable for the economic health of a city, even if there is hardship for individuals."[28] Confident that the dominant forces producing today's city represent the collectivity—while members of displaced social groups are mere individuals—and, despite references to "social change," that such forces are immutable, interdisciplinary urban design teams—which now include public artists—fashion the mental and physical representations of New York's ascendancy. To do so, they must suppress the connection between redeveloped spaces and New York's homelessness.

Notes

Author's note: "Uneven Development: Public Art in New York City" was an interdisciplinary attempt to understand the social functions of contemporary public art by combining recent aesthetic and urban discourses. The article identified what seemed to be parallel developments in the two disciplines since the late 1960s: the growth in art criticism of a "social production of art" perspective and the simultaneous unfolding of a "social production of space" thesis in urban studies. The fourth section of the article, "The Social Uses of Space," elaborated this connection and, in order to understand public art's new urban sites, summarized materialist urban theories that explain spatial organization as a political process. Recently, there have been several other efforts to bring together urban and aesthetic disciplines. Some prominent urban scholars along with cultural critics using spatial theory have, for instance, published books that promulgate theories of postmodern culture. However, these works establish an adversarial relationship between developments in the two disciplines. Placing materialist urban analysis in the service of a totalizing social theory, they turn their attention to art only to defend that theory

against the challenges raised by recent cultural practices (as well as by new social movements and political philosophies). Remaining unaware of the complexity (or, in some cases, even the existence) of materialist aesthetic discourse, failing to differentiate among diverse art practices, and ignoring current redefinitions of culture, they implicitly or explicitly criticize—indeed condemn—"postmodern" art and especially feminist critiques of representation as fragmenting forces. For a discussion of these new urban/aesthetic ventures that, without denying the importance of a political-economic approach to urban space, criticizes them as authoritarian, see my "Men in Space," *Artforum* (February 1990), pp. 21–23; and "Boys Town," *Society and Space*, Environment and Planning D, vol. 9 (1991), pp. 5–30.

1. For a discussion of the concept of "the urban" that informs art history, see Rosalyn Deutsche, "Representing Berlin: Urban Ideology and Aesthetic Practice," in *The Divided Heritage: Themes and Problems in German Modernism*, ed. Irit Rogoff (Cambridge: Cambridge Univ. Press, 1991), pp. 309–340; and Deutsche, "Alternative Space," in *If You Lived Here: The City in Art, Theory, and Social Activism: A Project by Martha Rosler*, ed. Brian Wallis (Seattle: Bay Press, 1991), pp. 45–66.

2. Douglas Crimp, "Serra's Public Sculpture: Redefining Site Specificity," in *Richard Serra/Sculpture*, ed. Rosalind Krauss (New York: Museum of Modern Art, 1986), p. 53.

3. Ibid., pp. 53–55.

4. Raymond Ledrut, *Les images de la ville* (Paris: Anthropos, 1973), p. 28.

5. Eric Gibson, "Public Art and the Public Realm," *Sculpture* 7 (January–February 1988), p. 32.

6. "Remarks by Mayor Edward I. Koch at Awards Luncheon of the American Institute of Architects," May 18, 1988.

7. For a discussion of Koch's substitution and a brief account of each talk, see Deutsche, "Uneven Development," pp. 5–9.

8. The role of these images—the beautiful city and especially the well-managed city—in legitimating uneven patterns of urban growth such as redevelopment in the 1980s is discussed in the first section of "Uneven Development," "Beauty and Utility: Weapons of Redevelopment," pp. 3–9.

9. Douglas C. McGill, "Sculpture Goes Public," *New York Times Magazine*, April 27, 1986, p. 45.

10. Nancy Princenthal, "On the Waterfront: South Cove Project at Battery Park City," *Village Voice*, June 7, 1988, p. 99.

11. Nancy Holt, quoted in McGill, "Sculpture Goes Public."

12. Robert Jensen, "Commentary," in *Architectural Art: Affirming the Design Relationship* (New York: American Craft Museum, 1988), p. 3.

13. See Gibson, "Public Art and the Public Realm."

14. Essentialist concepts of spatial use and the way they operate to deny and perpetuate existing power relations are discussed in the first section of "Uneven Development." Urban theories of the social production of space are summarized in the fourth section, "The Social Uses of Space," pp. 23–30.

15. Kate Linker, "Public Sculpture: The Pursuit of the Pleasurable and the Profitable Paradise," *Artforum* 19 (March 1981), p. 66. Linker's article recognizes

the functions of the new public art in raising the economic value of its sites but, perhaps because it was written at an early stage in the contemporary redevelopment process, remains uncritical and does not address the social consequences of this function.

16. Quoted in McGill, "Sculpture Goes Public," p. 63.

17. Ibid., p. 67.

18. Quoted in Princenthal, "Social Seating," *Art in America* 75 (June 1987), p. 131.

19. Ibid.

20. McGill, "Sculpture Goes Public," p. 66.

21. Diane Shamash, "The A Team, Artists and Architects: Can They Work Together," *Stroll: The Magazine of Outdoor Art and Street Culture*, nos. 6–7 (June 1988), p. 60.

22. The term *ascendancy* refers to *New York Ascendant,* a report generated by the mayor's Commission on the Year 2000 (New York: Harper & Row, 1988) and discussed at the beginning of "Uneven Development" as an example of one prevalent approach to redevelopment. As its title suggests, this optimistic document depicts redevelopment as a uniformly beneficial process which, in time, will unfold its advantages to all New York's residents. *New York Ascendant* does acknowledge the increased visibility of poverty and homelessness in the city, but it also epitomizes a standard response to these phenomena: recognizing, even deploring, the existence of urban "social problems," *New York Ascendant* isolates them from the hierarchical differentiation of social groups and spaces that is the condition of urban growth under capitalism. Failing to understand that residential components of prosperity—gentrification and luxury housing—are not distinct from, but in fact depend upon, residential facets of poverty—disinvestment, eviction, displacement, homelessness—*New York Ascendant* treats homelessness only as an accidental by-product of redevelopment, a problem that can be solved by more "growth." It thus prescribes a cure that is to a great extent actually the cause of homelessness. See "Uneven Development," pp. 4–5.

23. John Beardsley, *Art in Public Places: A Survey of Community-Sponsored Art Projects Supported by the National Endowment for the Arts* (Washington, D.C.: Partners for Livable Places, 1981), p. 81.

24. Michael Brenson, "Outdoor Sculptures Reflect Struggles of Life in the City," *New York Times,* July 15, 1988, pp. C1, C28.

25. Beardsley, *Art in Public Places,* p. 90.

26. Kay Larson, "Combat Zone," *New York,* May 13, 1985, p. 118.

27. Neil Smith, "Gentrification, the Frontier, and the Restructuring of Urban Space," in *Gentrification of the City,* ed. Neil Smith and Peter Williams (Boston: Allen and Unwin, 1986), pp. 18–19.

28. Jonathan Barnett, *An Introduction to Urban Design* (New York: Harper & Row, 1982), p. 46.

PART III

Public Art and Public Response

The very concept of public art, defined in any meaningful way, presupposes a fairly homogenous public and a language of art that speaks to all. These two prerequisites were never present in the United States. Western European art was, for the most part, the art of monarchs and the church, not the product of a democratic society. Understandably, there were conflicting attitudes surrounding a tradition of art that is elitist in origins but still admired by many. Art was from the nation's beginnings surrounded by an aura of ambivalent distrust and admiration, and it has been viewed by a heterogenous audience with mixed feelings ever since. Art has never been an integral part of our public education curriculum.[1] (In a budget crunch, it is still the first item to be cut, if it was present at all.) In the context of a Protestant work ethic, it is an unnecessary frill. Seen from the vantage point of economic underclasses, public art is affirmation of their exclusion from power and privilege. Art in the public domain, a sign of the power of its patrons, frequently becomes the focus for discontents that often have nothing to do with the art. Small wonder that public art and controversy seem to have been joined at birth.

This phenomenon is not unique to public art in this country or to modern public art.[2] In centuries past, as one monarchy was overthrown so were the sculptural representations of its ruler. Recently, such was the fate of statues of Lenin in the former Soviet Union and Eastern Europe. Public response to public art is also problematic when the form or subject of the art is not immediately accessible to its audience. It then becomes even more difficult to separate the art and the non-art issues. For instance, Frederick MacMonnies's *Civic Virtue,* a monumental fountain for Manhattan's City Hall, conceived in 1891 in the style of the American Renaissance (typified

by the 1893 World's Columbian Exposition), was later caught in what Michele Bogart describes as "an atmosphere of distrust toward public statuary [that] had surfaced after World War I." Between its conception and its eventual installation in 1922, politics as well as attitudes toward art had changed. With Virtue depicted as male and Vice as female, the sculpture was anathema to suffragettes, who had only recently obtained the vote. This literal reading of an allegorical sculpture prefigured similar interpretations of later abstract works. As such, this interpretation grasped an essential element of the content, not recognized at the time of its conception. Bogart analyzes the complicated web of political agendas that ensnared the sculpture as it made its way through New York City bureaucracy during a period of changing values.

Although it is not surprising from a contemporary vantage point to contemplate *Civic Virtue* as the object of controversy, it is nothing short of shocking to discover that New York's "library lions" were also much maligned in their day. Probably the city's most popular sculptures, a frequently designated meeting place, they announce the Christmas season with their annual wreaths as clearly as the Rockefeller Center tree. What problems could there possibly have been with the city's favorite cats? Susan Larkin demonstrates that the sculptures suffered from their artist's remote personality (who today remembers the name of Edward Clark Potter?), the problems surrounding the building of the library, and the choice of the animals themselves. Then, when the preliminary sketches were made public, they were ridiculed by the popular press (also a continuing problem for contemporary public art). As Larkin traces the lions' transformation from scapegoats to mascots, it becomes clear that the history of public art is vulnerable to many extraneous forces.

When the subject of public art itself is controversial, its fate is even more precarious. Joseph Disponzio traces the fate of George Segal's sculpture *Gay Liberation,* which initially aroused strong objections from its intended Greenwich Village community and later became the object of a power struggle within the gay community. Finally, it could only be sited on the neutral turf of a university, in this instance Stanford. A similar fate befell Segal's sculpture to commemorate the violence at Kent State University, which was finally sited at Princeton next to the chapel, where the religious allusion (to Abraham and Isaac), rather than specific political references, was emphasized. In both instances individuals at the intended sites were directly involved in the issues that the sculptures addressed and had their own ideas of how they should be represented or if they should be commemorated at all.

In this country, race is as potentially provocative as sexual preference. Robert Graham's *Monument to Joe Louis,* the widely admired black boxer who held the world heavyweight title from 1937 to 1950, engendered a controversy that had issues of racial ideology at its core. As Donna Graves shows, sponsorship of the monument to the Detroit-born boxer was motivated by public relations concerns of both the actual patron, *Sports Illustrated,* and the Detroit Institute of Arts, which received the funds to commission the sculpture. Furthermore, the relative secrecy in which the commission evolved subsequently aroused the anger of the community, a common occurrence with public art independent of the form a commission may finally take. However, Graham's sculpture of a clenched fist proved particularly provocative, open to a wide variety of interpretations, some of them far from the artist's or patron's intent.

In a public arena, audience response is not restricted to an art context. In fact, art or aesthetic concerns are frequently irrelevant. As Danielle Rice shows in "The 'Rocky' Dilemma: Museums, Monuments, and Popular Culture in the Postmodern Era," the public's taste in monuments may be radically at odds with that of the culture establishment (artists, critics, or curators). After completing the filming of *Rocky III,* Sylvester Stallone donated the prop of the Rocky statue to the city of Philadelphia with the hope that it would remain in front of the Philadelphia Museum of Art. This placement, however, dramatically established a direct confrontation between so-called high art and popular culture, raising a host of difficult questions about the place of public art in a democracy. The ensuing controversy addressed none of these issues directly; rather it used bureaucratic means to sidestep them. Although Rice recounts a wonderfully fantastic ending to the real-life story, the conflict between the widespread appeal of popular culture (the movies) and the more limited accessibility of art (the museum) has yet to be resolved. It is in the arena of public art that this conflict so often erupts, with no side emerging victorious.

To understand the various hostile responses to public art in our culture, it is necessary to take a more analytical look at the objections themselves. Thus, Harriet F. Senie's "Baboons, Pet Rocks, and Bomb Threats: Public Art and Public Perception" probes some typical responses to get beyond the flip comparisons to the fundamental contradictions embedded in the very idea of public art. In moving our focus from the issue of controversy to that of public response, we get a clearer sense of what is really at stake: not aesthetic concerns about the art itself (although that is how the issue is most frequently expressed) but the various things it stands for in the public's mind at any given time or place.

Notes

1. The place of art education in our public schools has been the subject of a number of important recent studies. See, for example, *Coming to Our Senses: The Significance of the Arts for American Education* (New York: McGraw-Hill, 1977), a panel report, David Rockefeller, Jr., chairman; *Beyond Creating: The Place for Art in America's Schools* (Los Angeles: Getty Center for Education in the Arts, 1985); and *Toward Civilization: A Report on Arts Education* (Washington, DC: National Endowment for the Arts, 1988).

2. See, for example, Albert Elsen, *Rodin's Thinker and the Dilemmas of Modern Public Sculpture* (New Haven: Yale University Press, 1985). The historical problem of public art and its audience is addressed by Marianne Doezema and June Hargrove, *The Public Monument and Its Audience* (Cleveland: Cleveland Museum of Art, 1977). See also Gerald Nordland, *Controversial Public Art from Rodin to di Suvero* (Milwaukee Art Museum, 1983), which documents the controversies surrounding works by artists as diverse as Auguste Rodin, Aristide Maillol, Diego Rivera, Thomas Hart Benton, Pablo Picasso, Claes Oldenburg, George Segal, Robert Arneson, and Mark di Suvero, among others.

11

The Rise and Demise of Civic Virtue

MICHELE H. BOGART

The achievements of American sculptors at the World's Columbian Exposition had held out bright hopes that there were to be no limits to their expressive reach. At this fair, a new generation of French-trained professionals had created an extraordinary panoply of temporary statues and architectural sculptures depicting allegorically everything from the Progress of Transportation to Bison and Indian Corn, and American sculptors felt they had every reason to assume that these rich artistic opportunities would continue in more permanent form. In New York City, events of the first fifteen years of the century reinforced these convictions. Despite the political and organizational conflicts surrounding various sculptural projects, and despite some frustrating setbacks to their civic beautification efforts, sculptors steadily obtained commissions for important public works. Official receptiveness to public sculpture was at a peak around 1910. Artists and civic reformers, optimistic that Progressive and City Beautiful principles would prevail, continued to plan sculptures and monuments to celebrate their imminent triumph.

The most notorious sculptural assertion of Progressive values was *Civic Virtue*, a monumental public fountain by Frederick MacMonnies. First conceived in 1891, it was commissioned for the grounds of Manhattan's City Hall in 1909, but not erected until 1922. This project typified not only the underlying message of New York civic sculpture but also its fate. For while the fountain was ultimately completed, its numerous problems reflected the breakdown of Progressive ideals. Their weakened influence was manifested in the responses to MacMonnies's allegorical imagery.

An atmosphere of distrust toward public statuary had surfaced after

Frederick MacMonnies, *Civic Virtue,* 1922, City Hall Park, New York, NY.
(Photo: United States History, Local History & Genealogy Division, The New
York Public Library, Astor, Lenox and Tilden Foundations)

World War I. In the case of *Civic Virtue,* suspicion turned into downright hostility. In the earlier case of *Purity,* a small number of outsiders created a situation that encouraged negative and ambiguous interpretations. With *Civic Virtue,* the schism between artistic intention and the public's interpretation extended to a wider segment of the middle class. This worsened sculptors' ongoing problems of exerting influence and of acquiring institutional support. The outcries against it were symptomatic of the disintegration of what had once been, among middle-class Americans, an unchallenged belief in the meaningful correspondence of sculptural representation and allegorical content. In responding to *Civic Virtue,* much of the viewing public passed over the interpretation that the sculptor hoped they would "receive." In short, they missed the abstract concept, and read the image literally. Taken this way it was a scandalous depiction of a male trampling two females who, to make matters worse, were supposed to represent Vice. This in turn generated a different, more topical, set of meanings—the battle between the sexes and the oppression of women. Much of the contemporary viewing audience was more sensitive to this sexually charged reading than to the interpretation MacMonnies ascribed to the work. Many people questioned not only the politics of this imagery but the representation itself.

The sculptor had difficulty comprehending that the relationship between the allegorical image and its (signified) content was no longer necessarily meaningful and, moreover, that there could now be no assurance that the public would ever permit it to become so. To MacMonnies, the vociferous negative reaction seemed the unfortunate consequence of an overly literal reading of the image and a misreading of its allegorical significance. Many New Yorkers, particularly those supporting women's suffrage, did tend to stress the literal aspects of MacMonnies's rendering. But the group seemed offensive to them because its imagery carried an emotional charge whether it was read "figuratively" (as Civic Virtue) or "literally" (as a man trampling a woman). It elicited complex responses that were not the ones that the artist himself had consciously intended to convey.

For suffragists, *Civic Virtue* and its "language" of representation embodied a male-constructed vision of the world and of sexual differences no longer grounded in fact. By 1922, the intent of allegorical personifications could no longer necessarily be taken as self-evident.

The history of *Civic Virtue* spanned almost the entire period of New York civic sculpture. In her will of 1891, Mrs. Angelina Crane, a widow, had bequeathed about $52,000 to the City of New York to erect a drinking fountain in her memory.[1] The inception of the work thus represented part

of the first wave of enthusiasm for urban beautification. But the delays that followed both on the part of the sculptor and of the city also typified what frequently occurred with public sculpture commissions. The executor handed the funds over to the municipality in 1901, but the city took no measures to spend the money until 1908; the sculptor did not finish the model until 1914. As already mentioned, the statue was not installed until 1922.[2] It epitomized the frustrations encountered both by art organizations and sculptors in trying to exert influence and to maintain consistent official recognition. City officials snubbed the artistic experts by assigning a site for the new fountain without consulting the Art Commission first. Although the National Sculpture Society had expressed interest in being involved with the commission, Mayor George B. McClellan took matters into his own hands and selected the eminent sculptor Frederick MacMonnies, who had been living in Giverny, France, for some years. While MacMonnies certainly kept up with what was going on in New York, he had participated little in the NSS's municipal improvement activities. Thus his selection could not have represented much of an acknowledgment of that organization's importance.[3]

McClellan had not anticipated that it would take MacMonnies nearly six years just to complete his designs. The city, which advanced the sculptor $10,000 when he signed his contract in 1909, began to get impatient, and in early 1914 the park commissioner began to insist that MacMonnies finish his work.[4] Citing commitments to other projects as the reason for his delay, MacMonnies promised to have his work completed by November. Actually, he submitted a completed design scheme in early October.[5] The plans called for the fountain to replace an old, "outdated" fountain in the southeast corner of City Hall Park near municipal offices. MacMonnies's finished scheme called for a twenty-eight-foot-wide, fifty-seven-foot-high sculptural fountain and a series of basins with decorative jets and overflows. The main portion of the fountain would depict civic virtue. According to MacMonnies, it would consist of allegorical groups, "the principal one" of which would be supported by "American mountain lions." A young man with a sword representing civic virtue, justice, order, and peace would be rendered "as having caught the siren vice in her own nets."[6]

While MacMonnies thought he had finished his plans successfully, he soon encountered difficulties. First, between 1914 and 1919, the Art Commission repeatedly disapproved his designs. The 1914 Art Commission subcommittee assigned to judge this project (Karl Bitter; John A. Mitchell, an editor of *Life Magazine;* and manufacturer Frank L. Babbott) had no objection to the subject matter or to MacMonnies's proposed imagery. But

they found the fountain's bulk, the shape of its basins, the size of its figure, and even its "general style" all problematic. In their view the work did not relate properly to its surroundings or to City Hall. Bitter wrote informally to MacMonnies, urging him either to submit a completely new design or, if not, to take his chances with a new Art Commission the next year. However, pressured by the Park Department to finish, MacMonnies ignored Bitter's advice. He went ahead and submitted his design to the current Art Commission, which promptly disapproved it.[7]

Having lost this first official round, MacMonnies asked architect Thomas Hastings—for whose New York Public Library he had just finished modeling sculptures of *Beauty* and *Truth*—for help in developing a new plan. A year later Hastings submitted new designs, which the new Art Commission subcommittee (sculptor Hermon MacNeil, art historian I. N. Phelps Stokes, and architects Henry Bacon and Jules Guérin) approved. However, it took MacMonnies another four years to revise his models for the sculpture.[8]

In 1919 yet another Art Commission approved the general design, but now the subcommittee (sculptor Edmond T. Quinn, architect Henry Bacon, author Luke Vincent Lockwood, and painter Henry Watrous) objected to the statue's gigantic size. MacMonnies argued that only a huge statue could harmonize in scale with the growing numbers of "colossal" buildings in the City Hall area. Unconvinced, the commission took the unprecedented step of having a full-size silhouette of the sculpture, central pedestal, and basin erected *in situ* in early October so that they could inspect the work in context.[9] After examining the silhouette the subcommittee still insisted that MacMonnies and Hastings reduce the height of the entire structure. The commission and Department of Parks approved the final designs in October 1919, but it took the firm of Piccirilli Brothers until 1922 to finish carving the huge group in marble and to have the work installed.[10]

The finished *Civic Virtue* consisted of a stern-looking male Virtue with a sword resting on his shoulder, standing astride two female figures representing vice and lying amidst sea creatures at Virtue's feet. Far from being a simple memorial drinking fountain, as Mrs. Crane had stipulated in her bequest, the sculpture was a monumental mythification of the pursuit of good city government. The emphasis on virtue and its representation were by no means new. But as conceived at this particular time, the notion of civic virtue had acquired a special importance for municipal reform crusaders.

MacMonnies's own discussions of *Civic Virtue* indicate that he was very much in touch with these sorts of concerns. Discussing his search for a motif that would be especially appropriate for the City Hall site, the

sculptor determined that whatever he depicted would have to suggest that the men governing the city were honest and had the strength to uphold the city's laws and its dignity even in the face of constant lures to stray from these "straight" paths into "devious ways."[11] His moralizing rhetoric echoed that of Progressive reformers like Theodore Roosevelt, who in such books as *The Strenuous Life* described existence as a continuing struggle for "righteousness," strength, and courage—a "ceaseless contest with the forces of evil."[12] Like Roosevelt, MacMonnies drew clear-cut distinctions between virtue and vice.

"What concrete image could best suggest these reflections?" he had asked. His solution: "youth with its transparent simplicity, directness, idealism, expressed in figure and attitude; the unspent strength of a young man; [and] the sword, original authority back of all law ... purposefully shortened to suggest that it has become the symbol of law rather than the active instrument of justice it once was in the brutal days." The youth would hold the sword not just "as any one would hold a weapon of war, but rather as one would wear an insignia of office." In a "secondary action," the youth would be freeing "himself almost unconsciously from the snares thrown around him." They would drop "away from him without much effort on his part." Hence Virtue

> looks out into the distance so concentrated on his great ideal that he does not even see the temptation. To suggest this temptation, its dual nature which dazzles while it ensnares, its charm and insinuating danger, one thinks of the beauty and laughter of women; the treachery of the serpent coils of a sea creature wrapped around its prey. These lovely sea women coil themselves about their victim. Their scaly, sinuous tails entwine him. With one hand, each one draws about him the net disguised in tangled seaweed; with a smile on her lips one holds, half hidden, a skull, sinister suggestion of disillusionment and death. The other hides her face as we hide all dark designs. They entirely surround him, but he steps out triumphantly and places his foot on a firm rock. Below him lies the wreck of a ship which had sped gaily, its proud figurehead of victory overturned—torn shreds of hope.[13]

Like Roosevelt, MacMonnies conceived of civic virtue in totally masculine terms. To be virtuous was a sign of strength and virility. The "goodness" that in Roosevelt's words was "whatever is fine, straightforward, clean, brave, and manly" was conceived by the sculptor as (male) "youth with its transparent simplicity, directness, [and] idealism." The resemblance between the muscular, youthful figure and Michelangelo's *David* also seemed appropriate; indeed the likeness was deliberate, for *Civic Virtue* was to represent the "modern idea formerly expressed in the figures of Saint

Michael, Saint George and the Bragon [*sic*] and also David and Goliath."¹⁴ *David,* which stood in front of the Palazzo Vecchio, had become a powerful symbol of the city of Florence. Inspired by the great *David, Civic Virtue* seemed a model of civic and sculptural propriety. There was also particular significance in the conception of vice as female, as a "temptation" that "dazzles while it ensnares" and that virtue must ignore at all costs. The image appeared in the immediate aftermath of antiprostitution and antivice campaigns. New York's Committee of Fifteen, established in 1900, had been the country's first vice commission, and was at the forefront of the movement. Later, with the support and funding of John D. Rockefeller, Jr., groups like the Bureau of Social Hygiene (founded 1911) conducted all-out battles to control prostitution. They presented themselves as being constantly on guard to ferret out the dens of sin and to protect poor women and young men from the evils of temptation.¹⁵ Indeed, MacMonnies's conception of what was high-minded seemed unexceptional in 1914. He could hardly have been prepared for the political strife that would surround *Civic Virtue* eight years later.

During the war, women's groups had struggled hard, and ultimately successfully, for passage of the Nineteenth Amendment. By 1920 they had the vote and a new degree of political power, and were especially sensitive to what appeared to them to be the survival of obsolete attitudes about the status of women.

In late February 1922, before the fountain's imminent installation in City Hall Park, newspapers published several articles with illustrations of the statue. With titles such as "Civic Virtue Statue, a Youth with a Club Soon to Menace Sirens in City Hall Park," the articles were bound to make politically conscious women take notice. Even before its official unveiling in April 1922, the statue began to provoke indignant outcries from several women's groups, who argued that MacMonnies had degraded women by representing the youth with his foot at the head of a "prostrate temptress."¹⁶ Mary Garrett Hay, head of the National League of Women Voters, led the ranks of those objecting to MacMonnies's depiction of Civic Virtue as male, and Vice as female. "In this age," she argued, "woman should be placed not below man but side by side with him in any representation of Civic Virtue."¹⁷ Indeed, while it was unlikely that MacMonnies was aware of the dispute over *Purity,* those who recalled it must have noted a certain irony in the use of the female form to represent both Virtue (with irony) and Vice.

New York politicians, newly conscious but uncertain about women as a political force, suddenly became concerned about the imagery of *Civic Virtue.* Tammany-supported mayor John Hylan had already fueled the fires

of discontent by making snide comments about the statue as early as late February. As protests by supporters of women's suffrage and other groups mounted, Hylan acted quickly to identify himself with the popular side of this heated issue. In mid-March, he demanded threateningly to know whether any of his appointees to the Art Commission had been involved with the approval of the statue.[18] The mayor then called for a Board of Estimate hearing, over which he would preside, to determine whether the Art Commission, in approving the statue for the site, had "overreached its artful eye."[19]

Responding to the mayor, Deputy Controller Henry Smith (who as park commissioner under the earlier McClellan administration had approved the choice of MacMonnies as sculptor) strongly objected on the grounds that the Board of Estimate had no jurisdiction over this matter. But Hylan, anxious to appear to be the defender and protector of the rights of (newly enfranchised) women, insisted that as the representative of the people the Board of Estimate did have jurisdiction and that the meetings would be held.[20]

At the hearings, opinions were expressed by the members of women's organizations and by individual supporters of the statue. These included a public school teacher, NSS members, several municipal officials who had held office in McClellan's administration, and other women, such as National Women's Party member Elizabeth King Black. The atmosphere was described as less than dignified. Some felt that the work looked stylistically incongruous. A "Florentine" statue looked wrong in conjunction with a "colonial style" City Hall and, moreover, blocked the view of it. But most of the negative argument centered on MacMonnies's depiction of Civic Virtue and Vice. Many of the statue's critics viewed this choice as wholly inappropriate not only because in the nineteenth century Virtue had usually been depicted as female but also because it was totally out of line to show women "just sprawling and crawling beneath the feet of man." Saint Catherine's Welfare Association president Sarah McPike pointed out her fear that "many people would interpret literally the statue of a man thrusting his toes on a woman's neck."[21]

Indeed, in spite of his careful allusions to earlier images of civic virtue, MacMonnies had broken away from recent iconographic traditions in choosing to personify the concept of Virtue as a male. His motivations for doing so and his manner of representation were deliberate and politically conservative. The problem was that many viewers felt that his methods were antiquated to the point of being offensive. MacMonnies's sculptural group provoked the extremes of anger that it did because its allegorical personifi-

cations had taken on new connotations within a period of a few short years. When interpreted in the contemporary sociopolitical context, the sexual differences signified by MacMonnies's traditional representations now seemed too loaded with meaning.[22]

The sculptor, although at first amused by the situation, began to lose his sense of humor.[23] But his comments in his own defense did not help matters. He simply dug himself into a deeper hole. In explaining his choice of imagery to a reporter, MacMonnies described his concerns in the anachronistic rhetoric of a turn-of-the-century genteel professional. He observed that it was the artist, as expert, who had to set the standards for the representation of artistic truth. At the same time, his disdain for his audience and his emphasis on the inviolability of the artistic creation was decidedly contemporary. MacMonnies admitted proudly that he created quite consciously for an elite, and purposefully had not taken into consideration the "narrow prejudices" of the rest of the people.[24] In time, the people would come to respond, even if they did not like at first what they were given. "They will accept a poor thing if they are not given anything better," MacMonnies observed, "but they will always choose the best that is offered them."

The most beautiful form known was that of woman, he insisted. "When we wish to symbolize anything tempting we use the woman's form. It has always been so. Justice, devotion, inspiration and other beautiful, noble or graceful things are symbolized by it. But the man—his form is rugged and suggests strength and we use it to symbolize strength. . . . I did not invent this scheme of things," he continued. "God Almighty made the forms of man and woman and for a long, long time we have used the two forms to represent two different things. . . . The attainment of suffrage by women . . . and the entry of the fair sex into public prominence, has not yet taken from them their grace and beauty of form."[25]

Although twenty years earlier many people would have accepted these views as a matter of course, these convictions no longer met with uniform enthusiasm. Even MacMonnies himself now seemed aware that his opinions and his dandified womanizing persona were hopelessly outdated. Ironically mocking his own statements in another newspaper interview, he commented that temptation was usually made feminine because "only the feminine really attracts and tempts," and that no one would object if it were the other way around.[26] Other MacMonnies supporters also took this stand. Park Commissioner Gallatin noted that "sirens, as is known, are not women. Coming down town to-day I saw a devil on a billboard. He was represented as a man, but should man object to being so portrayed?"[27]

Two important questions lay underneath this argument: What should be the relation between representation and symbolism? Under what circumstances should one draw distinctions between the two? MacMonnies maintained that his women were not mere women, but sea creatures, sirens— which were commonly depicted as symbols of evil and temptation in fin-de-siècle imagery. Yet he continually emphasized "feminine" traits in drawing his connections between the representational forms and their allegorical referents. This only fueled the skepticism of many women about the artist's real motives in attempting to distinguish between the allegorical and the literal.[28] Concurring with one of his critics, MacMonnies contended that the root of the entire problem was the growing tendency of the public to "read" sculpture too literally. "Where," he asked, "would the fine arts be if such limitations were placed upon them, if an allegory were always to be taken literally? The thing is ridiculous," he scoffed. "Such literalmindedness carried to its logical conclusion would be a blow at all the fine arts. . . . These things have to be treated allegorically," he stated emphatically. "This limitation of art by a literal mind is ridiculous. . . . If we harness our art so that it can be understood by babies is there any hope for us?"[29]

Other artists echoed MacMonnies's concerns. The *New York Times*, for example, quoted NSS president Robert Aitken and painter William de Leftwich Dodge. At the hearings they expressed their indignation that in this generation it should even be "necessary to defend a symbolic work of art against attacks by those who saw in it nothing but a strong boy standing on a woman's neck."[30]

Notwithstanding the outcry and the Board of Estimate meetings, political and economic issues took priority over concerns about interpretation, representation, and signification. During one of the first hearings Park Commissioner Gallatin had apparently provided (from municipal officials' point of view) a very compelling argument for keeping the statue. He reminded those present that since the statue had been a bequest to the city and since MacMonnies had already been paid the rest of his $60,000 on acceptance of his work, the city, bound by the terms of the contract, would have to bear the $60,000 cost of a substitute if *Civic Virtue* were removed. Gallatin therefore suggested erecting the fountain and then letting the "people decide" what its fate should be. This solution of course overlooked the fact that it would be much more difficult to take the work down once it was up.[31]

The mayor had already reaped the political benefits of catering to his female constituency. As the *Times* noted, "It was a happy day for the Mayor, who heard many pleasant things about himself." Now he also agreed that

perhaps the fountain should in fact go up. "We can pull it down fast enough," he was quoted as saying.[32] Thus the statue, nicknamed derisively "strong boy," "fat boy," and "rough guy," was erected in front of City Hall in late April 1922.[33] It remained in this location until February 1941, when Parks Commissioner Robert Moses had the entire *Civic Virtue* fountain hauled away to its present location at Queens Boulevard at Union Turnpike, next to Queens Borough Hall, and out of his jurisdiction. The final irony was that Moses, himself a former crusader for good government, no longer had to have anything to do with this statue which he—along with others who had outgrown Progressive idealism—now rejected and detested.[34]

The response to *Civic Virtue*, the "literalmindedness" that MacMonnies saw as threatening, exemplified diminished public receptivity to civic sculpture. To be sure, the waning acceptance of such allegorical monuments resulted partly from the new fashionable aesthetics of modernism. Advocates of modernism emphasized the immediate, "literal" experience of pictorial or sculptural elements rather than the comprehension of conventional, differentiated allegorical images.[35] They believed that it was futile and unnecessary to try to represent specific complex ideas by means of a traditional academic style. But . . . an additional set of interpretative problems arose out of the interplay between representations and the broader social context. In the case of *Civic Virtue*, the controversy had nothing to do with issues of modernist aesthetics.

The mass audience had once been the beneficiary of the artist's Progressive object lessons. Now it posed a potentially hostile threat even to the academic sculptor. By 1922, MacMonnies's benign didactic "intentions" were stripped from his work, leaving an empty ideological message that was felt to represent an anachronistic tradition of representation, a bankrupt set of meanings, and a futile struggle for cultural authority on the part of the artist. Civic Virtue as a concept was further mocked by the realities of New York's contemporary political scene, especially by Mayor Hylan's manipulation of the issue for political purposes. *Civic Virtue* was opposed not just by women's groups but also by ardent supporters of the mayor, who during his tenure had dismantled many of the organized Progressive efforts at zoning and on behalf of the languishing City Beautiful plan.[36] Like many Tammany politicians, Hylan sought to depict himself as protector of the downtrodden, and presented formidable political opposition to the older elite civic groups' organizations whose interests were represented by MacMonnies and the Art Commission.

The interpretation of *Civic Virtue* as antifemale, structured in political as much as in cultural terms, misread MacMonnies's expressed intentions,

foiled his desire for neutrality, and ultimately favored Tammany's anti–City Beautiful contingent. Once a broader segment of the public had been exposed to questions of representation, they began themselves to question the imagery, site, and purpose of such monuments. It thus became increasingly difficult to plan for future sculptural monuments on any grand scale.

Notes

1. Mrs. Crane's will made the front page of the *New York Times* when her daughter contested the fact that she had only been left $5, while the entire rest of the estate had been left to charitable institutions and to the City of New York. "Only $5 for Her Daughter," *NYT*, 4 October 1894, p. 1.

2. Robert de Forest to Joseph Haag, 21 March 1921, de Forest correspondence, Art Commission of the City of New York.

3. National Sculpture Society Minutes, 10 November 1908. "Memorandum *in re* Crane Fountain," de Forest correspondence, ACNY.

4. MacMonnies's contract (signed 3 May 1909) had no set time limit, but stipulated that he was to receive $5,000 on submitting the models, $20,000 on completion of the stonework, and a final $10,000 on acceptance of the work. Contract between the City of New York and Frederick MacMonnies, in Crane Fountain file, II-Corr (1902–1930), ACNY.

5. "Seeks MacMonnies Fountain," *NYT*, 10 April 1914, p. 5; "Crane Fountain in Marble," *NYT*, 15 May 1914, p. 4; "Civic Virtue Row Takes on a New Twist," *New York American*, 25 March 1922, p. 4.

6. Crane Fountain, exhibit 822A, disapproved 30 November 1914, ACNY; "City Turns Down MacMonnies Work," *NYT*, 11 January 1915, p. 5.

7. Karl Bitter to MacMonnies, 14 October 1914 and 1 December 1914, Bitter file 436, ACNY. The Art Commission was especially scrupulous about works of art placed in the vicinity of City Hall. City Beautiful advocates had targeted the area as a model for the development of a monumental civic center, and the commission wanted to be certain that they could control any artworks placed around there to assure harmony with the overall City Beautiful scheme. For discussion of plans for the City Hall area, see Robert A. M. Stern, Gregory Gilmartin, and John Montague Massengale, *New York 1900: Metropolitan Architecture and Urbanism, 1890–1915* (New York: Rizzoli, 1983), pp. 61–64. MacMonnies was now back in New York, after leaving Giverny to escape the war.

8. Hastings planned a "circular marble fountain" with a "series of overflow basins." Crane Fountain, exhibit 822J, approved 24 December 1915, ACNY.

9. Michele Cohen, labels for exhibition *On City Hall, in City Hall*, October 1984 (hereafter cited as Cohen labels). See also Crane Fountain file, exhibit 822Z, 14 July 1922, ACNY.

10. Exhibit 822A–D, disapproved 30 November 1914, ACNY; " 'Civic Virtue Pagan,' Women Tell Hylan," *NYT*, 23 March 1922, p. 17; Cohen labels.

11. " 'Civic Virtue Pagan,' " *NYT*, 23 March 1922, p. 17.

12. Theodore Roosevelt, *The Strenuous Life* (New York: Century Co., 1900), pp. 2, 16, 42–44, 155.

13. " 'Civic Virtue Pagan,' " *NYT,* 23 March 1922, p. 17.

14. "Civic Virtue Statue, a Youth with a Club Soon to Menace Sirens in City Hall Park," *NYT,* 26 February 1922, p. 19.

15. See Paul Boyer, *Urban Masses and Moral Order in America, 1820–1920* (Cambridge, Mass.: Harvard University Press, 1978), pp. 193–204; Allan M. Brandt, *No Magic Bullet: A Social History of Venereal Disease in the United States* (New York: Oxford University Press, 1985), pp. 23–39; Raymond B. Fosdick, Jr., *John D. Rockefeller, Jr.: A Portrait* (New York: Harper & Row, 1956), pp. 137–140.

16. "Say Virtue Degrades Women," *NYT,* 16 March 1922, p. 13.

17. "The Quiz of Civic Virtue," *NYT,* 17 March 1922, p. 16. On feminism, see William O'Neill, *Everyone Was Brave: The Rise and Fall of Feminism in America* (Chicago: Quadrangle Books, 1969); William Henry Chafe, *The American Woman: Her Changing Social, Economic, and Political Roles, 1920–1970* (New York: Oxford University Press, 1972), pp. 3–132. Of related interest is Ellen Carol Du Bois, "Working Women, Class Relations, and Suffrage Militance: Harriot Stanton Blanch and the New York Woman Suffrage Movement, 1894–1909," *Journal of American History* 74, no. 1 (June 1987): 34–58.

18. The Art Commission had to fend off reporters who mistakenly thought that the commission had appointed MacMonnies. Assistant Secretary of the Art Commission to Robert de Forest, 16 March 1922, de Forest correspondence file, ACNY. See also "Home Again," *NYT,* 28 February 1922, p. 18.

19. "Hylan to Preside at Art Inquisition," *NYT,* 18 March 1922, p. 13; "Hylan Gives Heed to Statue Protest," *New York American,* 16 March 1922, p. 6.

20. Hylan's astute political calculations worked in his favor. During the hearing, certain women's groups embraced the mayor as the first to represent their interests. Some even suggested that MacMonnies's rendition of *Civic Virtue* be replaced with a statue of Mayor Hylan instead. "Hylan Put Forth as Civic Virtue Model," *NYT,* 6 April 1922, p. 19; " 'Let John Hylan Pose for Civic Virtue,' Women Plead," *New York Daily Tribune,* 6 April 1922, p. 3; "Public Statues Vote to Bar Civic Virtue," *New York American,* 20 March 1922, p. 6; "Women Laud Mayor's Civic Virtue Stand," *New York American,* 23 March 1922, p. 3.

21. "Women Laud Mayor's Civic Virtue Stand," *New York American,* 23 March 1922, p. 3; " 'Let John Hylan Pose,' " *New York Daily Tribune,* 6 April 1922, p. 3. Among those attending were members of the National Women's Club, Women's Christian Temperance Union, League of Women Voters, National Women's Party, Home Rule League, and Brooklyn Alliance Club. Some people also criticized the proportions of the Virtue figure. A Mrs. John Jerome Rooney said the legs of *Virtue* looked like those "a subway guard should have to jam people into cars."

22. "Civic Virtue," *NYT,* 17 April 1922, p. 6. Controversy was nothing new to MacMonnies. In 1893 he had acquired a national reputation as a result of the Boston Public Library trustees' outraged responses to the *Bacchante and Infant Faun* he had created for the library courtyard. That debate had arisen over the "realism" of the female figure and over the perceived impropriety of depicting her both naked and drunk. But at least that controversy had involved only a limited

group of people. There was no question of misreading an allegory; MacMonnies never purported to be creating a didactic work. The exceptional prudishness of the Boston trustees became a joke among New Yorkers, and in a display of one-upmanship, the trustees of the Metropolitan Museum accepted the *Bacchante*. For *Bacchante* controversies, see MacMonnies scrapbook, MacMonnies papers, reel D245, fr. 68, Archives of American Art.

23. " 'Civic Virtue Pagan,' " *NYT,* 23 March 1922, p. 17; "Criticism Absurd, Says MacMonnies," *New York American,* 26 March 1922, p. 4.

24. "Criticism Absurd, Says MacMonnies," *New York American,* 26 March 1922, p. 4.

25. " 'Can't Alter Nature,' Says MacMonnies," *NYT,* 2 April 1922, p. 1.

26. "Hylan to Preside at Art Inquisition," *NYT,* 18 March 1922, p. 13.

27. " 'Let John Hylan Pose,' " *New York Daily Tribune,* 6 April 1922, p. 3.

28. On whether the sirens were women, see Cohen labels.

29. "Hylan to Preside at Art Inquisition," *NYT,* 18 March 1922, p. 13; "Criticism Absurd, Says MacMonnies," *New York American,* 26 March 1922, p. 4.

30. " 'Civic Virtue Pagan,' " *NYT,* 23 March 1922, p. 17.

31. " 'Let John Hylan Pose,' " *New York Daily Tribune,* 6 April 1922, p. 3.

32. "Hylan Put Forth as Civic Virtue Model," *NYT,* 6 April 1922, p. 19.

33. "Hylan 54 Years Old," *NYT,* 21 April 1922, p. 13.

34. Robert Moses to A. Everett Peterson, 26 February 1941, exhibit AO, Crane Fountain file, ACNY.

35. On allegory as differentiation, see Richard Shiff, *Cézanne and the End of Impressionism: A Study of the Theory, Technique, and Critical Evaluation of Modern Art* (Chicago: University of Chicago Press, 1984), pp. 47, 83; idem, "Remembering Impressions," *Critical Inquiry* 12, no. 5 (Winter 1985): 442–47.

36. Harvey A. Kantor, "Modern Urban Planning in New York City: Origins and Evolution, 1890–1933" (Ph.D. dissertation, New York University, 1971), p. 310; Robert A. Caro, *The Power Broker: Robert Moses and the Fall of New York* (1974; New York: Vintage Books, 1975), pp. 84–85; 325–26. See also Joseph D. McGoldrick, "John F. Hylan," *Dictionary of American Biography,* supplement 2, 11: 330–31.

12

From Scapegoats to Mascots

The New York Public Library Lions

SUSAN LARKIN

If the success of public art is measured by public recognition and affection, the lions flanking the grand staircase outside the New York Public Library are among the most successful examples in America. They have been featured in cartoons, children's stories, a Woody Allen monologue, and a play by John Guare. In the background of tourist snapshots or television news footage, they communicate instantly that the setting is New York, New York. Festooned with yuletide wreaths, they symbolize Christmas in the city. But these sculptures, now so cherished, were at first maligned. A reckless media onslaught spawned by a personal vendetta soured initial public reception of the library's most conspicuous art.

From the beginning, the construction of the New York Public Library was plagued by political controversy and labor disputes. When architects John Carrère and Thomas Hastings signed the contract in December 1897, the work was expected to be completed in three years. Instead, it dragged on for fourteen.[1] In that contentious atmosphere, the architects did not attempt a lavish art program like those for the Boston Public Library or the Library of Congress. They designated sculptures for only four locations on the building's facade. The most visible would be a pair of lions flanking the entrance stairs on Fifth Avenue. Probably on the recommendation of Augustus Saint-Gaudens, the architects commissioned Edward Clark Potter to sculpt the lions.[2]

Potter was respected among his peers but, then as now, little known to the public. His obscurity was due partly to his collaboration with Daniel Chester French on equestrian monuments, for which French would execute the rider and Potter the horse. The more famous sculptor generally received

189

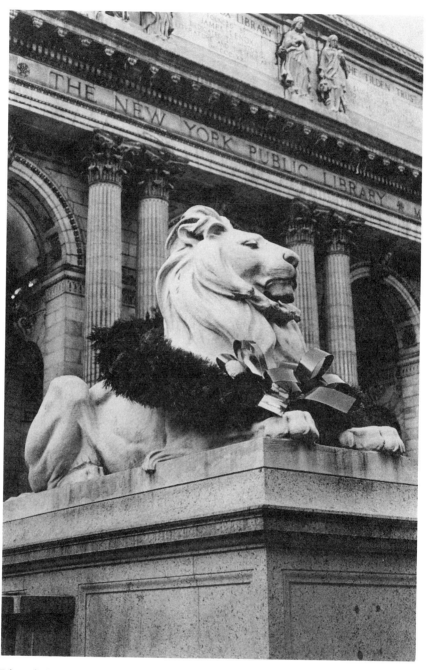

Edward C. Potter, *New York Public Library Lion*, 1910. (Photo: Courtesy of New York Convention and Visitors Bureau)

the entire credit for these works, although he repeatedly insisted that Potter deserved greater recognition. French said of their *General Washington*, the first monument to an American hero by American sculptors erected in Paris, "I did not confine myself to the human figure; neither did Potter stick to the horse; we swapped work and ideas constantly, and I think the group benefited by it."[3]

Potter's personality was another factor in his obscurity. Henry Wysham Lanier, who in 1906 wrote the only contemporary essay on the sculptor's work, described him as "a rather bluff and hearty man" who was "extremely modest . . . [so that] he has withdrawn even from proper publicity."[4] Mrs. Daniel Chester French, a close friend of the Potters, revealed that "we called him 'Old Potter' because he was so serious and because of a curious way he had of putting his foot into it." Saint-Gaudens, also a friend, once referred to him as "that sepulchre on wheels."[5] This combination of traits would not have endeared Potter to reporters seeking a lively interview.

Potter was so indifferent to publicity that even the year and place of his birth are reported inconsistently in accounts published during his lifetime. He was born on November 26 in 1854, 1857, or 1859 in either New London, Connecticut, or Enfield, Massachusetts. After two years at Amherst, he enrolled at the school of the Museum of Fine Arts in Boston. About 1883 he became French's studio assistant. In the mid-1880s he went to Paris to study the human figure under Antonin Mercié and to join Emmanuel Frémiet's classes in animal sculpture at the Paris zoo.

The turning point for Potter, as for many late-nineteenth-century American artists, was the World's Columbian Exposition, held in Chicago in 1893. He collaborated with French on the quadriga atop the triumphal arch and on four groups of farm animals with human attendants installed around the lagoon of the Court of Honor. The latter were, according to sculptor-critic Lorado Taft, "among the most admired" of the works created for the exposition.[6] After the fair, Potter and French collaborated on five equestrian monuments. Meanwhile, Potter demonstrated his versatility in independent projects, including the equestrian *DeSoto Sighting the "Father of Waters,"* which won a gold medal at the St. Louis Exposition in 1904.

Although he was best known for horses, Potter also sculpted other animals. Among them were a pair of lions in front of railroad magnate Collis P. Huntington's four-story brownstone on the southeast corner of Fifth Avenue and Fifty-seventh Street. Potter created his first public lions in 1903, when architect Charles F. McKim commissioned a pair for the entrance to the Pierpont Morgan Library on Thirty-sixth Street between Madison and

Park avenues. Potter was paid $10,000 for the Assyrian lionesses.[7] The anatomically convincing beasts recline on a downward plane paralleling the gentle grade of the stairs. Their laid-back ears, wary vigilance, and tense posture suggest potentially dangerous coiled energy. Like the spirited horses restrained by expert riders in Potter's equestrian monuments, these animals convey the power of the man with whom they are associated.

When Carrère and Hastings were assigning commissions for the New York Public Library, Potter's experience at the library six blocks south and his solid professional reputation made him a natural choice to sculpt the guardian lions. His fee, $8,000, was less than he had received for the smaller Morgan sculptures seven years earlier. (An additional $5,000 went to the Piccirilli Brothers for carving the lions in Tennessee pink marble.) The art budget for the new library had been slashed, however, and the commissions were assigned with "everybody concerned understanding that the amounts allowed were inadequate, but the artists agreeing to do the work primarily as a labor of love."[8]

Even before Potter designed the sculptures, the subject was criticized. One faction would have preferred a pair of industrious beavers, while big-game hunter Theodore Roosevelt wanted elk or moose.[9] The library's board held out for lions, however, and Potter produced realistic small-scale models. When Hastings inspected them, Lanier revealed in a letter to a newspaper columnist forty years later, he "praised the life-likeness of the big cats, but finally said he felt they should be somewhat more 'architectural.' " Potter struggled with revisions, "changing posture, facial expressions and so on, trying to match some admittedly vague idea in the architect's mind. The final result was not as real or powerful as the first clay sketch, but while it did not satisfy Potter's artist eye, it was accepted, and he went ahead on that basis."[10]

Photographs of revised, full-scale models were approved by the Art Commission as preliminary sketches on April 12, 1910. In late September, the plaster models were installed on the library pedestals so that their relationship to the site could be evaluated before they were carved in marble. Almost immediately, the mockery began. The sculptures were not judged by knowledgeable art critics but ridiculed by general reporters. They were called " 'absurd,' 'squash-faced,' 'mealy-mouthed, complacent creatures.' " One writer derided their supposed resemblance to Norwegian dramatist Henrik Ibsen.[11] Even the relatively responsible *Times* published a "defense" of the sculptures that was merely a vehicle for the writer's witticisms. "As plaster lions go, these are of far above average merit," the editorial began.

They do not suggest nearly as much as does the lion of St. Mark's the results a biologist would expect to get from crossing a dachshund with a Welsh rabbit, and if they do not look as much like real lions as does the lion of Lucerne or the one in the Bargello of Venice, that is nothing against them.... [They] differ in many respects from those that wander over African plains.... As library lions, however, they are all right. Their cast of countenance is distinctly reflective and intellectual, and if their faces show a combination of melancholy and ennui, that is natural enough in the circumstances.[12]

That writer was at least amusing, but most of the criticism was as clumsy as it was uninformed. A typical example was a letter to the *Times* on September 30, 1910 (page 12, column 6), in which the writer, identified only as E.C.B., attacked the anatomical knowledge of the experienced *animalier.* "The head is possibly a lion's. The body resembles what might be a cross between a hippopotamus and a cow; as for those semi-human hind legs, words fail."

Why did the lions provoke such virulent criticism? They do not deserve it on artistic grounds, for they admirably suit the scale and mood of the site, as architects and sculptors maintained at the time.[13] Although they lack the fierce vitality of the Morgan cats, they embody the aristocratic dignity conventionally associated with guardian lions.

One likely explanation for the criticism is that the library's most conspicuous ornaments became scapegoats for the institution. After years of enduring the unsightly, disruptive construction on the city's main thoroughfare, even New Yorkers not politically opposed to the institution must have been exasperated. Ironically, then, the lions' role as symbols of the library began in animosity.

According to a later report, it took a personal confrontation to ignite the lingering public resentment. Henry Wysham Lanier, Potter's neighbor during the controversy, related that the initial attack was the revenge of a "wisecracking woman reporter," ignorant of art, who was irritated that the reticent sculptor had no photographs to give her and refused to cooperate with the "intimate personal publicity" that was her specialty. Reporters on competing papers quickly joined the scuffle, vying to concoct the best joke at the sculptures' expense.[14]

However petty its origins, the controversy was embarrassing to an institution weary of confrontation. The beleaguered architects were so eager to end it that they made the public, to a degree, collaborators in public art. In response to complaints that the lions were too hairy, they had Potter shave the manes. A comparison of the photograph of the model of the

southerly lion in Potter's studio with one taken several months later at the Piccirilli Brothers' yard reveals the once-luxuriant mane crudely flattened. Hastings promised further changes. When passersby protested that the plaster lions were too large, he reassured a New York Times reporter that the marble figures would be scaled down.[15] Fortunately, there is no evidence that this was done.

The architects' application for final approval of the sculptures "urgently" requested quick action. Approval was granted on October 11, 1910, and five days later the lions made what was probably their first cartoon appearance. The drawing in the Sunday Times shows two scrawny beasts reading atop pedestals shaped like thick books. Although the caption ("If we must have lions in front of the new library") implies that it would be better not to have the sculptures at all, the cartoon conveys an amused affection that would grow with time.

The finished sculptures were installed without fanfare some time in 1911 and were promptly forgotten by the newspapers. The next taunts surfaced where Potter must least have expected, in American Art News. Apparently referring to a temporary mend on one of the sculptures, S. H. P. Pell of New York City wrote to the editor, "I have suspected for some time that the model for the good natured lions in front of the public library ... was a stuffed one. On careful examination I am confirmed in my opinion. Directly behind the right fore leg of the northernmost lion is a patch showing distinctly that whoever executed the copy was more than Chinese in his love for detail and exact reproduction."

Daniel Chester French, by then America's most esteemed sculptor, hotly rebuked the art journal's editors for publishing a letter he called "not only useless and silly, but cruel and unjust." The indignant French wrote, "The statues which are treated so flippantly are the serious product of a sculptor who, as you know, has produced and is producing works of exceptional merit, and who has the high respect of his fellow artists. I think you, too, should accord him the respect which his talents and his sincerity have won for him in the art world, and that you should guard him and all other serious artists from ridicule, as far as you can." The editors expressed regret that "Mr. Pell's humorous little fling at the Library Lions should have so annoyed Mr. French," adding blandly that they intended no "reflection on Mr. Potter's ability as a sculptor."[16]

Potter died in 1923, no doubt still considering the lions a humiliating failure. His obituaries reflect confusion about the sculptures that are today his most famous works. In one, they are grouped with his equestrian

monuments as "the Lyons statue in front of the Public Library, New York."[17] The *New York Times* and *Art News* mentioned the lions at the Morgan Library but not those at the New York Public Library.[18]

Within a few years of Potter's death, however, the true public attitude toward the lions emerged—and it was dramatically different from the condescending mockery that had filled so many newspaper columns. Now the press followed the public, reflecting their attitude in cartoons and reporting the nicknames, seasonal ornamentation, and anecdotes that demonstrated widespread affection for the sculptures. Two themes underlay the varied expressions of this authentic public response: the sculptures' site and their subject.

The lions' location near one of New York's busiest intersections makes them a reassuring landmark, a convenient rendezvous. They are bold accents in a great urban space, which they enhance without invading. A 1932 *New Yorker* cartoon plays on their role as meeting place; scrawled on one lion's rump is the message, "Mr. Knox, I couldn't wait any longer. Mabel." During World War II, a soldier who couldn't keep a date sent a telegram to his girlfriend addressed simply "Care of the North Lion, Public Library."

The sculptures' subject is also central to their popularity. As animals, and placid ones at that, they inspire a basic human response that no allegorical figures, obelisks, or portrait sculptures would evoke even on the same site. Furthermore, because they hold little intrinsic meaning, they are subject neither to the obsolescence of sculptures that embody discarded values nor to the reverence that surrounds such meaning-laden works as the Statue of Liberty. Instead, the lions can carry whatever personal meanings the public invests in them. Cartoonists and storytellers frequently imagine them as living creatures, usually with the characteristics of humans or household pets. A 1935 *New Yorker* cartoon shows a policeman bewildered by a litter of cubs around one pedestal. Another *New Yorker* cartoon, titled "Revised Statuary for the City of Tomorrow," shows scholarly lions wearing spectacles, heads propped on paws while they read enormous books. The most literal identification of the lions as public pets was published by the library itself in 1953. A poster depicts a boy engrossed in a book, his bare feet propped on a furry lion who dozes as companionably as a Labrador in front of his chair.

Like any pets, the lions were given names. The most enduring, Patience and Fortitude, are credited to Fiorello La Guardia, New York's mayor from 1934 to 1945. La Guardia used the phrase to sign off his popular radio broadcasts.[19] " 'The people of this city have two cardinal virtues, Patience

and Fortitude,' " he told a reporter.[20] In naming the lions for these virtues, the mayor made them stand for "the people of this city."

First, however, the lions stood for the library. By the mid-1920s, cartoonists were using them as symbols of the landmark building. They were so thoroughly identified with the library by 1930 that the *New Yorker* drew laughs from a cartoon of two men who confused the library's mascots with the MGM trademark. The library claimed the lions as its symbol only after the public had assigned them that role. The institution used the "Revised Statuary" cartoon as the cover for one of its publications and the cubs cartoon for its 1943 Christmas card. During the '40s, its stationery carried a profile of one of the cats and the slogan "Read Between the Lions."[21] The library began adorning the sculptures with Christmas wreaths in 1950,[22] subsequently adding top hats, spring flowers, and other ornamentation for special events.

The institution has been more fickle than the public, however. The lions were dropped from the letterheads in the mid-'70s, and graphic designers were hired to create a trendy new logo. Four years later, a library official admitted what the public had known for decades: "We didn't need to spend hundreds of dollars on creating a corporate image [because] we already had one."[23]

Today, the lions are an inescapable symbol of the library. New Yorkers see them every time they use a library card, open a library book, receive a letter from the institution, pick up its calendar of events, or glance at a Friends brochure. Whatever they buy in the library shop is placed in a bag bearing a lion's profile. Inside the bag, a lion may appear on a greeting card, a paperweight, or the cover of the latest library publication. Even the name of the computerized catalog, CATNYP, is a coy reference to the lions.

Media attacks did not permanently taint the public's response to the sculptures, nor did any public relations campaign inspire their appreciation. People simply like the lions. This affection was firmly established before the library began embellishing them with wreaths or reproducing them as bookends and stuffed toys. Indeed, New Yorkers' spontaneous, natural response to the big cats may make them the most genuinely popular public art in America.

Notes

1. Michele H. Bogart, *Public Sculpture and the Civic Ideal in New York City,* 1890–1930 (Chicago and London: University of Chicago Press, 1989), p. 177.

2. Henry Hope Reed says Saint-Gaudens recommended Potter but does not give any source for this information. I have found no reference to it elsewhere. See Reed, *The New York Public Library: Its Architecture and Decoration* (New York: W. W. Norton, 1986), pp. 37–38.

3. Joseph McSpadden, *Famous Sculptors of America* (New York: Dodd, Mead, 1924), p. 134.

4. Henry Wysham Lanier, "The Sculpture of E. C. Potter," *World's Work* 12, September 1906, pp. 7975–76. The son of poet Sidney Lanier, Henry W. Lanier (born 1873) was secretary of Doubleday, Page & Co. from 1900 to 1912 and author of *The Romance of Piscator* (1904), according to *Who's Who in America,* 1916–17. According to Lanier's 1948 correspondence with *The Villager* columnist N. S. Olds, he was a neighbor of Potter in Greenwich, Connecticut.

5. Mrs. Daniel Chester French, *Memories of a Sculptor's Wife* (Boston and New York: Houghton Mifflin, 1928), pp. 166–67.

6. Lorado Taft, *The History of American Sculpture* (New York: Macmillan, 1903), p. 474.

7. The contract was signed on April 24, 1903. For information on the Morgan lions, I am grateful to Sue Eisner of the Morgan Library's education department. Another potential precedent for the NYPL lions is mentioned in a letter from the Library's Art and Architecture Division to Mrs. Edward R. Hoehl on September 26, 1973. The letter, which is duplicated in the Artist's File at the library, refers to a notice in *Library Journal* (December 15, 1968) identifying the bronze lions at the State Library Board building, Columbia, South Carolina, as possible "study models" for the NYPL lions. However, according to the reference librarian in Columbia (phone interview, November 1989), those lions are attributed to sculptor A. Pelzer.

8. Harry Miller Lydenberg, *History of the New York Public Library* (New York Public Library, 1923), p. 508.

9. Deirdre Carmody, "Library's Decaying Lions to Get a Bath, Then a Treatment," *New York Times,* October 22, 1975, p. 47, col. 2.

10. Lanier's letter was quoted in "The Stroller" by N. S. Olds, *The Villager,* January 6, 1949, p. 16.

11. Phyllis Dain, *The New York Public Library: A History of Its Founding and Early Years* (New York Public Library, 1972), p. 325. Dain's newspaper references are based on a microfilmed NYPL scrapbook.

12. "Topics of the Times: Very Good Lions, Considering," *New York Times,* September 28, 1910, p. 10, col. 4.

13. Lydenberg, *History of the NYPL,* p. 509.

14. Lanier to N. S. Olds, quoted in "The Stroller," *The Villager* (January 6, 1949), p. 16. An unidentified library official had offered Olds essentially the same explanation, but without the specifics about the woman journalist, as reported in "The Stroller" on December 9, 1948, p. 20.

15. "To Change Library Lions," *New York Times,* September 28, 1910, p. 22, col. 1.

16. For the exchange of letters, see "Correspondence," *American Art News* 14: January 22, 1916, p. 4, col. 2; February 5, 1916, p. 4, col. 4; and February 12, 1916, p. 4, col. 2. The periodical's name was shortened to *Art News* in 1923.

17. "E. C. Potter Dead," Greenwich *News & Graphic,* June 22, 1923, p. 1, col. 1.

18. "Edward C. Potter Dies," *New York Times,* June 23, 1923, p. 11, col. 6. "Edward Clark Potter," *Art News,* vol. 21, no. 38 (July 14, 1923), p. 6.

19. John K. Hutchens, "His Honor the Radio Showman," *New York Times Magazine,* July 16, 1944, p. 41.

20. S. J. Woolf, "The Mayor Talks About Our Town," *New York Times Magazine,* September 30, 1945, p. 52. I have not been able to pinpoint the occasion when La Guardia named the lions. His affection for them may have been heightened by his close friendship with Attilio Piccirilli, at whose family's workshop the sculptures were carved. This friendship is noted repeatedly in *This Man La Guardia* by Lowell M. Limpus and Burr W. Leyson (New York: E. P. Dutton, 1938).

21. N. S. Olds, "The Stroller," in *The Villager,* December 9, 1948, p. 20.

22. A photograph dated 12-18-50 in the NYPL Archives (folder "Central Building—Lions") shows a crowd watching a workman festoon a lion with a Christmas wreath.

23. Michiko Kakutani, "Library's Lions Roar Thanks to New Yorkers," *New York Times,* November 30, 1979, p. B3.

13

George Segal's Sculpture on a Theme of Gay Liberation and the Sexual-Political Equivocation of Public Consciousness

JOSEPH DISPONZIO

In Memory of Kenneth S. Wein

On May 14, 1979, Commissioner Gordon Davis of the New York City Department of Parks and Recreation received a three-sentence letter from a Peter Putnam of Houma, Louisiana. It was an inquiry to "find out if the City of New York would like to accept a donation of George Segal sculpture for Seridan [sic] Square." Few details were given: "The sculpture would take the form of four white bronze figures seated on two park benches, two men on one bench and two women on the other. The sculptor would assume a minimum installation cost." That was all.

In this letter, written on plain white paper, with a manual typewriter, Putnam identified himself as a trustee of the Mildred Andrews Fund, 3127 East Main Street, Houma, LA. Houma, a bayou town in the Mississippi delta some 40 miles southwest of New Orleans, was not terribly well known as an arts center. Who was Peter Putnam and what was the Mildred Andrews Fund? Why was he willing to donate a George Segal work to the City of New York? And why, with the parks system's 25,000 acres of parkland, did he choose a postage-stamp-sized park for the location? Intrigued, Davis had his director of historic parks, Joseph Bresnan, investigate.

Bresnan wrote Putnam that the "acquisition of a George Segal work" would be most attractive to the city, but that several questions remained: Did the artist have a preference for a park bench? Were the figures properly anchored against overturning and theft? Were security and aesthetic lighting to be considered? Bresnan mentioned that the site Putnam seemed to be

199

suggesting—Christopher Park—was in "shabby condition" and rather constricted.[1] Had he thought of other sites? Most important, Bresnan asked Putnam to "provide some greater detail on the idea and background of the site suggestion."

The answers came quickly. Putnam "assumed" that Bresnan "knew the sculpture [was] being commissioned by the National Gay Task Force for donation to the city. Sheridan Square was picked as it was the scene of the Stonewall Riots, in the summer of 1969, which, in the mythology of gay liberation represents a crutial [sic] turning point."

Thus began one of the most important and controversial chapters in the annals of public art in recent New York City history. After ten years of public debate, controversy, successful maneuvering through the hurdles of the city's approval process, apathy, and neglect, George Segal's sculpture on the theme of gay liberation has yet to be placed in Christopher Park.

Not a novice in art, politics, or New York, Putnam was not uninformed when he wrote his letter to Davis. As sole trustee of and contributor to the Ohio-based Mildred Andrews Fund, Putnam controlled assets of over $32,000,000. The fund, named for his mother, was known for its support of high-profile, politically liberal causes, including civil rights, the underprivileged, and black artists. Most notably, it had commissioned George Segal's *In Memory of May 4, 1970, Kent State: Abraham and Isaac* to commemorate the students killed by the Ohio National Guard at Kent State University.[2] The fund was also familiar with the New York art world, having underwritten the artwork for Louise Nevelson Plaza in lower Manhattan and Richard Hunt's *Harlem Hybrid* sculpture uptown.

Before writing to Commissioner Davis, Putnam had consulted with Henry Geldzahler, then the city's commissioner of cultural affairs. As a former curator of twentieth-century art at the Metropolitan Museum and the most prominent "acknowledged homosexual" in city government, Geldzahler had expertise, if not sympathies, of importance to Putnam. Undoubtedly Geldzahler had told Putnam to contact Davis, because all public art on city park land was under his jurisdiction. Likewise, Geldzahler, as a courtesy, probably informed Davis of Putnam's proposal. That might explain why Davis's memo to Bresnan asking him to write Putnam was so brief: "Please investigate. I have some interest in it." With good reason Putnam had "assumed" Bresnan knew what the Segal work was about; he already had been in contact with the official New York art world.

Putnam's understated letter to Davis in May 1979 matched the undramatic first public notice of the event for which the Segal work was

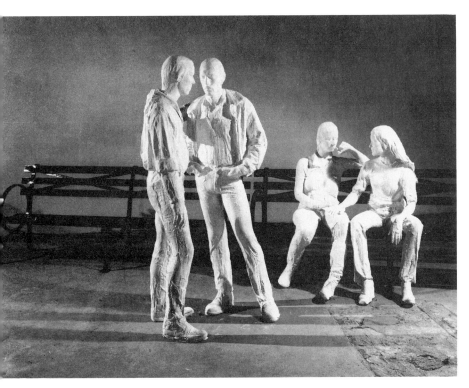

George Segal, *Gay Liberation,* 1980. (Photo: © George Segal/VAGA, New York, 1991. Courtesy Sidney Janis Gallery, New York)

commissioned. The *New York Times* of Sunday, June 29, 1969, ran a modest headline in the innermost column of page 33: "4 Policemen Hurt in 'Village' Raid." The newspaper reported a raid by New York police on the Stonewall Inn at 53 Christopher Street (opposite Christopher Park) in the early morning hours of the previous day, for allegedly selling liquor without a license. The article noted that the Stonewall Inn was known for its "homosexual clientele" but refrained from mentioning that it was better known for men who liked to dress up in ladies' clothing. Police raids on gay bars were not new—there had been two others within the last six weeks—but what was new, and now newsworthy, was for the "queens of the night" to fight back. A forty-five-minute melee, with an estimated 400 people, ensued. In addition to four policemen being injured, thirteen people were arrested.

As the *Times* was going to press Sunday morning, a repeat rampage was occurring at the Stonewall Inn. The newspaper reported this second incident in Monday's edition: "Police Again Rout 'Village' Youths." This time, however, the report was not of a police raid–bar brawl but of a specific and angry reaction to police harassment of homosexuals. Within twenty-four hours of the previous night's raid the " 'village' youths" had reassembled, this time covering the windows of the Stonewall with slogans including "support gay rights" and "legalize gay bars." That the symbolic start of the gay rights movement occurred that weekend would not be made explicit until four years later, when, in covering the fourth annual Gay Liberation Day parade, the *Times* wrote of Stonewall as "the beginning of the homosexual rights drive much the same way that the refusal of Rosa Parks to step to the back of the bus is seen as the watershed for the black civil rights movement."[3]

The Stonewall Inn was long closed when Putnam called Bruce Voeller to see if there was any interest in New York in an outdoor artwork to commemorate the gay rights movement. Voeller, a former researcher at Rockefeller University and executive director of the National Gay Task Force, was well connected in national gay politics. As early as May 1977 he and Putnam had discussed a "project celebrating gay liberation." By February 1979 the focus and aim were clearer. Although the type of work or artist was still undetermined, Putnam believed that whatever form the work took it had to be by "a major artist and [located] in Sheridan Square to have impact." His concerns went beyond aesthetic considerations. Putnam felt that the "gay revolution [needed] deeper ideological roots" and suggested the potential of art to "help generate the groundwork for rethinking."

Finding a major artist whose work could spur the "rethinking" would prove less controversial than finding one whose sexual preference was

politically correct. A major artist who was gay, and was known as such, was clearly on Putnam's and Voeller's minds when they approached Louise Nevelson about the commission. Nevelson was a choice not because her sexuality was public knowledge or because she identified herself as being a gay artist but because it was generally known in artistic circles that she was a lesbian. The operative word in such matters was "discretion." Nevelson's sexuality was not going to be promoted, but when challenged it could pass muster. As will be seen shortly, the selection of George Segal—an "unregenerate heterosexual"—would become an issue. Perhaps Nevelson knew this and decided not to get involved. Believing that her life and works were a "testimonial for the cause," Putnam respected and accepted her decision to decline the gay liberation work.

Segal's selection was not surprising. As noted, Putnam had commissioned him for the Kent State memorial, but he had not yet accepted the gay liberation commission when Putnam wrote Davis offering New York the sculpture. Such presumptive anticipation by Putnam was fact, however, when Grace Glueck, writing in the *New York Times* of July 21, 1979, announced that "Ten years after the police raid on a Greenwich Village bar that led to the formation of the homosexual-rights movement, plans are being advanced for a homosexual-liberation monument to be placed in Sheridan Square [*sic*]." Glueck's unequivocal opening paragraph straightforwardly and succinctly thrust the gay liberation monument into the public arena on its own terms. Glueck's candor was matched by official distance. The Parks Department made no comment. Henry Geldzahler was quoted as saying: "The piece should be judged esthetically, not for its subject matter."

Despite a sympathetic and pro–gay rights City Hall administration, getting Segal's sculpture approved was not going to be easy. The best strategy would be to ignore the sculpture's content and promote George Segal's renown, in other words, the "esthetic angle." Geldzahler's plea, ignored by almost everyone else, would characterize the official Parks Department position throughout the long approvals process required for all artworks on city land.

There was no public outcry following the *Times* article. That was probably a result less of political strategy than of the fact that there was no artwork to respond to, no city sponsorship, and the approvals process, including the Art Commission, the Landmarks Preservation Commission, and the local Community Planning Board, was still to come. A politically savvy citizenry knew better than to react to something not yet perceived as real.

Meanwhile Putnam, Voeller, and Segal were moving quickly. At the time of Glueck's article, Segal had not yet refined the concept of the work; by April 1980 plaster casts were complete. The grouping of two couples that Putnam had written to Davis about was now differentiated by the male couple standing and the female couple sitting.

Segal also sent Bresnan an explanatory letter. He wrote that he had visited the neighborhood where the sculpture would be placed and found that "despite its reputation as a gay community [he] noticed many young mothers pushing strollers, school yards, and the usual complex religious and ethnic mix of a New York residential neighborhood." Such observations were significant, yet they posed a potential conflict with portraying the "emerging, out of the closet gay community" the piece was to celebrate. Figurative representation of such a theme had to be dealt with honestly, yet discreetly.

That Segal walked the neighborhood and recorded his observations suggests his awareness of the thorny issues informing his commission. Although Segal was clear in his understanding of the intentions of the work, he said that it was not a "political statement." Rather, his response was a personal one, culled from the "individual experience [he] had with many gay friends." He wrote that he identified with gay people and their struggle, and that he had tried to express the universal, human qualities of "intelligence, delicacy, sensitivity and loyalty so often demonstrated" among gay people he knew. The resulting sculpture, neither flamboyant nor fearful of affectionate, well-placed tactile communication, is quintessential Segal.

With Segal's photos and word that the sculpture casts were complete, the Parks Department began the legally mandated approvals process for public art. The sculpture was thus catapulted into the public arena. Reaction would be swift.

"Sculpture Planned for 'Village' Brings Objections" read the *Times* headline of the August 28, 1980 article breaking, once again, the news of Segal's sculpture. In case anyone missed the boldface, three-column headline, the article was accompanied by a photo of the work—the first published—and a bird's-eye view of Christopher Park, with inset locator map. Additionally, the sculpture now had a name: "Gay Liberation." Unlike the last year, when few seemed to care, now everyone did. Battle lines were drawn for the fight to come at the public hearings scheduled for the fall.

Although community boards are sanctioned by the New York City Charter, their opinions are taken only under advisement and carry no authority. This does not, however, stop them from taking their responsibil-

ity seriously and making their voices heard. Of the city's community boards, few were as well informed, active, organized, factionalized, and boisterous as the Village's Board Two. In a city where few issues arouse the public's passion as much as parks, Board Two was known to turn out 300 angry mothers—with children in tow—to protest the slightest change to their parks. To mix parks, politics, art, and morality in one issue and to open it to public debate, as was required, was to offer an entertainment extravaganza guaranteed not to disappoint.

The first public hearing convened on September 18, 1980. Not even a ten-dollar cover—as some suggested was a fair price for the show—would have thinned the standing-room-only crowd. Village resident Vera Schneider, speaking against the sculpture, dramatically punctuated her impassioned peroration by tossing a 20-foot-long scroll, with over 500 signatures, into the hall. The crowd went wild. At the next month's hearing, Bruce Voeller challenged Schneider with a 3400-name pink petition, which he and supporters unraveled, circling the auditorium.

To the uninitiated, the circus atmosphere of public hearings must appear to be the complete breakdown of public decorum. For the regulars, it is the imprimatur of New York–style democracy in action. Somehow, in the free-for-all filled with desperate calls to order, pleas for quiet, spontaneous applause, jeers, hisses, boos, and denunciations, serious, impassioned, often relevant discourse emerges. In reality public hearings are just what they look like, shows of strength that rarely change anyone's mind. Opinions are set in advance and handed out at the door via leaflets, typed position papers, scribbled notes, buttons, and the like.

No stranger bedfellows hath art, parks, and politics made than those united in opposition to "Gay Liberation." Prime-time middle-American TV-family types, stereotyped radical gay men and lesbians, "respectable" homosexuals of the Mother's unmarried brother type, drag queens, doctors, fundamentalists, cooks, cranks, clergy, an assortment of people defying categorization, and probably others—in general the standard disparate mix that one would expect to find in the Village—made up the opposition.

They were united in opposition only. The more traditional mainstream residents, individually or collectively identified with one of the dozen or so local block associations and civic groups opposed to the sculpture. They argued that Christopher Park, only one-seventh of an acre, was too small to accommodate four life-size figures, and that the white bronze sculpture would be out of character with the nineteenth-century landmark park.

Their less literal reason for opposing the sculpture was that it promoted "special interests." They reiterated that they did not oppose homo-

sexuals, homosexuality, gay rights, gay life-styles, and so forth, but they were opposed to special interest groups forcing on them a sculpture whose purpose was clearly political. They feared that the sculpture would change the tranquil park into a "focal point for sightseers and sensation seekers, demonstrations and confrontations." Astutely, they challenged the sponsor's principal reason for locating "Gay Liberation" in Christopher Park— proximity to the Stonewall Inn—because at least one other casting of the work was being sanctioned for Los Angeles. They made clear that they did not oppose the conception of a "memorial or commemorative." Some noted that Christopher Park by its "very existence can be regarded as a memorial to the culture and historic events" of gay people just as a "wall, a place, a park" can take on a commemorative role.

The protests were, as one observed, "only a smokescreen for more deep-seated objections." Bruce Voeller was more explicit; he called them "homophobic." The Village residents' opposition to "Gay Liberation" was not overt, conscious bias; it was not antigay, it was antidisplay. To the extent that a minority wishes to show itself openly, it is subject to bias. Acceptability is achieved through conformity. In matters of sex, the homosexual embrace is morally subordinate to the heterosexual kiss. A plaque to commemorate Stonewall was acceptable to the community opposition, but a representational artwork called "Gay Liberation" was not.[4] Arguments of special interests were aimed only at the Segal work while hundreds of other special interest artworks in proximity to the park, not to mention Philip "The-only-good-Indian-is-a-dead-Indian" Sheridan in Christopher Park itself, were ignored. Despite protestations to the contrary, and without their recognizing it, the community opposition was covertly harboring sex preference cultural biases that not even their Village residency could purge. They didn't say it, their actions did.

The clergy and morally conservative individuals had no trouble saying it. They denounced and condemned "Gay Liberation." Sodom and Gomorrah-on-Hudson would not be given official sanction. The Council for Community Consciousness warned that the sculpture would "advertise New York as a mecca for homosexuals, who will view the statue . . . as an international shrine." A missionary writing from Nigeria warned of the disgrace that the United States would be subjected to if such a "perversion of God's laws was allowed." Others simply and crudely condemned the "homo sculpture" as pornographic. New York's major newspapers took no editorial stand on the work, but New World columnist Larry Moffit hid little of his prejudice: "I cast my vote with the birds, bees and the rest of nature in insisting that homosexuality is a perversion."

The least expected, most secular, and often mordant criticism came from gay people themselves. In general they did not object to the idea of a monument, only to how it was being handled and to the merit of the work itself. They were few in number but vocal enough to give the impression of a rift within the gay community, so much so that some gay leaders took issue with local press implications that a split existed.[5]

Nevertheless, a gay opposition did exist. The Gay Activist Alliance objected to spending $100,000 on art instead of on a legal defense fund or some political cause to help the gay movement, which it felt was moribund. The newly organized group Lesbians and Gay Men Against the Statue found it unacceptable "to have one individual or even a handful of individuals deciding on what will become a very important and enduring symbol for all of us."

Exacerbating the fait accompli complaint was George Segal's heterosexuality. Craig Rodwell, owner and founder of the Oscar Wilde Bookstore, objected that "lesbian and gay artists were given no opportunity to even submit designs or suggestions for [the] statue." Bruce Voeller answered that "to have selected a sculptor because he was gay would [have been] discrimination on the basis of sex."[6]

It is interesting that it was the gay opposition that, in their ability to supersede moral issues, heeded Geldzahler's plea to judge the sculpture as a work of art. Their naively literal criticism betrayed a serious understanding of the importance and power of representational art. Rodwell further objected to the sculpture's Caucasian models. He noted that Melvin Boozer, a black gay man nominated as the vice-presidential candidate of the Gay and Lesbian Caucus at the 1980 Democratic Convention, dispelled the "myth that gay rights is a white movement." Robert Rygor, a gay resident of the Village, found Segal's figures "grotesque stereotypes." (His rebuke was silently rebutted by the four models, who posed for the work by wearing T-shirts imprinted with "Grotesque Stereotype.") Lesbians objected to the sexist stereotypes implied by the "male-active" standing, "female-passive" sitting opposition. Drag queens wanted representation for their role in Stonewall too. The hairsplitting demands for equal representation for subgroups within the minority presented a reductio ad absurdum program that no artist or work could satisfy.

Behind the suspicion and rancor were essential artistic considerations, which, while lost in the clamor of the public debate, were not overlooked by some in the artistic community. James M. Saslow's thorough yet essentially negative analysis of "Gay Liberation" in *Christopher Street* of February 1981 was among the most important and serious discussions of the work.

Saslow situated the work within the broader context of public art, the unique problems of gay Americans, and American society itself.[7]

Saslow had problems with Segal's works in general. He saw Segal as "the poet of isolation, alienation and . . . the lonely crowd." Segal could not adequately celebrate the nature of gay liberation as Saslow deemed it. He felt that Segal's style contradicted the monumental "sense of elevation" required of public sculpture and that the "narrow emotional range of Segal's oeuvre" was insufficient to express the more demonstrative qualities needed to embody an emerging gay movement, one that had to dispel the notions of isolation, alienation, and loneliness.

Saslow was bothered by the unflattering interpretation to which "Gay Liberation" was subject. He felt that the sculpture too directly and acutely tapped into the "lack of a coherent sense of [gay] group identity." What Saslow found distressing was precisely Segal's strength, as Saslow himself observed: "Sad to say, their blank stares, narcissistic isolation, and awkwardly hesitant contact devastatingly reflect the true emotional tensions both within and between the inhabitants of those metropolitan ghettos Segal understands so acutely." And in an honest display of self-examination he added: "All things being equal, I too would have preferred a gay artist— but things are in fact far from equilibrium, and would not any sensitive gay sculptor have recorded the same unease?"[8]

What Saslow found disturbing in "Gay Liberation" was upheld as its major achievement in Fred Licht's eloquent defense of the Segal work. Licht, a former director of the Art Museum of Princeton University, had worked closely with Segal during the period "Gay Liberation" was commissioned. He thought it was "one of the most important" projects worked on at the time. Whereas some saw narcissism in Segal's figures, Licht saw introspection and vulnerability. Whereas some saw a casual pickup on a park bench devoid of intimacy, contact, and trust, Licht saw an "intimate, tender and highly individualized [moment] of human existence." He believed that the strength of Segal's opus, and "Gay Liberation" in particular, was its ability to maintain individual identity in "context with the modern American scene so frequently indifferent to the needs and perplexities of the individual." Rather than portraying the "rebellious beginnings of Gay Liberation," Segal chose to express the "insistence on the right of everyone to realize his profound need to love and be loved, to be loyal to his nature, and to friendships that give meaning and substance to existence." Segal's "Gay Liberation" will endure, Licht concluded, "all the more for having been proclaimed in a sculptural form that expresses the dignity of the cause and that respects the intimacy and sensibility" of the gay community. Whereas

Saslow would have neoclassical heroism, Licht embraced realist human drama.[9]

Community Board Two had more prosaic notions in mind, however, when, on October 16, 1980, bucking the recommendations of its own parks and landmarks subcommittee, it passed a resolution giving tentative approval to the installation of "Gay Liberation" in Christopher Park, with conditions. The board demanded a complete restoration of the park, something they had been asking for since 1976, and the establishment of a $10,000 maintenance fund for the sculpture.[10]

Shortly after Board Two's approval, Andrew Stein, borough president of Manhattan, in accordance with his custom "not to take a stand on a community issue prior to the affected . . . board's decision," concurred with the board's decision. Other elected city officials, including councilmen Antonio Oliveri and Henry Stern, and councilwomen Carol Greitzer and Miriam Friedlander, followed suit. By early spring 1981, Parks Commissioner Davis wrote to Board Two District Manager Rita Lee committing his department to "giving priority to the Christopher Park" renovation as stipulated by the board.

"Believe it or not we think we are ahead of schedule." Director of Historic Parks Joseph Bresnan wasn't kidding when he wrote Putnam in January 1983, informing him that the last of the approvals for the reconstruction of Christopher Park, including the installation of "Gay Liberation," was complete. Construction could start by spring; if all went well, "Gay Liberation" could be installed by January 1985.

But for Putnam things were going disappointingly slowly. He was a nervous and suspicious man, who doubted the city's good-faith efforts. All he saw were unaccountable delays. Twice during 1981 he had threatened to withdraw his offer but was appeased by Geldzahler, whom he apparently still trusted. In February 1982 he had written Bresnan an uncharacteristically long and forceful letter filled with consternation over a process he could not fathom. He clearly believed that there was a possibility that the sculpture would not be installed. In that eventuality, he asked Bresnan to "find some informal way to let [him] know so that the Mildred Andrews Fund [could] pursue other possibilities." In his February letter he added a significant condition to his gift: "the piece must be kept in Sheridan Square Park [*sic*] for twenty years, or else the title reverts to the Mildred Andrews Fund, to protect the interests of the gay community." He reiterated, however, his commitment to the work and restated the ideological importance

of Christopher Park as its location. He noted, prophetically, "It is worth waiting for ten years if need be."

Putnam was having problems with Voeller, too. Their relationship was deteriorating. Putnam, a reclusive man, rarely entered the public eye. In Voeller he had found a dynamic, articulate gay activist who could serve as public advocate for "Gay Liberation." Indeed, it was Voeller who faced reporters and angry constituents. Voeller always felt confident in claiming sponsorship of the Segal work, a claim Putnam seems never to have taken exception to, at least until the end of 1981, at which time the two men were not on speaking terms. In truth, although Voeller was a cosponsor, Putnam always maintained financial control of the work. In virtually everyone's eyes, Putnam, not Voeller, was the custodian of "Gay Liberation."[11]

Christopher Park's reconstruction neared completion in early 1985, and "Gay Liberation" could, at long last, be installed. Putnam was notified, as was City Hall. The last weekend of June would be the preferred dedication date, because it coincided with the Stonewall anniversary. But 1985 was an election year. Although Mayor Koch faced virtually no opposition and was a strong supporter of gay rights, City Hall preferred a date more removed from November. It asked that the sculpture be placed by March. Everything was set, almost.

No one was quite prepared for Putnam's letter to Bresnan of January 17, 1985, reconfirming the Mildred Andrews Fund's gift of "Gay Liberation" but with some new conditions. Putnam reiterated what he had told Bresnan in February 1982, that the "sculpture be kept in Christopher Park for at least the next twenty years" and that if "for any reason the sculpture [could] not be kept there, title shall revert to the Mildred Andrews Fund." In 1982 the conditions had been sidestepped because the sculpture was so far from being installed. Now, with the installation imminent, they could not be. Additionally, Putnam stipulated that if the city "no longer wish[ed] to assume the burden of maintaining the sculpture in good condition for the next twenty years at Christopher Park, then title shall revert to the Mildred Andrews Fund." Upon written acceptance of his conditions, Putnam pledged $10,000 for the maintenance fund that Board Two had mandated.

In establishing his conditions, Putnam was motivated, as he always had been, by a firm commitment to the Segal work. Throughout the years he remained firm in his conviction that "Gay Liberation" must remain in Christopher Park. He never lost sight of the primary purpose of the work: it was political. He knew only too well that the work was at risk of vandalism—a second casting at Stanford University had been so seriously damaged in 1984 that Segal had had to recall the sculpture to repair it.

Putnam feared that the city would allow the work to deteriorate to such an extent that it would become meaningless as public art, or worse, that the city would not provide sufficient guarantees to prevent repeated vandalism and would therefore remove the work. His letter was a deliberate attempt to ensure, as best he could, the ideological and aesthetic integrity of "Gay Liberation."

Although Putnam's motivation was sincere, his conditions would present a severe setback. Much had changed in the intervening years. The same administration occupied City Hall, but Parks Commissioner Davis was gone. Perhaps the most significant change was the evaporation of interest concerning the work. When Christopher Park went into construction and "Gay Liberation" went on the road, everyone seemed to forget about the sculpture. The papers dropped the story; momentum was dead. In such an atmosphere, not fueled by a vocal lobby, a dormant controversial subject was encouraged to sleep.

The new parks commissioner, Henry Stern, would not accept Putnam's conditions. It wasn't that the city didn't make deals. Stern himself, at the very moment he was rejecting Putnam's conditions, was agreeing to similar conditions put on the gift of Henry Moore's *Two-Piece Reclining Figure: Points.* The donors, George and Virginia Ablah, had stipulated that "the sculpture be maintained and preserved up to museum standards for outdoor works, and if for some reason this were not possible, the sculpture would be returned to [them]." Stern, in a letter cosigned by Commissioner of Cultural Affairs Bess Myerson, accepted "the terms as outlined."

It wasn't that Stern was equivocal on gay rights either. He was a cosponsor of the city's gay rights bill and had been one of the city councilmen to endorse "Gay Liberation." Strictly speaking, Stern's objections to Putnam's conditions were mundane and technical. They were real and tangible and convenient. Once installed, "Gay Liberation" was going to be a liability Stern wanted to avoid. Putnam's conditions could be parlayed into further delay.

Matters were not made better by the reemergence of Bruce Voeller, who had not been heard from in almost two years. With Christopher Park nearing completion, Voeller called the Parks Department in March 1985 to check on "Gay Liberation." He was informed that the installation was on hold pending resolution of the latest crisis. Voeller was outraged. He wrote Stern a letter rebuking the Parks Department for accepting Putnam's claim of ownership of the work. Voeller argued that the city already owned the work and thus didn't have to listen to Putnam. He made a veiled threat to sue if the city didn't recognize its own right with regard to the statue.

In the long history of "Gay Liberation," no one had ever questioned

its ownership. Stern, a Harvard-trained lawyer, knew that most people, including those in his department, assumed that Putnam was the legal owner. He also knew that Voeller didn't have the resources to go to court. He knew that bringing in the lawyers was not a shortcut. So he did. "Gay Liberation" was sent to the legal limbo-land of the city's Corporation Council for a determination on who owned the work.

In January 1986 the Corporation Council ruled in favor of the Mildred Andrews Fund as sole owner of "Gay Liberation." Although the ruling was significant, it did not resolve the still extant issues of maintenance and insurance, upon which Putnam and Stern could not agree. The untimely death of Peter Putnam in December 1987 was another blow. With his death the Mildred Andrews Fund would be dissolved, a circumstance that, ironically, was an incentive to resolve the lingering problems facing "Gay Liberation." However, matters were still unresolved when Henry Stern left office in February 1990. By then "Gay Liberation" was virtually forgotten, its constituency dead, gone, or not caring. New York's new mayor, David Dinkins, and new parks commissioner, Betsy Gotbaum, may conclude this story, but in matters of art, parks, and politics we know better than to hold our breaths. After more than a dozen years since Peter Putnam first wrote to Gordon Davis, Christopher Park has yet to receive George Segal's sculpture on a theme of gay liberation.

Postscript

AIDS has changed everything.

When Peter Putnam wrote Gordon Davis in 1979, he could not have known that another "crucial turning point" was about to happen in gay history. AIDS was making its rounds, soon to hit so brutally and virulently that it would test the resources of the gay community to their breaking point. Over the past decade, though deadly, AIDS has not been the mortal blow to the spirit of a new consciousness unleashed with Stonewall. Because no one else would, the gay community had to save itself. In the ongoing struggle, gay people have more than once, and against horrific odds, demonstrated those human qualities of "intelligence, delicacy, sensitivity and loyalty" that George Segal found so admirable in them. Nothing in gay life is the same in the era of AIDS, not even a monument to gay liberation. Art under siege by a tiny virus transfigures into a memorial.

ED. NOTE: After delays of more than a decade, George Segal's *Gay Liberation* was installed June 23, 1992 in Christopher Park, Greenwich Village, New York City.

Notes

All quotations are from documents on file at the New York City Department of Parks and Recreation, unless otherwise indicated.

1. There is a long history of confusion concerning Christopher Park and Sheridan Square. Christopher Park is a city park bounded by Grove, West Fourth, and Christopher streets. Sheridan Square—more an irregular parallelogram—is bounded by Barrow, Grove, and West Fourth streets and Washington Place. They are around the corner from each other. Undoubtedly the presence of a monument to General Philip Sheridan (of Civil War fame) in Christopher Park adds to the confusion.

2. The Kent State Memorial is now at Princeton University. It was deemed "in poor taste" by Kent State University officials.

3. The gay rights movement is generally conceded to have begun with the "Stonewall uprising." Shortly after the events of June 28–29, 1969, political gay activism became more aggressive, vocal, and visible. A demonstration of this new activism was the establishment of the Gay Liberation (or Gay Pride) Day parade. This annual event, now as entrenched in New York culture as the St. Patrick's Day and Columbus Day parades, marks the anniversary of Stonewall.

4. Canadian artist Lea Vivot's *Lovers Bench,* which depicts a nude couple in a "heterosexual" embrace, was displayed without incident in both Dante Park (opposite Lincoln Center) and Battery Park on temporary loan for six months in 1985.

5. Over one hundred gay leaders and representatives of over thirty gay organizations endorsed the sculpture.

6. Voeller's retort was specious. Louise Nevelson was approached precisely because of her sexual preference.

7. Saslow took his cues, in part, from essays by Hilton Kramer dealing with Segal's oeuvre, which appeared in the *New York Times* during the fall of 1980. Kramer had an unflattering view of Segal's art.

8. James M. Saslow, "A Sculpture Without a Country," in *Christopher Street,* February 1981.

9. Very few pro letters were received. Most such letters supported the work on its artistic merits. Some mentioned how well Segal achieved his objective, yet none mentioned the merits of having such a monument. Of the hundreds of letters against the work, few rejected it on aesthetic grounds.

10. Community Board Two's stipulation was an astute political move, but it would further delay the installation of the sculpture. A reconstruction contract for Christopher Park was subject to the same approvals process that the sculpture had undergone, except longer. At each stage of a typical design contract—schematic, preliminary, final—approval was needed from the board, the Art Commission, and the Landmarks Preservation Commission. Additionally, Board Two had two internal levels of review—its parks subcommittee and its landmarks subcommittee—both of which opposed the sculpture. It is a testament to the design and diplomatic skills of Philip Winslow, the landscape architect who redesigned the park, that an approved plan was adopted by December 1982.

11. The falling out between Voeller and Putnam began over a disagreement

about the site location of a second casting of the Segal work intended for Los Angeles. The "L.A. Segal" was envisioned as early as 1980. Joel Wachs, president of the Los Angeles City Council, was an enthusiastic supporter of the work. He wrote Voeller (June 18, 1980) that he was "willing to 'go to the mat' on this one," but he showed less courage when he wrote the commissioners of the Board of Recreation and Parks of Los Angeles asking approval of the work. He mentioned neither the work's name nor its content. His description was familiar: "four life-size figures, two standing, and two seated." Putnam became disenchanted with Los Angeles and broke off with Voeller. He then offered the second casting to San Francisco. Voeller read about it in the Bay Area newspapers. He wrote San Francisco Mayor Dianne Feinstein (January 13, 1981) objecting to Putnam's unilateral action. Feinstein thanked him for alerting her to a potential conflict with a sister California city and said she would take no action as long as Los Angeles had an interest. Putnam later withdrew his offer to San Francisco and gave the second casting to Stanford University, where it is now displayed outdoors.

14

Representing the Race

Detroit's Monument to Joe Louis

DONNA GRAVES

When Olympic medalists Tommie Smith and John Carlos raised black-gloved fists during the national anthem at the 1968 Olympics, their fleeting posture was captured in photographs that highlighted current racial politics. At the time, sociologist Harry Edwards described the athletes' protest of racist Olympic policies as emerging from the same source as "the sit-ins, the freedom rides, and the rebellions in Watts, Detroit, and Newark."[1] This potent gesture and its relationship to the politics of race is also central to Robert Graham's *Monument to Joe Louis* in Detroit. Commissioned seventeen years after the Detroit rebellion of 1967, often described as the most violent civil disturbance in U.S. history, the Joe Louis memorial translated this physical gesture into bronze, enlarged it to monumental scale, and located it in downtown Detroit. Although it was conceived as a gift to the city that might lend a badly needed boost to the public image of its sponsors, the monument instead became a focus for debate about appropriate methods of memorialization and, on a deeper level, about racial ideology and racial tensions in urban America.

The controversy that ensued, like many that have accompanied contemporary memorial commissions, arose from the inability of the patron and artist to control the signifier, to define and circumscribe the limits of what is being called to public mind. Analyzing the planning, design, and reception of the Louis monument is illuminating, not only in terms of the politics of public art but also for what it can tell us about the politics of representation and race when they enter the arena of the urban built environment. In the last decade, historians and cultural critics have identified and analyzed the symbols and patterns that characterize attitudes

215

Olympic Racial Protest, Mexico
City, October 16, 1968. (Photo:
AP/Worldwide)

Ed Hamilton, *Joe Louis*, 1987.
(Photo: City of Detroit)

toward race and difference in American culture. The work of literary theorist Henry Louis Gates, Jr., reminds us of the importance of exploring the ways in which "attitudes toward racial differences generate and structure literary texts."[2] Analyzing public monuments is a related task, for visual images are created and defined by similar attitudes and become especially charged when applied to the public spaces of urban America.

In October 1984 Time Incorporated announced that *Sports Illustrated* magazine would donate $350,000 to the Detroit Institute of Arts to underwrite a public monument to Joe Louis, the African American boxer who grew up in Detroit and claimed the world heavyweight title from 1937 to 1950. At the time of the commission, Detroit's chronic segregation by race and class had been compounded by a fiscal crisis brought on in part by the local automobile industry's threatened failure, which resulted in one-third of the city's population lacking any earned income and 60 percent receiving some form of public assistance. While the major car manufacturers lost $3.5 billion, approximately 700,000 workers lost their jobs in auto factories and supplier industries. Predictably, the African American community was hit hardest; by 1981 black unemployment stood at 25 percent.[3]

During the 1960s and 1970s Detroit's central city had suffered from stagnant property values, rising taxes, and capital flight to outlying areas. White residents moved out of the city across the dividing line of Eight Mile Road, in retreat from what many described as a threatening, chaotic wreck; Detroit's black citizens and administration, in turn, accused prosperous suburbanites of abandoning Detroit to economic crisis. As the citizenry of Detroit became predominantly black and poor, racial tensions were escalating over issues such as discrimination in housing and hiring, school segregation, and brutality by a mostly white police force.[4] Although the last three decades have brought increasing disparity in the economic status of whites and blacks in Detroit, the political arena has witnessed a more positive transformation; the black community gained political power as they achieved majority population status. First having gained positions in city and statewide offices through a coalition of black, labor, and liberal organizations, by the late 1960s, African Americans were aiming for more independent political power in Detroit. Years of strong and persistent black activism led to a significant redistribution of political power and the election in 1973 of the city's first black mayor, Coleman Young, one of the most powerful mayors in Detroit history and a key proponent of the Joe Louis monument.[5]

Time Incorporated claimed civic altruism as the motivation for their monumental gift, but maintaining a positive profile was especially important for the publishing conglomerate in the face of the severe recession in

the auto industry, which had traditionally provided a major source of advertising revenues for their magazines. The corporation extended their relationship to the monument, and to the city, by initiating an annual Joe Louis Award. Additional miniature reproductions of the "fist" were commissioned from Graham to be awarded annually to "the individual associated with the city's sports community who best exemplifies the spirit of the great boxer and humanitarian."[6] The Detroit Institute of Arts needed a public relations boost even more desperately: under municipal investigation for mismanagement in the year preceding the commission, the museum— which had a predominantly white, suburban clientele—counted the Louis monument as one of a series of strategic moves designed to improve its relationship to the city's black population and power structure. At the center of the controversy over the DIA were Mayor Young, who wanted the city to have greater control over the museum's large state appropriations, and museum officials and supporters who believed the DIA would be harmed by increased government supervision.[7]

Presumably, Time and the museum believed that the widely admired black boxer, who died in 1981, was both a politically expedient and a safe choice as the subject for a public monument. Joe Louis's career had been carefully managed to construct a public image that would assuage white fears about blacks. Haunted by the memory of the first African American heavyweight prize fighter, Jack Johnson, who was vilified by the white press for relationships with white women and his "arrogant" manner, Louis's trainers, both black and white, presented him as patriotic, a clean-living family man, and "a credit to his race."[8] Yet the public reception to Graham's tribute to Louis could not be so readily controlled.

Graham, a Los Angeles–based artist known for his anatomically precise depictions of the human form, was selected for the commission in 1983 by *Sports Illustrated* from a short list supplied by the museum, and the artist's maquette was approved the following year by representatives of the DIA and the mayor's office. The site chosen by Graham and the monument committee placed the sculpture prominently at the terminus of Woodward Avenue, the major north-south axis in downtown Detroit's Beaux-Arts plan. Surrounded by the matrix of Detroit's political and economic powers, the Louis monument is adjacent to City Hall, the financial district, and the Detroit riverfront, a prime target for urban redevelopment strategies and site of Henry Ford II's Renaissance Center.

A public dedication ceremony was held in October 1986, when, at the sound of boxing's traditional round-ending bell rung by Mayor Young, the monument was unveiled to reveal a 24-foot-long forearm with clenched fist

suspended within a 24-foot-high pyramid of four steel beams. Although commentary by the mayor and several former prizefighters at the ceremony emphasized Louis's contributions to the city and to racial pride, the monument itself was the subject of immediate controversy. Robert Graham's tightly focused realism and his use of the traditional sculptural medium of bronze make him traditional by art establishment standards, and the DIA and Time may have believed that this conservative choice would foreclose interpretive ambiguity. However, although Detroit's citizens apparently felt a rare unanimity in their agreement on the appropriateness of Joe Louis as the subject for a public monument, the process by which the sculpture appeared before the public and the image that was chosen to symbolize Louis were both sources of grievance for members of the community.

Strenuous objections had been raised at the previous evening's City Council meeting by members who argued that important procedures for municipal review had not been observed. The city's zoning ordinance requires review and approval by the City Council and City Planning Commission of the design and location of all structures, including public artworks, in the downtown area. The Louis monument had been reviewed and accepted in model form by the DIA and the mayor's executive assistant, but the work had been approved only in concept by the city's Arts Commission and City Council, and had not been put before the Planning Commission at all.[9] When the City Council approved the monument in February 1986, they were told that "the exact form of this work will remain undisclosed until its public unveiling, at the request of the donors. The artist has proposed a symbolic tribute to the great fighter rather than a literal representation of Louis."[10] Despite over a decade of national precedents for community input and review in the public art process, the Louis commission had proceeded in relative secrecy and suffered the predictable consequences.

Some of the sculpture's critics objected to the manner in which it was "sprung" on the public, while others felt that the site was inappropriate and lobbied to have the monument moved to a place that had more recognizable connections to Louis's life and career, such as the Joe Louis Sports Arena. The factors affecting the location of the Louis monument were determined by the aesthetic, political, and economic agendas of the artist, local politicians, and the sponsors. Graham selected the site for its kinetic qualities, believing that the sculpture would be "energized by all [the] activity and traffic and visual information" of the bustling intersection.[11] The downtown location aided efforts by the DIA and Time Incorporated to strengthen their images with the citizenry and political structure of Detroit. The work's

proximity to City Hall helped efforts by Mayor Young, who had been raised in the same "black bottom" neighborhood as Louis, to appropriate the boxer as a symbol reinforcing connections to his black constituency. Finally, the sculpture's location in a redevelopment area near the waterfront indicates that an economic purpose may have been envisioned for the monument. Pro–public art planners and developers throughout the United States have been vocal in their arguments that an important utility of public art is its capacity to unlock economic potential in given spaces. In fact, the Louis monument's connection to the nearby Renaissance Center, a major mixed-use redevelopment project, was made explicit in one DIA press release in which the artist's "classical" style was touted as a "symbol of Detroit and its Renaissance spirit."[12]

A few weeks after the unveiling, the *Detroit Free Press* ran a tongue-in-cheek article about the controversy and asked for readers' response to the question "What do *you* think should be done with The Fist?" The more than 150 responses to this query ranged, according to the author of a follow-up article, "from thoughtful to vulgar to humorous, and though a minority defended it, most said it stinks."[13] People's objections to the sculpture were varied. Some complained that the ungloved arm did not capture the range of Louis's achievements, while others expressed concern that the sculpture was a reminder of racial tensions and urban violence in a city often referred to as the Murder Capital of America. Few of the journalistic accounts of the monument's reception described respondents by race, so racial identity is difficult to link with position on the monument. Yet it is equally clear that race has been a central factor in the controversy surrounding the monument. One perceptive local journalist commented that "the fist touched off an unexpected political forum, revealing how people felt about race, power, and violence."[14] Some observers, including Louis's nephew, were disturbed by the sculpture's resemblance to the clenched-fist "black power" symbol of the 1960s. Others agreed with one of the monument's supporters, who saw it as a hopeful reflection of the black community "fighting against all the odds, rising out of obscurity, refusing to be a passive victim of an unjust system."[15]

An understanding of the controversy generated by this sculpture is strengthened by considering the complicated relationship that Graham's image bears to the history of cultural stereotypes of African Americans and the racial ideology that has shaped them. Sociologist Jeffrey Prager describes racial ideology as the cultural meanings derived from the socially constructed distinctiveness of black people, which are negotiated and systematically organized through public channels, including the courts and the press,

political movements, and intellectual discourse.[16] I would add the built environment and, more pertinent to this study, public monuments to Prager's list of cultural artifacts that sustain and reproduce racial ideology. At the most basic level, twentieth-century American cities support racial ideology by spatial segregation that casts residents of each ethnic neighborhood as "other" to outside groups. And even in cities such as Detroit, whose citizens are now primarily (so-called) minority, the real majority has a difficult time finding their culture and history adequately represented in the urban built environment. From one perspective, the *Monument to Joe Louis* can be seen as a prominent instance of placing what has been marginalized by dominant culture at the center; it remains one of a handful of monuments that honor African Americans in the urban public realm. Yet, while representing a group traditionally considered peripheral to official history, it recalls elements of a visual language that developed to describe African Americans as the "other."

Building upon the contributions of early-twentieth-century African American art historians, such as Freeman Murray and Alaine Locke, recent works by Albert Boime, Hugh Honour, and Guy McElroy have explored the ways in which the European and American visual record of people of African descent has been conditioned by racial theories of hierarchy, exclusion, and otherness.[17] Reductive stereotypes denying self-definition and the full range of human activity and expression have been the most common means of representing those deemed other, whether defined by race, gender, class, or sexual preference. The monumental tradition itself is to essentialize and distill the historical record, an inclination that can all too often lead to distorted understandings of the past and present. One refrain in public comment on the Joe Louis monument was that Graham's symbolic tribute reduced Louis's meaning by emphasizing only one aspect of the black hero's legacy to Detroit. In this case, Louis's physical and athletic prowess was monumentalized without reference to his importance as one of the first blacks in any profession to break the color barrier and win national acclaim.

It would be difficult to exaggerate the impact Joe Louis had upon black and white attitudes toward racial issues during the Depression and war years. As an athlete, Louis excelled in one of the two arenas open for black achievement: traditionally, sports and entertainment have been the primary fields that allowed African Americans to gain national prominence. Until the post–World War II period, boxing, along with track and field, was the only sport in which black Americans were able to compete under equal rules and to display their full talents.[18] Yet Louis's national meaning went far beyond that of a sports hero.

In bouts with Italian and German heavyweight fighters in the mid-1930s, Louis was fashioned by both the black and the white media into a symbol of the United States and a champion in democracy's war against fascism, a role he continued to play during his enlistment in World War II, when visits to troops and charity bouts reinforced this patriotic image. In 1940, Langston Hughes penned the lyrics for a skit celebrating Louis as "America's Young Black Joe," a parody of the shuffling stereotype "Old Black Joe."[19] Beyond his athletic skills, Louis's deeper meaning lay in his example as a black man not only capable of self-defense but able to triumph over powerful white men at a time when most black Americans experienced daily powerlessness in the face of white racism. Self-defense, a crucial tenet in African American political theory from the Harlem Renaissance through the Black Panthers, is an especially powerful concept to draw upon for a monument to a black American hero. Ironically, Detroit's monumental fist, selected by Graham as a symbol of action and power, is static within its stable triangular frame, immobilized by cables that call to mind slave shackles. Literally disembodied, the arm is severed from the brain that lends intelligence and intention to its driving force.

Members of social categories defined as other are commonly perceived by dominant culture as unindividuated and undifferentiated, as in "all African Americans are poor" or "all gay men are effeminate." By distilling his symbolic tribute to the single image of the punch, Graham ran the risk of recalling the ways in which the lives and legacies of African Americans have been reduced to stereotypes in the public record. With this in mind, it is interesting to compare the Louis monument with what is possibly the most famous monument to African American history, Augustus Saint-Gaudens's *Robert Gould Shaw Memorial.* Unveiled on the Boston Common in 1897, Saint-Gaudens's "fusion of traditional equestrian and relief sculpture" elevates the young white commander, Shaw, above the anonymous black troops, who remained nameless until just a few years ago.[20] Like names, faces are a fundamental index of individual identity, and some perceived a similar depersonalization in Graham's faceless tribute to Joe Louis; the fighter's widow, Martha Louis, lamented that "it could be anybody's arm" when she was shown the monument in 1987.[21]

This criticism of Graham's sculpture ran throughout commentary when a second monument to Louis was unveiled in the atrium of Detroit's Cobo Convention Center in 1987. For what was touted as the "people's tribute" to Louis, the national memorial committee, drawn from the art community and local government and business, had specified their desire for a sculpture that "the community could identify with." Funding by an anonymous donor was matched by Detroit citizens, Louis's family, and

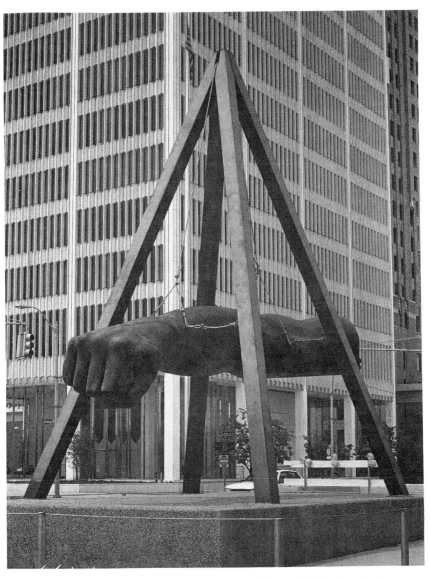

Robert Graham, *Monument to Joe Louis*, 1986. (Photo: © The Detroit Institute of Arts, Founders Society Purchase, with funds from *Sports Illustrated*)

public school students, teachers, and staff.[22] Viewed by many as a corrective to Graham's fist, the memorial took the form of a 12-foot bronze likeness of Louis in boxing stance. Although the second monument also focuses on Louis's pugilistic image, many of Detroit's citizens seem to feel more comfortable with the approach of Ed Hamilton, African American sculptor and winner of the public competition. Believing that capturing physiognomy was crucial to representing the full identity of the man, Hamilton was quoted in an interview as stating, "You try to capture Louis, who he was, in the face."[23] Notwithstanding reported popular support, it would be difficult to argue that the more representational monument goes any further than Graham's in commemorating the extent of Louis's accomplishments in a resonant fashion. Both commissions represent a great missed opportunity to convey the range of meanings ascribed to this African American hero's life and to link him to his hometown in a significant way.

Whether he intended it or not, Graham's focus on the physical nature of Louis's import links this image to ideas of racial difference first developed in the eighteenth century, when a "great chain of being" was devised by European Enlightenment philosophers to organize all forms of life in a hierarchical order, with European males at the top and Africans linked with lower forms of life. The aesthetic catalog based on physical attributes that formed the basis for this pseudoscientific theory was extrapolated to become an index of intellectual, moral, and social capacity. Cultural historians have described the prominence of representations of people of African descent in the fine and popular arts that also focused on physical differences of skin color, hair texture, and size of facial features. Guy McElroy lists the "black buck" as a key stereotype in such visual representations of African American men, a concept that was applied by some members of the white press to Louis and other black fighters, whose achievements were attributed to their "brute strength" and "animal nature."[24]

The myth of black males' animal nature has also contributed to stereotypes about their alleged uncontrollable sexuality. In fact, exaggerated sexuality has been assigned to both black men and black women since the Enlightenment, when European obsession with black sexuality produced detailed visual records of black genitalia deemed aberrant by their white recorders. The phallic connotations that can be read into the Louis monument situate it within this tradition of racial-sexual representation as well, with an added twist. If read as a huge, disembodied black penis, the monument calls to mind both the projection of Anglocentric culture's fears about black power onto black male sexuality and the tradition of brutal repression of African American men by lynching and sexual mutilation.

The volatility of public representations of sex and race has surfaced in another recent commission by Robert Graham. His proposal for a monument to African American musician Duke Ellington in Central Park has elicited criticism for its incorporation of nude black women, which evince Graham's obsession with idealized human form and intricately fashioned genitalia. Nine female nudes positioned below Ellington and his piano serve for Graham as "muses" that literally and figuratively support the fully clothed composer and his music. However, what the artist and some critics might see as the "classical" allusions in idealized female nudes, or in a colossal human fragment such as the fist, have little meaning for many of the citizens who encounter these public works and whose referents are not so closely bound to the canon of Western art history. For other viewers, the Ellington monument reinforces traditional notions of the relationship between gender roles and the public sphere that have restricted most representations of women in public monuments to allegorical figures.[25]

Given the volatile response to his Joe Louis tribute, Graham's assessment of the Detroit commission as "a dream situation" is ironic. He elaborated, "With corporate support from *Sports Illustrated*, aesthetic backing from the DIA, a cultural hero for a subject and a great site in the center of the city. That's public art at its best."[26] In his focus on patron, subject, and site, Graham appears to have ignored the monument's audience and the fact that such a commission must be read against the complex reality of social, political, urban, and institutional history. Those who commissioned, created, and placed the Louis monument seem to have been oblivious to many of the implications of the sculpture's iconography. They could not control, and did not consider, the ways in which this particular image recalled for many viewers a set of cultural and visual stereotypes borne of denigrating racial ideologies. The full story of the Joe Louis monument must include a cautionary tale about responsibility for representing the collective past in public monuments, where the contested terrains of history and the built environment meet.

Notes

1. Arthur R. Ashe, Jr., *A Hard Road to Glory: The History of the African-American Athlete Since 1945* (New York: Warner, 1988), 190.
2. Henry Louis Gates, Jr., "Writing 'Race' and the Difference It Makes," *Critical Inquiry* 12 (Autumn 1985): 15.

3. Joe T. Darden, Richard Child Hill, June Thomas, and Richard Thomas, *Detroit: Race and Uneven Development* (Philadelphia: Temple University Press, 1987), 4.

4. Ibid.

5. Richard Child Hill, "Crisis in the Motor City: The Politics of Economic Development in Detroit," in *Restructuring the City: The Political Economy of Urban Development* (New York and London: Longman, 1983), 91–109.

6. *Sports Illustrated* (27 October 1986): 4.

7. Stephen Advokat, "Detroit Recalls Its Museum," *Art News* 82 (December 1983): 60–67.

8. Jeffrey T. Sammons, *Beyond the Ring: The Role of Boxing in American Society* (Chicago: University of Illinois Press, 1988), 97.

9. Letter from Marsha S. Bruhn, director of the City Planning Commission, to Detroit City Council, 6 November 1986.

10. *Detroit Legal News*, 17 February 1986.

11. Joe Lapointe, "A Fistful of Controversy," *Detroit Monthly* (January 1987): 96.

12. "Detroit's Newest Public Sculpture" (press release), Detroit Institute of Arts, 16 October 1986.

13. Roddy Ray, "Fist Gets Readers' Best Shot," *Detroit Free Press*, 17 November 1986.

14. "A Sculpture Delivers the Biggest Punch," *Detroit Free Press*, 26 December 1986.

15. "Joe Louis Monument Dedicated," *Macomb Daily*, 17 October 1986; "Sculpture Delivers," *Detroit Free Press*, 26 December 1986.

16. Jeffrey Prager, "American Racial Ideology as Collective Representation," *Ethnic and Racial Studies* 5 (January 1982): 99–119.

17. Albert Boime, *The Art of Exclusion, Representing Blacks in the Nineteenth Century* (Washington, DC: Smithsonian Institution Press, 1990); Hugh Honour, *The Image of the Black in Western Art: From the American Revolution to World War I* (Houston: Menil Foundation, 1990); Guy C. McElroy, *Facing History: The Image of the Black in American Art, 1710–1940* (San Francisco: Bedford Arts, 1990).

18. Joe Louis Barrow and Barbara Munder, *Joe Louis* (New York: McGraw-Hill, 1988), xv.

19. Arnold Rampersad, *I, Too, Sing America*, vol. 1 of *The Life of Langston Hughes* (New York and Oxford: Oxford University Press, 1986), 391–92. Louis's heroic stature still stands; Roger Wilkins, the coordinator of Nelson Mandela's 1990 American tour, recently compared Louis's meaning to African Americans with that of the South African leader, and Mandela himself has spoken of Louis's legacy as a hero for South African boys. Roger Wilkins, "With Mandela," *Mother Jones* 15 (November–December 1990): 18–19.

20. Stephen J. Whitfield, "Sacred in History and in Art: The Shaw Memorial," *New England Quarterly* 60 (March 1987): 9, 3.

21. "Nice Statue, Strange Fist, Joe Louis' Widow Decides," *Detroit Free Press* (10 November 1987): 3.

22. *The Monitor*, 29 October 1987.

23. Joy Hakanson Colby, "Louis' Image Stands Tall at Cobo Today," *Detroit*

News, 15 September 1987; "Second Louis Sculpture to Adorn Cobo Hall," *Michigan Chronicle,* 12 September 1987.

24. McElroy, *Facing History,* xviii; Christopher Mead, *Champion—Joe Louis: Black Hero in White America* (New York: Charles Scribner's Sons, 1988).

25. *Robert Graham: The Duke Ellington Memorial in Progress* (Los Angeles: Los Angeles County Museum of Art, 1988). For public comment on the memorial, see Dennis Hevesi, "Ellington Statue Puts Some in Mood Indigo," *New York Times,* 4 May 1990.

26. Joy Hakanson Colby, "The Man Behind the Monument: Robert Graham Visits Detroit," *Detroit News,* 16 October 1986.

15

The "Rocky" Dilemma

Museums, Monuments, and Popular Culture in the Postmodern Era

DANIELLE RICE

In 1982 United Artists film studios installed a statue of Rocky Balboa, the celebrated boxer played by Sylvester Stallone, at the top of the steps of the Philadelphia Museum of Art for the making of *Rocky III.* In the film, the statue is ceremoniously dedicated in front of a cheering crowd and a humbly bashful Rocky. The actor-mayor thanks Rocky on behalf of the citizens of Philadelphia for his many accomplishments and his generous contributions to the city's charities. He lauds the monument as a "celebration of the indomitable spirit of man," and, as the sculpture is unveiled, Rocky's eyes open wide with surprise at the larger-than-life bronze posed in his characteristic victory gesture. While the band plays and the crowd applauds, Rocky turns bashfully to his wife, Adrian, who declares, "It's beautiful!" as she eyes the statue admiringly.

After the completion of *Rocky III,* Stallone donated the film prop to the city of Philadelphia, assuming that the statue would remain in its prominent and strategically significant position, overlooking the grand Benjamin Franklin Parkway, on axis with a monument to George Washington and the statue of William Penn located atop City Hall. But, after much controversy, the statue was removed to the Spectrum, the sports stadium in South Philadelphia where the fictional Rocky and the real Stallone have their roots.

In 1989 United Artists requested permission to reposition the statue for the filming of *Rocky V.* Having been burned the first time around, when they had to pay to have the statue removed from the museum steps, museum authorities negotiated to have the film studio remove the statue at their expense immediately after the shooting. But Stallone reopened the debate

regarding the proper home for the Rocky statue at a press conference that generated much interest in his new film, supposedly the last in the series. In a conflation of fiction and reality characteristic of the Reagan era, Stallone claimed that he had done as much for the museum as Walter Annenberg (who donated $5 million and recently loaned his art collection for exhibition at the museum) and that he had single-handedly done more for Philadelphia than Benjamin Franklin. Museum authorities were once again accused of elitism, and the media eagerly picked up the ball and stirred up the old controversy, casting it in the expected terms of art authorities versus ordinary citizens, elite culture versus popular culture.

Although the museum does not actually have jurisdiction over the disposition of sculpture on its grounds—city property supervised by the Fairmount Park Art Association—it clearly is the most visible and influential target. Museum authorities had to fend off the media attack. They began by arguing that the statue was not art because it had a specific function, that of movie prop. This line quickly became untenable given the nature of the museum's diverse collections, including the celebrated ready-mades of Marcel Duchamp. Stallone hired lawyers to keep the statue there. His lawyers began by arguing the legitimacy of the sculpture as art. It is the work of a Colorado-based artist, Thomas Schomberg (b. 1943), who was called by *Sports Illustrated* (March 23, 1987) "perhaps the best known sports sculptor working today." It is interesting that Schomberg's name is not actually mentioned in any of the numerous newspaper articles about the statue, a fact that would indicate that the piece was indeed conceived of more as a prop. That is, in fact, what Stallone's lawyers ultimately decided when they did an about-face and embraced the museum's initial position, claiming that indeed the sculpture was merely a movie prop and not art at all. This reversal was logical in light of the fact that the Philadelphia Art Commission, and not the museum, has ultimate responsibility for the disposition of public art. In claiming that the statue was not art, Stallone's lawyers hoped to keep the decision on its ultimate disposition out of the hands of the Art Commission and in the hands of city officials eager to capitalize on the statue's popularity with tourists. In the end, the Art Commission considered a number of possible sites for the statue; however, because the piece had already been removed to the Spectrum, and substantial funds were required for the transfer of the 1,500-pound bronze, the Rocky monument remains at the sports arena at the time of this writing.[1]

It could be argued that the Rocky movies themselves constitute a popular monument more appropriate to today's culture than any other form of art, such as sculpture, because the movies more accurately reflect

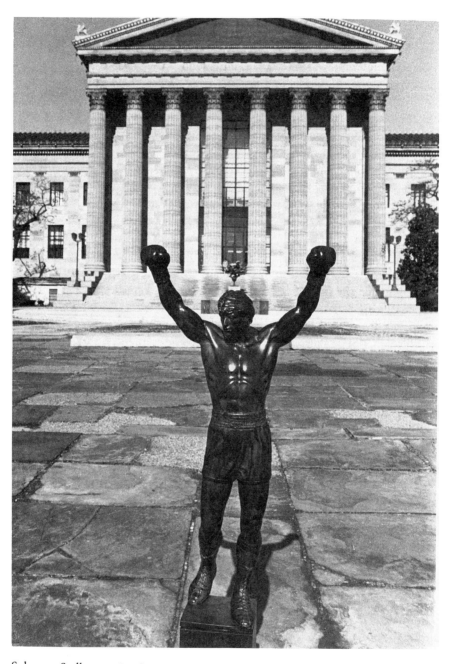

Sylvester Stallone as Rocky Balboa, film prop from *Rocky III*, 1982, United Artists. (Photo: Mort Bond)

the tastes of a majority. But it is clear that these tastes have been rather consciously manipulated for the financial gain of a few individuals rather than for loftier ideals. The myth of the Rocky films is the wish-fulfillment fantasy of the hometown boy who achieves success through perseverance and hard work but maintains his humility despite a number of challenges and temptations. After confronting his own limitations and sometimes awesome foes, the hero always triumphs and generally savors the fruits of his success in the arms of the woman he loves. Rocky's rigorous training includes a symbolic run from the bowels of South Philadelphia, a neighborhood inhabited largely by a mixture of working-class Italian, African, and Asian Americans, down the imposing Benjamin Franklin Parkway. The run climaxes at the top of the museum steps, that ultimate monument to ascendant, owning-class culture. The message of the working-class boy triumphing over the authority of the elite is thinly veiled, although it is never explicit in the movies. Inspired by the Rocky story, thousands of tourists and busloads of schoolchildren each year ascend the museum steps, now commonly referred to as "The Rocky Steps," in order to jump up and down with their hands in the air at the top, like their hero.

While situated at the top of the museum steps, the Rocky statue was acknowledged by city officials to be the second largest tourist attraction in the city after the Liberty Bell. State senator Vincent Fumo introduced a resolution to keep the statue at the museum, saying that it is "a symbol of the spirit of Philadelphia" much like the famed Liberty Bell itself.[2] Because tourism in modern industrial societies helps people define who they are and what matters in the world, it may be interesting to consider the significance of the Rocky monument as a tourist attraction. In his book entitled *The Great Museum,* Donald Horne deconstructs the symbolic language of European monuments, pointing out that "as tourists moving among Europe's sights, we are moving among symbols that explain the world in ways that justify the authority of the few over the many."[3] This symbolic discourse of monuments can probably also be applied to the United States. But there is a second rhetorical thread that is particular to the American tourist experience.

One of the powerful concepts sustained in the three primary nationalistic tourist sites in the United States—Boston, Philadelphia, and Washington, DC—is the peculiarly American notion of the rights of the individual, more broadly defined as the pursuit of liberty. In Boston one visits the places where the pursuit of liberty began in the American Revolution; in Philadelphia one pays homage to the cradle of the documents of liberty, the Declaration of Independence and the Constitution; in Washington, DC, one

can be awed by the hallowed halls that safeguard liberty in the present time. The operative American definition of liberty is the opportunity to achieve enormous individual success and wealth through hard work and perseverance.

The Liberty Bell and the Rocky monument are not as dramatically different as they may at first appear. Rocky is perfectly suited to reinforcing the mythic vision of liberty as free enterprise, and thus it molds itself perfectly to the American dream. During the Reagan era, this myth of self-fulfillment through hard labor took on heroic proportions and became the prime justification for the free-market economic system that shaped the policies of the administration. Ronald Reagan himself, a movie star, had achieved the ultimate symbol of success, the presidency of the United States. The discourse of the Rocky movies is the perfect complement to the mythos of the Reagan years and may in part account for the great popularity of these redundant flicks. The "he-man" boxer, not much brains but lots of heart, is the perfect counterpart to Reagan's tough-man persona, the man who created "Star Wars" and the readiness to fight the "Evil Empire." Like Reagan, Rocky is a small-town boy who does good. And if a movie star can become president, why not a monument to the fictional hero himself who, as the real-life mayor of Philadelphia, Wilson Goode, argued, "represents the struggle of so many people."⁴

As a number of analysts have pointed out, the Reagan era was characterized by a great conflation of illusion and reality. Barbara Goldsmith in "The Meaning of Celebrity" suggests how the long-term American preference for illusion has been given new meaning and power in the last twenty years, owing to the combination of technological expansion and the collective disillusionment following the destruction of the heroes of the 1960s—Martin Luther King and the Kennedys—and the Watergate-Vietnam crises.⁵ In her book, *Selling Culture,* Debora Silverman traces the degradation of historical thinking in the Reagan era. She points out how during the 1980s museums also participated in this illusionism, celebrating the aristocracy of taste, often with little concern for historical issues. Her study focuses on a number of exhibitions organized by the Metropolitan Museum's Costume Institute and shows how these extravagant installations not only corresponded with marketing efforts at department stores such as Bloomingdale's and Neiman-Marcus but often were indistinguishable from displays in the stores. Silverman cites the exhibitions "Chinese Imperial Robes" (1980), "The Eighteenth-Century Woman" (1981), "La Belle Epoque" (1982), and "Twenty-five Years of Yves Saint Laurent" (1983) and describes how they both glorified aristocratic tastes and disregarded historical accuracy in favor

of an approach that celebrated the cult of visible wealth and distinction as a new cultural style concordant with the politics born at the first Reagan inauguration.[6]

A *New Yorker* cartoon recently defined a hero as "a celebrity who has done something real." The confusion between real and manufactured heroism today is clear in the newspaper coverage of the Rocky statue controversy. One Philadelphia writer expressed her regrets that the Rocky statue had been removed as follows: "A hero: But to the museum administrators and their Main Line cohorts, Rocky belonged anywhere else. He was a boxer, after all, a hero of the masses: hardly one of the cultured elite."[7] Clearly this author's definition of hero does not require that he or she have done anything real at all.

Rocky probably comes closer to embodying a modern-day hero than any actual historic figure. He is more widely known than actual historic figures in this society, where curriculum in history varies considerably from school to school and district to district. Only television and the movies can now create such broadly known and revered figures as Rocky and the president of the United States. As a result, Rocky is in a sense more real to a large number of people than George Washington or William Penn, the subjects of the two monuments on axis with the Rocky statue when it was displayed at the top of the museum steps.

The popularity of the Rocky movies and their perfect fit with the myth of the day combined to give the debate over the placement of the Rocky statue the flavor of political controversy. But, whereas in 1982 the controversy over the statue was cast primarily in terms of popular versus elite culture, in 1989 the public brouhaha was all the more poignant against the backdrop of the conservative backlash against the arts brought on by the censorship of the Robert Mapplethorpe and Andres Serrano exhibitions. The aggressive actions of conservative politicians such as Senator Jesse Helms, seeking to destroy government funding for the arts by limiting the powers of the National Endowment for the Arts, also fueled a public outcry against the perceived esoteric nature of contemporary art. Although Helms and his supporters supposedly attacked obscenity in art, all art of an obscure and difficult nature became suspect.[8]

In the art world, the realm of expertise and specialization that is characteristic of all disciplines today has traditionally been more suspect than in other fields, such as math and science. The public institutions of the art world, especially art museums and art education, founded as they are on Enlightenment idealism, still celebrate the concept of art as a universal language. Ironically, this assumed universality of art, the principle that

museums and art world institutions represent, can be inverted by outsiders to call into question any art practice that one does not understand or accept. In effect, this is what gave Senator Helms his self-righteous position against the judgment of art world experts.

The idealist theory of art as a universal language comes into direct and virtually daily conflict with the actual practices of the contemporary art world. Thomas Crow characterizes the art world as a village culture, with a localized dialect. This dialect, the language of high theory, he says, "has become part of the material of art-making."[9] Thus the meaning of art is not the concrete, perceptible substance of the art objects; rather it is everywhere extrinsic to them. In this kind of village culture, outsiders who fail to understand the local argois are doomed to remain outsiders. In contemporary museum culture, however, outsiders are all too aware of their outsider status, and resentful of it. The media further fuels the fire by creating the illusion of a universal culture.

Conservative politicians are easily able to capitalize on the ready resentment of people excluded from the high art hegemony. Although many people did not support the more restrictive of Senator Helms's attempts to limit artistic expression, large numbers registered their dissatisfaction with the practices of the art world. For example, a *Los Angeles Times* poll taken September 14–19, 1989, revealed that while two out of three Americans supported freedom of speech, on the issue of who should make decisions regarding government funding of the arts, an overwhelming majority thought the question should be put to public vote (as opposed to being decided by artists or government-picked experts as is currently still the procedure).[10]

The Rocky controversy coincided with this upsurge of hostility toward the "authority" of the art world, symbolized by the imposing structure of the museum itself. Rocky atop the steps of the Philadelphia Museum of Art stands for the victory of the disenfranchised outsiders of the art world over their snooty and elitist cousins. Hostility toward the hegemony of art world practices easily translates into a hostility toward oppressive authority in general, thus the self-righteous tone of many of the articles in the Rocky controversy.

It is not surprising that this same political environment nurtured another well-publicized controversy over the removal of a symbol of art world authority from a public space. Richard Serra's *Tilted Arc* was removed from Federal Plaza in New York City during the summer of 1989, just a few months before the Rocky controversy. The destruction of Serra's piece resulted primarily from the efforts of a single individual, the politically

appointed General Services Administration's regional administrator, who took office in 1984, three years after the piece had been commissioned and installed.[11]

Public art, specifically the contemporary practice of installing works of art in urban spaces, usually through a process that combines jurying by art world "experts" with consensus building among bureaucrats and city dwellers, has traditionally provided a forum for the airing of conflicting opinions about the nature and role of art. The controversies over the Rocky statue and *Tilted Arc* highlight the failure of communication between the practitioners and experts of the art world and the diverse publics of urban environments. But the controversies also reveal the active—and to a great degree unstudied—role of the media in mythifying and representing so-called public opinion. It is not coincidental that these media-supported and, in the case of Rocky, probably media-created controversies ensued in this particular political climate at this particular moment. Under a banner celebrating mass culture over elite culture, strong individuals have tried to bypass well-established, democratic review procedures either for reasons of personal aggrandizement, as in Stallone's case, or for political ones, as in the case of Helms and Diamond (the GSA administrator responsible for the demise of *Tilted Arc*). Much remains to be written about the pressure from conservative politicians to erode in the 1980s the due processes established in the 1970s for the facilitation of public art and the granting of public money for art.

Finally, the controversy over the Rocky statue raises questions about the nature of the monument in contemporary society. What does a monument of our age look like? Who gets to decide? Is an authentic artifact of a fictional hero the perfect answer? Could the Rocky monument have been transformed from self-aggrandizement and pop cult worship to a form of public art able seriously to engage people in questioning modes of authority? The difficulty of resolving such questions may make one wish for a simpler, gentler time, just like in the movies. Inspired by the Rocky controversy, David Boldt imagined the following scenario:

> Sylvester Stallone has stopped by the museum for a late afternoon glass of sherry with his new friends, museum president Robert Montgomery Scott and director d'Harnoncourt. After an hour or so of pleasant chat, Sly gets up to go, and with a smile playing on his face, starts talking in his Rocky voice as he hands an envelope to Scott.
> "Bob and Anne, diss is something I wanted youse to have," he says. "De only ting is dat I don't want youse to tell where youse got it. Unnerstan?"
> Scott glances at what's in the envelope, looks up and says, *"Absolutely,* Mr. Balboa."

A month or six weeks later a brief press release from the museum announces that thanks to a huge gift from a donor who desires to remain anonymous, the museum's current capital fund campaign goal has at last been reached. Maybe even exceeded.[12]

Ah, would that life were really just like in the movies!

Notes

1. Philadelphia Art Commission, "Report on the Rocky Statue," March 23, 1990. The commission's report evaluates four sites: the museum steps, the Philadelphia Visitors' and Convention Bureau, the current Spectrum site, and a location in South Philadelphia, the home of the fictional Rocky. The report concludes that the South Philadelphia site would be the most desirable.

2. Quoted by Steve Lopez, *Philadelphia Inquirer,* February 22, 1990, p. 1B.

3. Donald Horne, *The Great Museum* (Sydney and London: Pluto Press, 1984), p. 1.

4. Lopez, *Philadelphia Inquirer.*

5. Barbara Goldsmith, "The Meaning of Celebrity," in *New York Times Magazine,* December 4, 1983, p. 80.

6. Debora Silverman, *Selling Culture* (New York: Pantheon Books, 1986), p. 11.

7. Paula Guzzetti, "Yo Adrian! Is This Art?" *Newsweek,* June 18, 1990.

8. A large number of art journals covered, with self-righteous indignation and a sense of impending doom, the developments on Capitol Hill. See, for example, the May 1990 issue of *Art in America* for a number of discussions regarding the conservative censorship crusade.

9. "Versions of Pastoral in Some Recent American Art," in *The Binational: American Art of the Late 80s* (Boston: Institute of Contemporary Art and Museum of Fine Arts, 1988), p. 20.

10. *The* Polling *Report,* December 4, 1989, pp. 6–8.

11. Harriet F. Senie, "Richard Serra's *Tilted Arc*: Art and Non-Art Issues," *Art Journal,* Winter 1989, p. 298.

12. David Boldt, *Philadelphia Inquirer,* March 25, 1990.

16

Baboons, Pet Rocks, and Bomb Threats

Public Art and Public Perception

HARRIET F. SENIE

The "Chicago Picasso," the sculpture that signaled the revival of public art that began in the late 1960s, is frequently compared to a baboon or an Afghan (the dog, not the blanket). In Seattle two very different sculptures (Isamu Noguchi's *Landscape of Time* and Michael Heizer's *Adjacent, Against, Upon*) were, at the time of their installation, related to the then popular "pet rock" craze.[1] And two even more radically different works (George Sugarman's *Baltimore Federal* and Richard Serra's *Tilted Arc*) were perceived as physically dangerous, likely to inspire bomb throwers and rapists.

Such public responses to public art are consistently elicited and gleefully reported in the popular press and on the nightly news. After all, they constitute a human interest story—always good for a laugh, and always bad for art. The public derides art, and the art community bemoans the ignorance of the public. Time and time again well-meaning individuals (local officials, public art administrators, and artists) involved with a public art commission are shocked that their carefully considered project is so glaringly misunderstood. Hands are wrung, wounds are licked, participants commiserate, the public laments, and yet another opportunity for dialogue and understanding is lost. Underneath the comical comparisons, disparagements of monetary worth, and expressions of anxiety lies a core of expectations for art in our society, and particularly for public art imposed on a communal space. These are the expectations that must be addressed if public art is to communicate with its intended audience.

When William Hartmann, an architect at Skidmore, Owings & Merrill, initiated and pursued the commission of a Picasso sculpture for Chi-

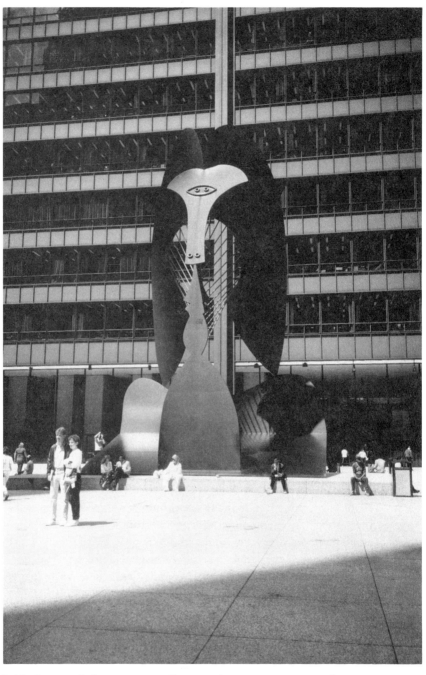

Pablo Picasso, "Chicago Picasso," 1967, Chicago Civic Center. (Photo: Burt Roberts)

cago's Civic Center, he stated simply: "We wanted the sculpture to be the work of the greatest artist alive."[2] In 1963, when the sculpture commission was initiated, Picasso was indeed the most famous living artist, yet he had never had a monumental sculpture built, hated commissions, and had never been to Chicago. Hartmann's concerns were those of an art collector steeped in the tradition of Western European art—one that placed art before the public and expected appropriate approval and appreciation. After much cajoling, Picasso produced a maquette for a signature piece, a Cubist-derived abstract image conflating his wife and pet dog.[3] At its unveiling, members of the general public reportedly compared it to, among other things, "a baboon, bird, phoenix, horse, sea horse, Afghan hound, nun, Barbra Streisand, and a viking helmet."[4] Jokes persisted, but the sculpture was not subject to the art analysis common to Picasso's much interpreted museum works.

What might be deemed the sculpture's success as public art was the result of Mayor Richard J. Daley's public support and a good public relations campaign. For the first few years of its existence, on the anniversary of its installation, birthday celebrations were held in the plaza, complete with cakes provided by a local advertising agency. After a winning season, the sculpture may sport a Chicago Cubs' baseball cap or a Bears' headband. At the time of Mayor Daley's death in 1976 one cartoonist portrayed the sculpture shedding a tear. Gradually Picasso's untitled sculpture became the "Chicago Picasso," in name and in fact. What was obscured in the process was the actual content of the piece. What was affirmed was the unstated intention of the patrons.

Picasso's conflated image of his wife Jacqueline and his pet Afghan combines, in abstract form, the objects of his most intimate affections and desires. Sexual connotations become apparent as one walks around the sculpture, and Hartmann speculated that Picasso "got a bang over the fact that this was Chicago, a strong vulgar city. . . . I thought then that it came at a nice point—it was kind of an off-beat interlude in his life. So it might have been a little stimulus and Madame Picasso enjoyed it too."[5] Although sexual content is often a significant factor in Picasso's work, it has been ignored or unconsciously repressed in discussions of the "Chicago Picasso."

The patrons (the architects, led by Hartmann of SOM, with Daley's approval) wanted to create a plaza for Chicago's Civic Center based on European precedent, one that would ensure Chicago's place on the cultural map and give the city a sense of prideful ownership of art comparable to that of a collector or a museum. (Hartmann subsequently became a board member of the Chicago Art Institute.)

Although some members of the public saw the sculpture for what it was, a woman and/or an Afghan hound, they were never apprised of its actual significance, which related only to Picasso and his art, and not at all to Chicago. Nevertheless, the public, encouraged by the mayor and the media, adopted the sculpture as a locus of civic pride. Thus Picasso's fame (his nearly universal name recognition) sufficed to make the sculpture acceptable even if it made no sense to its primary audience. The sculpture was perceived and used as a civic logo, much the way that Alexander Calder's *La Grande Vitesse* in Grand Rapids (the first sculpture sponsored by the National Endowment for the Arts' Art in Public Places program) was, just a few years later.

The public responding to the "Chicago Picasso" followed a direct "looks like" approach in trying to make sense of it. This metaphorical process is a necessary method of identification in life and art. The primary difference between the two is the context in which the process takes place. In a museum or gallery, a select and voluntary audience places the art in a context relating to a known body of work—both the artist's and a larger art historical oeuvre. An involuntary audience in a public place has as its primary frame of reference the context of daily life. Without an art context, usually provided as a matter of course to an already informed audience in a museum, a general audience must rely on literal comparison ("it looks like a baboon") or generic category ("it's art," or "it's abstract art") for identification. Neither is sufficient. Without an accompanying art education component, the public audience is excluded from the art experience ostensibly intended for them and the art remains a foreign object on familiar turf.

If a strange-looking art object cannot be readily identified, it can sometimes be cleverly translated into vernacular terms. A few years ago a proposed public sculpture by Joel Shapiro became the object of a furious debate when the public (or press) dubbed the rather innocuous-looking piece with a heavy price tag "the headless Gumby." T-shirts with this image were manufactured at once and became an immediate success.[6] Identifying the abstract sculpture with Gumby brought it into an accessible frame of reference and made it an object of easy attack and ridicule. A similar translation of so-called high art into popular culture occurred when Noguchi's *Landscape of Time,* a General Services Administration commission of 1975, was related to the contemporary "pet rock" craze.[7] Noguchi's sculpture consisted of five natural stones with surfaces incised by the artist, arranged in an open composition in front of the Seattle Federal Building. Michael Heizer's *Adjacent, Against, Upon* (1977), also in Seattle, was subject to the same comparison. Although different in appearance and content

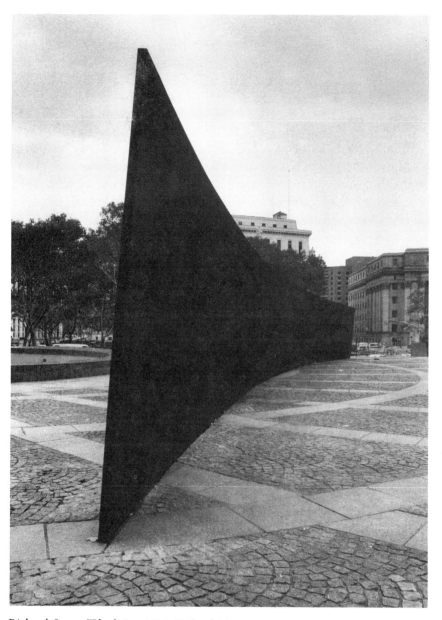

Richard Serra, *Tilted Arc,* 1981, Federal Plaza, New York, NY, removed 1989.
(Photo: Dith Prahn, courtesy Richard Serra)

(Heizer was concerned with the physical relationships defined in the title), both works utilized natural rocks, apparently a sufficient basis for the glib comparison that revealed a problem of considerable magnitude.

Although material costs are easily calculated, the creative process is difficult to evaluate in monetary terms. Referring to Noguchi's *Landscape of Time,* the National Taxpayers' Union was quoted as saying, "The rocks ... look for all the world like common boulders. Though the boulders were available for $5.50 a ton, or a total value of $44, when they were mined, the hard bargainers at GSA purchased the entire collection for $100,000."[8] The relationship between art and money is never a comfortable one. CBS news reporter Walter Cronkite prompted a considerable public outcry when he announced the outlay of federal funds for Claes Oldenburg's *Batcolumn* (Chicago, 1977) the night before income tax returns were due. When art and money are juxtaposed (as they frequently are on the front page of newspapers), the inevitable association is one of conspicuous and suspect luxury if the patron is an individual or private corporation, or excessive spending when public money is involved. Although the intrinsic value of art is not translatable into monetary terms, in our consumer culture money is easier to understand than art and it appears to be an accessible and accurate barometer of worth.

If a work of art is not tamed or framed by being placed within a familiar context, a sense of unease persists, sometimes to the point where the work of art itself is perceived as threatening. Richard Serra's *Tilted Arc* (GSA, Federal Plaza, New York, 1981) was compared to the Berlin Wall, and a physical security specialist for the Federal Protection and Safety Division of the GSA went so far as to contend that the sculpture presented "a blast wall effect . . . comparable to devices which are used to vent explosive forces. This one could vent an explosion both upward and in an angle toward both buildings."[9] In the same vein, Charles Ginnever's *Protagoras* (1974), a GSA commission in St. Paul, was seen as "a potential machine-gun nest" and the "undercarriage of a UFO-type flying saucer."[10]

It is interesting that the perceived threat of physical violence is not unique to monolithic minimal sculpture. George Sugarman's colorful *Baltimore Federal* (GSA, 1978), an open latticework, multipart piece that provides seating, was seen as threatening because theoretically it "could be utilized as a platform for speaking and hurling objects by dissident groups ... its contours would provide an attractive hazard for youngsters naturally drawn to it, and most important, the structure could well be used to secrete bombs or other explosive objects."[11] These responses may be seen as a metaphor for the violent feelings the sculptures aroused in their primary

audience—users of the government buildings where the works were sited. Recent history has shown this reaction to be especially common among judges and security officials, who, respectively, serve precedent and protect the public. Thus both Sugarman's and Serra's sculptures may be perceived as especially threatening, as either unprecedented or new and strange looking, by those whose professional capacities demand an approach based on the known past or one that, of necessity, views the new with suspicion and distrust.

In a broader context, seeing art as dangerous is an acknowledgment of its power. Public art in particular is powerful, because it stands for "the powers that be." Thus, as recent events in the former Soviet Union have once again shown, a political coup is immediately followed by the destruction of public art images of the previous rulers and heroes. Even public art without specific political connotations may fall prey to the political agendas of different administrations and the political climate of the time. But, although public response may be influenced or manipulated by those in power, it still reveals deep-seated attitudes or approaches to art.

Art embodies values, an intangible content that represents a tangible reality which may or may not have been part of the artist's intent. That is what people respond to when they attack statues of rulers no longer in favor or sculpture that stands for a system that doesn't address their most basic physical or spiritual needs. When people compare a Picasso sculpture to a baboon, they are really saying, "You (the powers that be) have put this strange object in my space (without asking me, the powerless individual). How does it relate to my known world, me, my life?" When people relate Noguchi and Heizer sculptures to the pet rock craze, they are really saying, "That's a rock (or rocks). I can see that, and I can buy one of those (only smaller, but neatly boxed) at the local five-and-dime. This is a rip-off." These comparisons are attempts to understand the seen, to make sense of the visible world, to place strange objects that have invaded a familiar space into a known context.

Most tellingly, one outspoken colonel when first confronting the "Chicago Picasso" suggested, "If it is a bird or an animal they ought to put it in the zoo. If it is art, they ought to put it in the Art Institute."[12] In other words, "Unfamiliar art doesn't belong here in this public space. It belongs in a place that clearly identifies its objects as art so you only have to look at them if you want to." What all these responses are telling us is that an understandable context is missing and without that another one will be found (with or without the assistance of facile journalists). The "What is it?" question must be answered. And if all we can come up with is "It's art,"

George Sugarman, *Baltimore Federal,* 1978, Edward A. Garmatz Federal Building and Courthouse, Baltimore, MD. (Photo: Courtesy George Sugarman)

that's not enough, unless it comes with a useful art context that will begin to make the work meaningful to any viewer.

In the decades since the "Chicago Picasso," public art has evolved to include more than individual sculpture. It often addresses the entire site and takes on functions (seating, lighting, plantings) that in the past were the domain of landscape architecture or city planning. Thus the public's physical needs are recognized. At other times it presumes to speak for or to the public through messages or gestures that address contemporary social problems, such as homelessness. Although in recent years the emphasis in public art commissions in this country has increasingly been on "the public" rather than the art component of this complex genre, basic presumptions are still being made and work is still being produced that makes sense primarily or only to an art-informed audience.

One immediate solution is to provide a public art education component along with the art, no matter what form it takes.[13] (Another, on a broader basis, is to continue to lobby for art education in the public schools.) What we cannot afford to do is dismiss public responses or presume to know what the public wants. If we want to know the answer to that vexing question, we have to talk directly, at length, to the various individuals who constitute or represent "the public" at any given time and place. Through dialogue, specific concerns and underlying issues must be addressed, and then artists and public art administrators have to decide whether and how best to translate these factors into public art.

At issue here is not just the future of public art but an understanding of art's place in a democratic society that is trying to broaden the definition of its constituency in a meaningful way.

Notes

1. The "pet rock" craze of the mid-1970s involved the sale of small rocks, neatly packaged in cardboard boxes, whose only distinction was their designation as pets.

2. For a detailed discussion of this commission, see Harriet F. Senie, *Contemporary Public Sculpture: Tradition, Transformation, and Controversy* (New York: Oxford University Press, 1992), ch. 3.

3. William B. Chappell, "The Chicago Picasso Reviewed a Decade Later," *Art International,* October–November 1977, pp. 61–63, establishes the derivation of the piece beyond any doubt.

4. Patricia Balton Stratton, "Chicago Picasso" (M.A. thesis, Northwestern University, 1982), p. 145. See also Gerald Nordlund, *Controversial Public Art from Rodin to di Suvero* (Milwaukee Art Museum, 1983), pp. 40–42.

5. Stratton, "Chicago Picasso," p. 219. Hartmann's observations were made in an interview with Stratton on August 11, 1981.

6. These events were related to the author in October 1988 by a private resident of Charlotte, North Carolina, as well as an individual closely involved with the commission.

7. The GSA has been a major patron of public sculpture with its percent-for-art program, in effect since the late 1960s. For a discussion of this program, see Donald W. Thalacker, *The Place of Art in the World of Architecture* (New York: Chelsea House and R. R. Bowker, 1980).

8. Ronald G. Shafer, "A Touch of Class? Washington Planners Beset by Critical Public over Their Efforts to Put Art into Architecture," *Wall Street Journal*, September 21, 1976, p. 48.

9. This and other testimony is available in the proceedings on the GSA hearing on *Tilted Arc*, which took place on March 6–8, 1985. For a complete discussion of the controversy and removal of the sculpture, see Harriet F. Senie, *Dangerous Precedent: Richard Serra's "Tilted Arc" in Context* (Berkeley: University of California Press, 1993).

10. See Thalacker, *Place of Art*, p. vii.

11. For a summary of the controversy, see JoAnn Lewis, "People Sculpture: Objections Overruled," *Art News*, December 1976, pp. 83–85. A more detailed account is provided in Thalacker, *Place of Art*, pp. 8–13.

12. Edward Schreiber, "Picasso Work Rubs Reilly in Wrong Places," *Chicago Tribune*, June 14, 1967.

13. More experimentation is necessary to determine what programs work best in different communities. Artists' talks, public symposia, descriptive panels or video programs at the site to explicate the art and discuss it in the context of the artist's career as well as of other public art, and outreach programs in local schools and corporations are among many approaches that have been tried and proved useful.

New Directions in Public Art

During the last two decades, as funding opportunities proliferated and contemporary artists gained more experience working in the public realm, public art changed in both form and function. No longer seen as a discrete art object, it began to address conditions of the urban environment and the concerns of the public who inhabited it. Thus a new focus on landscape and the importance of site was seen in works by Alan Sonfist, Mary Miss, Athena Tacha, and Elyn Zimmerman. As an extension of such public sculpture, which included landscape elements or took the form of mini-parks, some artists—such as Robert Morris, Herbert Bayer, Michael Heizer, Nancy Holt, and Pat Johanson—began making public works that actually functioned as land reclamation.

In 1972 Robert Smithson noted, "Art should not be considered as merely a luxury but should work within the process of actual production and reclamation."[1] Although none of Smithson's land reclamation projects were realized, Robert Morris in 1973–74 executed the first publicly funded one in Grand Rapids, Michigan, home of Calder's *La Grande Vitesse,* the first sculpture funded by the National Endowment for the Arts' Art in Public Places program. Some six years later, in 1979, as part of an exhibition at the Seattle Art Museum entitled *Earthworks: Land Reclamation as Sculpture,* Morris executed a second land reclamation sculpture in southern King County, just outside Seattle. His essay here, reprinted from the exhibition catalog, examines the moral dilemma of such sculpture, which in effect beautifies or masks the environmental damage caused by negligent corporate use.

In the 1980s the issue of public sculpture and utility was addressed by

a new generation of public artists who saw their responsibility in the public realm as more closely akin to that of an urban designer. The pioneering public art of Scott Burton took the form of hybrid sculpture/furniture that provided much welcome seating in many urban contexts while maintaining the look of art. Thus, for the Wiesner Building at the Massachusetts Institute of Technology (1985), Burton determined the shape of the interior seating and the stair railing, while Richard Fleischner designed the exterior areas linking the building to its surrounding spaces and architecture, and Kenneth Noland provided color and pattern on the exterior and interior surfaces of the building itself.[2] Further developing an approach to public art as an integral element of urban design, artists began to make sculpture that functioned variously as gates (R. M. Fischer, Lauren Ewing, Donna Dennis), bridges (Siah Armajani), and lighting (Stephen Antonakos, Rockne Krebs), thus addressing a wide variety of urban needs that had traditionally fallen under the category of street furniture created by designers or engineers.

New thinking about the nature of public spaces and the public that inhabits them led to a different development that also sought to achieve a greater democratization of public art. Dolores Hayden's essay "An American Sense of Place" seeks to expand the references and locations of significant buildings and sculpture. The collaborative project *Biddy Mason's Place* (1989) marks the site of the first building owned by a black woman in Los Angeles, thereby reclaiming a previously neglected individual and community history. Similarly, a recent exhibition, *Places with a Past,* curated by Mary Jane Jacobs in Charleston, South Carolina, featured works by Kate Ericson and Mel Ziegler, Houston Conwill, Anthony Gormley, and David Hammons, among others, that were sited in "the other Charleston," previously invisible to the city's tourists and many of its own inhabitants.[3]

The public art experiment of MacArthur Park in Los Angeles also placed a variety of art forms by contemporary artists in a deteriorating urban location. Architect Steven Bingler's evaluation of the projects considers, among other things, the danger of equating urban sculpture with urban renewal.

As the siting of public art expanded beyond traditionally significant locations usually associated with the existing power structure, so did the public it addressed. Contemporary community mural projects depicting the history and concerns of their local communities recall the social concerns of the Mexican mural movement of the 1930s. However, today's murals are frequently executed by neighborhood residents, usually under the direction of a professional artist. The pioneering *Wall of Respect* (1968) in Chicago was painted collaboratively by the Visual Arts Workshop of the Organiza-

tion of Black American Culture, led by the charismatic William Walker.[4] The artist Seitu Jones, in "Public Art That Inspires: Public Art That Informs," addresses the impact of this project on its immediate community, other black organizations, and minority artists in general.

There is today a growing body of significant public art that includes works by individuals who are not professional artists. Surely one of the most moving of such works is the NAMES Quilt, composed of squares measuring 6 feet by 3 feet (the size of a coffin), made by mourners for the victims of the twentieth-century plague AIDS. But the NAMES Quilt, as well as the community projects cited by Seitu Jones, takes a form that fits no traditional definition of art. This issue is confronted by E. G. Crichton in "Is the NAMES Quilt Art?"

As the definition of public art continues to expand, the role of temporary projects becomes increasingly important. These projects, such as the ones discussed by Patricia Phillips in "Temporality and Public Art," provide a valuable testing ground for the parameters of public art. They offer the opportunity to determine what constitutes public art at a time when the definitions of both the recognized public and art itself are in constant evolution.

Notes

1. Nancy Holt, *The Writings of Robert Smithson* (New York: New York University Press, 1979), p. 221. Smithson's proposals for land reclamation are detailed by Robert Hobbs, *Robert Smithson: Sculpture* (Ithaca, NY: Cornell University Press, 1981), pp. 215–27.

2. For a complete documentation of the project, see *Artists and Architects Collaborate: Designing the Wiesner Building* (Cambridge, MA: MIT Committee on the Visual Arts, 1985).

3. See Mary Jane Jacobs, *Places with a Past* (New York: Rizzoli, 1992).

4. For a complete documentation and discussion of this development, see Alan W. Barnett, *Community Murals: The People's Art* (Philadelphia: Art Alliance Press, 1984).

17

Earthworks: Land Reclamation as Sculpture

ROBERT MORRIS

It has always seemed to me that when an artist is asked to speak about his work, that one of two assumptions is being made: one, that because he has made something, he has anything to say about it, or two, if he does, he would want to. Questionable assumptions, in my opinion. But in my case, I was not asked, I was told. It was part of my contract and I couldn't get it changed. In any case one should not forget Claes Oldenburg's remark that anyone who listens to an artist talk should have his eyes examined.

Now the work I came out here to do is not even started, so it seems premature for me to discuss it or attempt a dialogue with you who've not yet experienced it. Some twenty minutes of restful silence might be the most positive contribution I could make here, but it would, I'm afraid, be misinterpreted. So treading the edge of silence, I will speak in the most general terms.

I would like to address the question: what is public art? But the very question suggests further questions rather than answers. For example, if there is such a thing as public art, what then is private art? I think we would agree that whatever else it might or might not be, the term public art has come to designate works not found in galleries or museums (which are public spaces), but frequently in association with public buildings, and funded with public monies.

For about a decade now, there have been works produced which are found neither in galleries nor museums, nor in association with architecture. This is the type of public art I want to address here. Such work is invariably manifested outside and is generally of a large scale. Other than those two characteristics, it has been fairly varied. Some has focused on the earth itself,

some veers toward architecture, some involves both construction and rear-
ranging of the landscape. Such work has been termed earthworks and
siteworks. Much of it has been impermanent—in some cases, set up only
for the sake of documentation. Such work exists then as a photograph and
reverts back to being housed in a gallery, or in the media. It would not be
accurate to designate privately funded early works of Smithson or Heizer
or De Maria in remote parts of the desert as public art. The only public
access to such works is photographic.

However, since the early 70's, a number of large-scale works, both
permanent and impermanent, situated outside, have been accessible to the
public, and to a greater or lesser extent, have been made possible by public
funds. So to some extent, large outside projects, earthworks or otherwise,
have moved from the private domain (that is, private in the sense of private
funding and physical remoteness) to that of the public.

Of course, it is a question as to whether we have in such works, leaving
aside their financing and use of alternative spaces, anything in significantly
structural ways different from works found in art galleries.

In my opinion, there is a certain amount of earthwork and sitework
that has been done, or is being done, that brings new structural assumptions
to artmaking.

Of course, any attempt to class these works as more in the public
domain, more accessible, more directed to a public use, is in one way rather
comical in the face of the literal busloads of people prowling the museums
and galleries of New York City, and that neo-Paxtonian disco-delirious
culture palace of Beaubourg in Paris. The public is breaking the doors down
to get at it in these two cities. Perhaps here, the U.S. government has
observed this fact, and their current populist, middle-brow policies of
bringing the mediocre to the many are perceived by them as an emergency
measure designed to diffuse concentrated culture. Perhaps they fear cultural
riots.

In any case, whether it be SoHo or Seattle, art has come to be
perceived as fun, as accessible, as entertainment rated G. Many have sighed
with relief and taken the popularity of the arts as convincing evidence that
there is no longer an hermetic and recalcitrant avant garde. I'll return to this
notion in connection with modernism and its demise.

In attempting to assess the notion of public art, it might be useful to
examine the history of the genre. If we turn to examine nineteenth-century
public art, we are addressing the monument. Clearly, the antecedent to the
work we are discussing is sculpture and not architecture or even mural
painting. I think that it is important to bear in mind that all of the people

Robert Morris, Untitled (land reclamation sculpture), 1979, 3.7 acres, King County, Washington State. (Photo: Burt Roberts)

who've made advanced work in the mode of earthworks and siteworks or even certain quasi-architectural ones have been sculptors. And it is only out of historical pressures, and formal exhaustions of sculpture, that the present large-scale, outside works could have come. The nineteenth century abounds in forgotten neo-classical monuments to larger-than-life events and people. The crisis and gradual retreat from the possibility of sculpture as monument come with Rodin. His figurative group, *The Burghers of Calais*, was barely accepted after great difficulty. The later *Balzac* was never installed in the intended site, and the *Gate of Hell* was never finished. The two major works of Rodin, the *Balzac* and the *Gate*, both conceived as monuments, were failures in those terms. As Rosalind Krause has pointed out, it is at this point in the crisis and failure of the outside monument that sculpture comes indoors to thrive in the homeless, non-sited modernism. Historicizing at the generally accepted reckless pace, one could say that from the generalizing volume of the *Balzac*, Brancusi fragmented and volumized further to put sculpture firmly on the road to the independent object, finding its apotheosis in the minimalism of the early 1960's, from which point it turned toward the door and finally made it outside again. This is one narrative which features not only Rodin and Brancusi, but Judd, Lewitt, Andre, Smithson, Serra, Oppenheim, Morris, and others.

One could trace another, chronicling the movement as independent object and see an unbroken chain of burdensome marble, bronze, and steel adorning architectural plazas, courtyards, sculpture gardens, and fountains, and featuring Carpeau, Pevsner, Smith, Caro, di Suvero, Oldenburg, and others. No doubt, this goes to show that one person's historicizing is another's fiction.

In any case, the work we are discussing not only does not adorn architectural spaces, but in most cases has a dialectical relationship to the site it occupies. Another characteristic of the work under discussion and one inherited from minimalism is the coexistence of its space with that of the viewer. The emergence of this characteristic in the 60's also signalled, more than any other formal one, the termination of indoor sculptural efforts as modernist for it purified the work as a sculptural object and drove it toward architecture, toward temporal rather than instantaneous perception. The pressures for increased scale in the lateral dimension, by extending and articulating a space, which included the viewer, pushed such work out of the confines of the gallery.

Hence, it is no surprise that the first large-scale exterior earthworks and site constructions of Smithson, Heizer, Serra, Morris, and others exhibit strong gestalt forms, extended into space, as a heritage from minimalist

form. But I think it is fair to say that by the mid-60's, there were more than just formal pressures forcing sculpture to move outside. Part of the impetus was the raging commodity use to which gallery art was being put. Such were the times when a collector like Robert Scull could say to another collector, "I just bought ten works by X." To which the other collector replied, "I never heard of him; he's a nobody." To which Scull replied, "After I bought ten of them, he's somebody."

The fact that the first large-scale works were privately funded, some by Mr. Scull himself, indentured the artist, perhaps more than any gallery sale. There was a feeling, however misguided, that the artist was operating outside the crassness of the marketplace, that he had left off producing saleable objects, that he was somehow specially privileged by this patron relationship, that he was acting more in the real world.

I think these attitudes were illusions, but at the time they were prevalent.

In passing, it is worth making a distinction here between modernism and avant garde. During the early 60's the two coincided momentarily, but the formal lines of painting and sculpture were maintained. In the late 60's this was not the case. Formats were dismantled and forms proliferated. In my opinion, this proliferation has not engendered a pluralistic kind of liberal tolerance which has diffused critical art issues. I believe there are still avant garde art issues of a structural and critical nature. Such issues do not happen to be identified exclusively with particular, ongoing forms, but they are avant garde in the sense of being at the leading edge of critical thought and art moves—moves which, needless to say, are not self-critical in the old-fashioned modernist sense. Some present-day earthworks and siteworks manifest such moves.

Some of the ostensible formal elements involved—space, scale, and time—are not simply expanded, made larger in siteworks of extended size. Such elements become quite different to deal with in an exterior context. Perception of large spaces and distances is of a different order from the relatively undemanding instantaneous order for objects in closed interior spaces. Priorities can shift within the handling of these formal elements. What may have been latent and unemphasized in interior work may come to the fore in an outside situation in quite different ways. Take the element of time, for example. It is not much emphasized in previous object sculpture. In fact, it was generally assumed not to be a formal parameter at all, as objects are pretty much apprehended all at once. But, as I indicated, as a space expanded in certain minimalist work, time began to emerge as a necessary condition under which the work is perceived. Complex and

extended works which assumed the viewer's presence from within, so to speak, locked time into space itself. Outside works expand and articulate this much further, and because siteworks are inseparable from their places, an element like time or space is not bound entirely as a formal element within the object properties of the work. Such elements must be acknowledged as existential properties of the complex of work and site together, and can't be separated from such features as changes of topography, of light, of temperature, of the seasons. Those works which respond as well to historical, economic, social, or political features of a place are then reaching beyond even these transmuted formal properties in shaping a work.

An awareness of the myriad existential functions of the particular place, be this desert or town, hillside or swamp, gravel pit or vacant lot, demands a range of responsiveness and opportunities for change not implied for the most part in the gallery or museum context.

When the better work is examined, it seems evident that the encounter with the existential conditions of place has been formative. Reactions to particular features of that place, be they temporal, geological, topographical, social, spatial, historical, economic, et cetera, have moved the arts significantly off a purely formal axis. Making the work more locally relevant has not made it more parochial, in my opinion, but more inextricably a part of the time and place in which it exists.

Sophisticated formal concerns are not so much weakened here as they have come to be assumed as a necessary requirement, but perhaps now not the central motivating concern.

I would argue that the formative uses of these transmuted formal and transformal, locally relevant conditions of place have added a significant structural new element to the artmaking. Such usages derive from the context of place, and form the art with what can once again be called a theme. It will be remembered that both Rodin's and Brancusi's works are informed by what can be described as themes. Fairly general and romantic in Rodin's case, jejune and mystical, perhaps, in Brancusi's.

If the thematic in the new work represents in some sense a return or reconnection to nineteenth-century art, this is, in itself, a new art issue. But the redefinitions involved in the formal and thematic, and as we shall see, the uses to which the art is put, also raise new issues.

The incorporation of a new motive and internal structure, that is, the thematic as a contextural response, constitutes more than a variation. Here we are not talking about mere empirical differences between past indoor sculptures and siteworks, but about a shift in the basis for proceeding to make the work. Such different assumptions, motives, responses, and results

also do more than raise aesthetic issues as to what art can be. They raise moral questions, as well, as to where art should be, and who should own it, and how it should be used.

In terms of broad thematic differences between various siteworks which now exist, one general grouping can be made—of those who have chosen to work in inaccessible parts of the great Southwest to pursue various themes of Emersonian transcendentalism truly reminiscent of nineteenth-century attitudes, a kind of re-living of the pioneer spirit, of subduing the West in artistic terms. There can perhaps be found the last rugged individualist, toiling with a bulldozer rather than Conestoga wagons to construct quasi-religious sites for meditation.

Those working closer to urban sites and in less overwhelmingly romantic landscapes have produced work more often informed by social, economic, political, and historical awarenesses, as well as by concretely physical ones relevant to the site.

My intention here is not to give a critique, either in formal or thematic terms, of existing siteworks but, as I said at the beginning, to tread near that treacherous, crumbling edge of the general, where broad differences come into view. But examples abound of the distinctions I am making. Those less public works done in the desert are fairly well-known. Less known perhaps are works of such artists as Tractis, Miss, Aycock, Singer, Asconti, Fleischner, Irwin, Holt, and others, all of whom have worked frequently in non-spectacular and sometimes dense urban sites with extremely varied formal and thematic approaches. Such work, in my opinion, presents a sharper critical edge than that which is more pastoral and remote. It is also more public in the literal, aesthetic, and social senses.

It should be apparent that in using the term "thematic" in relation to the new work I am using the term in (1) a very general way, and (2) a very different sense from how it is relevant to nineteenth-century work. The thematic in the work I have mentioned is not commemorative of great events or people; neither is it narrative in the illustrative sense. Rather, it is commemorative of one or another of the various aspects of the site itself. I am using the term to designate this referential aspect, the many things about the work which do not exhaust themselves in purely formal terms.

In spite of sharp thematic and formal differences between the types of work, there is, not surprisingly, little sense of an internal dialogue between various works. Unlike the modernist enterprise of redefinition of sculpture that was going on in the 60's, there is no comparable discourse cast in terms of formal moves from one outside work to another. While such work has inherited many formal and perceptual assumptions worked out by minimal-

ist sculpture, it seems to be work of quite a different order, primarily because, as I have argued, it is structured by thematic responses to its context of site. Formal innovations have not been generally the focus of this work. If some of the first earthworks now seem a little romantically over-blown, no doubt their spectacle aspect has had something to do with their popular appeal.

It might be worthwhile to discuss the notion of public access, how it is achieved, and what it might mean. It seems every effort is being made to amplify these Seattle projects in the media. The cynical might say that such an effort masks an anxiety to justify the money spent on the projects. For as we have witnessed, intense media coverage, even if it is controversial, tends to be a form of legitimization in this country. The popular media is not always in a position to evenly assess events so much as it is to promote them to the realm of the super-real, the mythical, and ultimately, if there is enough repetition, the historical.

But I think other assumptions lie beyond the media push surrounding these projects—namely, the assumption that there is something especially relevant to and open for the public in these projects, that they defend an aggressive, non-elitist, an even anti-museum stance, while at the same time counting as advanced art. Again, a cynic might reply that it is the spectacle aspect of much outside site and earthworks which is responsible for their popular appeal. Now, I don't have anything against spectacle. In the 60's I was one of the early ones to perform nude in a work called Waterman Switch. The effort elicited sneers from some of my colleagues and a certain amount of media attention. But the attention was addressed to the spectacle nature of the work and offered no informed critical response. It has been the fate of much sitework to be addressed by the media for its sensational aspect: *art*'s answer to Disneyland. Come on out and risk your life crawling through tunnels and teetering on ladders! Or better still, if you're man enough, I should say person enough, make a risky pilgrimage to the inaccessible desert wilderness where, if one can avoid the sidewinders and the cryptic remarks of the taciturn artist, one can return sunburned, but definitely enriched, or at least thrilled, and with a stack of Kodachrome slides. John Ford, eat your heart out!

Still, siteworks will never approach certain forms of more popular art in eliciting the highest forms of sensationalist response. Pauline Kael de-scribed the sounds of Maria Schneider's panties being ripped off by Marlon Brando in *Last Tango in Paris* as comparable to the first four notes of Beethoven's Fifth. Now, it is a sad but true fact that no lowly plastic artist could ever attain such heights or depths, as the case may be. I don't want

to imply that the spectacle-oriented responses are illegitimate. Art doesn't legislate responses, but, in my opinion, art that is interesting is interesting by virtue of its internal structures, notwithstanding whatever external spectacle it might present. Rather, it is art in which there is an importance in how things are put together by the human mind, those inventive, perceptual, ordering achievements which make art fascinating and deep from the inside, as it were.

What is frequently and popularly termed great art, usually in relation to long dead artists, often involves nostalgia, often a nostalgia even for long-lost spectacle—hero worship or some comforting sense of the familiar. Why else would major museums want lavish shows on third-rate, but solid gold King Tut artifacts, or why else would the Museum of Modern Art follow the Cézanne show, an unnecessary non-modern but by now thoroughly familiar set of images, with a museum-wide exhibition of Picassos, again as familiar as calendar images. Such popular judgments are made from the outside, or else in the interest of attendance.

But the assessment of internal structure demands a certain informed response, at least that level that is available in interest in art. It's available in much sitework, which is not to say it denies any spectacle or popular appeal the work might have.

I only want to indicate here in general terms the ways in which recent site and earthworks are different from previous sculpture, by virtue of their internal structures, and to raise some discussion as to how such work qualifies for the designation public art.

In doing so, I want to draw attention to its continuity with the past tradition of modernism in nineteenth-century work, as well as its break from those traditions. If it represents a new direction, it can equally be seen as a return via certain redefinitions to a justification for monumental work which had been cast aside at the birth of modernism and now appears once again on the dual grave sites of modernism and abandoned industrial landscapes.

In contrast, nothing now seems deader than large-scale outside object sculpture, that other tradition I mentioned. Attempting to live in symbiosis with architecture, insofar as it retained its autonomy as an object, it forfeits any structural or thematic relation to its context.

I'd go even farther in the cases of those artists still producing the sort of work which achieved identity and recognition in the 60's as modernist and include modes of work derived from Cubist antecedents as well as the minimal. The continued production of such works placed outside, or even inside for that matter, seems more than suspect at this time. It is true that

artists must live for the most part by the production of saleable objects. But that does not justify art that reduces its ambition to the tiny focus of mere variation of past modes for the sake of sales. It reduces art to a craft function, and blackens its image as an ambitious undertaking concerned, as any ambitious discipline, to go forward by risking attempts at internal structural discovery. In short, much like manufacturing, masquerading as art today, large-scale object sculpture has abdicated the objective of art, which is the ambition for new structure in the most extended sense. Such an aim lies on the other side of either superficial newness for its own sake, or the permutation of desiccated modernist ideas.

Generalizing further, I would say that the weakened position of much art of the 70's is endemic, and can be linked to a lack of significant intellectual dissent in the country at the present time. But this is the subject for another discussion.

Of course, so long as mindless city planning prevails, and bureaucratic architecture yearns for decor, there will be dumb sculpture burdening plazas, and greenswards and siteworks will have to find dumps, swamps, gravel pits, and other industrially ravaged pieces of the landscape, if they are to be located near urban centers. Personally, I prefer such wasted areas to those numbing plazas and absurd sculpture gardens. In regard to the present situation here in Seattle, we have an alternative to art as urban decor in the form of art as land reclamation.

In closing, I want to take this opportunity to thank the King County Arts Commission for sponsoring these present projects. To my knowledge, this is the first time that art has functioned as land reclamation. The idea of cleaning up the landscape that has been wasted by industry is not, of course, new. I have previously had discussions with coal mining interests in West Virginia, and I know Robert Smithson was negotiating some time ago with coal miners in the West.

But a few things have not been discussed, to my knowledge, about art as land reclamation.

The first thing seems rather bizarre to me. That is, that the selling point was, is, that the art was going to cost less than restoring the site to its "natural condition." What are the implications of that kind of thinking . . . that art should be cheaper than nature? Or that siteworks can be supported and seen as relevant by a community only if they fulfill a kind of sanitation service?

The most significant implication of art as land reclamation is that art can and should be used to wipe away technological guilt. Do those sites scarred by mining or poisoned by chemicals now seem less like the entropic

liabilities of ravenous and short-sighted industry and more like long-awaited aesthetic possibilities? Will it be a little easier in the future to rip up the landscape for one last shovelful of non-renewable energy source if an artist can be found (cheap, mind you) to transform the devastation into an inspiring and modern work of art? Or anyway, into a fun place to be? Well, at the very least, into a tidy, mugger-free park.

It would seem that artists participating in art as land reclamation will be forced to make moral as well as aesthetic choices. There may be more choices available than either a cooperative or critical stance for those who participate. But it would perhaps be a misguided assumption to suppose that artists hired to work in industrially blasted landscapes would necessarily and invariably choose to convert such sites into idyllic and reassuring places, thereby socially redeeming those who wasted the landscape in the first place.

18

An American Sense of Place

DOLORES HAYDEN

Adrienne Rich, in her poem "Origins and History of Consciousness," defines the true nature of poetry and of all art as "The drive to connect. The dream of a common language." It is this dream of a common language that I want to explore, as it applies to the search for an American sense of place by architects, designers and urban planners. What follows is an exploration of the intellectual history of that search, as I understand it.

In the last decade and a half, architects have engaged in extensive polemics about whether or not it is possible to find a common language to connect with the average American who wants to understand and enjoy the urban built environments that provide the settings for everyday life in the United States. Many of these polemics were initiated in the late 1960s by young designers or "social architects" (I was one) involved in what was called advocacy architecture or advocacy planning. We attempted to help community groups halt highway construction, to help tenant groups re-model inadequate housing and to help idealistic social workers and health workers create storefront ghetto service centers. In his book *All That Is Solid Melts into Air,* political scientist Marshall Berman characterizes this era as "a shout in the street," a protest against brutal urban redevelopment schemes and "the expressway world" of bureaucratic master builders like Robert Moses.

While these polemics about the public, social meaning of architecture and urban space have continued and become more sophisticated since the late 1960s, for most architectural audiences they have been eclipsed by the rise of what has been called "post-modern architecture," beginning with denunciations of the heroic social aspirations of some of the designers of the

modern movement and continuing with an enthusiastic period of historical eclecticism. Architecture as art was rediscovered, architecture as "built sociology" dismissed as utopian, unworkable and silly. The "art for art's sake" polemics generated the energy and aesthetic liberation needed for designers to produce thousands of beautiful drawings, but there were three problems in the search for meaning in architecture in America that could not be resolved within the disciplines of art history, linguistics and philosophy as these became the popular realms for discussing a post-modern sense of meaning.

First of all, an earnest search for complexity, subtlety, color, ornament, historical context and urban context was often conducted by designers without extensive knowledge of the history of distinctive American pre-industrial vernacular environments. To give just two examples: the glorious colors and intriguing geometries of painted tepees and sun dance circles, or of Shaker village plans and sacred mountains, are not generally well understood by American designers. Despite a great revival of interest in architectural history, the favored historical allusions have come from England, France and Italy. Thus some of the most celebrated examples of American post-modern architecture of the 1970s could have been built anywhere—north, south, east or west—except the American towns or cities they were meant for. The better the formal innovation, the more placeless many new American projects appeared.

Second, the search for meaning in architecture often progressed without serious contemporary analysis of the economic, social and physical conditions of the American city. The years since 1973 have not only been the years of post-modernism, but also the years of the oil crisis, Big Mac, Cleveland's default, Three-Mile Island, Diablo Canyon (where the nuclear power plant was built with the blueprints reversed), years of increasing unemployment, impoverishment of ghetto populations and declining urban physical infrastructure. The brilliance of many American designers' formal inventiveness, set against so many reasons for urban unease, generated a certain disorientation, a timelessness or a lack of projects well-situated in historical time as well as in American places.

Third, the search for meaning in architecture has often been divorced from critical analysis of urban planning and speculative urban development. Despite what was called "contextualism," the renewal of interest in the meaning art history holds for architects, and the closer relationships of architects to artists (because architects' drawings are sold in art galleries and shown in museums), has had the effect of breaking off many architects' ties to urban planners. It also has had the effect of deemphasizing the architec-

tural *program* in favor of emphasis on style. Traditionally architects and planners had often tried to analyze issues such as place, location and meaning together, under the headings urban design, land use and community participation. When this analysis was superseded by architects' intense conversation with artists, planners tended to console themselves with Marxist crisis theory which had the intellectual attraction of being just as unintelligible as some architectural semiotics to the average American experiencing either economic recession or the visual blight of the strip. The ability of practitioners in both disciplines to make an effective economic and aesthetic response to speculative development was severely handicapped by this split between planning and architecture.

Skyscraper downtowns, convention centers, freeways, shopping malls, suburban tracts, commercial strips, parking lots, all represent the common language of American speculative real estate development. That is, they represent the production of space as a commodity. This is a common language most Americans recognize and criticize as "placelessness." Developers and banks may justify the production of similar spaces from coast to coast as the logic of the market—the more similar spaces are, the easier it is to know what to charge for their sale or rental.

Some post-modern architectural theorists, however, have not distinguished between the American pre-industrial vernacular and commercial space under contemporary capitalism—in tracts, on the strip, downtown—calling the latter "the vernacular" that Americans understand and like. Similarly, some designers have confused such commercial recreational spaces as Disneyland's "Main Street" with the experience of real Main Streets (decaying from lack of care in thousands of real towns). Disney's Main Street is actually a profitable shopping center where a contemporary spatial program is masked by the use of style from an earlier period of economic development. This is as true of Levittown's Cape Cod houses, or of Las Vegas's casinos as it is of Disneyland, Disney World, and Epcot's new "American Adventure."

The false vernacular confuses designers who need to be able to make a better analysis of what is problematic about shopping malls and office towers. One cannot redeem badly planned and programmed commercial space with references to academic historical styles, pre-industrial vernacular styles or contemporary commercial culture. However great the American popular hunger for history and a sense of place, aesthetically and politically these tactics won't work, and the most brilliant post-modern designers will never be able to endow monotonous speculative space with an enduring sense of place.

I have come to believe that for both architects and planners the dream of a common language must be rooted in the programming of new kinds of private and public spaces to explore genuine economic and social conditions in a historical and environmental context, before most new forms of aesthetic experiment can result in convincing American places. Rather than taking any architectural fragment and making it stand for the whole cultural history (the literary device of metonymy), I propose looking again at the whole cultural history, the environmental, social and historical experience, and asking, how can this concrete, material reality best be explored as the basis of a new architectural, vernacular language? The components are the natural landscape, the surrounding built environment, the lived experience, varying by gender, class, ethnicity and race, of religion, education, work and politics. All of these could be part of a potential language of American place-making, based on popular communication, and I am now working on a project to develop such a common language in Los Angeles.

Most Americans agree that of all our cities, Los Angeles is usually the first one singled out as having a problem about sense of place. The history of Los Angeles, its ethnically and racially diverse population, its remarkable natural environment, and its extensive built environment, does not reveal itself easily to the new resident of the city, the casual visitor, the experienced urbanist or the millions of young people growing up in Watts, East Los Angeles, Koreatown or Brentwood. Experts and novices may be equally perplexed: an urban historian from New York recently described Los Angeles as a "featureless plain"; an architectural historian from Boston described it as a city "without any history"; a labor leader from Washington, D.C., "had no idea there was so much industry" and an urban designer from Paris bemoaned the lack of "edges and nodes." While Jack Smith at the *Los Angeles Times* often spoofs ignorant reviews of Los Angeles as the United States's scapegoat city, it is more common for even fond residents to quote Gertrude Stein's sentence about Oakland when summing up urban design in Los Angeles: "There's no there, there."

Yet Los Angeles is a rich, complex, spectacularly beautiful city with a fascinating history. It is located where the majestic Santa Monica Mountains meet the Pacific Ocean. It includes more buildings of architectural distinction listed on the National Register than San Francisco and San Diego combined, but its urban form cannot be perceived and interpreted in the same way as traditional nineteenth-century cities of the East Coast or of Europe. Beaux Arts planner Charles Mulford Robinson did try to bring his ideas of city design and civic art here in 1909, but another set of economic forces and a twentieth-century transportation pattern cast this terrain into

a different, more urban pattern. Los Angeles is the largest, most complex mid-to-late-twentieth-century city in the United States, and if Americans don't like it or can't decipher it, the production of speculative space in our own times is to blame, not the efforts of the Beaux Arts missionary, Robinson, who failed to create sufficient public squares, rows of trees and cultural centers grouped around museums.

As Carey McWilliams pointed out in 1943 in *Southern California: An Island on the Land* (still in many ways the best book about Los Angeles), here a new physical form, the urbanized region formed by several dozen cities, evolved. To preserve and interpret the history of that process requires fresh approaches to historic preservation and urban design, involving new methods of social history. So many different populations have lived and worked here that a single "American" cultural history will isolate rather than inspire groups. So many contests over the natural and the built environment have occurred here (with constant cycles of demolition and development) that a single history of preserved monuments and monumental buildings will also be false to the larger, more dramatic urban story.

I propose to identify between ten and twenty themes of importance to the history of the natural environment, the built environment and the economic development of southern California and Los Angeles, and use them to locate sites to be developed as public places in an experiment in new approaches to social and economic history, urban design, public art and historic preservation. These sites will not be previously developed and heavily interpreted public places (such as the La Brea Tar Pits or El Pueblo). Rather they will be sites with great unexploited potential as public places of importance to Los Angeles.

A few sites will represent significant themes in the history of the economic development of the natural environment and resources in the region. Another set of sites will be chosen to represent the economic contributions of all major ethnic and racial groups that have settled in this landscape: Native Americans, Mexicans, Blacks, Japanese and Chinese, as well as Caucasians from different parts of the United States and Europe. These sites need to reflect the material reality of daily life in previous times more than the military victories of war heroes or the political triumphs of leading officials. They must speak to the experiences of laborers as well as bankers and business leaders, of women and children as well as men. But I don't wish to choose themes of bitterness, such as the 1910 dynamiting of the *Los Angeles Times* or the 1946 movie studio strike. Rather, I wish to show how each group's labor helped build the city's wealth.

Work is the theme I believe can truly interest people, across lines of

race, class and gender, as I think Studs Terkel has demonstrated in literary terms. For example, the Chinese built the railroads, the Irish built the irrigation systems, the Japanese launched the fishing industry and Japanese and Chicanos have been the agricultural workers. Blacks and white women built the World War II defense industries crucial to the region's expansion. Chicano, Asian and Anglo women staff the sweatshops that make Los Angeles a garment trade center, and a project on women's traditional textile imagery is what I propose for the barrio sweatshop area.

The sum of all the sites—the chosen places—should be a network of new public places designed for the preservation and interpretation of Los Angeles's unique social history. This group of places represents complex layers of citizens' experience of art, history and urban culture. Visited in sequence, these sites would highlight the differences of social and economic development in various neighborhoods as well as the continuity of settlement history. One example of an existing sequence of historic sites is the Freedom Trail in Boston, Massachusetts. There the sites are linked by a line of bricks in the sidewalks connecting these places over an itinerary of several miles. In Los Angeles, the significant places are not compressed into the scale of a "walking city" like Boston; nevertheless, the sense of a journey on a historical path, or even the sense of a pilgrimage route (like the route to Canterbury) can be cultivated.

The educational and political experience of making such a trip could go beyond the historical interpretation and aesthetic expression involved. The first precedent for programming such a sequence of sites was Frederick Law Olmsted's idea of the 1870s to build a network of public parks in every American city (like the Emerald Necklace in Boston). He dedicated these parks to nature, but he also wanted cultural institutions such as museums and libraries located nearby. Now, in Los Angeles, I'm seeking the collaboration of architects and planners, artists, oral historians and geographers, to assist in the development of political support and imagery necessary to the pursuit of my proposal. It is, of course, an experiment in finding new sources of patronage for urban design, historic preservation and public art, as well as new content and imagery representative of Americans' lives.

Afterword: The Power of Place's Recent Projects

The goal of The Power of Place has been to make multicultural history visible in public places in Los Angeles, as well as to make it known through workshops, publications and walking tours. The Power of Place has been committed to identifying landmarks of ethnic history not yet seen as cul-

Biddy Mason: Time and Place, 1989, detail of 8-foot-high, 80-foot-long, black poured concrete wall, artist Sheila Levrant de Bretteville, text by Dolores Hayden, part of the Biddy Mason project by The Power of Place, Los Angeles, CA. (Photo: Lois Gervais)

tural resources; creating more balanced interpretations of existing land-marks to emphasize the ethnic diversity of the city and recruiting nationally known artists and designers to collaborate with historians and planners to create new works of art celebrating ethnic history in public places.

The first public art project undertaken by The Power of Place focused on Biddy Mason. When I first saw the site of Mason's homestead, it was a parking lot between Third and Fourth streets, Spring and Broadway, an unlikely place for a history project. Then in 1986 a planner at Los Angeles Community Redevelopment Agency, Robert Chattel, contacted me and asked if The Power of Place would be interested in proposing new public art for the site which was about to become the Broadway-Spring Center, a ten-story retail and garage complex. The developers and their art consultant, Michelle Isenberg, were also supportive of the project. The National Endowment for the Arts' Art in Public Places Program provided preliminary funding. Eventually we raised $212,000 in cash and in-kind contributions. I served as the project director as well as historian on the team, which included graphic designer Sheila de Bretteville, artists Betye Saar and Susan King, and curator Donna Graves. The first public event was a workshop in 1987 at which historians, planners, community members, students and the project team members discussed the importance of the history of the African-American community in Los Angeles, and women's history within it. Mason's role as a midwife and founder of the AME Church were stressed.

Eventually the Biddy Mason project included five parts. First, Betye Saar's assemblage, *Biddy Mason's House of the Open Hand*, was installed in the elevator lobby. It includes motifs from vernacular building of the 1880s as well as a tribute to Mason's life. Second, Susan King's large-format letterpress book, *HOME/stead*, was published in an edition of thirty-five. King incorporated rubbings from the Evergreen Cemetery in Boyle Heights, where Mason is buried. These included vines, leaves and an image of the gate of heaven. The book weaves together historical text with King's meditations on the homestead becoming a ten-story building. Third, an inexpensive poster, "Grandma Mason's Place: A Midwife's Homestead," was designed by Sheila de Bretteville. Historical text I wrote for the poster included midwives' folk remedies. Fourth, *Biddy Mason: Time and Place*, a black poured concrete wall with slate and granite inset panels, designed by Sheila de Bretteville, chronicles the story of Biddy Mason and her life. The wall includes a midwife's bag scissors, and spools of thread debossed into the concrete. De Bretteville also included a picket fence around the homestead, agave leaves and wagon wheels representing Mason's walk to freedom from Mississippi to California. Both her "Freedom Papers" and the deed to her

homestead are among the historic documents and photographs bonded to granite panels. And fifth, my article "Biddy Mason's Los Angeles, 1856–1891" appeared in *California History*, Fall 1989.

The various pieces share some common imagery: gravestone rubbings in the book and carved letters in the wall; a picket fence, a medicine bottle and a midwife's bag in the lobby and the wall. One old photograph of Mason and her kin on the porch of the Owens family's house appears in four of the five pieces, as does a portrait.

Everyone who gets involved in a public history or public art project hopes for an expanded audience, beyond the classroom or the museum. The wall by Sheila de Bretteville, finished in 1989, has been especially successful in evoking the community spirit of claiming the place. Youngsters run their hands along the wagon wheels, elderly people decipher the historic maps and the "Freedom Papers." People of all ages ask their friends to pose for snapshots in front of their favorite parts of the wall.

A second public art project, led by Donna Graves, concluded in 1991. It involved the history of community and labor organizing in Los Angeles in the 1930s and 1940s, especially among garment workers and cannery workers at the Embassy Theatre. A well attended public history workshop was held in the building in 1991. Artists Rupert Garcia and Celia Muñoz, architects Brenda Levin and Alison Wright, and historian George Sanchez were part of the team. Garcia designed a poster commemorating organizing by Luisa Moreno, Josefina Fierro de Bright and Rose Pesotta. Muñoz produced an artist's book, *If Walls Could Speak/Si Las Peredes Hablaran*. She reinterpreted the social history of the building, which had previously been known as a landmark only for its architecture.

Beginning in January 1992, The Power of Place will be located in Guilford, Connecticut.

19

The Macarthur Park Experiment, 1984–1987

STEVEN BINGLER

In September 1983, the Otis/Parsons Institute of the Parsons School of Design launched an interdisciplinary public art program involving the visual, performing, and design arts. The site for the program, the thirty-two-acre MacArthur Park, is located adjacent to the Parsons School and serves as a focal point for the Westlake District in downtown Los Angeles. The goal of the project was to contribute to the revitalization of the 104-year-old park, which had fallen on hard times and ceased to function as a thriving neighborhood amenity.

In her critical overview of the Los Angeles's MacArthur Park, Galen Crantz describes the park's evolution and its place in the history of park design in the United States: "It originated as a pleasure ground and has been successively modified with reform, recreation, and open space system elements. But today it does more than mirror history. Its planners actively promote a new ideology that public art and culture can and should be used to unite park design and community development."[1]

The planners and participants in the MacArthur Park experiment allied themselves with a long line of cultural workers advocating social responsibility in the arts. Included in this list are the advocacy planning teams of architects and students who formed local community design centers in abandoned ghetto storefronts during the late 1960s and early 1970s to apply the art of architecture as a catalyst for social empowerment. Even the modern master, Walter Gropius, in response to what he saw as a new industrial-social order, created the Bauhaus in Germany with some of the collaborative, interdisciplinary, and socially idealistic goals that are common to emerging theories about a new public art.[2] Besides their many accom-

plishments, these movements have raised questions about the validity of mixing fine arts with social causes. They have failed, for the most part, to meet their social expectations or to produce a sustainable body of work commensurate with their idealistic goals. They have often served as examples for those who question whether fine art has any place in the public domain.

MacArthur Park's Art-in-the-Park project director, Al Nodal, encouraged the use of the arts to

> provoke an understanding of the park and its various levels of meaning. . . . MacArthur Park's cultural master plan is guided by the belief that art has an inherent social responsibility, and that artists have a vital contribution to make to the public realm. At the same time, the plan confirms the integrity of art as a singularly powerful aesthetic activity. . . . Public art was used in MacArthur Park, one of the oldest and most important parks in Los Angeles, as a tool to achieve community consensus and urban revitalization.[3]

MacArthur Park is not the only public art project in America with such far-reaching goals. The *Great Wall of Los Angeles* project by Judith Baca, Clyde Casey's *Another Planet,* the Candlestick Park Arts Project in San Francisco, and works by many independent artists are all examples of projects that represent an emerging humanistic ethic in public art.[4] A sense of justice and concern for the common good does not compromise the aesthetic component of art, but rather adds a new sense of social conscience to the prevailing preoccupation with individual creative genius. In the context of this ethic, art transcends its often limited role as a vehicle for personal expression or social commentary, and becomes an active and compassionate tool in the development of social change.

But the role of art in social development has yet to be adequately defined. Most of the projects that successfully manifest these optimistic and humanistic goals have not involved art at all. They have been the work of social and economic professionals focusing on stabilization and improvement of disadvantaged neighborhoods. A leading proponent of such methods, Dr. Denis Goulet, calls upon all experts involved in social development to respect the needs, aspirations, and cultures of underdeveloped communities and vulnerable peoples and to apply an attitude toward development that he calls "authentic," based on three primary criteria: (1) the fulfillment of basic human needs; (2) the principle of human solidarity; and (3) a collaborative and participatory process of decision making.[5] Says Goulet, "The essential task of development ethics is to render development decisions and actions humane. . . . More fundamentally, however, the primary mission of development ethics is to keep hope alive."[6]

The art placed in MacArthur Park was to provide an active symbol of hope for the area's disenfranchised communities. The momentum developed by the Arts Program generated neighborhood activities and community organizations that reminded residents and park users that people cared about them and their park. When the planning process began in 1984, the Los Angeles Police Department was overwhelmed by the amount of criminal activity taking place there and had all but given up on the park. The park's main users were the working-class Central American families living nearby in cramped single-occupancy hotel rooms, and a large population of drug-related vagrants. The prevailing sense of futility was exacerbated by a long history of negative press coverage emphasizing the park's problems. The MacArthur Park planners set out to reverse this negativism by promoting and supporting community solidarity among neighborhood residents. One of the key ingredients of the plan was a participatory design process involving a broad cross-section of neighborhood groups, public agencies, and individuals. The catalyst for rediscovery of the park was art. Besides serving its aesthetic function, each new artwork and performing arts program introduced into the park represented a further step towards a resolution of the park's problems.

One early example of the process in action was the first annual Summer Youth Arts Festival that included a program aimed at reclaiming the park's slowly deteriorating bandshell. The program included an execution of public murals, performances, graffiti abatement, and general repair and repainting. Under the direction of Patssi Valdez, who identified local graffiti "taggers" from the neighborhood gangs and educated them in the process of mural painting, a work entitled *We Are the World, the Future* was executed on the outside of the bandshell. One of the young taggers, who goes by the street name of "Zender," later went on to study art at the Otis/Parsons Institute and returned two years later to execute his own "legal" self-portrait, entitled *The Beginning of a Future,* on the wall of the lake pumphouse.

In the months following the first festival, more community arts programs were implemented. In June 1986, the park's centennial was celebrated with a children's carnival, a sidewalk magic display by a team of Guardian Angels, and a two-day Latin music festival in the bandshell that drew thousands of people from the surrounding neighborhood. Additional performance festivals were scheduled, including presentations by a consortium of over forty Los Angeles–based performance artists and a three-week performance workshop conducted under the direction of New York Re Cher Chez Studio for the Performing Arts and LACE. The celebration

culminated in an all-day multicultural avant-garde performance at the band-shell that included over fifty-five artists, musicians, and dancers.

The park's neighbors responded to the reopening of the bandshell by adopting it for their own functions, including an annual Cinco de Mayo celebration, an annual Philippine Independence Day Festival, a Czechoslo-vakia Patriots memorial rally, a Marshall Jackson Gospel celebration, the Korean New Year Sunrise Service, and an annual "Jugaremos en Familia" cultural event. The second annual Summer Youth's Employment program brought two major anti-graffiti murals to the park's underpasses by artists Bob Zoell and Robert Williams, who collaborated with teams of neighbor-hood graffiti artists. In concert with the program's strategic combination of cultural projects and community involvement, the same youths were paid to repaint the park's five hundred park benches.

The park's planners also developed a series of other visual arts projects that were implemented in rapid succession over a four-year period. The projects began with a two-week, on-site information gathering and analysis exercise between the artists and representatives from the surrounding com-munity. The process continued informally for three months. This participa-tory exchange generated a list of community needs that included improving the quality of lighting and security, preserving the park's rich neighborhood history, adding provisions for children's play spaces and youth services, and curtailing the proliferation of graffiti.

In June 1985, the first artwork installed under the arts program re-sponded directly to the community's call for increased lighting and security. The entry gates, by New York sculptor R. M. Fischer, consist of a pair of arches constructed of steel columns, large black fiberglass balls, urns, and eagles mounted on metal disks. Recalling the park's strong military associa-tions, the arches signify triumphal gates for two of the park's most promi-nent entrances along Wilshire Boulevard. The arches include lighting fix-tures that, at the time of their installation, were the only operable light fixtures in the park. Through years of neglect, the park's lighting systems had slowly disappeared, and the restoration of night lighting at these en-trances led the way to rejuvenation of street lights and area lighting through-out the park.

The community's wish to express the neighborhood's special history and culture was addressed by several artists. Alexis Smith created a series of commemorative works with illustrated quotations taken from the literature of Raymond Chandler. One of the pieces, located on a sidewalk adjacent to a park bench, is a bronze cast of a small suitcase with an inscribed Chandler quotation. Another piece, cast in terrazzo into a sidewalk, depicts a couple

R. M. Fischer, entry gate to MacArthur Park, 1986, Los Angeles, CA. (Photo: Courtesy *On View*)

Luis Jimenez, *Cruzando El Rio Bravo* (Border Crossing), 10'7″, fiberglass, 1989. (Photo: Courtesy *On View*)

dancing and includes the phrase "crazy as a pair of waltzing mice." Smith also undertook the restoration of the neighborhood's glamorous 1920s neon hotel signs that tower over the park's perimeter. A large chain-link mural sculpture depicting a political rally in progress, titled *Silent Voices,* was designed by artist William Herron as a reminder that the park was for many years the city's central forum for political and religious demonstrations. Other artists responding to the theme of memory and neighborhood culture included Doug Hollis and Richard Turner, who collaborated to produce a poetry garden and seating area equipped with outdoor speakers and electronic poetry readings in Spanish, English, Tagalog, Korean, and several other languages common to the neighborhood. The poetry garden includes a series of three cast-concrete benches placed into a steep bank on the north side of the park. Another commemorative piece by George Herms, titled *Clocktower: A Monument to the Unknown,* refers to the passing of time in the neighborhood and is dedicated to the chess players who congregate in the park on the corner of Seventh and Park View streets. The work is an assemblage of discarded objects, including five dented and rusty ocean buoys, a rusted metal chute that doubles as a clocktower, and a contemporary three-faced clock that includes the word "Love" in English, Spanish, and Korean.

Artist Judy Simonian took up the community's desire for children's play sculpture. With the help of Latino ceramicist German Rugerio, she constructed a pair of child-sized pyramids connected by an underground speaking tube. The pyramids were stepped to a height of four to five feet and covered with ceramic tiles. Likewise, sculptor Franco Assetto's *Big Candy* celebrated the spirit of fun, surprise, and wonder in a new children's playground.

One of the park's most successful and moving pieces was installed two years later in the summer of 1989 by Luis Jimenez. It has been estimated that seventy-seven percent of the 5,500 residents in the surrounding twenty-block area are Latino, mostly immigrants from El Salvador, Nicaragua, Guatemala, and Honduras. With *Cruzando El Rio Bravo,* Jimenez recalls MacArthur Park's history as the "Ellis Island" of Southern California. The ten-foot-high sculpture, depicting a man carrying a woman and her baby on his back, evokes a sight familiar to the thousands of illegal aliens who have crossed the Rio Grande to find freedom and prosperity in Los Angeles. Jimenez depicts them as heroes of the American dream.

Another product of the park's public arts program, and the organization responsible for its continued development, is the MacArthur Park Community Council. The council includes representatives from all of the

park's constituencies, including the Y.M.C.A.; senior citizens; the Los Angeles Police, Fire, and Recreation departments; neighborhood residents; and owners of surrounding businesses. The council served throughout the design process as the center of community input and interchange with the artists. This interchange established the framework for community involvement and perpetuated the dynamic and interactive process of the park's ongoing creation.

Although the council has continued, its effectiveness has diminished over time. Dominated by small business interests, the council now meets every six months, primarily to discuss the park's problems rather than solutions. Otis/Parsons cannot continue to allocate significant funds to the Art-in-the-Park project. With the absence of new art programs, discussions in the community council meetings have turned to defensive measures to protect existing improvements—and a plan for controlled access—foremost of which is a proposal to fence the park.

The early accomplishments of the MacArthur Park project demonstrate that artists and their work can serve as effective catalysts for community organization and development. In addition to expressing the artists' personal vision, the visual and performing arts projects served over a three-year period to sustain momentum for the community's rediscovery of the park as a neighborhood amenity. The willingness of the artists and planners to embrace the community and its concerns challenged the previously hopeless condition of the park, effected a reduction in crime by more than forty percent, and developed a spirit of optimism that encouraged neighbors, businesses, and even members of neighborhood street gangs to support the effort and become a part of the creative process. The MacArthur Park Art-in-the-Park program, with its emphasis on neighborhood solidarity through a participatory process, has addressed all three of the criteria for "authentic" development as expressed by Denis Goulet. It is this spirit of authenticity that stands as a model for public art. The success that MacArthur Park enjoyed for a brief three years was founded in a sense of fellowship that transcended current notions of collaboration as the appropriate tool for extracting art from the studio and making it more useful and meaningful in the public arena.

At the same time, the MacArthur Park project has had its share of problems. By the spring of 1986, *Silent Voices* had been vandalized beyond repair and had to be removed from the park. That spring, the project's director moved on to another challenging position, and since then MacArthur Park Community Council and Otis/Parsons have not managed to sustain the program's early momentum. Meanwhile, the national rise in

drug-related crime has created what many feel could be an insurmountable obstacle to further development of the park's neighborhood programs. Yet another threat to the continuity and stability of the arts program is the impending construction of a new Metro Rail station that will force the draining of the lake and turn much of the park into a construction site over the next few years. Finally, it cannot be denied that some opportunities were missed in the design process. Although each individual art project stands as a work of high caliber, the development of the works into an ensemble with the park as an integrated design statement has not yet been fully realized.

The Art-in-the-Park project was an experiment, and it remains a piece of urban research in progress. In spite of its difficulties and shortcomings, however, the program has contributed to the development of a new humanistic public art ethic. It represents a peaceful protest against the negative forces of society that impact the quality of life of vulnerable people. It takes a strong position about the value of art beyond the abstract and aesthetic. It supports socially and culturally functional art that is inclusive rather than exclusive. The MacArthur Park project embodies the willingness of artists to break from the limits of modern heroic expression and embrace a postheroic search for the role of art in the broader spectrum of cultural needs. It is motivated by the same underlying ideals that make the public art movement more than just another aesthetic or intellectual exercise.

The Tibetans say that obstacles in a hard journey such as hailstones, wind, and unrelenting rains are the work of demons, anxious to test the sincerity of the pilgrims and eliminate the fainthearted among them. Our search for a more complete manifestation of the needs, aspirations, and ideals of the public realm, and our articulation of public art's mandate, requires great patience.

The MacArthur Park project, the *Great Wall of Los Angeles,* Candlestick Park, *Another Planet,* and the many projects being executed by individual artists have all made positive advances, against great odds, toward the realization of a new and constructive role for art in the public domain. Together they embody a new and meaningful ethic for public art.

Notes

1. Al Nodal, *How the Arts Made a Difference* (City, Hennessee & Ingalls, Inc., 1989), p. 18.
2. Walter Gropius, *Idee and Aufbau des Staatlichen Bauhauses Weimar* (Munich: Bauhausverlag, 1923).

During the fourth year of the Bauhaus at Weimar, Walter Gropius published "The Theory and Organization of the Bauhaus," which addressed issues related to the spirit of the epoch in which the Bauhaus was formed. In his introduction Gropius concludes: "The old dualistic world concept which envisaged the ego in opposition to the universe is rapidly losing ground. In its place is rising the idea of a universal unity in which all opposing forces exist in a state of absolute balance. This dawning recognition of the essential oneness of all things and their appearances endows creative effort with a fundamental inner meaning. No longer can anything exist in isolation."

In the making of architecture, Gropius's search was for a collaborative framework to serve as the armature around which this unity would evolve. "A vital architectural spirit, rooted in the entire life of a people, represents the interrelation of all phases of creative effort, all arts, all techniques. Architecture today has forfeited its status as a unifying art. It has become mere scholarship. . . . The art of architecture is dependent upon the cooperation of many individuals, whose work reflects the attitude of the entire community."

One of Gropius's concerns was with the existence of a great "art proletariat" trained by the arts academies and isolated from the community: "Lack of all vital connection with the life of the community led inevitably to barren esthetic speculation. The fundamental pedagogic mistake of the academy arose from its preoccupation with the idea of the individual genius and its discounting the value of commendable achievement on a less exalted level."

3. Nodal, p. 60.

4. The *Great Wall* project consists of a half-mile-long mural produced by Judith Baca and her team of 450 multicultural youths and artists. Operated by the Social and Public Art Resource Center, the works celebrate the diversity of the city and promote neighborhood pride. Team members worked with a community coordinator in workshops that promoted cultural understanding through exercises focusing on ethnic histories, cultural differences, and commonalities.

Another Planet, an arts center for the homeless in downtown Los Angeles, was organized by homeless artist Clyde Casey as a creative refuge for the homeless. Housed in an abandoned gas station, the center provided musical instruments, video access, and artist materials for willing participants and became the site for late-night jam sessions, which were often taped and sometimes recorded. The center was destroyed by fire in the fall of 1989. The Candlestick Park Arts Project in San Francisco is an ongoing art park project in which artists also work directly in the neighboring community to affect social change and community education.

Independent artists who are addressing social needs include Krzysztof Wodiezko, a Polish artist whose *Homeless Vehicle* accommodates a temporary shelter, transport and storage of personal belongings, and up to five hundred bottles and cans for sale at salvage. The work-in-progress is continually being refined based on input from homeless users.

Another independent artist, Susan Lacy, has organized two Mother's Day rituals, one in La Jolla, California, and another in Minneapolis, Minnesota, focusing on shared conditions of being female. In Minneapolis, six hundred older women gathered at tables of four in the Crystal Court of Philip Johnson's I.D.S. center to execute a series of simultaneous movements suggesting the process of quilt-making.

This ritual performance, titled *Crystal Quilt,* was designed to empower its participants. Lacy measures the success of her work, at least in part, by the process of networking established through the performance. In Minnesota, ten of the women involved later founded an organization dedicated to challenging stereotypes of older women and offering programs statewide for women with community-oriented leadership skills.

A New York artist has applied his skills to educating emotionally handicapped and learning-disabled children in the South Bronx. Tim Rollins, who is also an art teacher, has assembled a small band of students known as "Kids of Survival" who produce collaborative paintings that are an innovative model for learning. Rollins and his team travel extensively to other communities where they pass on their ideas to students and teachers. (See *Utne Reader,* July–August 1989, pp. 71–76, for more complete descriptions of these three artists.)

5. Denis Goulet, *Cruel Choice: A New Concept in the Theory of Development* (New York: Atheneum, 1971), p. 157.

6. Goulet, p. 166.

20

Public Art That Inspires

Public Art That Informs

SEITU JONES

I first saw the *Wall of Respect* in 1968. It was not listed on any official travel brochures as a must-see attraction, but it was a stop that many Black people made while visiting Chicago. My grandfather first showed me the wall; it was in the neighborhood where he grew up. It was a symbol of pride pointed to as a ray of hope by residents of the South Side like my grandfather. Whenever I visited the Wall, there were always other African-American visitors there as well, coming to a modern-day shrine. It became an outdoor museum, a declaration of independence from art center walls. Black patronage for public art at its best.

The *Wall of Respect* was painted by the Visual Arts Workshop of the Organization of Black American Culture. It was a collaborative effort that featured the work of more than ten visual artists, photographers, and poets. The general theme of the wall was Black achievement and Black heroes. The contemporary mural movement began with this public artwork. The art historian Edmund Barry Gaither says that the *Wall of Respect* was also the "spiritual source of the Black art movement in the visual arts" of the 1960s and 1970s. Within two years of its completion, other Walls of Respect were created in African-American communities in Boston, Detroit, and St. Louis. This movement helped spawn the Inner City Mural Program of the National Endowment for the Arts.

What is most important about the Wall is not when and where it was created, but how it functioned in its community. It was completely self-endowed. The artists, many of whom went on to establish national reputations, donated their time and, with donated paint, created the Wall. There was no money from the City of Chicago, from the Illinois Art Council, or

Seitu Jones, *Tranquility Rise,* 1989, North Commons Park, Minneapolis, MN.
(Photo: Courtesy *Public Art Review*)

the National Endowment for the Arts. The *Wall of Respect* and other similar walls were created with the spiritual and emotional support of their communities.

Although I didn't know it then, I can look back and see the effect that the Wall had on me and my perception of what art could be.

What does public art mean in African-American communities? What role or function does it have? There are many answers to these questions, but for now, let us focus on three functions. Public art challenges and supports values and traditions; public art inspires; public art informs.

Public art documents our place in time by visually rendering issues, ideas, traditions, and history. Through visual symbols, signs, and images, it identifies and comments on the challenges that affect us. Public art can be a mirror we hold up to ourselves and a reflection of ourselves we present to the outside. Unlike work displayed in museums and galleries, public art is a shared and common experience.

In the Harrison Neighborhood of north Minneapolis, local organizer Annie Young is using public art as a tool to inspire and transform the neighborhood. Harrison is six blocks wide and two miles long. Housing prices range from six figures to government subsidized projects. Thirty-five hundred people—white, Black, and Asian—live there. Some residents have been there for more than fifty years; others, for various reasons, move several times a year.

Annie Young believes that public art "promotes the image of an improving neighborhood." Through five years of community art and beautification efforts, Ms. Young has collaborated with several muralists and the mostly Black and Asian youth of the neighborhood to create a new image for Harrison. She has a goal of creating at least ten murals along the main drag, Glenwood Avenue. Thus far, four murals have been completed and at least two more are being planned. Ms. Young admits that convincing some residents of the worth of public art is a challenge. Many would rather raise money to install motion detectors and institute crime patrols rather than support and encourage teenagers with paintbrushes. But Ms. Young remains convinced that the community supports her goals. The Harrison Neighborhood was awarded a Twin Cities Mayors' Art Award and an award from the Committee on Urban Environment. Furthermore, none of the murals have been vandalized. When a community is proud of its art, inspired by it, and has a sense of ownership of the work, it will protect it.

If, on the other hand, a work is not well received in a community, the response can be quick and brutal. Check out what happened to David Hammons' artwork *How Ya Like Me Now?* in Washington, D.C. in 1989.

The Washington Project for the Arts (WPA), an alternative gallery and artists' space, commissioned the piece as a part of an exhibit, "The Blues Aesthetic." According to Debra Singer, Director of Public Relations for WPA, the organization has a history of showing African-American artists, and with each show has commissioned a piece.

Enter David Hammons, whose work has always been infused with equal doses of humor, social commentary, and charm to create works that challenge our aspirations and perceptions. Hammons is like Eshu-Elegba, the imaginative, unpredictable, and mischievous trickster god of fate from Yoruba mythology, who teaches through challenge. Hammons is steeped enough in African-American culture and life outside the studio to be able to make critical analyses and comments on day-to-day life. He does this not only by challenging Western perceptions of what art is, but by challenging many of our own aspirations and dreams.

Hammons created a fourteen-foot-by-fourteen-foot head-and-shoulders painting of a blond and blue-eyed Jesse Jackson. At the bottom of the painting were the words "How Ya Like Me Now?" He said the piece was a comment on racism in a country that would have elected Jesse Jackson if he were white.

Minutes after *How Ya Like Me Now?* was installed in an African-American neighborhood, by an all-white crew, it was attacked by a group of Black residents with a sledgehammer. Most of the artwork was knocked to the ground. This is almost the visual art equivalent of the legendary audiences at the Apollo Theater in Harlem, who booed uninspiring performers off the stage within sixty seconds.

This is not the first time that Hammons' work has been physically attacked. In 1988, he created a piece entitled *Higher Goals,* which consisted of a basketball hoop atop a fifty-five-foot telephone pole on a vacant lot in Harlem. This was his comment on the often-misplaced goals of young Black men to become basketball stars. *Higher Goals* was cut down anonymously.

The salvageable portions of *How Ya Like Me Now?* were placed on view in the WPA Gallery. Jesse Jackson toured the exhibit and in *People* magazine he commented, "I'd like to see the pieces of the portrait stay— along with the sledgehammer. They both represent the anger felt by Blacks." Through this piece, Hammons acknowledges the common reality of racism that affects us all, but challenges us to action. He was quoted in *People* magazine saying "part of an artist's role is to ruffle sacred feathers."

For many years, I have aspired to create environmental artworks that honor, inform, and inspire communities. It is said that there are very few outdoor sculptures dedicated to Black personalities or issues. None exist on

Calvin Jones, Mural, 1990, Atlanta, GA. (Photo: Courtesy *Public Art Review*)

Derrick Webster, detail of yard art, 1990, Derrick Webster house, Chicago, IL. (Photo: Courtesy *Public Art Review*)

any state-owned property in the Twin Cities. I and others intend to change this. I have recently begun a collaborative work with five African-American students, a writer, and a historian on a project about African-American presence in early Minnesota. The piece will be a temporary sculptural installation at Fort Snelling, the earliest fort in the region. The installation will honor Dred Scott and many other African-Americans, both slaves and "freedmen" who lived at or near the Fort before the Civil War.

Dred Scott, whose name was later to become a rallying cry on both sides of the slavery question, was owned by Army surgeon John Emerson and lived for several years at Fort Snelling, outside of St. Paul. In 1846, Scott sued for his freedom, claiming that he had lived as a free man during his stay at Fort Snelling, and that the Fort was in free territory. In 1856 the case went before the Supreme Court, which determined that despite living as a free man in free territory, Scott was still a slave and not entitled to the rights of citizenship, including the right to sue.

The sculptural installation will consist of a bench and sixteen low-relief cast concrete pavers aligned on a north-south axis outside the restored fort. The pavers will be set into the ground to point to the four compass points, and will carry information and images of African-American experiences in Minnesota. The bench, constructed of high density particle board covered with a protective lacquer, will be reminiscent of West African Ashanti stools.

My goal here is not to merely mark a spot but to inform and honor. Although this piece will not be placed in an African-American neighborhood, it could serve as a cultural beacon that will begin to draw African-Americans and others to what is an important historical site. It will be a space for information and reflection.

Sometimes there are very deep motivations for the art of African-Americans. Witness the work of Tyree Guyton in Detroit and Derrick Webster in Chicago. A noted art historian, Robert F. Thompson, has coined the term *yard artists* for this group of artists who transform space not in any special sculpture garden but in residential areas or even in back and front yards. Thompson and others have pointed to certain characteristics that are reminiscent of West African traditions. These yard artists like Guyton and Webster are motivated by tradition and spirit. What they are doing is creating a new criteria for Black space by drawing from existing tradition.

Derrick Webster, a native of Central America, has been producing art in his home on the South Side of Chicago for over ten years. During that time, he has created small sculptures from found objects, such as jewelry,

stone, metal, and pieces of wood. He has also created several large sculptural installations surrounding his house, creating an atmosphere that ". . . recalls West African ancestral shrines," according to Regina Perry. His sculpture consists of figures, geometric shapes, and wooden whirligigs painted strong primary colors. Ms. Perry says, "The numerous sculptures which decorate Webster's yard and home appear to pulsate with the vibrancy of African drums and African-American jazz." Webster creates on the beat of African-American culture.

In Detroit, Tyree Guyton has used vacant houses, vacant lots, trees, and the streets for his palette. Collaborating with neighborhood children and with his grandfather, Guyton uses discarded bicycle frames, suitcases, broken bottles, tables, and chairs to embellish his sites with powerful magic. The power and magic of his installations are so strong that they have reportedly scared away undesirables, including drug dealers and prostitutes. Guyton says his work talks to him. He describes his motivations: "I keep hearing beautiful music from it. Every day I come out here and I listen to it, and study it, and it makes me see things I never thought I could see. What I love is the magic that I feel from it. It keeps making me do more." Here is a public artist possessed by the spirit.

The works of yard artists, undeniably, are not always welcomed in the Black community, but they are respected. My point here is that art takes many forms and has many functions in a community. It reflects our values and dreams, and as our society is changing around us, it is changing, growing, and evolving. Artists like Martin Puryear, Beverly Buchannon, Richard Hunt, Tacoumba Aiken, to name a few, are forever changing our cultural and physical landscapes. New Walls of Respect are being created all the time. Let us hope that these works continue to inform, inspire, and challenge us all.

Note

While Seitu Jones was preparing this article, *Tranquility Rise,* a sculptural installation he had created for North Commons Park in Minneapolis, was destroyed by fire, apparently the victim of a turf war between rival gangs. Jones regrets the loss of the piece, saying that he wished it had been strong enough to withstand the negative forces that are tearing at so many African-American communities. He also reiterated his resolve to create artworks aimed at counteracting those forces.

21

Is the NAMES Quilt Art?

E. G. CRICHTON

It is beautiful, powerful, and inspirational. But is it art? The NAMES Project Quilt started in San Francisco with one cloth panel to commemorate one AIDS victim. In a little more than a year it has grown to over 5000 panels from every region in the country. For each person who has taken up needle and thread, paint, and mixed media to create a piece of the Quilt, there are many more who have walked among its connected grids, often in tears. No one with this experience would deny its force and magic as a national symbol of the AIDS tragedy. But from where does this power derive? Why has the NAMES Project Quilt captured our hearts and minds like no other project to come out of the gay community? One answer lies in the Quilt's power as art: art that lives and grows outside established art channels.

The NAMES Project organizers promote the Quilt as the "largest community arts project in the nation." They are aided by a national media that is surprisingly willing to report on events surrounding its display. The art world, however—that ivory tower that is reported to us via a handful of glossy national art magazines—has overlooked the Quilt. The art critics who write in these magazines are not rushing to interpret the Quilt's significance in the history of art.

Art is important, most people agree, but the reasons why are sometimes elusive. There is nothing elusive, though, about the NAMES Project Quilt; it is extremely concrete as visual communication. This accessibility is exactly what throws the Quilt's status as "real art" into question. Unlike much of what we find in galleries and museums, the Quilt has a connection to our daily lives that seems unrelated to the remote world of "high art,"

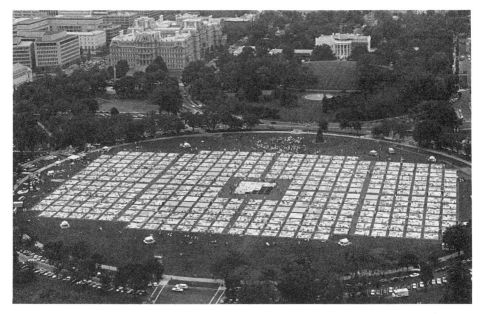

The NAMES Project AIDS Memorial Quilt, October 1989. 10,848 individual (3 × 6 feet) panels. Sponsored by The NAMES Project Foundation. (Photo: Mary Gottwald)

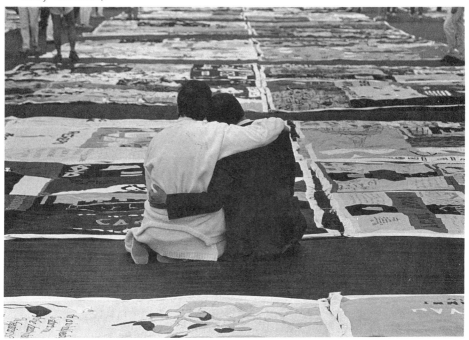

The NAMES Project AIDS Memorial Quilt. Sponsored by The NAMES Project Foundation. (Photo: Mary Gottwald)

or "fine art"—art that is promoted by critics, museum curators, and art historians. To understand the source of discrepancies about how our culture defines art, it helps to look at some of the assumptions made about art and who makes them.

Art, in Western culture, is first and foremost made by the artist—that individual genius whose work and life we come to recognize through a network of museums, media, dealers, and historians. Despite the fact that a myriad of people make art, a very select few are promoted in a way that grabs our attention. This process works like any good marketing strategy: we are told which art is hot, and why, by those who seem to know best. As a result, our taste is inevitably influenced by what appears to be an objective window on aesthetics. It is very hard to regard art found outside these institutional channels as serious. We don't go to the local craft fair to find serious art. It is not the needlepoint your grandmother did, nor the sketches you do in your spare time. And it's not a project like the NAMES Quilt that thrives entirely outside the art world. "Real art" is a luxury item for sale in an elite marketplace that takes it away from the artist's hands, and any community connection we might relate to.

Critics argue a bit about art, trying to maintain the illusion of democratic options, but they essentially define "good art" around a fairly narrow set of assumptions. It is virtually impossible to understand most modern mainstream art without the translation of these intermediaries. They generally promote obscurity as a desirable feature, and cast accessibility in an untrustworthy light; art we can too easily understand is more like entertainment. And, if you want to include a social message, make it vague at best.

Given this milieu, it is no wonder that potential art fans often feel suspicious of famous artists, seeing them as con-artists instead who try to fool us into thinking their enigmatic puzzles are great art. In contrast, the Quilt seems trustworthy partly because we are the artists. Although not for sale on the art market, it generates important funding for local AIDS services networks. It is not the offspring of a famous artist, yet its scale is monumental and attention grabbing. And it isn't found where most important art is found; the "museums" where we view the Quilt are convention centers, pavilions, gymnasiums, and the Capitol Mall—hardly the retreats of high art. Yet one thing is clear: the Quilt has succeeded in creating a visual metaphor for the tragedy of AIDS that transcends individual grieving to communicate beauty and hope. What more could be expected of a great work of art?

If the establishment art world places the NAMES Quilt outside the holy realm of high art, other art traditions do not. In the early seventies, feminist

artists working within the art world successfully revived an interest in the folk art of quilting and sewing bees—"low art" historically associated with women. New materials explored during this period gained acceptance as legitimate fine art ingredients: cloth, clay, and rope, for example. Many artists, both male and female, started to inject more personal and autobio-graphical content into their work. In general, the division between high and low art melted a little.

Several large-scale projects were also organized that introduced the idea of bringing together many people's labor into one artistic vision. Judy Chicago attracted hundreds of craftspeople to her "Dinner Party" project. The end result was a huge and complex installation illustrating the lives of specific women throughout history with china place settings around a huge table. In a very different project, the artist Christo engaged the help of hundreds of people to set up a "Running Fence" of fabric that wound for miles through northern California countryside, focusing attention on the land and its natural contours. In both cases, people skeptical about the initial vision were drawn in and became enthusiastic through participation. Chicago and Christo are the rare mainstream artists whose work and vision have crossed out of the exclusive art world to be accessible. The Vietnam War Memorial, designed by an architectural student named Maya Ying Lin, set a precedent for the simple naming of victims of a tragic war instead of merely immortalizing the warmonger leaders.

Tribal art from all ages has influenced Western artists interested in introducing ritual to their work. The holistic integration of art with the spiritual and survival needs of a community, characteristic of tribal art, appeals to many of us brought up on the doctrine of "art for art sake." Many artists have also been influenced by ancient art like the prehistoric Stone-henge. Monuments like this reveal a very different set of assumptions about art and the artist. No one knows exactly who created them—their massive scale obviously required the labor and creativity of many people, over many life spans. It seems as though the individual artistic ego was not important here, and that art had a function in society beyond visual aesthetics.

The contemporary art that is perhaps most similar to the NAMES Project Quilt are the *arpilleras* created by anonymous Chilean women resisting the fascist junta ruling their country. Pieced together from sca-venged factory remnants, these patchwork pictures use decorative imagery to protest specific government policies or to commemorate "disappeared" political prisoners, often relatives of the artists. They are smuggled out of the country to communicate the conditions in Chile to the rest of the world. The *arpilleras* are also the only surviving indigenous Chilean visual art, now

that murals have been destroyed and artists of all kinds murdered and imprisoned.

What the NAMES Project Quilt has in common with feminist, environmental, ancient, tribal, and Chilean art is a tradition of collaboration, a mixing of media, and an emphasis on process that makes the reason for the art just as important as the finished product. In art like this, the individual artist's identity is less important than the purpose of the art in the life of a community or people. This purpose might be the need to remember a part of history in a visual way, a means of marking time, or a tribute to the dead created not by a government, but by those who mourn. The NAMES Project Quilt started as one panel, one person's need to commemorate a dead friend. It soon expanded to a collaborative vision with a plan for how the Quilt could grow: panels approximately the size of a human body or a casket; panels to remember people who are most often cremated and leave no grave plot to visit; panels sewn together into grids—individual lost lives stitched together, woven into an enormous picture of the effect of AIDS.

This vision is dependent on the contributions of a growing number of individual artists who work alone or with others to stitch and paint a memory of someone they loved. They do this in the best tradition of quilting, using pieces from the person's life, articles of clothing, teddy bears, photographs, messages to the dead from the living who mourn them. People who have never before felt confident about making art testify about the healing nature of this participation in a larger artwork—one that also allows them to "come out" around AIDS. Instead of mourning alone, they link their grief to others both visually and organizationally. Finally, in keeping with the unifying principle of the whole Quilt, they stitch or paint the person's name who died, committing that name to an historical document that physically shows real people, not mere statistics.

Art needs an audience. The NAMES Project Quilt has an unusually large one: hundreds of thousands of us across the nation who have walked amidst the panels, stood in the sea of colorful memories, cried, found panels of people we've known, hugged strangers—in general been awed, moved, and inspired by the power of the total vision. We, the audience, have received much of the healing communicated by the artists through the ritual reading of names and physical beauty of the Quilt. It is a rare work of art that can transcend its material components to communicate this kind of collective power. A political demonstration could not have done the same. Neither could a single memorial service nor a walk through a graveyard.

* * *

There are other reasons the Quilt is effective art. The quilt form itself feels very American. It is almost apple pie in its connotations, and when used to communicate thoughts and feelings about AIDS with all the stigma, a powerful dialectic occurs. Tangible evidence of individuals who lie outside of society's favored status gets woven into a domestic metaphor. The Quilt reveals that these people had domestic lives of one kind or another—family, friends, lovers who banded together to make the panels. The quilt form historically is a feminist metaphor for integration, inclusiveness, the breaking down of barriers, the pieces of someone's life sewn together. It is not surprising that women and gay men would pick up on this traditional women's art. Sewing and weaving have been metaphors for life, death, creation, and transformation in many cultures. Just as the spider weaves from material that is pulled from inside, women have woven their ideas and emotions into cloth decorated with the symbols of their culture. The NAMES Quilt picks up on all these traditions.

The grid pattern is another important part of the Quilt's effect as art. Formed by a huge (and growing) number of individually made panels, the pattern signifies inclusiveness and equality. Unlike a cemetery where class differences are obvious, this grid unites the dead regardless of who they were. It is as though the dead are woven together, visually mirroring the networks the living form to create the quilt. Within this grid pattern there is an amazing and unplanned repetition of imagery. Items of clothing dominate—remnants of someone's wardrobe, T-shirts, jeans, jewelry, glittery gowns, and sashes. Teddy bears are common, too, a kind of cuddly accompaniment to the dead, a lively symbol of rest and sleep. The dates that show up so often are shocking because of the abbreviated life spans they illustrate. Some of the most powerful panels contain messages written directly to the dead, stitched or painted: "Sweet dreams," "I miss you every day."

The NAMES Quilt bridges the gap between art and social consciousness. Art is too often peripheral to our society, seen as superfluous fluff. Political activism, on the other hand, is often perceived as uncreative and separate from culture. The Quilt is a rare successful integration of these two worlds so separate in Western culture. We should be proud of an art form that originated in the gay community and that is able to communicate beyond to other communities. What is communicated is as complex as any art would strive for, something that will have historical significance beyond all of our lives. Developed outside established art channels, shown mostly in non-art environments, the Quilt could nevertheless teach the art world

a great deal about organization, collaboration on a grand scale, and the communication of an aesthetic that crosses many boundaries. Very few artists or art projects are able to reach so many people in such a way.

Parts of the art world have started to hear about the Quilt. At least two or three well-known artists have created panels. In Baltimore, the Quilt will not be hung in one of the pavilions, gymnasiums, and civic centers that house the Quilt elsewhere on its national tour—it will be hung on the walls of the Baltimore Art Museum. Organizers are excited by these developments, viewing them as evidence of the far-reaching effects of the Quilt. But what will happen to the present spirit of the Quilt? Will focus turn to "famous" panels more than others? Will museums become a more targeted locale for the Quilt, changing the vantage point from ground to wall? These are important questions because so much of the Quilt's power lies in its existence outside the official art world. It would be unfortunate if the category of "non-artist" became accentuated by more of a focus on "real" artists, and intimidated wider participation. I would hate to see the Quilt swallowed up in the land of institutional art and co-opted from its community roots.

We should be proud of the Quilt, but we should also stand back and reflect on its process as often as necessary. The NAMES Project is growing at an overwhelming pace, one that demands a look at how centralized the vision can remain. The power of the Quilt is fully communicated when people walk among the squares, physically becoming part of the vast grid, feeling tiny in scale compared to the whole. Its power also lies in its capacity to educate about AIDS in the universal language of quilting. I am concerned that continuing centralization will make the Quilt unwieldy, both in organization and in size. Will continuous expansion make it impossible to display in one location? Will people have to see it only in pictures, or only in its home resting place of San Francisco?

What about communities deeply affected by AIDS but not yet familiar with the NAMES Project Quilt? In New York City, for instance, women of color and their children form a growing percentage of victims, yet I wonder how many panels reflect this. A continued centralization of the Quilt could stand in the way of the outreach that makes the Quilt's vision so powerful. One possible solution would be regional quilts that are more accessible to people. Smaller cities have already created their own quilts and displayed them locally before sending them to join the larger work. This link to something larger is an important part of the Quilt process, and it could easily continue with local areas concentrating on new outreach before

joining together regionally. Stores in areas where there are many AIDS deaths could be organized to hang quilt grids in their windows. People could get involved who would never travel to Phoenix, or Baltimore, or other places on the tour, people who would never hear about the Quilt through existing channels.

It must be hard to think about giving up control of a project that has been so successful so quickly—especially in an age of media co-optation of art and social movements. But one of the most important roles the Quilt has played is as a tool for organization: individuals networking to make panels, groups networking to form local quilt tour organizations. A central vision has been important and may be for some time to come. But AIDS is unfortunately with us for longer than that, and the vision could become stronger by branching out. The ritual unfolding of the panels and reading of names might change from region to region. New cultural influences would add new dimensions. The Northeast's Quilt might take on a very different character from the Southwest's. These differences would be exciting and would expand the Quilt's dimensions as art. It would reach more people. And the inevitable difficulties of large organizations would be strengthened by more autonomy at the local level. People could still feel part of a larger-than-life whole, yet not be subsumed by an abstraction out of reach. If four football fields of panels are overwhelming, are ten necessarily better?

These are questions and reactions I have amidst my own emotions about the power of the Quilt and its significance as art in an age when the institutions of art can be so devoid of spirit. Art and artists survive regardless of art market trends, and most art will never be seen in a museum or gallery. It is the art made by your neighbor or your lover, the art that someone is compelled to make for reasons other than money. I hope the Quilt will never be a commodity on the art market, never owned by an individual or corporation, never laid to rest in one museum. The NAMES Project Quilt is a living, breathing, changing work of art, one that was inspired by grief and grew to communicate hope. Let it continue to live in good health.

22

Temporality and Public Art

PATRICIA C. PHILLIPS

Life is never fixed and stable. It is always mercurial,
rolling and splitting, disappearing and reemerging
in a most unpredictable fashion.
—*Loren Eiseley*[1]

Immutability is valued by society. There is a desire for a steadfast art that expresses permanence through its own perpetualness. Simultaneously, society has a conflicting predilection for an art that is contemporary and timely, that responds to and reflects its temporal and circumstantial context. And then there is a self-contradicting longing that this fresh spontaneity be protected, made invulnerable to time, in order to assume its place as historical artifact and as concrete evidence of a period's passions and priorities. For the Venice Biennale in 1986, Krzysztof Wodiczko projected a collaged photographic image of a 35-mm camera, a gun belt with a grenade, and a large tank for several hours onto the base of the 600-year-old campanile in the Piazza San Marco. Besides providing a critique of tourism and politics, Wodiczko's project offered a potent dialectic on the ambivalent requirements for stability and preservation, and change and temporality. To make these points, it required both the unyielding permanence of the campanile and the ephemerality of projected light. Public art is about such dynamic issues; public life embodies such contradictions.

The late twentieth century has thrown these questions of time and expectation, change and value into high relief. It is an accelerated, acquisitive, and acquiescent age in which the presence of enduring objects has become as quixotic as time itself. What is substantial—what is coveted and depended on with some certainty, what endures across generations—is often no longer expressed or communicated by the same symbols. The visual environment transposes as rapidly as the actions of the mind and the eye. In both private and public life the phenomenological dimensions of indeterminacy, change, and the temporary require aggressive assimilation, not

because they are grim, unavoidable forces but because they suggest potential ideas and freedoms.

Coming to grips with the temporary does not require a fast, desperate embrace of absolute relativity; both strong lessons and substantial ideas can be discovered in the synapses, the alternatives that occur between, and conceptually connect, discrete phenomena. The reality of ephemerality is perhaps most persuasively and unmistakably felt in the vast public landscape. The private can offer some quiet refuge, some constancy of routine, but public life has become emblematic not of what is shared by a constituency but of the restless, shifting differences that compose and enrich it. Public life is both startlingly predictable and constantly surprising.

As Richard Sennett and others have suggested,[2] the private is a human condition, but the public is invented—and re-created by each generation. In retrospect, there has been a discernible public life in most societies throughout time, but the idea of public is mutable and flexible. The notion of public may, indeed, be the most quixotic idea encountered in contemporary culture. It is redefined not just by the conspicuous adjustments of political transition and civic thought but by the conceptions of private that serve as its foil, its complement, and, ultimately, its texture. The challenge for each person is to uphold this dynamic interplay of personal and public identity, to embrace the often stimulating and always difficult nature of this important dialogue, and to be as fully engaged in the world as with one's own psychic territory.

These developmental ideas about the public frequently run parallel to the current enthusiasms for public art that have overrun most cities and towns in the United States. It is as if the literature and legacy of the public process and the interest in public art production were separate entities, spontaneous eruptions uninformed by, and perhaps unaware of, the other. Discussions of public art frequently consider specific communities but rarely the public at large. There seems to be an implicit assumption that everybody knows what "public" means, and concerns turn to more observable, more easily calculable issues. Much has been said about the failures or successes of public art, but very little about the philosophical questions a public art may raise or illuminate, or even about whether the idea of a public art requires significant intellectual inquiry and justification in the first place. I think that the problem is that public art has sought to define itself without assembling all of the data and before entertaining all of the complex and potent variables it must accept and can express. Public art has been too often applied as a modest antidote or a grand solution, rather than perceived as a forum for investigation, articulation, and constructive reappraisal. Al-

though it is at an exploratory stage, public art is treated as if it were a production of fixed strategies and principles.

One way that artists and agencies can continue to generate public art and remain analytical about its purpose, its composition, and how it is to be distinguished (or not) from other creative enterprises is to support more short-lived experiments in which variables can be changed and results intelligently and sensitively examined. Public art requires a more passionate commitment to the temporary—to the information culled from the short-lived project. This proposal is offered not as an indictment of or indifference to permanent public art, but rather as an endorsement of alternatives. The temporary not only has a certain philosophical currency, but it permits art production to simulate the idea of the research laboratory. This proposal is conservative: a suggestion to take time, to study, to try more modest projects, to express what is known about the contemporary condition. It requires a comprehension of value based on ideas and content rather than on lasting forms, a flexibility of procedures for making and placing art, and a more inventive and attentive critical process.

In his book on geological time, *Time's Arrow, Time's Cycle,*[3] Stephen Jay Gould explores the dual nature of time in Western thought: temporality is experienced both cyclically and consecutively. The Western mind relies on conceptions of time that explain both the security of constancy and continuity and the stimulation of progress and change. The public is shaped by similar coincidental and contradictory ideas. People return cyclically to annual public events even when these seem empty and reflexive; they provide a fixed point of reference. But public life must also accommodate the actions of progress; on this depends the enhancement of democratic values and the enrichment of life. Linearity enables the public to rally its strength and vision to work for improvement and revision. These opposing conceptions of temporality are intrinsically connected to public life—to expectations that guide actions, to the events and occurrences that constantly define and transform experience. And these potent, problematic ideas are what art has traditionally addressed through its formal and temporal manifestations. Public art is like other art, but it is potentially enriched and amended by a multiplicity of philosophical, political, and civic issues. It need not seek some common denominator or express some common good to be public, but it can provide a visual language to express and explore the dynamic, temporal conditions of the collective.

Clearly, public art is not public just because it is out of doors, or in some identifiable civic space, or because it is something that almost everyone

can apprehend; it is public because it is a manifestation of art activities and strategies that take the idea of public as the genesis and subject for analysis. It is public because of the kinds of questions it chooses to ask or address, and not because of its accessibility or volume of viewers. This is, of course, a far more difficult and obscure definition of public art, and the methods and intentions of production and criticism are less predictable, more unruly. It requires a commitment to experimentation—to the belief that public art and public life are not fixed. There are many variables; time is perhaps the most crucial and the least frequently addressed.

If the "public" in public art is construed not as the audience for the art but as the body of ideas and subjects that artists choose to concentrate on, then public art cannot be examined for its broadness of communication, for its popular reception, for its sensitive siting. A temporal public art may not offer broad proclamations; it may stir controversy and rage; it may cause confusion; it may occur in nontraditional, marginal, and private places. In such an art the conceptual takes precedence over the more obvious circumstantial.

Public art is about the idea of the commons—the physical configuration and mental landscape of American public life. The commons was frequently a planned but sometimes a spontaneously arranged open space in American towns, but its lasting significance in cultural history is not so much the place it once held in the morphology of the city as the idea it became for the enactment and refreshment of public life—its dynamic, often conflicting expressions. If the actual site of the commons confirmed some constancy for people, the moment of the day and the time of the year defined the activities and priorities realized in the space. At times of conflict and war, the commons was used to train and drill militia; in the spring and summer, the open green space was used as another meadow for livestock to graze; at times of political election or civic debate it became the site for speech making, for the debate of issues, as the space of dissent. The commons was the stage where the predictable and unexpected theater of the public could be presented and interpreted. It was the physical and psychic location where change was made manifest. The kind of agitation, drama, and unraveling of time that defines "public" occurred most vividly and volatilely in the commons. It was not the site of repose or rigidity.

Those responsible for the sponsorship and production of contemporary public art would do well to follow the actual life of the commons and its harmonious, mythical misrepresentation. The space of the commons existed to support the collage of private interests that constitutes all commu-

nities, to articulate and not diminish the dialectic between common purpose and individual free wills. It is in that space that the idea of time and its relationship to the public may be best understood. The philosophical idea of the commons is based on dissent, transition, and difficult but committed resolution; this legacy remains current even as the space and memory of the commons are diminished.

In New York City, there are two organizations whose primary mission is to support and encourage the production of temporary, ephemeral public art. The irony of sustained institutional support for the most fleeting endeavors is obvious, but the aesthetic results are frequently informed by the exceptional situation. Their variety of productions has actually challenged the institutionalization of public art; whether all the work they have sponsored is good, or maverick, or communicative is not the issue. It is the field of experimentation that they have tried to cultivate that is remarkable. They take the idea of the commons to many different communities; the exercise of displacement has reinforced and provided fresh articulations of the commons as the symbol, if not the site, of public life. In contrast to these organizations, there are also artists who work independently to produce public art that is often unexpected, infrequently encountered, and deliberately short-lived. It is through many of these productions that the idea of a public art is acquiring a tougher accountability and identity.

In the early 1970s, Creative Time, Inc., began to organize its first public art productions. The organization began by using conventional sites offered by corporations with excess, underutilized real estate. The first site of a Creative Time production was Wall Street Plaza at 88 Pine Street. The 6,000-square-foot lobby was provided by Orient Overseas Associates. Between 1974 and 1978, four experimental works were installed in this vast space.[4] The one that was most participatory and perhaps most enthusiastically received was Red Grooms's *Ruckus Manhattan*. Grooms and a large number of assistants worked for more than seven months inventing and constructing a rich allegorical, visual narrative of Manhattan. The stories of pedestrians who visited the site were frequently adopted and transformed in Grooms's rowdy, accretive project.

Creative Time's most enduring and repeated project—*Art on the Beach*—was an annual event begun in the summer of 1978. On a two-acre landfill site at the north end of the Battery Park City development, the organization sponsored collaborative public-art projects involving artists, architects, dancers, choreographers, musicians, and other creative professionals. The projects were constructed at the beginning of the summer,

performances were scheduled during the season, and the entire extravaganza disappeared by autumn. In 1987, when *Art on the Beach* lost its sandy expanse in Manhattan, Creative Time transported the summer event to another, more gritty, landfill site at Hunters Point in Queens, which was provided by the Port Authority.

What is perhaps most significant and resonant about *Art on the Beach* and so many other Creative Time–sponsored public art activities is their temporality and the opportunity (and necessity) they provided for artists to be experimental. Every year, the structure of *Art on the Beach* changed: new variables were introduced, others were eliminated. It thus became a continuing laboratory for examining the relationship of collaborative process to aesthetic production in temporary work. In some years, Creative Time assembled the collaborative teams; in others, the artists themselves selected their colleagues. But it was the annual anticipation as well as the short-lived dynamics of each *Art on the Beach* that enabled and endorsed this kind of productive fiddling and fine-tuning. Perhaps a careful analysis of each *Art on the Beach* would reveal much about the nature of collaboration and about the intense compression of ideas that occurs in a temporary urban site in a squeezed period of time.

Although its sponsored productions are quite different from those of Creative Time, the Public Art Fund, Inc., founded in 1972, is dedicated to the temporary placement of public art in a variety of urban neighborhoods and contexts. The sites are commonly accepted public sites—parks and plazas—but the Public Art Fund projects come and go; the art becomes the dynamic variable in a series of sometimes predictable, sometimes unusual urban settings. One of the organization's most inventive sponsorships is the *Messages to the Public* series. Begun in 1982, this project makes the Spectacolor computer-animated lightboard on the north elevation of the building at One Times Square available to artists to program short (usually twenty seconds) spots that run about once every twenty minutes. Inserted between tacky and aggressive advertisements, these Public Art Fund "moments" not only provide a surprising, direct forum for public art but also raise questions about the relationship of public art to information and stimulate wry speculations about art and advertising. Some of the Spectacolor works project a deliberate ambiguity between the art moment and the ad, between the aesthetic-political agenda and the pitch to the consumer.

The Spectacolor projects programmed by artists are temporary and episodic; the medium demands ephemerality. The presentation of new information must be relentless; the balance of change and repetition must be carefully considered. Also, the encounter and experience of the audience

are unregulated; there are some public art enthusiasts who seek out this changing series of messages, but the majority of viewers are unprepared and arrive often by chance on site; *Messages to the Public* is often delivered to a public that is unfamiliar with the Public Art Fund, with the participating artists, or with this strange convergence of art images and advertisements. It is this unregulated encounter of the art and the ambiguity of its structure and content that make this series a rich, complex, and not adequately analyzed forum.

The landscape of public art in New York City would be greatly diminished without the kind of ephemeral theater and important data produced by the two organizations. But what is important about both Creative Time, Inc., and the Public Art Fund, Inc., is not simply the variety of art productions that they have brought to the streets and spaces of the city, but the forum they have provided to explore the meaning of public art in the late twentieth century. Because the work is part of the urban fabric for short periods of time, there is freedom to try new ideas, new forms, new methods of production. Perhaps there is also the willingness to engage difficult ideas and current issues in ways that more enduring projects cannot. The highly compressed and temporal circumstances are an incitement—and also a responsibility—to be courageous with ideas, to be vanguard about definitions of public art, and to make commitments that concern content rather than longevity.

Some of the most fruitful, provocative, temporary installations of public art have come from artists on their own initiative both with and without the support or restraints of official sponsors. Tom Finkelpearl has done short-lived public art projects with both Creative Time and the Public Art Fund, but some of his strongest public work has been independently produced. Several years ago, he moved to New York to study a common and growing phenomenon of abandonment in the city. Finkelpearl began his own guer-rilla project to explore and perhaps heighten some collective awareness of the attitude of obsolescence. At different sites, he finds old abandoned cars and painstakingly paints these rusted carcasses gold, endowing them with an artificial, ironic, sprayed-on patina of preciousness. These projects happen spontaneously; they last until the cars are finally towed away. It is as if the act of public art, the commitment to communication, the gesture of compas-sion and critique transcend the lasting qualities of the object. That these golden wrecks disappear often quickly and always unpredictably amplifies their disturbing, ambivalent iconography.

Several years ago Alfredo Jaar arranged with the Metropolitan Transit

Alfredo Jaar, *Rushes*, 1986, Spring Street Subway Station, New York, NY.
(Photo: Alfredo Jaar)

Authority and the lease-holders of the advertising space on the Spring Street subway platform in New York to insert his own installation. For just over a month, Jaar's pasted-on posters—images of a gold rush occurring in Brazil amid abject poverty—replaced the usual advertisements meant to induce people to part with their money. Along the length of the uptown and downtown platforms, Jaar placed large prints of photographs he had taken of this modern-day phenomenon; throughout the installation period, he regularly inserted posters with the current world gold prices in New York, Frankfurt, Tokyo, and London. On this subway line to Wall Street, passengers encountered these grim, grainy images of men who dig for gold with little hope of finding any for themselves. The artist offered no explanatory or didactic text; the public was asked to form its own perceptions and draw its own conclusions. But the success of this political production was the sense of urgency and dislocation embodied in the temporary. In this context, created to sell magazines, liquor, and underwear to waiting passengers, Jaar used the frames and format for advertising to engage the public in a complex and disturbing narrative about its own complicity in world events. His project asked people to overcome their insularity and isolation. The content was underscored by the immediacy and brevity of the installation. The fact that it appeared almost spontaneously and disappeared quickly helped to accentuate the urgency of the ideas.

There is a danger in a public art that is not challenged, that is based on naïvely constructed prescriptions. Some of the restraining assumptions made about public art concern where it should occur, who the audience is, what issues it can address, what ideas it can express, and how long it should last; much of this speculation is based on information and impressions formed more than a century ago. The historical precedents for public art offer no template for the present or for the future. Public art does not have to last forever; it does not have to cast its message to some unmistakable but platitudinous theme that absolutely everyone will get; it does not have to mark or make a common ground. As the texture and context of public life change over the years, public art must reach for new articulations and new expectations. It must rely on its flexibility, its adaptability to be both responsive and timely, to be both specific and temporary. Ephemeral public art provides a continuity for analysis of the conditions and changing configurations of public life, without mandating the stasis required to express eternal values to a broad audience with different backgrounds and often different verbal and visual imaginations.

The errors of much public art have been its lack of specificity, its

tendency to look at society—at the public—too broadly and simply. The temporary in public art is not about an absence of commitment or involvement, but about an intensification and enrichment of the conception of public. The public is diverse, variable, volatile, controversial; and it has its origins in the private lives of all citizens. The encounter of public art is ultimately a private experience; perception outlasts actual experience. It is these rich ambiguities that should provide the subject matter for public art; the temporary provides the flexible, adjustable, and critical vehicle to explore the relationship of lasting values and current events, to enact the idea of the commons in our own lives. A conceptualization of the idea of time in public art is a prerequisite for a public life that enables inspired change.

Notes

1. Loren Eiseley, *Man, Time, and Prophecy,* New York, 1966, p. 27.
2. Richard Sennett, *The Uses of Disorder,* New York, 1970.
3. Stephen Jay Gould, *Time's Arrow, Time's Cycle,* Cambridge, MA, 1987.
4. Anita Contini, "Alternative Sites and Uncommon Collaborators: The Story of Creative Time," *Insights/On Sites,* ed., Stacy Paleologos Harris, Washington, DC, 1984.

Notes on Contributors

STEVEN BINGLER is the founder of Concordia Architects in New Orleans, Louisiana, organized to promote teamwork and collaboration throughout the design and construction process. Its work has been published in *Architectural Digest, Architecture Magazine, Interiors, Progressive Architecture* and other magazines and journals. Bingler also created the nonprofit Association for Collaborative Arts to provide funding for education and research in participatory creative processes.

MICHELE H. BOGART is associate professor of art at the State University of New York at Stony Brook. She is the author of *Public Sculpture and the Civic Ideal in New York City, 1890–1930* (University of Chicago Press, 1989), which won the 1990 Charles Eldredge Prize from the Smithsonian Institution's National Museum of American Art. Her most recent publication is "Artistic Ideals and Commercial Practices: The Problem of Status for the American Illustrator," *Prospects* 15 (1990).

E. G. CRICHTON is a visual artist living and working in San Francisco. She helped found *Out/Look National Lesbian and Gay Quarterly,* and worked as editor and art coordinator for three years. She currently is pursuing a master of fine arts degree at California College of Arts and Crafts.

ROSALYN DEUTSCHE is an art historian and critic who teaches at the Cooper Union in New York City. She has written extensively about art and urban redevelopment.

JOSEPH DISPONZIO is a graduate student in the department of art history and archaeology at Columbia University. He was an assistant landscape architect for seven years with the New York City Department of Parks and Recreation. His work has appeared in *The New York Times* and *Modulus,* the architectural review of the University of Virginia.

305

VIVIEN GREEN FRYD is an associate professor of fine arts at Vanderbilt University. Author of *Art and Empire: The Politics of Ethnicity in the U.S. Capitol, 1815–1865* (Yale University Press, 1992), she is currently working on a book about Edward Hopper. Her various articles on 19th-century American sculpture have been published in a number of journals including *The American Art Journal, Phoebus* and *The Augustan Age.*

DONNA GRAVES is currently working on a book about interdisciplinary approaches to public art and is a doctoral candidate in the urban planning program at the University of California, Los Angeles. She is former director of The Power of Place, a nonprofit organization that interpreted multiethnic historic sites in downtown Los Angeles through public art and historic preservation.

CHARLES L. GRISWOLD, JR. is professor of philosophy and chairman of the philosophy department at Boston University. Dr. Griswold is the author of *Self-Knowledge in Plato's Phaedrus* (Yale University Press, 1986) and editor of *Platonic Writings, Platonic Readings* (Routledge, Chapman, and Hall, 1988). His writing has also appeared in the *Wall Street Journal, Washington Post, Wilson Quarterly* and *American Scholar.* Dr. Griswold was a Fellow at the Woodrow Wilson International Center for Scholars in 1989/91.

DOLORES HAYDEN is a social historian of American architecture and urban development and author of *Seven American Utopias* (MIT Press, 1976), *The Grand Domestic Revolution* (MIT Press, 1981), and *Redesigning the American Dream* (W. W. Norton, 1984). She is also a licensed architect and is currently professor of architecture and urbanism, and professor of American studies, at Yale University. Her current book in progress, *Winged Pigs and Midwives' Bags,* is a study of local history, memory, and the multicultural city in the United States. It is based on ten years as president of The Power of Place, a nonprofit corporation celebrating urban history, which she founded.

SEITU JONES is an artist who lives in St. Paul, Minnesota.

SUSAN LARKIN is an independent art historian. She organized the first permanent outdoor installation of a Native American totem pole in England in 1985 and chaired the Citizens Committee on Public Art for the symposium "Setting Sites: Process and Consensus in Public Art," held at the State University of New York, Purchase, in 1987. Her publications include "In the Public Eye," a critique of recent public sculpture in Connecticut (*Connecticut,* August 1987) and *J. Alden Weir: A Place of His Own* (William Benton Museum of Art, Storrs, Conn., 1991).

GERALD E. MARKOWITZ is professor of history and chair, Interdepartment of Thematic Studies at John Jay College of Criminal Justice, CUNY. He is the author, with David Rosner, of *"Slaves of the Depression": Views on Industrial Conditions* (Cornell University Press, 1987). He is the coauthor and curator with

Marlene Park of *New Deal for Art* (Gallery Association of New York State, 1977). His articles have been published in the *American Journal of Public Health, Journal of Social History, American Quarterly* and other publications.

DENNIS R. MONTAGNA is an architectural historian with the Mid-Atlantic Regional Office of the National Park Service in Philadelphia, and has published and lectured widely on public sculpture and its conservation.

ROBERT MORRIS is a sculptor and painter who lives in New York City.

MARLENE PARK is professor of art history at John Jay College of Criminal Justice, CUNY. She is the author of numerous articles appearing in *Art Quarterly, Sarah Lawrence Journal* and *Journal of the Warburg and Courtauld Institutes.* Her book reviews have been published in *Antiques World, The Journal of American History* and *The American Historical Review,* among others. She is the coauthor and curator with Gerald E. Markowitz of *New Deal for Art* (Gallery Association of New York State, 1977).

PATRICIA C. PHILLIPS is an associate professor of art and chair of art studio/ art education at SUNY—The College at New Paltz. She is a critic who writes on art, design, and public art and architecture for *Artforum* and other international publications. Recent essays have appeared in *Breakthroughs: Avant-Garde Artists in Europe and America, 1950–1990* (Rizzoli International Publications, Inc., 1991); *Melvin Charney* (Canadian Center for Architecture, 1991); *Sculpture;* and *Design Book Review.*

JIM POMEROY (1945–1992) was associate professor, teaching video and photography, in the department of art and art history at the University of Texas at Arlington. Pomeroy was also active in the development of innovative performance venues. He was one of the founding members of the San Francisco artspace, 80 Langston Street, and participated in ArtPark's public art projects.

DANIELLE RICE is curator of education at the Philadelphia Museum of Art. She has previously served in that capacity at the National Gallery of Art in Washington, DC and the Wadsworth Atheneum in Hartford, CT. She has published a number of articles in *Museum News* and *The Journal of Aesthetic Education* on the plight of the public in the museum setting.

KIRK SAVAGE is currently a Fellow at the Commonwealth Center for the Study of American Culture at the College of William and Mary. He is an assistant professor of American art at the University of Pittsburgh and has written for the *Smithsonian Studies in American Art.*

HARRIET F. SENIE is director of museum studies and associate professor of art history at The City College, CUNY, New York. She is the author of numerous articles on public art, *Contemporary Public Sculpture: Tradition, Transformation,*

and Controversy (Oxford University Press, 1992), and the forthcoming *Dangerous Precedent: Richard Serra's "Tilted Arc" in Context* (Berkeley, University of California Press).

SALLY WEBSTER is associate professor of modern and contemporary art and chair at Lehman College (CUNY), the Bronx. She is author of *William Morris Hunt* (Cambridge University Press, 1991).

JOHN WETENHALL is curator of painting and sculpture at the Birmingham Museum of Art, Birmingham, Alabama. He is coauthor (with Karal Ann Marling) of *Iwo Jima: Monuments, Memories and the American Hero* (Harvard University Press, 1991) and author of *The Ascendancy of Modern Public Sculpture in America* (forthcoming: University of California, Berkeley). He has also written, with Marling, "The Sexual Politics of Memory: The Vietnam Women's Memorial Project and 'The Wall' " for *Prospects: An Annual of American Cultural Studies,* vol. 14, 1989.

JAMES E. YOUNG is associate professor of English and Judaic studies at the University of Massachusetts, Amherst, and the author of *Writing and Rewriting the Holocaust* (Indiana University Press, 1988) and *The Texture of Memory* (Yale University Press, 1992). He is curating a traveling exhibition on "The Art of Memory" at the Jewish Museum in New York City in 1993.

Index

Grateful acknowledgment is made for permission to reprint the following articles:

"An American Sense of Place" (with an afterword) by Dolores Hayden: first published in *Design Quarterly* 122 (1983), Minneapolis.

"Camelot's Legacy to Public Art: Aesthetic Ideology in the New Frontier" by John Wetenhall: reprinted from *Art Journal* 48 (Winter 1989), by permission of the College Art Association, Inc.

"Earthworks: Land Reclamation as Sculpture" by Robert Morris: first published by the Seattle Art Museum in *Earthworks: Land Reclamation as Sculpture,* copyright 1979 by the Seattle Art Museum, Seattle, WA.

"Is the NAMES Quilt Art?" by E. G. Crichton: first published in *Out/Look: National Lesbian and Gay Quarterly* Vol. 1, No. 2 (Summer 1988).

"The MacArthur Park Experiment, 1984–1987" by Steven Bingler was first published in *On View Journal of Public Art and Design* (Spring/Summer 1990) and is reprinted by permission of The On View Public Art and Design Association, Cambridge, Massachusetts.

"New Deal for Public Art" by Marlene Park and Gerald E. Markowitz: first published in *Democratic Vistas: Post Offices and Public Art in the New Deal,* copyright 1984 by Marlene Park and Gerald E. Markowitz, reprinted by permission of Temple University Press.

"Political Compromise in Public Art: Thomas Crawford's *Statue of Freedom*" by Vivien Green Fryd: delivered as a paper at the College Art Association Annual Meeting in New York, February 1990, and expanded as a chapter in *Art and Empire: The Politics of Ethnicity in the U.S. Capitol, 1815–1865,* copyright 1992 by Vivien Green Fryd; reprinted by permission of The Yale University Press.

"Public Art and Its Uses" by Rosalyn Deutsche: excerpt from an article entitled "Uneven Development: Public Art in New York City," first published in *October* 47 (Winter 1988); reprinted by permission of The MIT Press, Cambridge, Mass.

"Public Art That Inspires: Public Art That Informs" by Seitu Jones: first published in *Public Art Review,* Vol. 11, No. 2 (Fall/Winter 1990); reprinted by permission of *Public Art Review,* a semiannual journal published by Forecast, a Minnesota nonprofit corporation.

"The Rise and Demise of *Civic Virtue*" by Michele H. Bogart: first published in *Public Sculpture and the Civic Ideal in New York City, 1890–1930* (1989); reprinted by permission of The University of Chicago Press.

"Selections from 'Rushmore—Another Look' " (with an afterword) by Jim Pomeroy: first published under the title "Rushmore—Another Look: Surveying the Icon"; reprinted with the permission of the San Francisco Art Institute, San Francisco, CA.

"The Self-made Monument: George Washington and the Fight to Erect a National Memorial: Philosophical Thoughts on Political Iconography" by Kirk Savage: first published in *Winterthur Portfolio* (Winter 1987); copyright by The Henry Francis du Pont Winterthur Museum, Inc.; reprinted by permission of The University of Chicago Press.

"Temporality and Public Art" by Patricia C. Phillips: reprinted from *Art Journal* 48 (Winter 1989), by permission of the College Art Association, Inc.

"The Vietnam Veterans Memorial and the Washington Mall" by Charles L. Griswold: first published in *Critical Inquiry* 12 (Summer 1986). Copyright 1986 by Charles Griswold; reprinted by permission of The University of Chicago Press.